THE COMPLETE GUIDE TO LANDSCAPE ASTROPHOTOGRAPHY

The Complete Guide to Landscape Astrophotography is the ultimate manual for anyone looking to create spectacular landscape astrophotography images. By explaining the science of landscape astrophotography in clear and straightforward language, it provides insights into phenomena such as the appearance or absence of the Milky Way, the moon, and constellations. This unique approach, which combines the underlying scientific principles of astronomy with those of photography, will help deepen your understanding and give you the tools you need to fulfill your artistic vision.

Key features include:

- Distinguished Guest Gallery of images from renowned nightscape photographers such as Babak Tafreshi, Bryan Peterson, Alan Dyer, Brenda Tharp, Royce Bair, Wally Pacholka, and David Kingham
- The twenty-five best landscape astrophotography subjects and how to photograph them
- Astronomy 101—build your knowledge of night sky objects and their motion: the Milky Way, moon, Aurora Borealis/Australis, constellations, meteors, and comets
- Information on state-of-the-art planning software and apps designed to enable you to capture and enhance your landscape astrophotography
- Field guide for creating a detailed plan for your night shoot
- Description of the best moon phases for specific types of nightscape images and the best months and times of night to see the Milky Way
- How-to guide for creating stunning time-lapse videos of the night sky, including "Holy Grail" transitions from pre-sunset to complete darkness
- Four detailed case studies on creating landscape astrophotography images of the Milky Way, full moon, star trails and constellations

MIKE SHAW is a renowned professional photographer who leads night and nature photography workshops around the world. He holds a Ph.D. in Materials Engineering from the University of California, Santa Barbara, an M.S. in Ceramic Engineering from the Ohio State University, and a B.S. in Materials Science and Engineering from the University of California, Berkeley. Shaw is a former physics and astronomy professor who has taught thousands of students. He also conducts educational photography workshops for the community, including astronomy and astrophotography outreach seminars for the U.S. National Park Service.

THE COMPLETE GUIDE TO LANDSCAPE ASTROPHOTOGRAPHY

UNDERSTANDING, PLANNING, CREATING, AND PROCESSING NIGHTSCAPE IMAGES

MIKE SHAW

Routledge
Taylor & Francis Group

NEW YORK AND LONDON

CONTENTS

Foreword by Babak Tafreshi, vii
Preface, viii
Acknowledgments, ix

SECTION I
WHAT IS LANDSCAPE ASTROPHOTOGRAPHY AND WHY NOW? **1**

1 Introduction and Goals of Book 3

SECTION II
**UNDERSTANDING ASTRONOMY AND ATMOSPHERIC SCIENCE
FOR NIGHTSCAPE IMAGES** **13**

2 The Night Sky and Its Movement 15
3 Sunrises and Sunsets 37
4 Aurora Borealis/Australis 49
5 The Moon 63
6 Solar System 85
7 Meteors, Meteor Showers, Comets, Fireballs, and Bolides 93
8 The Milky Way 101
9 Weather and Atmospheric Science 119

SECTION III
**UNDERSTANDING PHOTOGRAPHY FOR LANDSCAPE
ASTROPHOTOGRAPHY IMAGES** **133**

10 Light and the Human Eye 135
11 Camera and Lens Systems 147
12 Exposure 175
13 Light Painting and Light Drawing 191
14 Video, Time Lapse, and Motion Production 199

SECTION IV
PLANNING SUCCESSFUL LANDSCAPE ASTROPHOTOGRAPHY IMAGES **205**

15 The Twenty-Five Best Landscape Astrophotography Targets
 (and How to Photograph Them) 207
16 Developing Your Astrophotography Session Plan 235
17 Essential Software and Apps 257
18 Essential Hardware and Equipment 269

SECTION V

CREATING LANDSCAPE ASTROPHOTOGRAPHY IMAGES 283

 19 The Landscape Astrophotography Clinic 285
 20 Obstacles and Common Unexpected Problems 295

SECTION VI

PROCESSING LANDSCAPE ASTROPHOTOGRAPHY IMAGES 315

 21 Image Management and Processing Foundations 317
 22 Creative Nightscapes: Multiple Image Processing 335

SECTION VII

DETAILED CASE STUDIES 361

 23 From Concept to Curating—Four Detailed Case Studies 363

SECTION VIII

DISTINGUISHED GUEST GALLERY 393

 24 Distinguished Guest Gallery 395

SECTION IX

CONCLUSIONS 415

 25 Where Do We Go from Here? 417

APPENDICES

 I Equipment Checklist 420
 II Image Summary and World Map 421
 III Annual Night Sky Planner 428
 IV Homemade Planisphere 429
 V Polaris Altitude 431
 VI The Horizon 433
 VII Contributor Websites 434

 Index 437

First published 2017
by Routledge
711 Third Avenue, New York, NY 10017

and by Routledge
2 Park Square, Milton Park, Abingdon, Oxon OX14 4RN

Routledge is an imprint of the Taylor & Francis Group, an informa business

Library of Congress Cataloging in Publication Data
Names: Shaw, Michael C., author.
Title: The complete guide to landscape astrophotography : understanding, planning,
 creating, and processing nightscape images / Mike Shaw.
Description: Abingdon, Oxon : Routledge, 2017. |
Includes bibliographical references and index.Identifiers: LCCN 2016012383 (print) |
 LCCN 2016016868 (ebook) | ISBN 9781138201057 (hardback) |
 ISBN 9781138922860 (pbk.) | ISBN 9781315684840 (eBook) |
 ISBN 9781315684840 ()
Subjects: LCSH: Landscape photography--Handbooks, manuals, etc. | Night
 photography--Handbooks, manuals, etc. | Astronomical photography--
 Handbooks, manuals, etc.
Classification: LCC TR610 .S53 2017 (print) | LCC TR610 (ebook) |
 DDC 778.9/36--dc23LC record available at https://lccn.loc.gov/2016012383

ISBN: 978-1-138-20105-7
ISBN: 978-1-138-92286-0
ISBN: 978-1-315-68484-0

Typeset by Alex Lazarou

FOREWORD

The night sky is an essential part of nature and not just an astronomer's laboratory. However, for many people who live in urban light dominated areas, this part of nature is completely lost. Astrophotography in any form and level, either by only a photo camera and tripod or a complete set of telescopic equipment, helps to reclaim the forgotten beauty of the night sky.

There are few other scenes in nature that astound me so deeply in the way that the rise of the Milky Way does. I have photographed such fiction-like starry scenes from bizarre locations of the planet; from the boundless darkness of the African Sahara when the summer Milky Way was arching above giant sandstones, to the shimmering beauty of the Grand Canyon under moonlight, and crystal sharp sky of Himalayas when the bright winter stars were rising above the roof of the world Mt. Everest. Astrophotography is not only about recording a part of the outer space. It leads you to a life of adventures and enjoyment which are not experienced by most of the people on this planet.

The age of digital imaging has revolutionized astrophotography. The possibility of creating inspiring images of the night sky with today's off-the-shelf digital cameras, which was once only possible with highly sophisticated equipment, made a considerable amount of public interest to amateur astronomy and astrophotography, specially to nightscape (night sky landscape) imaging which is also often referred to as landscape astrophotography. This potential has been grown further since 2007 when an international photography and outreach program, called The World At Night (TWAN), started to increase public awareness on importance of natural night skies to our environment, culture, and art. Being the founder and director of this program allowed me to communicate with fellow astrophotographers around the globe and to learn about their characters, challenges, passions, and goals.

Mike Shaw is both an academic photography and astronomy educator and avid experienced night sky photographer who has experienced both generations, from the time of film cameras to these years that digital sensors are dominating photography. His world-class images and experiences are generated through both knowledge of physics and practice of photography. There are scattered online resources to educate nightscape photographers on various technical aspects. However, a step-by-step printed guide book has been a major missing element in the field. The "Complete Guide to Landscape Astrophotography" is an innovative and timely resource for both amateur and professional photographers with interest in the night sky and lowlight nature imaging, specially from an astronomical perspective and importance of planning. I'm privileged to collaborate with Mike Shaw on the growing number of projects such as joint workshops.

BABAK TAFRESHI
APRIL 2016

PREFACE

Landscape astrophotography combines compelling landscape subjects with carefully choreographed night sky objects. This book explains the science behind the art of landscape astrophotography in clear and easy to understand language. The goal is to help you learn how to successfully plan and create your own nightscapes of the Milky Way, star trails, the Aurora Borealis, and much, much more. *The unique approach of this book is its coupling of the underlying principles of astronomy and photography through practical, step-by-step methods to provide you with all the tools you need to fulfill your artistic vision.* Without this knowledge, an inefficient, time-consuming and often frustrating ad hoc, trial and error approach is the only alternative to gaining expertise and proficiency in landscape astrophotography.

The theme of this book is *preparation*. Understanding the basics of astronomy will give you deep insights into the "why" of the appearance or absence of the Milky Way, the moon, specific constellations, and more. Learning the relevant fundamentals of photography will enable you to adjust your camera's settings for perfect exposures of the night skies. Thorough planning and preparation will guide you to the right place at the right time and with the right equipment and experience.

Far more than a cookbook of recipes, this book delves deeply into the causes for the effects that you observe. This is accomplished through copious examples, detailed explanations, illustrations, field charts, and case studies. By mastering this knowledge, you will be able to predict with certainty, months and even years in advance, what you need to do; and when and where you need to go to create almost any new nightscape image you can imagine.

A specific goal of this book is to recognize and showcase landscape astrophotography images generously shared by prominent astrophotographers from locations around the world. Their images will both inspire you as well as illustrate why geography-dependent differences may arise. For example, you will see why the height of star trail circles depends on the latitude of the observer, or why certain constellations are only ever visible in either the Northern or Southern Hemispheres, regardless of the season. More frequently, however, you will see that all observers of the night sky have much in common, regardless of their location. The presence of the Milky Way, the appearance of the rising full moon, the movement of the stars, the glorious colors of sunsets and sunrises, meteor showers—these are nighttime phenomena we all experience, regardless of international boundaries. You will gain a deeper appreciation of what you may accomplish from wherever you're reading these words by studying these images from different global locations.

Finally, it is a great pleasure to present a select group of iconic images from the most renowned landscape astrophotographers in the Distinguished Guest Gallery. It is an honor to include their images in this book. I greatly respect their generous spirit of collaboration and deeply appreciate their willingness to do so. I hope you will enjoy viewing these extraordinary images and find them motivating as well as aesthetically satisfying. Landscape astrophotography has advanced rapidly in recent years owing in no small part to the creativity and ingenuity of these well-known pioneers. I wish to personally thank each of them for creating and sharing these remarkable images with you, the reader.

My hope in writing this book is to convey my love of nature, photography, and especially the night skies. Through it, I hope that you, too, may gain a deeper appreciation of our incredible universe each time you step into the night.

ACKNOWLEDGMENTS

This book is the outcome of years spent wandering and pondering outdoors at night in the wilderness. It would not exist without the generous help and support of many kind, knowledgeable, and creative people along the way. They have shared and greatly contributed to my journey; venturing into wild places with me, and helping me understand so many aspects of astronomy, photography, nature, and life.

In particular, I'd like to thank the following people: my parents for instilling in me their love of nature, science, photography, and exploration, and my siblings—Jennifer, Peter and Steve—for their patience and expertise in photography, astronomy, and art; Scott Freeman, for his intrepid friendship through countless trail and off-trail miles under less-than-ideal conditions; Tom Dunford, for many backcountry adventures and for introducing me to some of my first astronomical experiences; Michael Brint and David Marcey, for wrangling up many a photographic opportunity; David Larson, for sharing his deep knowledge of the Minnesota outdoors and for leading sailboat trips into the night; Kelsey Larson and Joey Wishart, for their unquenchable enthusiasm for tropical late-night expeditions.

I would especially like to acknowledge and highlight Babak Tafreshi's pioneering leadership in the field of landscape astrophotography. His work and the organization he founded in 2007, "The World At Night," twanight.org, have been a primary source of inspiration and wanderlust for me since its inception. I also wish to extend my deep appreciation to Babak for not only writing the Foreword to this book, but for reading the complete manuscript with painstaking thoroughness, correcting my errors, making countless crucial suggestions and, finally, for our treasured ongoing collaborations.

I also wish to specifically acknowledge the photographic genius of Bryan Peterson; for introducing me to my camera's light meter and manual exposure mode many years ago, enlightening me with his "bee" model for photographic exposure, generously sharing innumerable tips and secrets, and for educating and motivating me under any circumstance with his uniquely upbeat perspective on all things photographic.

Many thanks go out to my photography friends for all their advice and guidance, particularly Steve Hallmark, Tim Keagy, Matthew Moses, Jerry Thoreson, and Robert Folsom; as well as to Craig Carey for his timely advice and encouragement during the initial stages of this project.

I would also like to extend my deep appreciation to the wonderfully creative folks at the Santa Monica Mountains National Recreation Area for their friendship, support, and collegiality; specifically, Robert Cromwell, Sheila Braden, Rasza Cruz, Ken Low, Kate Eschelbach, Anthony Bevilacqua, and Robert Taylor.

My great thanks go to all the contributors to this book who kindly shared their work: Anthony Ayiomamitis, Alex Cherney, Alex Conu, Ben Cooper, Mike Crawford, Alan Dyer, Uli Fehr, Scott Freeman, Steve Hallmark, P-M Heden, Grant Kaye, Jan Koeman, Craig Lent, Donald Lubowich, Martin McKenna, Philippe Mollet, Bernd Pröschold, Gyorgy Soponyai, Babak Tafreshi, Yuichi Takasaka, Tunc Tezel, Cristina Tinta, Vaibhav Tripathi, Zhou Yannen, Steed Yu, Oshin Zakarian, and Caren Zhao. Your wonderful spirit of collaboration is deeply appreciated.

I would particularly like to express my profound gratitude to the distinguished guests who graciously agreed to share their images: Anthony Ayiomamitis, Royce Bair, Alex Cherney, Steven

Christenson, Alan Dyer, John Goldsmith, Phil Hart, Lance Keimig, David Kingham, Dora Miller, Marc Muench, Ian Norman, Wally Pacholka, Bryan Peterson, Tony Prower, Babak Tafreshi, Yuichi Takasaka, Brenda Tharp, and Andy Williams. It is an honor to include your work herein.

I would also like to gratefully acknowledge the support of all my colleagues at Routledge, Taylor & Francis, and Focal Press, particularly Kimberly Duncan-Moody for accepting the original book proposal and giving me this opportunity of a lifetime, Anna Valutkevich for her insightful suggestions and comments on early versions of the manuscript, Galen Glaze for his support and guidance, and Judith Newlin for her stalwart support and encouragement.

I wish to thank my tireless proofreaders: Jennifer Larson, Matthew Moses, and Scott Freeman, for their valuable efforts at proofreading portions of this manuscript. Your comments and corrections were an enormous help—thank you!

I would also like to thank all of you who have attended my field and online classes and workshops—education is truly a two-way street. I have learned something from each and every one of you, and appreciate our time together.

This section would be incomplete without a special note of appreciation for all of the anonymous acquaintances I have met out in the field, in remote locations, often in the dark but always in good humor.

Finally, I wish to thank my wife, Kirsten, for her enduring love, her friendship, and support; and for always cheerfully heading out the door with me precisely when everyone else is heading back inside.

To my wife, Kirsten,
with all the love,

and

To my mother, Betty Shaw, and my father, John Shaw,
for sharing their deep love and knowledge of nature,
and their unquenchable spirit of exploration

SECTION I
What Is Landscape Astrophotography and Why Now?

1

INTRODUCTION AND GOALS OF BOOK

A BRIEF HISTORY OF LANDSCAPE ASTROPHOTOGRAPHY

Landscape astrophotography, Figure 1.1, has been around for decades. Prior to the advent of modern digital cameras, however, only the most dedicated possessed the patience to persist in their pursuit of quality images. Success was elusive owing to the large number of obstacles and the steep learning curve, difficulties exacerbated by the major delay in image review resulting from the need to develop at least the negatives of the film. Nonetheless, the lure of the night sky was irresistible to many who carefully and meticulously perfected their art.

All this changed with the incredible improvements in affordable digital photography for the consumer market during the 1990s and 2000s. Suddenly, not only were digital single-lens reflex (DSLR) cameras available that were capable of producing images of comparable quality to those based on film, digital cameras provided instant feedback. This latter point was a true game-changer; the photographer could now determine, on the spot, if the focus was off; if the exposure was wrong; if the composition needed to be tweaked, and so on. You will find yourself constantly reviewing your images in the field, and you will improve your success rate enormously if you develop the habit of doing so. You will detect and be able to correct minor flaws that, if left undiscovered until you return home, could otherwise ruin an entire evening of shooting.

The other significant development in the late 2000s was the creation of the organization known as "The World At Night" (TWAN), developed and promoted successfully by Babak Tafreshi, Figure 1.2. TWAN quickly emerged as the premier, international online hub of landscape astrophotography. Unlike other organizations that emphasized either astronomy or photography, TWAN was the first organization to identify and promote the creative intersection of astronomy and landscape photography. TWAN was the place where notable landscape astrophotographers from around the world freely exhibited their work, and where guest astrophotographers could submit their own images for display. TWAN is a wonderful source not only for inspirational photographs, but is also an organized source of very practical examples, photography locations, and tips for those planning trips to international destinations.

Today, landscape astrophotography, also known as nightscape photography, has exploded into our everyday lives—through science news, advertising, and social media. New apps and online resources designed especially for landscape astrophotography, especially those integrating augmented reality, are constantly being developed and improved. Camera and lens systems continue to be refined to be available at ever-lower costs. A host of online communities can be found to share and learn about the most obscure of landscape astrophotography topics. Clearly, this is a golden era!

BOOK GOALS AND WHAT YOU WILL LEARN

"To give someone a fish is to feed them for a day, to teach them to fish is to feed them for a lifetime."—Unknown

This book aims to help you ascend the learning curve as quickly as possible. The goal is for you to acquire your own, broad foundation of knowledge so that you will be able to quickly understand, adapt, and apply future developments as they become available.

There are several elements that generally align in a successful landscape astrophotography image, all of which can be acquired and improved through dedication and study: (i) creative vision, (ii) correct

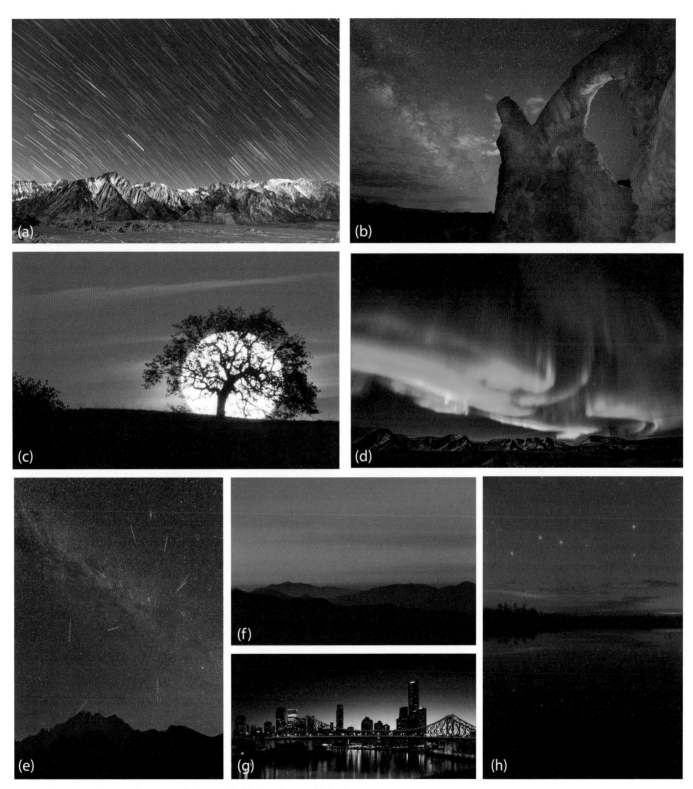

1.1 Landscape astrophotography images of (a) star trails; (b) the Milky Way; (c) the rising full moon; (d) the Aurora Borealis; (e) the Perseid meteor shower; (f) twilight; (g) cityscapes; and (h) starry skies. Landscape astrophotography combines compelling landscapes with carefully positioned objects of the night sky. This book explains and teaches all the astronomy, photography, and in-the-field knowledge you need to create images such as these.

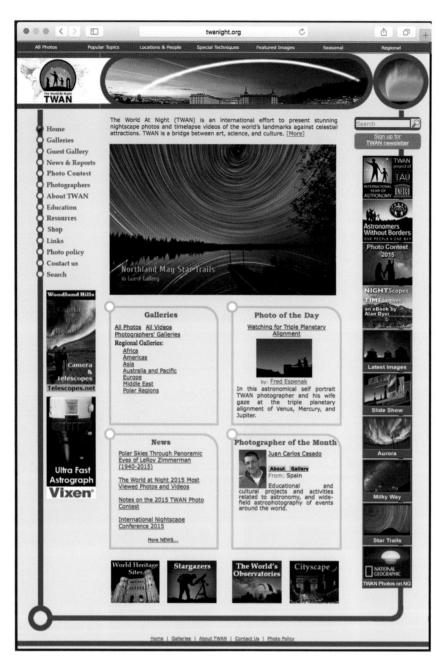

1.2 "The World At Night," or TWAN, is a premier, international online hub of activity of landscape astrophotography. TWAN was the first organization to identify and promote photography at the intersection of astronomy and landscape photography. TWAN is a place where notable landscape astrophotographers from around the world freely exhibit their work, and where guest astrophotographers may submit their own images for display. TWAN is a wonderful source for not only inspirational photographs, but also a host of very practical examples and tips for those planning trips to international destinations.

Source: The World At Night/twanight.org

subject and lighting, and (iii) technical proficiency. Your creative vision can be catalyzed by carefully studying the work of others, or simply by spending some time outdoors under the beautiful night sky and letting your imagination roam. A basic knowledge of astronomy can be gained directly from this book and the tools described herein, especially coupled with practice outside at night. Technical proficiency in photographic technique can be learned through careful study of the information presented herein and practice with your camera, lenses, and other equipment. It is certainly possible to rely on trial-and-error in creating a phenomenal landscape astrophotography image, however, there are many things that can go wrong. The abysmal success rate can be incredibly frustrating. Instead, thorough preparation will all but guarantee fulfillment of your artistic vision, time after time.

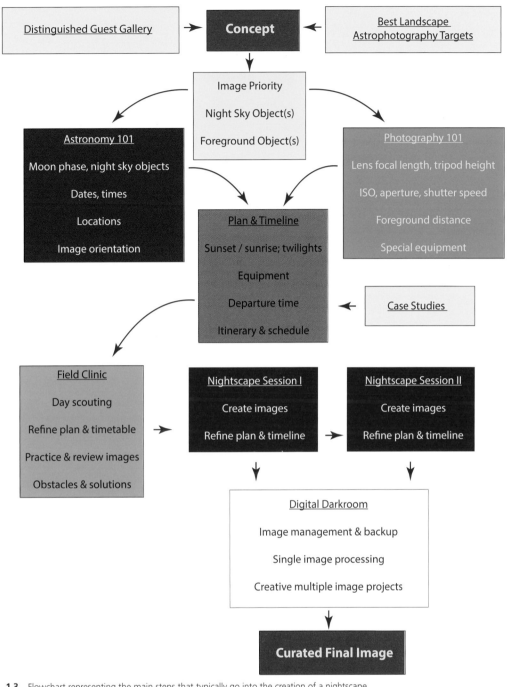

1.3 Flowchart representing the main steps that typically go into the creation of a nightscape image. Each of the topics shown here is covered in this book: concept development, astronomy 101; photography 101; planning, field reconnaissance, image creation, and image processing in the digital darkroom.

This book aims to help you learn everything you need to know to create landscape astrophotography images that reflect your personal creative vision. The different elements that comprise the process of successfully creating nightscape images generally fall into one or more of the following topics, each of which is a section of the book, Figure 1.3: (i) Understanding Astronomy and Atmospheric Science; (ii) Understanding Photography; (iii) Conceptualizing and Planning Landscape Astrophotography Images; (iv) Creating Landscape Astrophotography Images; and (v) Processing Landscape Astrophotography Images. This book also features a Distinguished Guest Gallery full of awe-inspiring images to help with your creative vision, along with a Case Studies section to help you plan out all the details of your image creation process.

In this book, you will:

- Learn about astronomy and know the best days of the year for different night sky targets
- Discover subtleties of photographic techniques unique to landscape astrophotography
- Learn about ways to prepare for your nighttime outings to overcome common obstacles and maximize your chances of success
- Integrate your astronomy and photography knowledge in the form of a detailed plan, itinerary, and schedule for your nightscape image expeditions
- Learn special techniques for processing your images to achieve spectacular effects
- Be inspired by the iconic images of world-renowned landscape astrophotographers in the Distinguished Guest Gallery

We begin with an overview of astronomy, and explain how the objects we see each night are always in motion. Their presence or absence varies depending on the month and season. We explore the science behind the amazing phenomena that accompany sunsets and sunrises. We explain the reasons and timing of the phases of the moon and why they're so important for astrophotography. We introduce the Milky Way; what it is, how, where, and when best to see it, along with a host of other key topics.

Next, we review the fundamentals of photography, beginning with the color and description of light, and its perception by human vision. We review camera and lens choices and explain the pros and cons of each. We go through the elements of correct photographic exposure and how the different camera settings affect the quality of the resultant images. We also describe ways of selectively introducing foreground light through controlled flash illumination and light painting. Finally, we briefly introduce the basic steps of creating nightscape time-lapses.

The subsequent sections deal with the nuts and bolts of astrophotography planning and execution—the hardware and software tools that are of critical importance. We describe how these tools prepare the astrophotographer for a successful outing by helping to identify the best night(s), times, and locations for optimizing their chances of success. We demonstrate the basics of astrophotography planning and execution by example, beginning with a pre-visualized concept all the way through to pressing the shutter release. We show how to select the exact location, orientation, month, date, and time for your photography as well as precisely which lens to pick and what International Standards Organization (ISO), aperture, and shutter speed you should use. Suggested exposure settings and examples for twenty-five popular nightscape images are provided to get you started!

We then explain and demonstrate the possibilities of image enhancement in the digital darkroom, using Adobe Photoshop, Lightroom, and other popular software. A number of plug-ins, scripts, and actions developed especially for landscape astrophotography are detailed. Methods for bringing out the best of individual images are described, as well as for combining two or more images for remarkable effects. Finally, four case studies are explained in depth, from initial visualization of the concept all the way through to curating of the final image. Successes and failures along the way are included to illustrate easy mistakes to make and how to avoid making them!

WHAT YOU WILL NEED TO GET STARTED—CAMERA, TRIPOD, AND HEADLAMP

This book is written for those who either own, or plan to acquire, a DSLR or equivalent mirrorless camera, Figure 1.4(a). A sturdy tripod and quality head combination is the second absolute necessity, owing to their stability and exquisite control over composition, Figure 1.4(a), (c). While it is possible to create landscape astrophotography images simply by propping up your camera on a fence, bench, or other support, a good tripod system really is essential. Finally, a headlamp or flashlight, preferably one with a red light bulb, or a red plastic cover, is needed, Figure 1.4(b). This is critical for your own personal safety as well as to help with the operation of your equipment. These are really the only three items necessary for the creation of landscape astrophotography images.

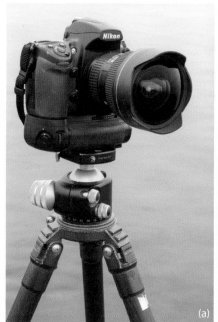 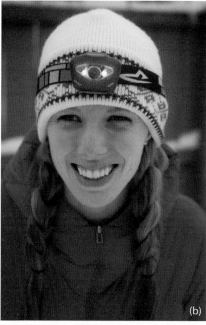

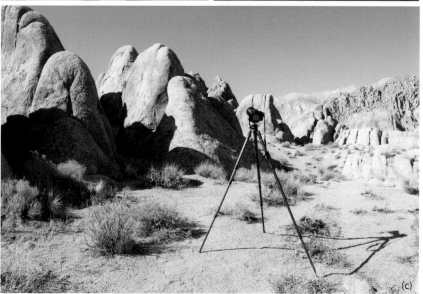

1.4 Basic equipment needed for landscape astrophotography: (a) a modern digital, single-lens reflex (DSLR) or mirrorless camera affixed to (b) a sturdy tripod assembly, preferably with a wide-angle lens (in the range of 14–24 mm focal length) and either a (c) headlamp with a red bulb or a flashlight, preferably with a red bulb or red plastic cover.

Satisfying nightscape images involving the moon, sunrises, and sunsets can often be created using contemporary smartphones and point-and-shoot cameras. Although their performance is constantly improving, such cameras simply aren't designed to capture the highest quality images of the most popular nightscape subjects – the Milky Way, stars, meteors, and so forth. Modern digital DSLRs and their mirrorless equivalents have considerably higher inherent image quality, and also offer a far greater control over exposure. DSLR cameras and their mirrorless equivalents are capable of producing simply incredible images of the night sky and are the focus of this book.

STARRY SKIES RECIPE TO GET YOU GOING TONIGHT

Here is a straightforward recipe to get you outside tonight and embarked upon your landscape astrophotography journey. Fingers crossed for clear skies!

Description:

The starry skies have fascinated us for millennia. Here, you will want a clear view of the sky, and you will want to use a wide-angle lens, one with a focal length of approximately 24 mm or less for a camera with a full-frame sensor, or 18 mm or less for a camera with a crop sensor. Needless to say, you will want to mount your camera on a sturdy tripod! Here's the recipe:

Makes:

One to two dozen (or more) images of starry skies, Figure 1.5.

Ingredients:

- Camera/tripod
- Manual shutter release or self-timer
- Manual exposure mode
- ISO 800–3200
- Aperture—*f*/4, *f*/2.8 or similar
- Shutter speed of say 5 seconds to start
- Headlamp preferably with red light, or red plastic taped over a white light

Directions:

During the day, focus your camera on the most distant object you can see—the horizon, distant mountaintops, or distant city buildings. After finding a good focus, set your camera lens and/or camera body to manual focus and leave it there. Many people will temporarily tape the focus ring of their lens in this position to keep this focus for the duration of the night, as can be seen in Figure 20.1(d). Other options for focusing can be found later in this book, for example in Chapter 20.

Next, before heading out, look up the time of sunset/sunrise. The skies generally become fully dark around 1½ to 2 hours after the sun has set. Plan on arriving on location at least an hour prior to this time to give yourself enough time to unpack, find a good location, and set up your camera system properly.

facing page

1.5 The incredible arrays of stars make up eighty-eight identified constellations, including Orion, a portion of which is shown here positioned over the eastern Sierra Nevada in California. Even massive Mt. Whitney (lower right), the tallest mountain in the continental United States, is dwarfed by Orion's size. You can make a similar image tonight simply by following the recipe in the text.

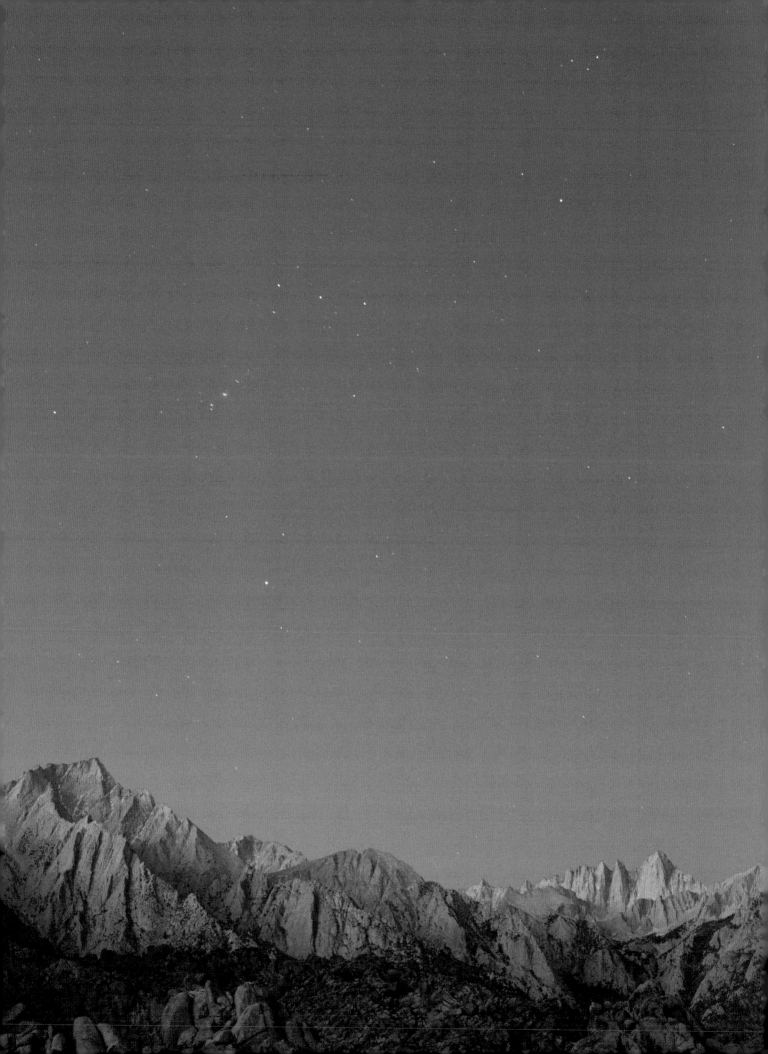

Set up your camera/tripod with a clear view of the sky; perhaps with an interesting foreground subject—a line of trees, mountaintops, or beach. If your camera doesn't have a viewfinder, don't worry. Just aim it so that it is generally pointing at the sky—and be sure to keep the manual focus setting in place!

With your camera pre-focused as described above, expose your first image and review it and its histogram on the back of the camera. If needed, increase or decrease the shutter speed—speeds of 20–30 seconds are very common. If the image is too dark at exposure times of say 20 seconds, bump up the ISO; just try to keep the ISO below 6400. If no clouds are present, you should be able to make at least a dozen or so high quality images. And if this doesn't yet make sense to you, it will; read on!

Bibliography

Keimig, Lance, *Night Photography and Light Painting*, 2015, Focal Press/Taylor and Francis, New York and London

www.twanight.org

SECTION II
Understanding Astronomy and Atmospheric Science for Nightscape Images

2

THE NIGHT SKY
AND ITS MOVEMENT

The night sky is rich with objects to observe and include in your nightscapes. There is the moon, meteors, the planets, comets, the Milky Way, and Iridium flares. All this on top of the multi-colored stars and the constellations they comprise, Figure 2.1! There are dazzling atmospheric phenomena you may wish to pursue: the kaleidoscopic colors of sunsets and sunrises, deep twilights, the zodiacal light, sky glow, ice haloes, noctilucent clouds, moonbows, and the hypnotic Aurora Borealis/Australis. *Your understanding of the origins and characteristics of the objects and phenomena of the night sky; and how they move during each night, between one day and the next, and from month-to-month, will be the basis for your landscape astrophotography journey.*

This chapter provides you with the astronomical foundations necessary for successful landscape astrophotography. First, we will briefly review the structure of the universe and how it relates to the most common night sky objects you will see. Next, we will learn how the earth's motion—both its daily *rotation* about its axis, and its annual *revolution*, or *orbit*, around the sun causes these objects to move across the sky. We will see why this motion depends on the compass direction you're facing, or from which of the earth's hemispheres you're observing. You will learn about two simple tools you will want to learn how to use to understand the constantly moving night sky and predict the constellations that will be visible for any time or date. Finally, we will conclude with a brief review of the cause and effects of the seasons.

OVERVIEW OF NIGHT SKY OBJECTS

As the sun slips below the horizon and night descends, its light slowly recedes from the sky. The glowing blue gases in the earth's atmosphere become transparent, allowing us to peer into the realms beyond. What a universe awaits us!

Moving beyond the earth, Figure 2.2(a), we first encounter our moon, along with our neighboring planets—Venus, Mercury, Mars, Jupiter, Saturn, Uranus, and Neptune, Figure 2.2(b). Our solar neighborhood includes *comets*, which are frozen masses of gas, ice, and rock, as well as the debris they leave in their path that gives birth to annual meteor showers. Moving beyond the solar system into the encompassing Milky Way Galaxy, Figure 2.2(c), we find a rich variety of stars, gas nebulae, and star clusters. Finally, venturing beyond the Milky Way into deep space and the rest of the visible universe, we find ourselves in the realm of other galaxies and galaxy clusters, Figure 2.2(d, e, f).

All of these night sky objects can be put into one of two main categories for our purposes. The first category includes objects whose position relative to each other *never changes*[1]—for example, the stars, the Milky Way, constellations, nebula, and star clusters. Once you've learned their arrangements, they will be your familiar night sky friends for the rest of your life. The second category includes objects whose position *constantly changes relative to the background positions of the stars.* This category includes the planets, whose name originates from Greek for *wandering star*, the moon, comets/meteors, satellites, and Iridium flares. This chapter focuses on the first

facing page

2.1 Many constellations and other objects are visible in this (a) wide-angle view of the night sky over California's Sierra Nevada and (b) corresponding simulation from Stellarium. From left to right, you can see Canis Major, Lepus, Eridanus, Orion, Taurus, Cetus, the moon, the Pleiades, Aries, Triangulum, Perseus, Andromeda, the Andromeda Galaxy, Cassiopeia, Polaris, Ursa Minor, and Cepheus. Many of the constellations contain asterisms, or sub-groupings of stars into familiar patterns like Orion's Belt, also visible above. The bright light of the nearly full moon washes out dimmer stars, allowing the brighter stars that form these constellations to stand out. Under moonless skies, their dimmer neighbors, as seen in Figure 5.2, can overwhelm them.

source: www.stellarium.org

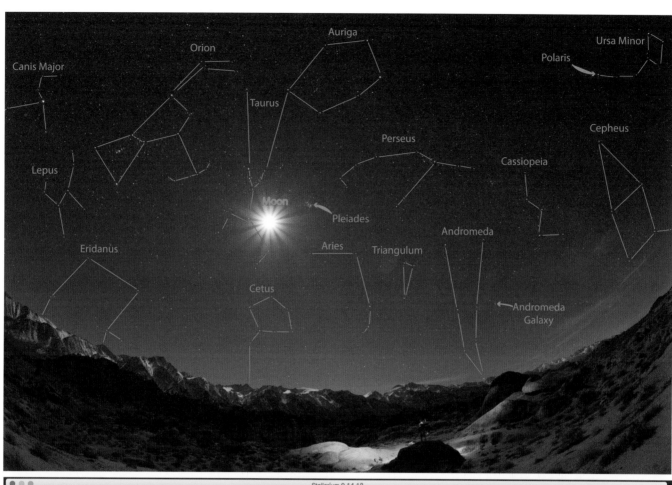

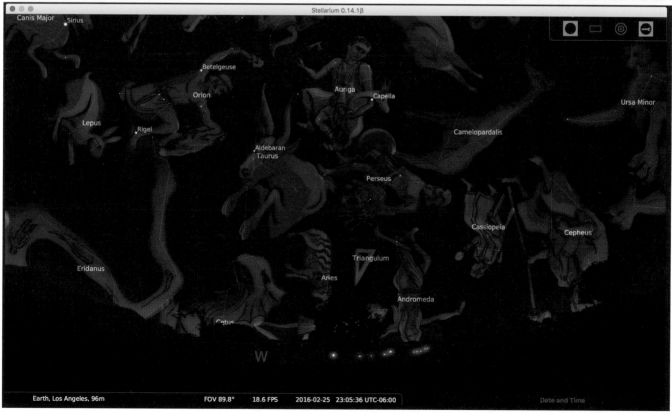

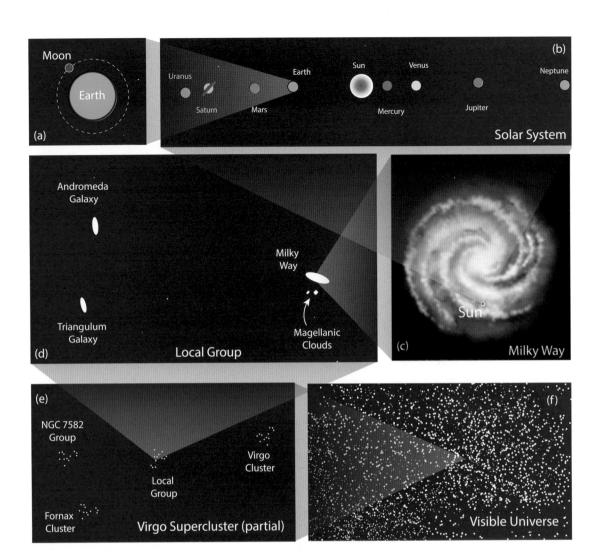

above

2.2 Schematic showing how the Earth relates to the solar system and the rest of the universe. (a) The Earth is orbited by the moon, along with swarms of man-made satellites. (b) The solar system contains the eight planets shown here, although Uranus and Neptune are generally invisible to landscape astrophotographers. (c) The solar system sits within the Milky Way Galaxy, which contains hundreds of billions of other stars. (d) The Local Group, within (e) the Virgo Supercluster, contains galaxies similar to the Milky Way. Only a few are visible to landscape astrophotographers, notably M31, or the Andromeda Galaxy, and the Magellanic Clouds. You may be surprised to observe that the space in between neighboring galaxies appears empty and largely devoid of stars! Finally, (f), the visible universe contains hundreds of billions of galaxies.

source: NASA/CXC/SAO

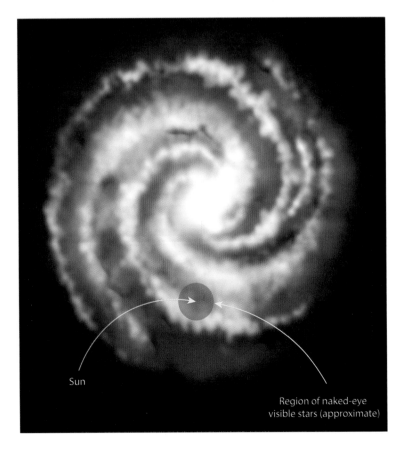

left

2.3 The shaded red circle in this schematic diagram of the Milky Way indicates the relatively small fraction of its billions of stars that are visible to the naked eye from Earth. Stars outside the shaded red circle are generally too dim to be seen individually with the naked eye, although many can be resolved using astronomical instruments.

source: NASA/CXC/SAO

category of objects, specifically, stars, and constellations. Subsequent chapters cover the night sky objects whose positions constantly change.

STARS AND CONSTELLATIONS

We begin with those objects whose position remains constant relative to one another: the glittering stars and the constellations they form. You may be surprised to learn that all the individual stars distinguishable with your naked eyes are only located within a relatively small portion of the Milky Way, Figure 2.3. Our eyes are only able to resolve galaxies in the vast space beyond the edges of the Milky Way in just a few instances.[2]

Einstein incorrectly considered the universe to be made up of a uniform "soup" of stars and occasional galaxies distributed within it. It was Hubble who first discovered that this wasn't the case; rather, the universe was comprised of discrete galaxies with essentially no stars or much else[3] in between. In fact, *nearly all the night sky objects you can see with your naked eye are relatively nearby stars, planets or other objects contained within our own Milky Way Galaxy, including our solar system*. The illusion of a universe filled with a more-or-less uniform distribution of stars, Figure 2.4(a), is created simply by the necessity of viewing the night sky from our position embedded within the Milky Way Galaxy, Figure 2.4(b). Our view of the Andromeda Galaxy, M31, thus includes all the Milky Way stars that reside within our line-of-sight. If we were to view M31 from a position outside the Milky Way, none of the stars would be present; we would simply see M31 floating alone in empty space.

The stars that make up the Milky Way, including our sun, are enormously varied in their color and brightness. Just look at the variety of stars in the constellations of Ursa Major and Scorpius, Figure 2.5. Some stars are brighter than others, depending on their size and proximity. Bear in mind that nearby, dim stars can have the same brightness as massive, dazzlingly intense stars that are much further away. Second, all stars have a characteristic color, ranging from deep red to vivid blue. The color of each star depends entirely on its mass and age—young, hot stars give off a noticeably bluer light than the deeper reddish light of older, cooler stars. The fact that hotter stars are blue while cooler stars are red may be opposite what you might think! Yet, owing to the peculiarities of human night vision, we perceive most stars as points of white light, with a few notable exceptions, such as the distinctly red gas giants Betelgeuse, Antares, and Aldebaran in Orion, Scorpius, and Taurus, respectively. Your camera, however, has the capacity to record the true colors of all the stars—and its images will likely astound you!

People have identified legendary figures, animals, and mythical creatures in the patterns of the stars across cultures for thousands of years. These groupings are called *constellations*, and some are most likely familiar to you, as seen in Figures 2.1 and 2.5. The International Astronomical Union established eighty-eight constellations with internationally agreed upon boundaries nearly a century ago. These constellations provide a useful structure for night sky navigation, in addition to their human interest. For example, we might say that Mars can be found in the constellation Leo on a given night, thus narrowing the region of the sky to examine.

Each star within a constellation is ranked in terms of its brightness. The brightest star is generally designated by the Greek symbol α, the second brightest star by the symbol β, and so on. Thus, for example, the star Sirius, which is not only the brightest star in the constellation Canis Major

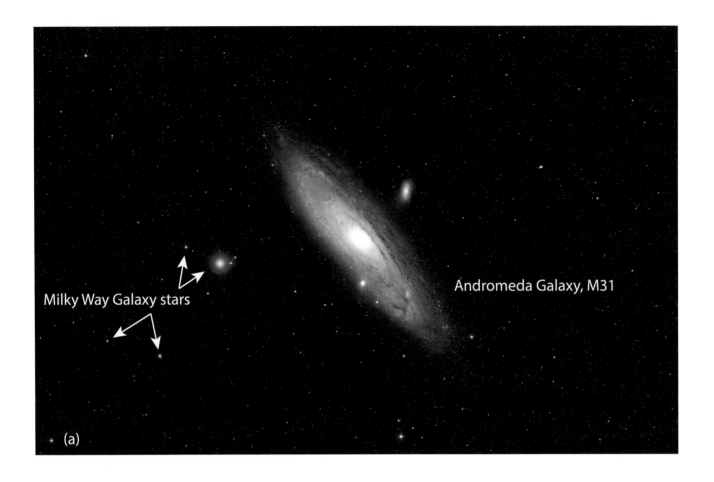

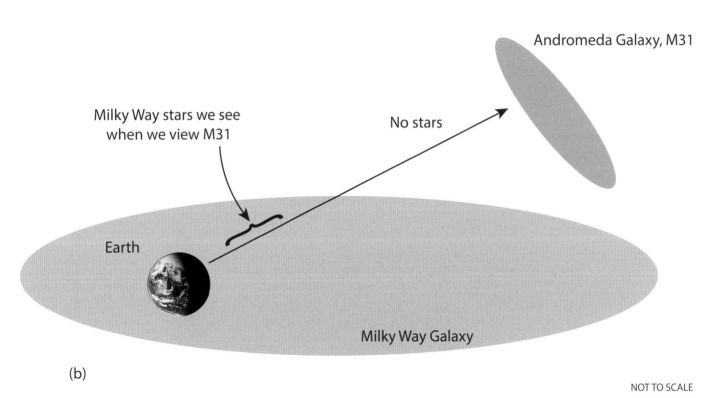

NOT TO SCALE

2.4 (a) Photograph of a region of the night sky containing stars of the Milky Way Galaxy as well as the Andromeda Galaxy, M31, which is well outside the Milky Way, Figure 2.2(d). (b) Schematic (not to scale) showing how our view of the Andromeda Galaxy inevitably includes a number of stars from the Milky Way Galaxy, owing to our viewing position from deep within the Milky Way. If we were to view the Andromeda Galaxy from a position outside the Milky Way, none of the stars visible in (a) would be present.

Source: NASA, ESA, Digitized Sky Survey 2 (Acknowledgement: Davide De Martin)

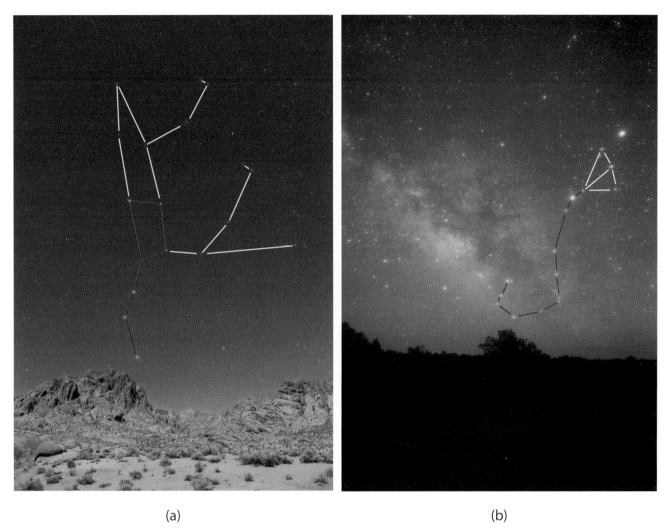

(a) (b)

2.5 Two favorite Northern Hemisphere constellations: Ursa Major (a) and Scorpius (b). The yellow and red lines depict the entire constellations; the red lines indicate two familiar asterisms: the Big Dipper (a) and the Fishhook (b). Note the differences in color, size, and brightness of the stars within each constellation. Also, notice how the presence of moonlight affects the relative brightness and appearance of both the sky and the foreground in (a), compared to their appearance under moonless skies in (b).

but also in the entire sky, is designated Canis Majoris. This information can be very helpful in pinpointing hard to see objects like comets, star clusters, and nebulae. For example, it greatly helps finding the North American nebula knowing it is near Cygni, or the second brightest star in the constellation Cygnus.

There are many widely recognized sub-groupings of stars within constellations known as *asterisms*. Probably the most familiar asterism in the Northern Hemisphere is the Big Dipper, which is part of the constellation Ursa Major, Figure 2.5(a). Other familiar Northern Hemisphere asterisms include Orion's Belt, the Teapot within Sagittarius, the Summer Triangle, the Winter Cross, and the Fishhook in Scorpius, Figure 2.5(b). Familiar Southern Hemisphere asterisms include the Southern Cross, the Southern Pointers and the Diamond Cross.

THE CELESTIAL POLES

It is well worth knowing how to quickly locate the celestial poles in either hemisphere. In the Northern Hemisphere, Polaris, or the North Star, is often mistakenly thought to be the brightest star in the sky, which it isn't. Instead, Polaris simply happens to be located roughly in line with the

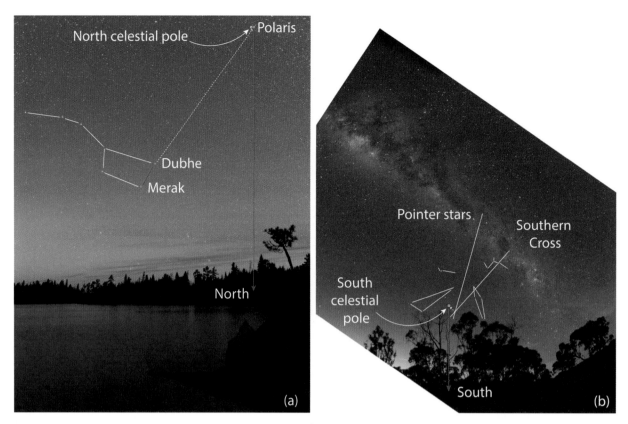

2.6 Locating the celestial poles. (a) Polaris can be easily found with the help of the Big Dipper's "pointer stars," Merak and Dubhe. Polaris lies at the end of the line connecting Merak and Dubhe. Due north is found by drawing a vertical line from the north celestial pole down to the horizon. The spot where this line intersects the horizon is due north. (b) Locating the southern celestial pole is also straightforward, despite the lack of a "South Star" that would be equivalent to Polaris. The southern celestial pole is found by connecting the two lines drawn through the Southern Cross and the southern pointers. The southern celestial pole is adjacent to their intersection point. Drawing a vertical line from the southern celestial pole down to the horizon establishes south.

axis of the earth's rotation.[4] This fact results in Polaris staying essentially motionless throughout the night.

The Big Dipper's two stars Merak and Dubhe, otherwise known as the "pointer stars," form a convenient line that is more-or-less in line with Polaris, Figure 2.6(a). Due north is then found simply by drawing a vertical line between Polaris and the horizon. Spend some time practicing how to identify Polaris at different times of the night throughout the year; this knowledge will serve you well. It is usually the very first thing I do when I step out each night.

While the Southern Hemisphere lacks a similar, favorably located star, the asterisms of the Southern Cross and the Southern Pointers allow you to easily establish the position of the southern celestial pole, Figure 2.6(b). Drawing a vertical line down from the southern celestial pole to the horizon establishes south, just as for the Northern Hemisphere.

THE BRIGHTEST STARS IN THE SKY

As we will see later in this book, achieving proper focus on the stars can be extremely challenging. Part of the difficulty lies in the scarcity of visible, sufficiently bright stars to use as targets. Knowing where to find them throughout the year can help. Several of the brightest stars in the Northern and Southern Hemispheres are listed in Table 2.1. Three examples are shown in Figure 2.7 along with their host constellations. Searching for the brightest stars is worthwhile, since they are your

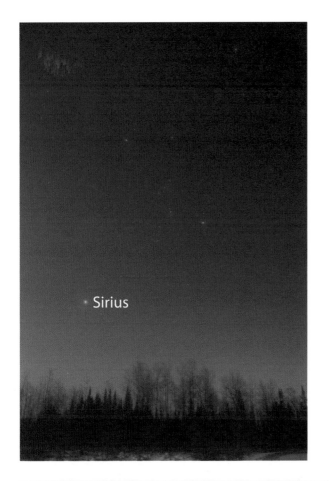
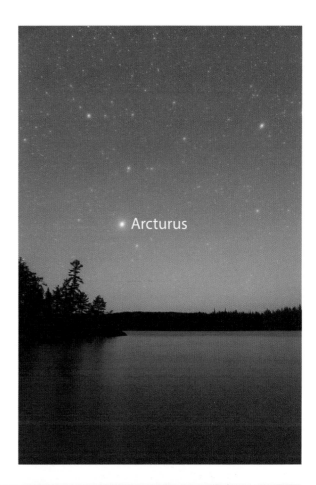
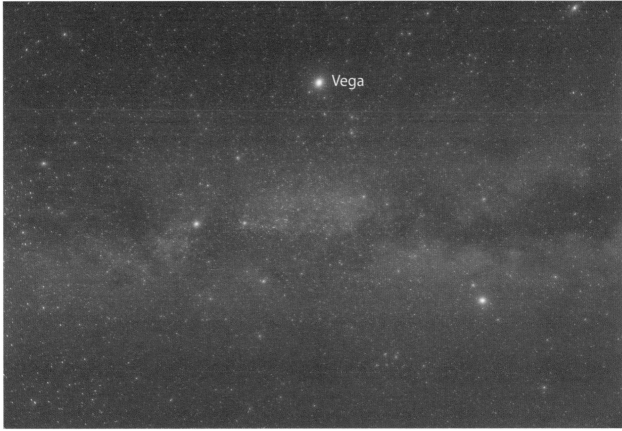

2.7 Examples of three bright, Northern Hemisphere stars that can aid in acquiring a sharp focus on the night sky: (a) Sirius, within Canis Major; (b) Arcturus, within Boötes; and (c) Vega, within Lyra.

best option for achieving a sharp focus on the night sky. Although they may be hidden behind a foreground object, such as a tree limb or building, knowing their presence and simply moving a short distance away can often bring them into view. This process allows you to achieve correct focus and then return to your composition of interest.

NAME	CONSTELLATION
Sirius	*Canis Major*
Canopus	*Carina*
Rigil Kent, Toliman	*Centaurus*
Arcturus	*Bootes*
Vega	*Lyra*
Capella	*Auriga*
Rigel	*Orion*
Procyon	*Canis Minor*
Achernar	*Eridanus*
Betelgeuse	*Orion*
Agena, Hadar	*Centaurus*
Altair	*Aquila*

Table 2.1 Brightest Stars in the Sky

HOW NIGHT SKY OBJECTS MOVE DURING THE COURSE OF A SINGLE NIGHT

Even the most casual observer will soon notice that night sky objects aren't stationary, but gradually move across the sky. Two of the main goals of this book are to help you understand this movement and learn how to use it to plan your landscape astrophotographs. An inherent difficulty in studying this topic is that while the earth and night sky are three-dimensional in nature, the pages of this book, regrettably, are limited to two-dimensions. Therefore, we will begin by introducing conceptual models that will help you construct your own understanding of how objects move across the night sky. While the following description is geared towards observers in the Northern Hemisphere at mid-latitudes, similar reasoning applies to observers at other latitudes and in the Southern Hemisphere.

Imagine we're facing south in the middle of a large field at night, Figure 2.8(a). It's a beautiful, clear night and the skies are filled with glittering stars. Now, also imagine that the compass directions are inscribed in the field below our feet: north, south, east, and west. Finally, let's imagine that all the stars, the moon, comets and everything else in the sky are attached, or glued, to the inner

facing page

2.8 Illustration of the celestial sphere model, (a), for understanding the movements of the night sky for observers in the northern hemisphere, (b)–(e). Star trail images facing: (b) east; (c) south; (d) west; and (e) north. Images such as these can help inform you of the azimuth of favorite viewpoints of unfamiliar destinations during your scouting research.

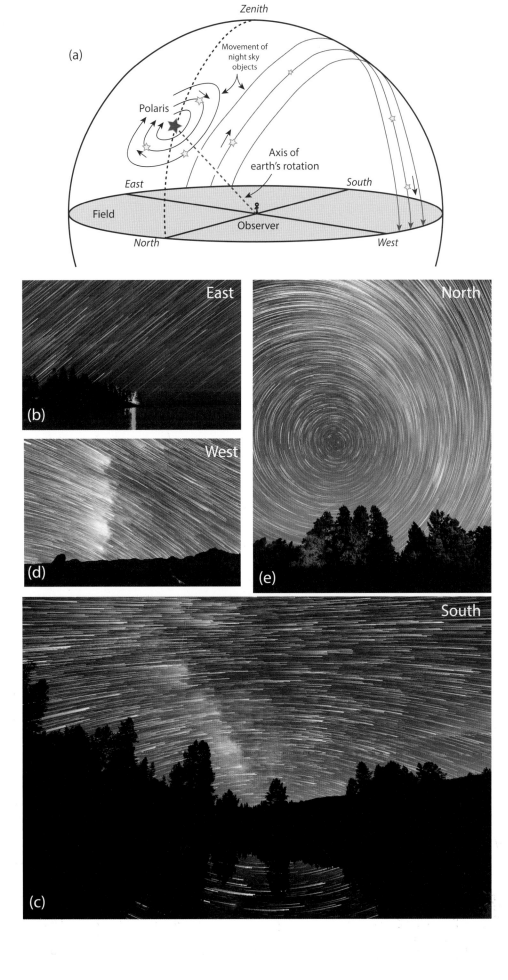

surface of a huge hemispherical dome, or *celestial sphere*, that covers us and the entire field like a giant umbrella, right down to the horizon.

The celestial sphere appears to rotate overhead from east to west as the night progresses. This rotation appears to occur about an axis passing from Polaris through the point beneath our feet. As we gaze to the east, which is to our left, we observe new stars appearing over the eastern horizon and ascending into the sky, Figure 2.8(b). If we turn our gaze to the west, or to our right, we observe stars sinking toward the horizon and ultimately setting below the horizon as the night progresses, Figure 2.8(d). And as we gaze due south, stars appear to gracefully arc across the sky from left to right, Figure 2.8(c).

Finally, imagine that we turn completely around so that we are facing north, Figure 2.8(e). Now when we view the sky above the eastern horizon to our right, we observe stars rising above the horizon and ascending into the sky. Similarly, we observe stars arcing downwards, and ultimately sinking below the western horizon to our left, as the night progresses. But what really catches our attention is the region of the sky immediately surrounding Polaris. Here, the stars simply rotate in counterclockwise circles around Polaris.

By the way, star trail images such as these can help inform you of the azimuth of favorite viewpoints of unfamiliar destinations during your pre-trip scouting research. Nightscape images featuring a very particular view of a specific foreground subject often have a surprisingly narrow range of suitable vantage points. Knowing ahead of time whether or not the chosen foreground subject will ever align with a desired night sky object from these specific vantage points can make or break a landscape astrophotography photo opportunity. Reviewing existing star trail images of the foreground subject made from the proposed vantage points will help reveal the answer.

You may want to practice simulating the movements of the celestial sphere at home. This is easily done by opening an umbrella (preferably dome), pointing it (approximately) at Polaris and slowly rotating it counterclockwise, when viewed from within. By observing the motion of its inner surface, you will see the types of movements just described. Namely, objects in the "east" will rise and ascend; objects in the "south" will arc from left to right, objects in the "west" will descend and finally, objects near the north celestial pole will rotate around it in counterclockwise circles. The benefits of the celestial sphere model are that it allows us to understand these movements and how the compass direction we are facing governs the movement we see of the stars and other objects.

The night sky movements described so far apply to observers at mid-latitudes in the Northern Hemisphere. How would these movements change for Northern Hemisphere observers at different latitudes? For those on the North Pole, Polaris appears directly overheard, or at the observer's zenith. All stars move in horizontal, counterclockwise circles. What a sight that would be to see! In contrast, for observers on the equator, Polaris lies on the northern horizon and stars rise in the east, perpendicular to the horizon, ascend vertically into the night sky and set vertically downwards in the west. For observers at intervening latitudes, the angular height of Polaris above the northern horizon corresponds to the local latitude, as described in Appendix V.

For Southern Hemisphere observers, the appearances of the night sky movements are simply reversed relative to those described above. While stars still rise in the east and set in the west,

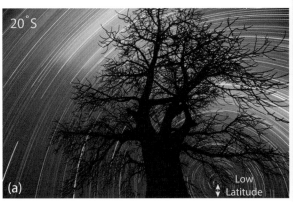

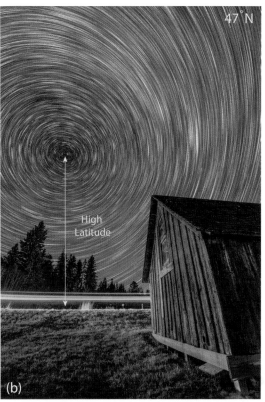

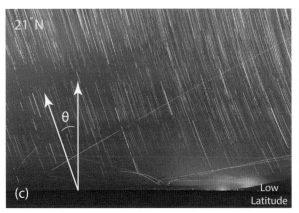

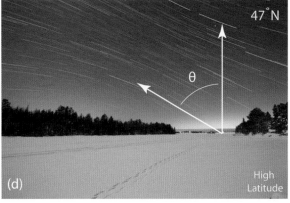

2.9 These images demonstrate the effect of latitude on star trails. (a) This south-facing image was made in Botswana (latitude 20° S) compared to its north-facing equivalent, (b) made in northern Minnesota (latitude 47° N). Notice how the height of the celestial pole is lower for the latitude closer to the equator, and higher for the latitude further from the equator. The orientation of east- and west-facing star trails relative to the horizon is also affected by latitude, as seen here for westward facing star trails created in (c) Maui, Hawaii (latitude 21° N) and (d) northern Minnesota (latitude 47° N). Relative to a vertical line drawn upwards from the equator, the star trails are oriented at an angle, θ, where θ is roughly equal to the local latitude.

Source: (a) Jan Koeman/www.koemanphoto.com/The World At Night

they circle the *southern* celestial pole in a *clockwise* motion, and arc across the *northern* sky from right (east) to left (west).

Four star trail images are shown in Figure 2.9 to highlight similarities and differences arising from latitude and hemisphere effects. The images in Figure 2.9(a) and (b) were both made facing their respective celestial poles at latitudes, 20° S (Southern Hemisphere) and 47° N (Northern Hemisphere), respectively. First, note how the stars encircle the celestial poles in both hemispheres, although the opposing directions of motion are not apparent (clockwise in the

Southern Hemisphere; counterclockwise in the Northern Hemisphere). Second, observe how latitude strongly affects the height above the horizon of the celestial pole: the 20° S celestial pole is much closer to the horizon than the 47° N celestial pole. As noted above, this is no coincidence; the angular height of the celestial pole is the same as the local latitude (Appendix V). This outcome will affect your choice of lens focal length and composition in the creation of star trail images such as these, since the celestial pole and horizon may not both fit into the composition if the lens field of view is insufficient. The images in Figures (c) and (d) were made facing west; specifically, (c) Maui, Hawaii (latitude 21° N) and (d) northern Minnesota (latitude 47° N). The orientation of the star trails relative to the vertical can be seen to correspond with the local latitude.

EARTH'S ANNUAL ORBIT—HOW OBJECTS MOVE DURING THE COURSE OF THE YEAR

So far, our discussion of the movements of the stars in the night skies has been confined to those that occur during a single night. What happens to our night sky view over the course of a year? This is easily answered by studying the changes that occur in our viewing direction as the earth orbits the sun, Figure 2.10. These changes affect what we see, just like the slow rotation of a revolving restaurant changes the view from its windows. For example, in September, the constellation Aquarius is directly overhead at midnight, whereas in January, the earth has changed position so now the constellation Gemini is directly overhead at midnight, Figure 2.10(a). The night sky objects that are visible during different times of year change simply as the result of the earth's motion along its orbit.

Now imagine that we were somehow able to discern the stars during the daytime. The constellations that become visible lie on the opposite side of the solar system from the sun, Figure 2.10(b). The sun would lie in the constellation that otherwise would only be visible at night, six months hence. For example, in January, the sun is positioned within the constellation Sagittarius, Figure 2.10(b), which we see at night during July, six months later. In May, it is positioned within the constellation Aries, seen at night during November. The narrow band of the sky that includes the path of the sun's orbit, or the *ecliptic*, is known as the *zodiac*. The twelve constellations found within the zodiac are known as signs of the zodiac, or sun signs, since the sun is positioned within each constellation during the different months of the year.

Knowledge of the changing nighttime view throughout the year results in predictable seasonal events. Many are highly relevant to landscape astrophotography. For example, the brightest, central part of the Milky Way, or its core, lies beyond Sagittarius and Scorpius, thus becoming visible between March and September. It is fruitless to attempt to photograph or even observe it during the rest of the year since it is obscured by the intervening sun and blue skies. Meteor showers only occur on specific dates and constellations are only visible during certain months, as we have seen. Consequently, it is extremely helpful to be able to forecast the appearance of the night sky for different dates throughout the year.

facing page

2.10 What we see at night changes during the year. (a) Top view schematic of the Earth's orbit around the sun, showing how the constellations visible from Earth at night change monthly as the Earth moves around the sun. For example, in January, the constellation Gemini is directly overhead at midnight, whereas in May, the constellation Libra is directly overhead at midnight. (b) In May, the sun appears within the constellation Aries, resulting in the familiar sun signs of the zodiac.

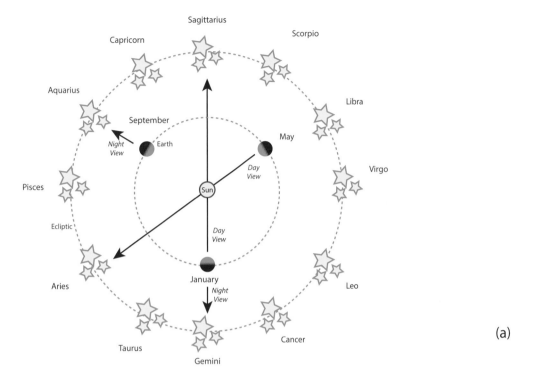

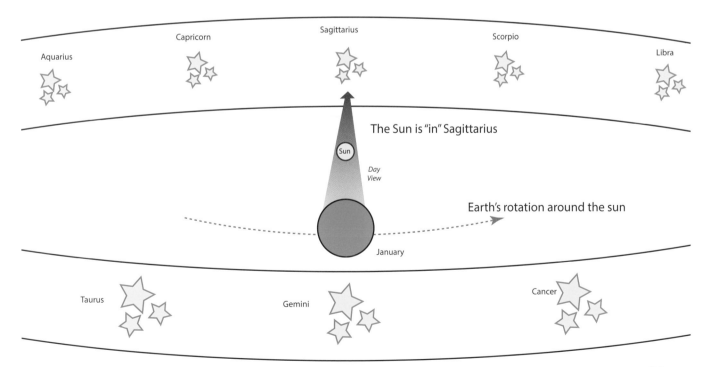

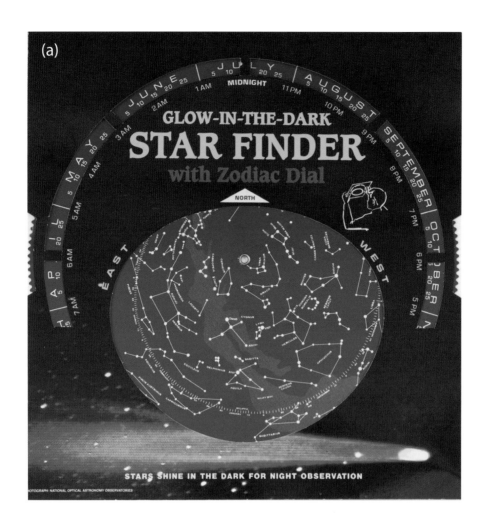

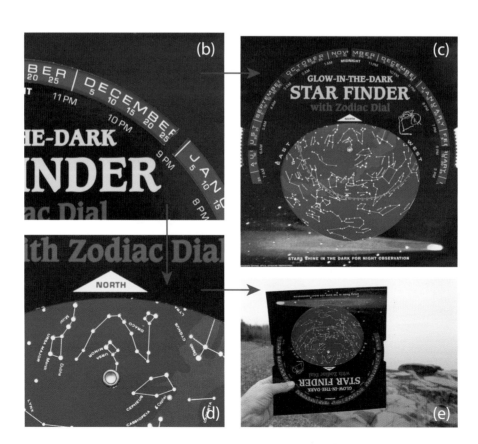

NIGHT SKY TOOLS

One simple and inexpensive tool for studying and predicting the appearance of the night sky for any date, past, present, or future, is the planisphere, Figure 2.11(a). Every serious landscape astrophotographer should either buy or make their own planisphere; instructions for making your own planisphere are provided in Appendix IV. Even with the proliferation of apps and other mobile/desktop planetarium tools described later in this book (such as the free, open source virtual planetarium Stellarium (Stellarium.org)), you will gain great insight through the regular use of a hand-held planisphere. It is extremely helpful in developing a sense of the positions and motions of the constellations on different dates and times, and invaluable in the field for identifying stars, constellations, and deep sky objects.

The planisphere comprises an inner, circular card containing all the constellations that are ever above the horizon at the planisphere's latitude, along with an outer housing with an opening. The edges of the opening represent the observer's horizon; the center of the opening corresponds to the point directly overhead, or the observer's *zenith*. Any location midway between the horizon and the zenith is approximately 45° above the horizon. Thus, the angular height of a constellation may be gauged by estimating its relative position between the edge and the center of the opening. In turn, the actual height of the constellation above the horizon can be estimated by noting that the angular distance between the tips of your outstretched thumb and little finger is approximately 20°. By rotating the inner card, which has Polaris as its axis of rotation, the constellations can be seen to move across the sky. Note that Polaris is positioned at an angular height above the northern horizon that corresponds to the observer's latitude.

The operation of a planisphere is simple. Let's see how it works by way of a couple of examples. We will first explore a few of the constellations visible at 10 pm on December 15. The year doesn't matter; the night sky view is the same each year on a given date. The first step is to orient the planisphere for the desired observation time and date by aligning the 10 pm mark on the edge of the opening with the date of December 15, Figure 2.11(b). Doing so positions the stars and constellations that are visible on that date and time within the opening in the outermost card, Figure 2.11(c). Hold the inner and outer parts of the planisphere tight against one another; the planisphere can now be used to locate and identify night sky objects for this date and time.

First, we wish to locate the constellation Perseus and need to know where in the sky to look. By studying the constellations visible within the opening, we see that Perseus is located near its center, Figure 2.11(c). This means that Perseus is directly overhead, or at our zenith, at 10 pm on December 15. In order to view Perseus, therefore, all we need to do is to step outside at 10 pm on December 15, look straight up and there it will be!

facing page

2.11 (a) A simple, inexpensive planisphere with glow-in-the-dark stars. The planisphere shows the brightest stars and constellations that are visible at your latitude on any given date and time. The edge of the opening represents your horizon; your zenith is the center of the opening. The planisphere rotates around Polaris, the brass grommet. You can make your own planisphere by following the instructions in Appendix IV. (b) Using the planisphere to explore the night skies at 10 pm on December 15. (c) The visible constellations at this time and on this date appear through the opening in the outer housing. (d) The constellation Draco is positioned next to the horizon at this time and on this date. (e) Facing north and holding the oriented star chart upside down correctly aligns it to observe Draco.

Next, we choose to observe the constellation Draco. A quick examination of the oriented planisphere reveals Draco to be located at the top of the opening and next to its edge, Figure 2.11(d). This means that Draco lies just above the northern horizon at 10 pm on December 15. We can use the planisphere in the field to help with identification simply by holding the oriented planisphere *upside down* and facing north at 10 pm on December 15, as illustrated in Figure 2.11(e). Holding the planisphere upside down correctly orients it with respect to the northern horizon; similar reasoning applies to any other direction of the compass. To view Draco, we simply face north, look directly above the horizon and there it will be!

Lastly, we wish to observe the spectacular constellation of Orion. Examination of the planisphere reveals that Orion lies approximately midway between the edge and center of the opening in the planisphere, or approximately 45° above the horizon at 10 pm on December 15, Figure 2.11(c). The direction in which to look is easily found simply by drawing an imaginary line between Orion and the edge of the opening, or the horizon below it, and then estimating the compass direction of this line; in this case roughly southeast. The final step is to go outside, face southeast, and look up in the sky at approximately 45° above the horizon, where we will find Orion. Simple!

You may also use the planisphere to simulate the motion of night sky objects. This is done simply by rotating the inner card in a counterclockwise direction and observing the movement of the stars within the opening in the outer housing. You will see stars and constellations "rising" above the eastern horizon and "setting" below the western horizon. You will also observe a group of constellations that always remain visible above the northern horizon, regardless of the date or time. These constellations are called *circumpolar*, meaning that they never set and are always visible throughout the year.

Finally, you may use your planisphere to determine the best date and time to observe a specific constellation. This is done by locating the constellation within the inner card and rotating the card until the constellation is due south. Doing so puts it at its highest position in the sky. Different combinations of suitable dates and times when it will lie at this location are then found around the perimeter of the opening. For example, Leo is at its highest position, or due south, at 9 pm on April 15, 10 pm on April 1, 11 pm on March 15, and so forth. Alternatively, you may apply this method to determine potential date and time combinations to observe Leo or any other constellation or object next to either of the horizons, or anywhere else you wish. Simply rotate the inner card until the object is positioned at the desired location, and then read off the possible date and time combinations from the perimeter of the opening.

AN INEXPENSIVE HOME "PLANETARIUM"

An inexpensive and incredibly useful home "planetarium" available at many bookstores or online is shown in Figure 2.12. It comprises a hollow plastic celestial sphere with all eighty-eight constellations, their key stars, common asterisms and the Milky Way marked with glow-in-the-dark paint. A small light bulb at the sphere's center provides a light to cast the stars in relief as shadows on the walls of a dark room. Finally, you may obtain a sense of the movement of the stars during the course of the night by rotating the sphere within the holder and observing their motion.

This planetarium is well worth considering since it provides an immediate, three-dimensional model for understanding the spatial configuration of the stars within their constellations as well as the

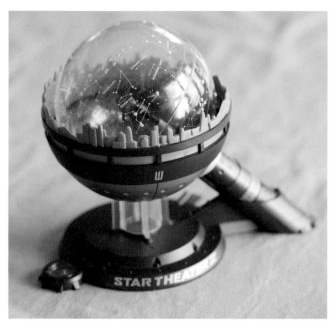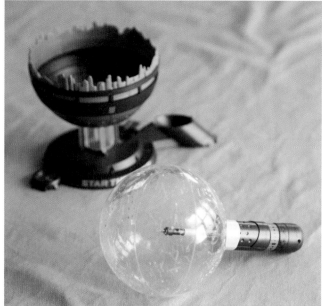

2.12 An inexpensive and incredibly useful home "planetarium" available at many bookstores or online. The planetarium comprises a hollow plastic celestial sphere with all eighty-eight constellations and their key stars indicated with glow-in-the-dark paint. A small light bulb at the sphere's center provides a light to cast the stars as shadows on the walls of a dark room. You may obtain a sense of the movement of the stars during the course of the night by rotating the sphere within the holder and observing their motion.

direction of movement during the night. Although the holder is designed to be used in the Northern Hemisphere, simply by lifting the sphere out of the holder and changing its angle, the planetarium works perfectly well at different latitudes in either hemisphere.

SEASONS

Seasonal effects are important for landscape astrophotographers. Sunrise and sunset positions change throughout the year, as do daylight, twilight, and darkness durations. The 23.5° angle between the axis of rotation of the earth and normal to the plane of its orbit, Figure 2.13(a), cause the seasons, not changes in proximity between the earth and the sun. The earth is actually physically closer to the sun during the Northern Hemisphere's winter than in the summer! Because of this tilt, as the earth moves around its orbit throughout the year, observers at different latitudes on Earth will experience more direct sunlight during some months than others. During the summer, those in the Northern Hemisphere receive (i) the highest, most direct intensity sunlight since the sun is higher in the sky; and (ii) for the greatest number of hours each day. Conversely, in the winter, they receive much less direct sunlight and for fewer hours each day.

An important outcome of the seasons is the changing position of sunrise and sunset on successive days during the year, Figure 2.13(b). This phenomenon can present a challenge to the landscape astrophotographer who wishes to capture the sun rising over a specific foreground object. One or more of the planning tools described in Section IV can be helpful in making this prediction, since the sunrise/sunset position changes slightly but perceptibly from one day to the next.

SOLSTICES AND EQUINOXES

There are four days during the year of special seasonal and cultural significance that can also provide unique landscape astrophotography opportunities with great popular interest. The summer

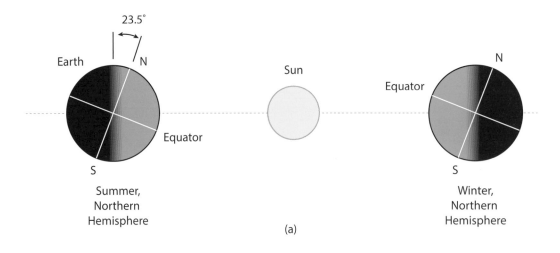

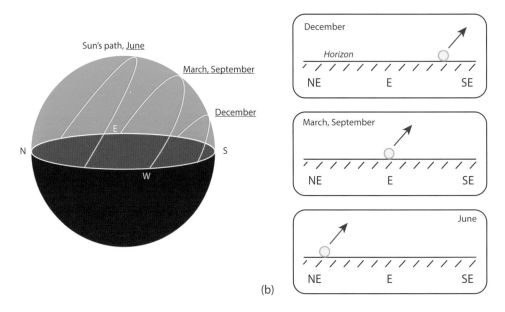

2.13 Schematic diagrams showing (a) how the Earth's tilt causes the seasons; and (b) how the tilt causes the position of sunrise along the horizon to change during the year.

and winter solstices are the longest and shortest days of the year, respectively. The spring and autumnal equinoxes, on the other hand, are the days with equal lengths of day and night. These important dates have been noted throughout human history, especially as they relate to the cultivation of crops. Stonehenge in England, the pyramids of Egypt and monuments throughout the southwestern deserts of the United States are just a few examples of the efforts of our predecessors to mark these dates.

One example of past civilizations marking the summer solstice is illustrated through a set of three, spiral rock petroglyphs inscribed in a rock boulder within an ancient Ancestral Puebloan village in southeastern Utah, Figure 2.14. The spirals are inscribed on an east-facing rock panel underneath an adjacent rock overhang. In turn, the rock panel is positioned a few feet to the west of a larger boulder, Figure 2.14(c), which casts a shadow on the petroglyphs during sunrise. This unique rock geometry results in the formation of two "light daggers" that appear on either side of the

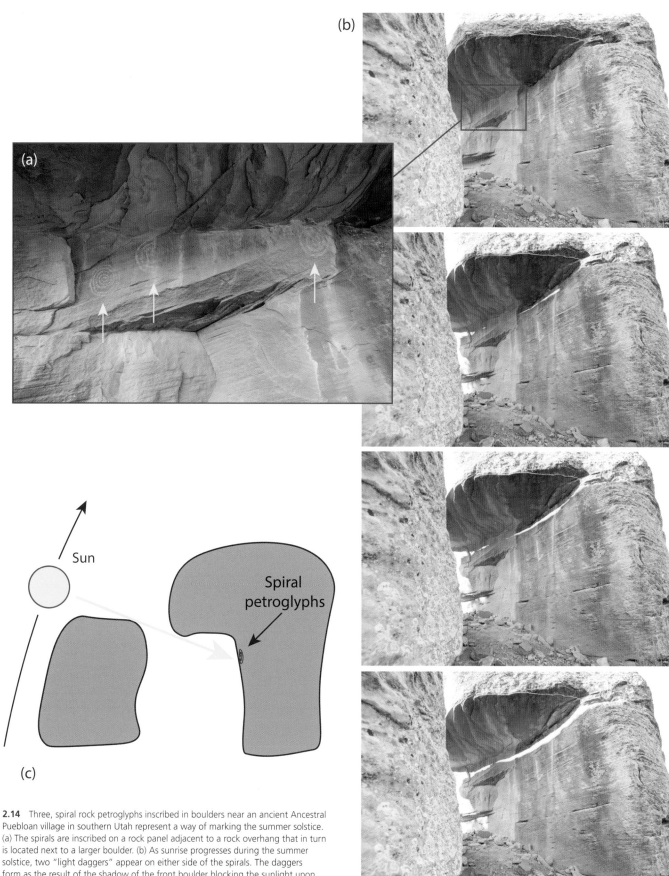

2.14 Three, spiral rock petroglyphs inscribed in boulders near an ancient Ancestral Puebloan village in southern Utah represent a way of marking the summer solstice. (a) The spirals are inscribed on a rock panel adjacent to a rock overhang that in turn is located next to a larger boulder. (b) As sunrise progresses during the summer solstice, two "light daggers" appear on either side of the spirals. The daggers form as the result of the shadow of the front boulder blocking the sunlight upon the rock panel underneath the rock overhang. As the sun ascends, (c) the daggers lengthen and eventually intersect directly through the three spiral petroglyphs, (b). This occurs because the sunlight is able to pass over the front boulder and illuminate the rock panel. During other times of the year, the changed position of the rising sun prevents this sequence of events from happening.

eastern boulder's shadow, Figure 2.14(b), during sunrise on the summer solstice. The positions of the three spiral petroglyphs were carefully chosen so that on the summer solstice, as the sun ascends and the light daggers lengthen and eventually intersect, *they do so directly through the three spiral petroglyphs*, Figure 2.14(c). This happens since the sunlight is able to pass over the front boulder and illuminate the rock panel. The different positions of the sun during the rest of the year preclude this sequence of events; the day when light daggers intersect the three spirals during sunrise confirms the summer solstice. Witnessing events such as these immediately forges a timeless bond between the observer, those in the past who created them, and the reliable cycles of astronomy.

Bibliography

Dickinson, Terence & Alan Dyer, *The Backyard Astronomer's Guide*, 2010, Third Edition, Firefly Books, Limited, Buffalo, New York

Dunlop, Storm & Wil Tirion, *How to Identify Night Sky*, 2006, Barnes and Noble, Inc., with HarperCollins Publishers, London

Goodman, Ronald, *Lakota Star Knowledge*, 1992, Sinte Gleska University, Mission, South Dakota

http://unclemilton.com/in_my_room/star_theater/

McKim Malville, J., *Guide to Prehistoric Astronomy in the Southwest*, 2008, Johnson Books, Boulder, Colorado

Schneider, Stephen E. & Thomas T. Arny, *Pathways to Astronomy*, 2015, Fourth Edition, McGraw Hill Education, New York

Seronik, Gary, *Binocular Highlights*, 2006, New Track media, Cambridge, Massachusetts

Tirion, Wil, *The Cambridge Star Atlas*, 2001, Cambridge University Press, Cambridge, England

Notes

1 Although I should say, "never changes during the course of our lifetimes," since on the timescale of millions of years, the changes in position of these objects resulting from their movement would indeed be noticeable.

2 For example, the Andromeda Galaxy (M31) and the Large and Small Magellanic Clouds, two nearby irregular dwarf galaxies.

3 The "emptiness" of the space in between galaxies is actually somewhat disingenuous; current models indicate that the vast majority of the matter and energy of the universe is not yet understood. This *dark matter* and *dark energy* very well may reside somehow within the "emptiness" of deep space.

4 Polaris is actually slightly off-axis; a fact that becomes quickly apparent during star trail exposures. Nonetheless, for general orientation purposes, this minor offset is safely ignored.

3

SUNRISES
AND SUNSETS

Undeniable feelings of renewal and hope accompany the sunrise; and comfort and peace with the sunset, Figure 3.1. It is no surprise that so much prize-winning landscape photography is created during these special times. This chapter explains the science behind the phenomena of sunrises and sunsets, and why they appear the way they do.

Consider Earth's appearance from space, Figure 3.2(a). The half of the earth facing the sun is brightly illuminated and experiences daylight, whereas the half of the earth facing away from the sun is in the earth's shadow, and experiences night. Sunset or sunrise occurs in the day-to-night transition zones. Clouds permitting, bright blue skies will cover the regions experiencing day owing to preferential Rayleigh scattering[1] of the blue wavelengths of sunlight by the oxygen and nitrogen gas molecules in the earth's atmosphere. Dark, clear skies will cover the regions experiencing night as the result of the intrinsic transparency of our atmospheric gases coupled with the complete absence of sunlight-induced Rayleigh scattering.

During the day, the entire sky dome becomes a diffuse source of bright, blue light in addition to the predominantly yellow light of direct sunlight. When we're outdoors on a clear, sunny day, it's like we're in a giant amphitheater with a glowing blue ceiling! The diffuse nature of the blue light

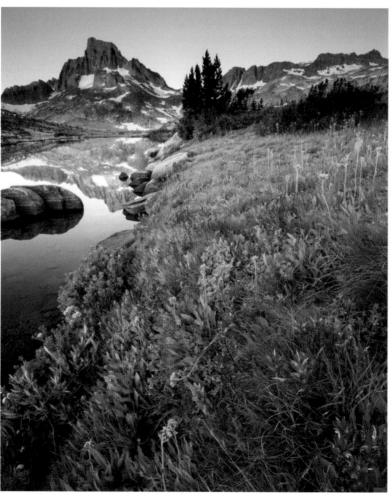

3.1 Sunrises and sunsets provide reliable opportunities to create beautiful images, in nature and in the city. Here, a new mid-summer's day dawns in California's High Sierra, as alpenglow paints the tips of Mt. Banner, left, and the Sierra crest, right, over Thousand Island Lake in the Ansel Adams Wilderness.

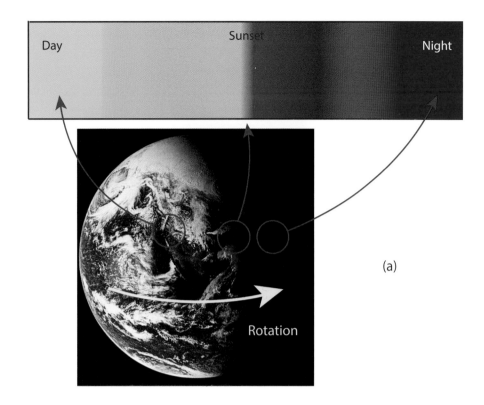

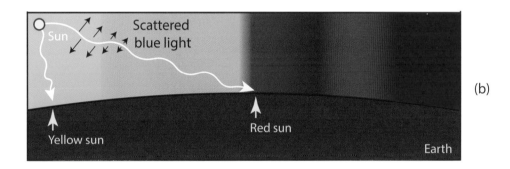

3.2 (a) The earth viewed from space and the corresponding sky color observed on Earth for different locations.
(b) Schematic showing how sunlight loses its blue components by scattering, resulting in its gradual reddening as the
length of its path through the atmosphere increases during sunsets and sunrises. (c, d) Comparison of the same location
along the Big Sur coast in California during (c) the harsh light of midday and (d) the warmer, redder light of sunset.

Source: NASA/NSSDCA

from the sky allows it to illuminate observers who are shaded and thus not directly in line with the sun. To observe this phenomenon, carefully examine a white sheet of paper outdoors in the shade of a tree or a building on a sunny afternoon. It will exhibit a distinctly bluish tint. If our sky had no atmosphere, shadows would be completely black, as they are on the moon, except for any light reflecting off nearby objects.

So if the daytime sky is blue and the nighttime sky is clear, what is the source of the vivid oranges and reds of sunsets and sunrises? These colors appear because the light from the sun and adjacent sky that reaches observers during sunset and sunrise has traveled through a much greater distance of the earth's atmosphere than during the day, Figure 3.2(b). As light travels through this greater portion of the earth's atmosphere during sunset and sunrise, most of its blue light gets scattered away and lost, thousands of miles away, before it reaches the observer. All that's left by the time the sunlight reaches the observer is predominantly red and orange light, with scarcely any blue light remaining. The greater the distance of travel, the more of its blue light is scattered and lost, leading to an increasingly red sun and sky as the sun approaches the horizon during sunset and sunrise, Figure 3.2(b).

These fiery, final red rays of sunset and first rays of sunrise that strike high altitude mountains, and clouds are the source of the gorgeous phenomenon of *alpenglow*, Figure 3.3. These beautiful orange, pink, and red colors only last for a few minutes before the sun slips too far out of position for these intensely colored rays to reach terrestrial and atmospheric objects. Nonetheless, these elusive colors are well worth pursuing—you won't be disappointed!

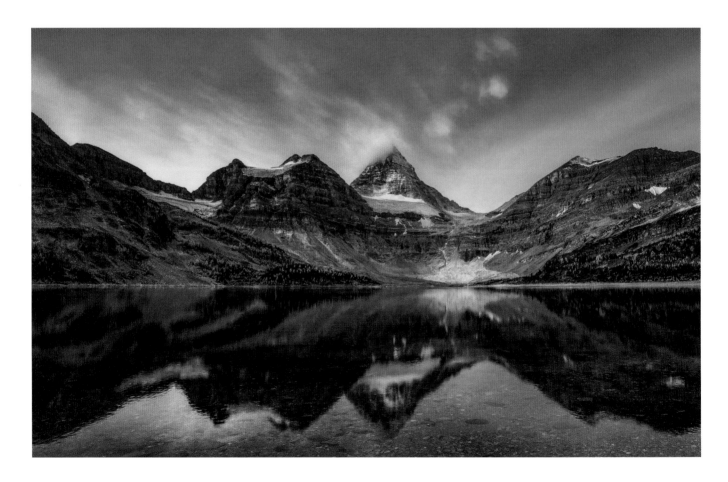

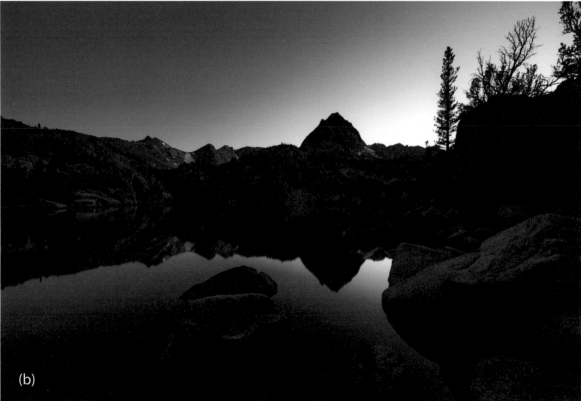

facing page

3.3 The delicate pink of alpenglow graces the clouds surrounding the peak of Mt. Assiniboine in the Canadian Rockies.

Source: Steve Hallmark/SteveHallmark.smugmug.com

above

3.4 Comparison of images created during (a) the golden hour and (b) the blue hour: (a) Santa Ynez Valley, California; (b) Lamarck Lake, California. Note the emerging stars in the upper left in (b).

The distinctly warm colors of direct sunlight during the hour or so immediately before sunset and immediately after sunrise lead to these periods being known to photographers as the "golden hour." They create wonderful opportunities for award-winning images, Figure 3.4(a). You can see this effect by comparing the two photographs shown in Figure 3.2(c) and (d); both created at the same location, but one during the harsh light of midday and the other during the warm light of the golden hour. Conversely, the approximately hour-long twilight periods just after sunset and just before sunrise are known as the "blue hour," Figure 3.4(b). The distinctly blue light from the sky during this period is the source of this name, since there is a total lack of any direct light from the sun. The blue hour provides many opportunities to create images with a very serene and calm mood.

CIVIL/NAUTICAL/ASTRONOMICAL TWILIGHT

The moment when the sun crosses the horizon is the key event for landscape astrophotographers, Figure 3.5(a). The precise moment of sunset or sunrise, i.e. when the last vestige of the sun disappears/appears over the horizon, conveniently represents the point in time against which all preceding and subsequent events can be measured. In case you're interested, Appendix VI has a more complete description of what actually is represented by the term, "horizon."

We start with the period of twilight between full darkness and either sunset or sunrise, earlier dubbed the "blue hour." Twilight is actually divided into three separate periods, each with its own name: *civil*, *nautical*, and *astronomical* twilight, Figure 3.5. Civil twilight is often relatively bright, Figure 3.5(b); it is often legal, although ill advised, to drive without headlights during civil twilight. Nautical twilight is characterized by darkening skies but few if any visible stars, Figure 3.5(c); stars really appear during astronomical twilight, Figure 3.5(d). Following astronomical twilight at night and before it in the morning is the period of *full darkness*, or what we know as night, during which the sky is as dark as it will become.

The transition between each twilight period occurs when the sun reaches a specific angular position below the horizon, as illustrated in Figure 3.5. The transition between civil and nautical twilight occurs when the sun is 5° below the horizon; between nautical and astronomical twilight when the sun is 10° below the horizon, and between astronomical twilight and full darkness when it is 15° below the horizon.

Astronomical twilight is especially important for landscape astrophotographers since it is the time when stars, constellations, and the Milky Way all attain their full brightness, Figure 3.6. Exquisitely colored skies along with visible stars can be observed during astronomical twilight; see, for example, the first Case Study in Chapter 23. Knowing the beginning and ending times of the different periods of twilight is thus extremely valuable as you prepare for your nightscape astrophotography sessions.

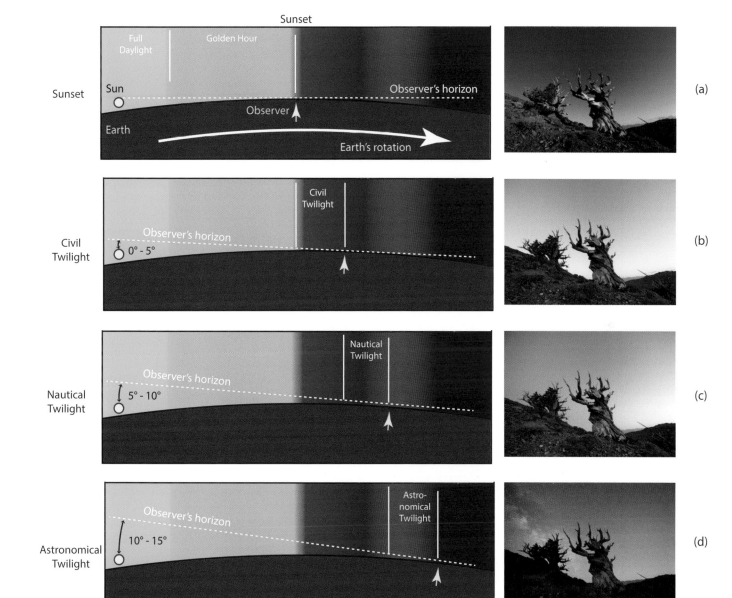

3.5 The three periods of twilight, civil, nautical, and astronomical, and their changing sky colors, are defined by the angular position of the sun below the horizon of the observer (yellow arrow). The sun's angular position relative to the observer changes as the earth rotates, here from left to right. (a) Sunset and the beginning of civil twilight occurs when the last visible part of the sun slips below the horizon; (b) end of civil and beginning of nautical twilight occurs when the sun is 5° below the horizon; (c) end of nautical and beginning of astronomical twilight occurs when the sun is 10° below the horizon; (d) end of astronomical twilight and onset of full darkness occurs when the sun is 15° below the horizon.

(a)

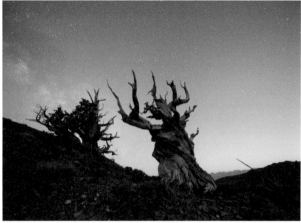

(b)

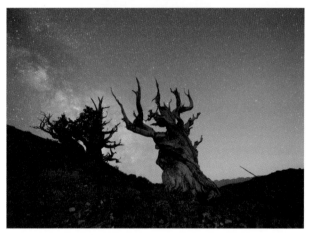

(c)

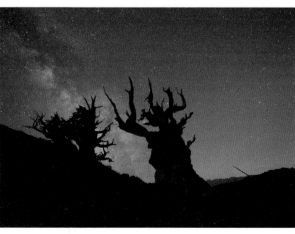

(d)

3.6 The brightness of the sky during astronomical twilight strongly affects the number of stars that are visible. As the brightness of the sky decreases, the number of stars that become visible correspondingly increase. These images were created after sunset, and (a) at the beginning; (b) one-third of the way through; (c) two-thirds of the way through and (d) at end of astronomical twilight and the beginning of full darkness.

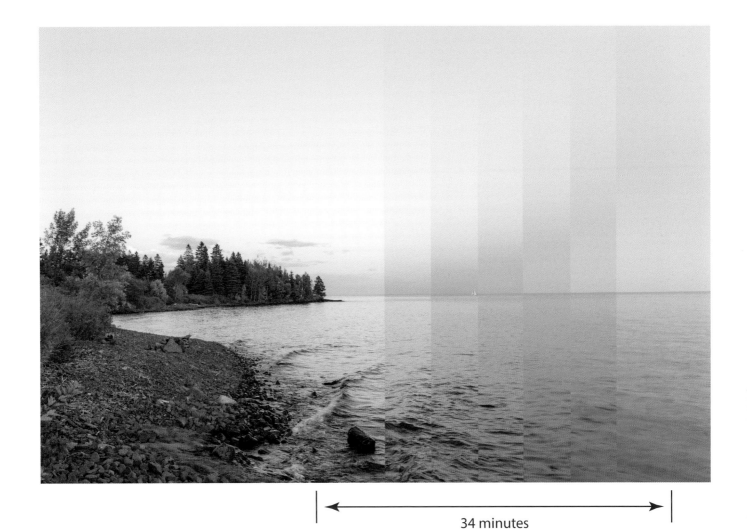

34 minutes
(July 31, 47°N)

3.7 The dark blue band of the earth's shadow, just above the eastern horizon, and the pink Belt of Venus directly above it, develop and progressively rise over Lake Superior in Minnesota, during civil twilight immediately after sunset.

The moment of sunrise and sunset also determines the times during which the *earth's shadow* becomes visible, along with the so-called *Belt of Venus*. The earth's shadow is that distinctly blue band that slowly rises or sets just above the horizon in the sky opposite the sun, Figure 3.7. Sandwiched between the earth's shadow and the slowly darkening blue sky overhead is a diffuse, pinkish band dubbed the Belt of Venus, Figure 3.7. The planet Venus is often visible on the opposite side of the horizon during this time; hence the name. The earth's shadow and the Belt of Venus both appear beginning immediately after sunset and before sunrise and present wonderful opportunities for landscape astrophotography images by themselves, or with a concurrent rising, or setting full moon, Figure 5.11.

(a)

(b)

3.8 Two sunrise images taken seconds apart facing: (a) east (into the rising sun) and (b) west (away from the rising sun) during the final moments of civil twilight. Note the *opposite* color transitions in the sky just above the horizon: the sky changes from orange to blue in the vertical direction facing east, but the reverse facing west: blue to pink/red/orange!

AZIMUTH EFFECTS OF SKY COLOR

The observer's azimuth, or compass direction, strongly affects the colors of the sky during the different periods of twilight, as is shown for civil twilight in Figure 3.8. This phenomenon provides endless opportunities for nightscape astrophotography images. You can choreograph nearly any sky color combination you wish simply by selecting the appropriate period of twilight and azimuth!

LATITUDE EFFECTS ON TWILIGHT DURATION

The appearance of the sun's east-to-west trajectory across the sky each day depends on the latitude of the observer for precisely the same reasons we discussed in the previous chapter. The daytime sky's motion is no different! Consequently, just as we saw for stars, for those near either of the earth's poles, the sun rises at a very shallow angle, Figure 3.9(a). In contrast, the sun rises nearly vertically from the horizon for observers on the equator, passes directly overhead at noon, and then sinks nearly vertically into the western horizon at sunset, Figure 3.9(c). For observers at mid-latitudes, the sun rises in the east at an angle to the normal roughly corresponding to the observer's latitude, rises to its maximum height and then sinks in the west with the same angular orientation, Figure 3.9(b).

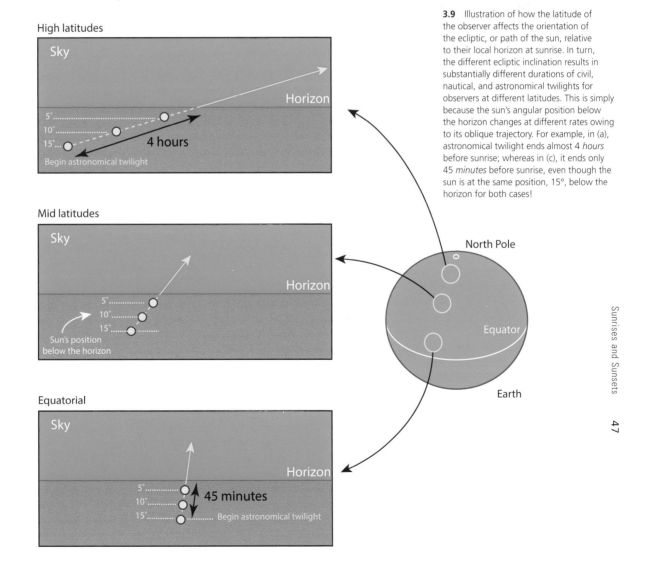

3.9 Illustration of how the latitude of the observer affects the orientation of the ecliptic, or path of the sun, relative to their local horizon at sunrise. In turn, the different ecliptic inclination results in substantially different durations of civil, nautical, and astronomical twilights for observers at different latitudes. This is simply because the sun's angular position below the horizon changes at different rates owing to its oblique trajectory. For example, in (a), astronomical twilight ends almost 4 *hours* before sunrise; whereas in (c), it ends only 45 *minutes* before sunrise, even though the sun is at the same position, 15°, below the horizon for both cases!

These latitudinal differences in the sun's trajectory during sunrise and sunset also strongly affect the twilight durations, and hence, your nightscape shooting schedule. The night sky becomes darker much faster for equatorial observers than for those at higher latitudes during sunset, and the reverse during sunrise. As the sun drops vertically below the horizon near the equator, its illumination recedes at its greatest rate. In contrast, for observers at higher latitudes, the sky can remain light for hours after sunset or before sunrise, and even stay illuminated for days on end! The reason is simple: the durations of twilight are greater for high-latitude observers simply because the sun's angular position below the horizon changes relatively more slowly owing to its oblique trajectory.

Bibliography

Dickinson, Terence & Alan Dyer, *The Backyard Astronomer's Guide*, 2010, Third Edition, Firefly Books, Limited, Buffalo, New York

Knight, Randall D., *Physics for Scientists and Engineers*, 2013, Third Edition, Pearson, Glenview, Illinois

Schneider, Stephen E. & Thomas T. Arny, *Pathways to Astronomy*, 2015, Fourth Edition, McGraw Hill Education, New York

Note

1 Rayleigh scattering is one type of scattering where certain wavelengths of light, in this case blue, are absorbed and re-emitted by gas molecules of a certain size. It isn't a chemical interaction but one simply based on the physical sizes of the molecules. Since oxygen and nitrogen gas molecules are approximately the same size, they both scatter the same, mostly blue wavelengths of light.

4

AURORA BOREALIS / AUSTRALIS

The shimmering, dancing lights of the Aurora Borealis and the Aurora Australis are certainly one of the most mystical and unforgettable phenomena of the night sky, Figure 4.1(a) and (b), respectively. The experience of witnessing cascading sheets of auroral light pouring over the dome of the sky has left many a night sky observer, including myself, speechless and in awe. Including an auroral display in a nightscape image is surely on the bucket list of most landscape astrophotographers.

Fortunately, aurorae are technically quite straightforward to photograph owing to their relative brightness compared to most of the other subjects described in this book. In many cases, even a smartphone will suffice! It can be challenging to view the aurora, however, since they are restricted to specific regions of the earth, often necessitate significant travel and occur only sporadically. It can also be tempting to over-process aurora nightscape images with results that are unnaturally over-saturated and over-contrasted. Popular locations for viewing the aurora with international air access include Fairbanks, Alaska; Yellowknife, Canada; Reykjavík, Iceland; Tromsø, Norway; and Kiruna, Sweden. Here, we will review the origins of the aurorae and the role of the earth's magnetic field so that we may predict when and where they are likely to occur. Tips for predicting the appearance of the aurorae are given later in this chapter, and recommended settings for photographing the aurora are given in Chapter 15.

ORIGINS OF THE AURORA

The sun is constantly hurling incomprehensible quantities of electrons, protons, and a host of other subatomic particles into space at immense speeds, Figure 4.2(a). While most of these emissions occur more or less uniformly over its surface, local disturbances, such as sunspots and flares, can cause locally concentrated outbursts of particles and energy, and a temporary increase in auroral activity on Earth.

The prevalence of notable auroral displays in a given year is thus strongly correlated with the manifestation of sunspots. In turn, the number of sunspots fluctuates in a cycle with a period of approximately eleven years, Figure 4.2(b). The most recent maximum occurred around 2013; the next maximum is expected approximately in 2024. Of course, aurorae occur even without sunspots; there is simply a higher chance of a strong display when sunspots appear.

Occasionally, the sun will "burp" and discharge a relatively large quantity of matter during an event called a *coronal mass ejection* (CME), Figure 4.2(a). CMEs can be responsible for spectacular displays of the aurora. This is because of their particularly high density of high-energy particles. When the massive quantities of high-energy particles ejected from a CME reach the earth, their interactions with the gases in the earth's atmosphere are so extensive the result is called a geomagnetic storm. Another source of energy into the earth's atmosphere are solar wind streams from *open coronal holes* in the sun, although they tend to be less strong than CMEs. In either case, communications and electrical power distribution systems can be adversely affected and even disrupted during a geomagnetic storm.

facing page

4.1 (a) The extraordinary Aurora Borealis display of June 22, 2015, dwarfs the setting crescent moon (lower left). This geomagnetic storm was so intense that the northern lights were visible as far south as northern Georgia in the United States. (b) The Aurora Australis near Hobart, Tasmania. The Large and Small Magellanic clouds are also visible in (b), along with the Milky Way.

Source: (b) Yuichi Takasaka/ www.blue-moon.ca /The World At Night

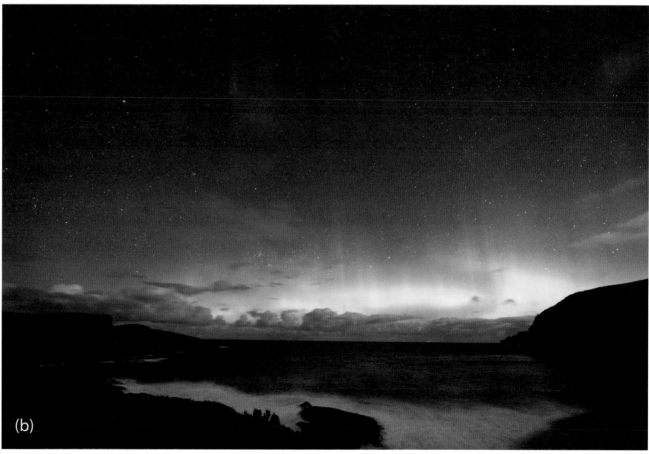

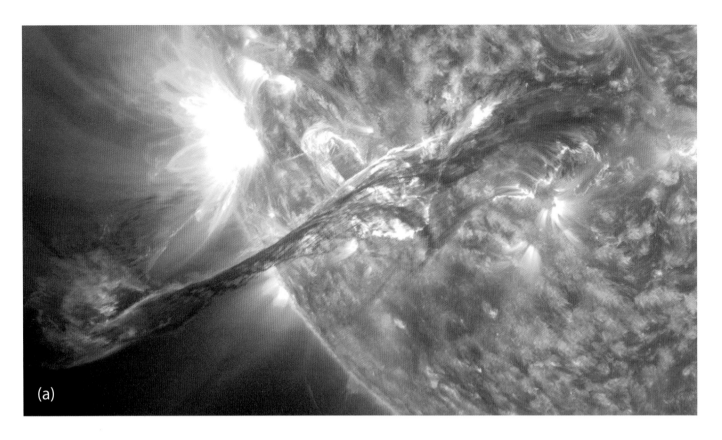

(a)

ISES Solar Cycle Sunspot Number Progression
Observed data through Oct 2015

(b)

Updated 2015 Nov 9

NOAA/SWPC Boulder,CO USA

Smoothed Monthly Values — Monthly Values — Predicted Values (Smoothed)

4.2 (a) The sun emits a wide range of subatomic particles from its surface, and especially from local disturbances such as sunspots, seen here as the bright patch in the upper left and an erupting solar filament or flare, seen across the diagonal of the photograph. This solar filament produced a coronal mass ejection on July 20, 2012, that impacted the earth and resulted in aurorae. (b) The number of sunspots that appear each year tends to follow a cycle that lasts approximately eleven years. A high number of sunspots favors higher levels of active auroral displays. The most recent maximum occurred around 2013; the next maximum should thus likely appear around 2024.

Source: NASA/NOAA/SWPC

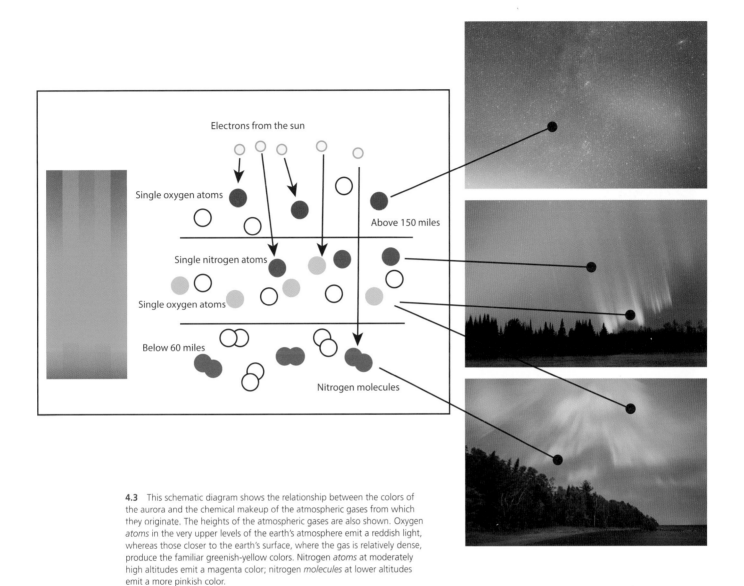

4.3 This schematic diagram shows the relationship between the colors of the aurora and the chemical makeup of the atmospheric gases from which they originate. The heights of the atmospheric gases are also shown. Oxygen *atoms* in the very upper levels of the earth's atmosphere emit a reddish light, whereas those closer to the earth's surface, where the gas is relatively dense, produce the familiar greenish-yellow colors. Nitrogen *atoms* at moderately high altitudes emit a magenta color; nitrogen *molecules* at lower altitudes emit a more pinkish color.

COLORS OF THE AURORA

When the particles emitted from the sun collide with the gas molecules in the earth's upper atmosphere, they interact and cause the gas molecules to emit light. The color of the light depends on which specific gas atoms or molecules are involved: monatomic oxygen atoms, (O), monatomic nitrogen atoms, (N), diatomic nitrogen molecules, (N_2), or something else, Figure 4.3.

The relationship between the colors of the aurora, the chemical makeup of the gases in the atmosphere, and their atmospheric heights is shown in Figure 4.3. Oxygen *atoms* in the very upper levels of the earth's atmosphere emit a reddish light, whereas those closer to the earth's surface, where the gas is relatively dense, produce the familiar greenish-yellow colors. Nitrogen *atoms* at moderately high altitudes emit a magenta color; nitrogen *molecules* at lower altitudes emit a more pinkish color.

ROLE OF THE EARTH'S MAGNETIC FIELD

One of the signature characteristics of auroral displays is their curtain, or sheet-like appearance; auroral "pillars" are often observed, Figure 4.4(a). Although not yet completely understood, the current theories for why the incoming particles localize into such clearly defined ribbons, pillars, and bands, instead of simply bathing the sky with a uniform glow, are all based on how the particles interact with the earth's magnetic field.

Why does the earth's magnetic field have anything to do with auroral displays? After all, the particles arriving from the sun aren't magnetic, or are they? In one of the most profound discoveries in physics,[1] moving, electrically charged particles, such as those responsible for the aurora, have been shown to *create* their own magnetic field as they travel through space! Their magnetic field accompanies them as long as they are moving, but vanishes once their motion stops. Since the majority of aurora-causing particles emitted by the sun are fast moving, electrically charged electrons and protons, each one creates its own magnetic field as it travels to Earth.

When the magnetic field surrounding each moving, charged particle encounters the enormous magnetic field of the earth, the two magnetic fields interact. The result of these interactions is a channeling and shaping of the flood of incoming particles into ribbons and sheets in an as-yet incompletely understood process. The particles within the newly formed streams and sheets then interact with the gas molecules of the earth's atmosphere to produce the familiar, flowing streams and ribbons of the auroral displays. The dimensions of these ribbons can be remarkable; they might be only a football field in width, yet hundreds of miles tall and thousands of miles in length! When viewed from directly below, their internal structure can be visualized, Figure 4.4(b).

PREDICTING THE AURORA

The near-term likelihood of an auroral display can be predicted by monitoring the surface activity of the sun, along with measurements of the magnetic fields of the earth and the sun. Vigilant aurora watchers monitor sunspot and other solar activity closely for any signs of an impending CME or other significant solar event. If an eruption occurs, scientists and amateurs alike carefully calculate the trajectory of the outgoing stream of particles to assess whether or not it is likely to significantly interact with the earth's magnetic field. Since aurora-causing particles have mass, they travel towards the earth at a fraction of the speed of light, and can take up to several days to arrive. In contrast, the light and heat emitted from the sun only takes a little over 8 minutes to travel from the sun to the earth. Consequently, aurora-causing geomagnetic storms can often be predicted up to several days in advance owing to the time required for CME particles to travel from the sun to the earth compared to the much shorter time required to visually detect the onset of a CME.

There are several space weather measurements constantly being made and analyzed to determine the likelihood of a near-term aurora display. Both the raw data and the results of the analyses are continuously generated from the U.S. Space Weather Center as well as the National Oceanic and Atmospheric Agency (NOAA), and are made freely available to the public in a variety of useful formats. You may wish to become familiar with how to access and interpret these rich sources of information. While none by themselves may be enough to predict a visible display with certainty, simultaneously favorable levels of two or more of the key indices can nearly guarantee a visible display.

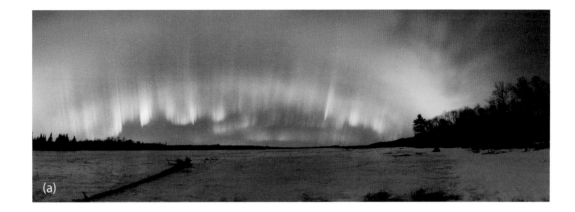

4.4 Examples of different appearances of the aurora: (a) side view of curtains, or pillars, (b) "Bottoms-up" view of a corona.

One set of data originates from the Advanced Composition Explorer (ACE), a satellite used to help forecast the imminence of solar storms, Figure 4.5. The ACE satellite sits at one of the earth's *libation points*, or a point in space where the gravitational field of the earth and the sun are approximately balanced. This balancing of the opposing gravitational fields allows the satellite to remain more or less stationary relative to the earth, which in turn allows it to continuously monitor space weather from a relatively fixed position. The ACE satellite will soon be replaced by the Deep Space Climate Observatory (DSCOVR) satellite, launched in early 2015.

The ACE satellite monitors several sun-related parameters relating to the potential for an auroral display: the intensity and shape of its magnetic field, the density of incoming low and high-energy electrons and protons, and many others, Figure 4.5(a). Clicking on any of the titles in Figure 4.5(a) brings up a set of graphs of these data, updated constantly. Data can be plotted for the preceding 2, 6, 12, or 24 hours.

Two of the most significant parameters for aurora watchers and measured by the ACE satellite are the magnitude and direction of the interplanetary magnetic field, B. This is the magnetic field largely caused by the sun that surrounds the earth but that is distinct from the earth's own magnetic field. The most important component of the interplanetary B-field is its B_z component, also called the B_z index. The B_z index is the component parallel to the earth's own magnetic field, which is oriented northward. When the B_z index is oriented southward, it effectively cancels the earth's magnetic field. When this occurs, favorable conditions are created for ejected particles from the sun to be channeled into the near-Earth regions, thus increasing the likelihood of an auroral display. A southward dip in the B_z index is shown as a negative trend in the ACE B_z graph, Figure 4.5(a). Whenever a significant dip is spotted, e.g. more than -10 for observers at latitudes of approximately 45° N, be sure to be on the alert for possible aurorae! The third parameter of interest is the high-energy proton stream—when it jumps, the CME has arrived!

A second key parameter is the K_p index, or the planetary K-index, which indicates the average strength of geomagnetic activity, Figure 4.5(b). In contrast to B measurements, which are made in space, the planetary K-index is determined from magnetometers located on the earth's surface. The K indices range from zero to nine with a higher number indicating a higher level of geomagnetic activity. The typical thresholds of the K_p index for visible overhead displays of aurorae are shown in Figure 4.5(c) for different locations around the world. Note that while K_p levels of three to five are not unusual, K_p levels of seven and higher are rare.

These measurements of the B_z, K_p, and other key parameters are continuously analyzed by NOAA and summarized in the form of a simple, color-coded, prediction for the likelihood of an auroral display in the next 24 to 36 hours, Figure 4.6(a). The University of Alaska provides another overall forecast of likely auroral visibility, Figure 4.6(b), for several Northern and Southern Hemisphere locations.

The aurora occurs within an oval shaped ring encircling the north and south poles. Depending upon the local conditions, the oval may be relatively large and wide, or small and thin. At its largest, the auroral oval may extend as far south as 35° N in the Northern Hemisphere. In the Southern Hemisphere, the oval may extend north as far as Southern Australia and Tasmania, Figure 4.1(b).

VIEWING TIPS AND ALERTS

Displays of the aurora occur every day of the year, day or night. However, most displays are insignificant and only visible at extremely high latitudes. Spectacular displays can also occur any day of the year and any time of night, although they are most commonly viewed after midnight owing to the dark skies, and around the spring and fall equinoxes. Dates around the new moon each month also result in the darkest possible skies and allow the most vivid colors to be seen at a given location. A crescent or quarter moon may cast enough light to illuminate the foreground without overexposing the sky, as discussed in the next chapter. Nights of the

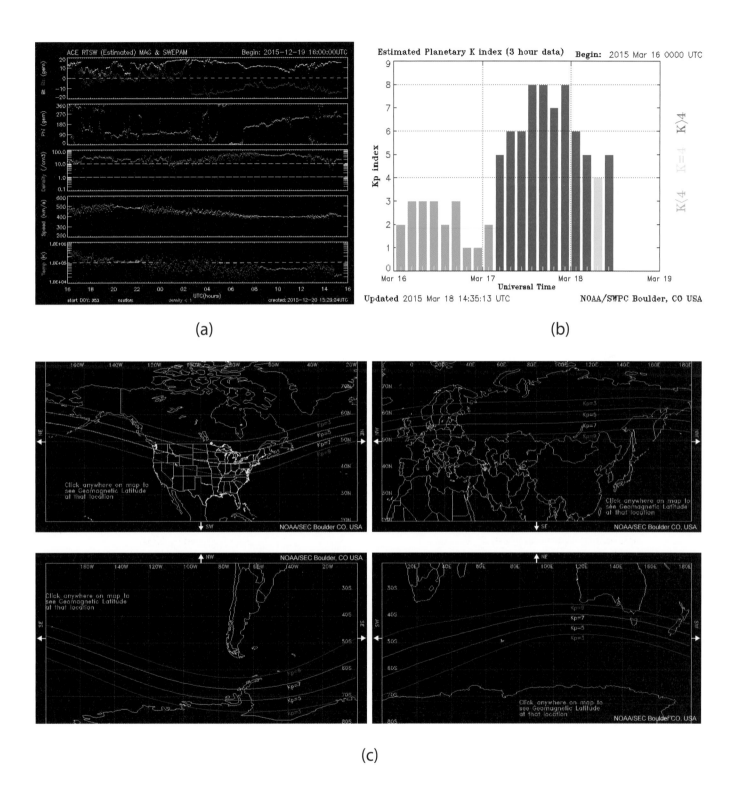

(a)

(b)

(c)

4.5 A variety of continuously updated data are freely available for aurora forecasting.
(a) Data from the Advanced Composition Explorer (ACE) satellite from the U.S. Space
Weather Center. The various components to the magnetic field are shown, including
the closely monitored B_z parameter in red. When the B_z dips, auroras are likely!
(b) The latest and most recent planetary K-index, or K_p index, from the U.S. Space
Weather Center. While K_p levels of three to five are not unusual, K_p levels of seven and
higher are rare. (c) This diagram shows the K_p threshold needed to observe the aurora for
different locations in high latitude regions of the Northern and Southern Hemispheres.

Source: NASA/NOAA/SWPC

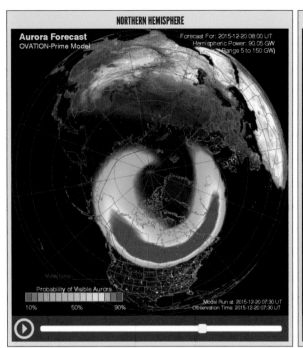
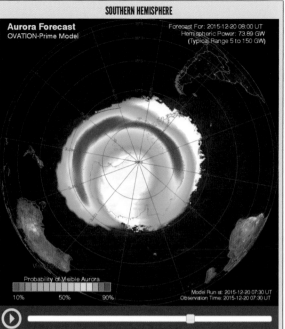

(a)

(b)

4.6 Predictions for the intensity, size, and geographical extent of the auroral oval from (a) the U.S. Space Weather Prediction Center and (b) the University of Alaska. These predictions are available for up to several days in the future.

Source: NASA/NOAA/SWPC, www.gi.alaska.edu/auroraforecas

full or nearly full moon tend to wash out the aurora owing to the relatively bright skies. Stunning images are often captured of the aurora over a large, calm body of water that produces gorgeous reflections.

There are several free and subscription services that allow you to automatically receive alerts of impending auroral displays. These alerts can be very helpful when a display unexpectedly develops in the middle of the night and you happen to be asleep. Several online communities also exist to help alert their members to ongoing displays. For example, one very active and popular Facebook group is the Great Lakes Aurora Hunters (GLAH) group, whose over thirteen thousand members actively report and generously share up-to-the-minute information and viewing tips. These are related to ongoing and imminent auroral displays across continental North America and Alaska, Canada, and Scandinavia. Finally, there is the time honored "telephone tree" in which friends simply call one another to drag them out of bed during an active display!

AIRGLOW/SKYGLOW

After you've been taking photos of the night sky long enough, you will undoubtedly notice faint patches, ripples, or even just a dim glow of greenish/reddish light in the atmosphere that in many ways appear similar to the aurora, Figure 4.7. In fact, these occasionally prominent and often-puzzling phenomena, termed *airglow* or *skyglow*, can provide enough illumination, along with the stars, to allow us to see at night, even without the moon. While airglow can be the bane of deep-sky astronomical imaging, since it can obscure the dimmest stars, it can be a colorful addition to modern nightscapes made in dark locations with cameras containing sufficiently sensitive sensors.

So what is it and where does airglow come from?

Airglow originates from the same atomic process that produces the aurora, namely, the emission of light from electronic transitions within individual oxygen atoms and compound molecules. However, the excitation mechanism is different. While aurorae are caused by impacts between atmospheric oxygen and nitrogen atoms and molecules with electrons and protons from the sun, airglow is caused primarily by the gradual recovery from the ionization of atmospheric atoms by the sun that regularly occurs during each day. Airglow can thus be seen anywhere on Earth and is completely independent of the fluctuations within the earth's magnetic field.

Airglow is most frequently observed to exhibit either a reddish or greenish color. These colors originate from the same atomic excitation mechanism described earlier for the formation of the colors of the aurora. The reddish colors originate from both oxygen and OH (Hydroxide) molecules, while the green colors are from excited oxygen atoms. The colors can change noticeably during a single night, with reddish colors generally observed more frequently in the evening, while the greenish hues are more prevalent during the middle of the night.

Airglow originates within the very high-altitude *thermosphere* layer of the earth's atmosphere. The oxygen atoms and OH molecules within this layer comprise invisible "clouds" that can be disturbed by the movement of gases within underlying layers, such as the stratosphere and troposphere, where most weather occurs. Like most fluids, the difference in densities results in the disturbances manifesting themselves as ripples and waves, akin to the formation of ripples on the surface of a calm pond after a stone is thrown in. These ripples produce the beautiful

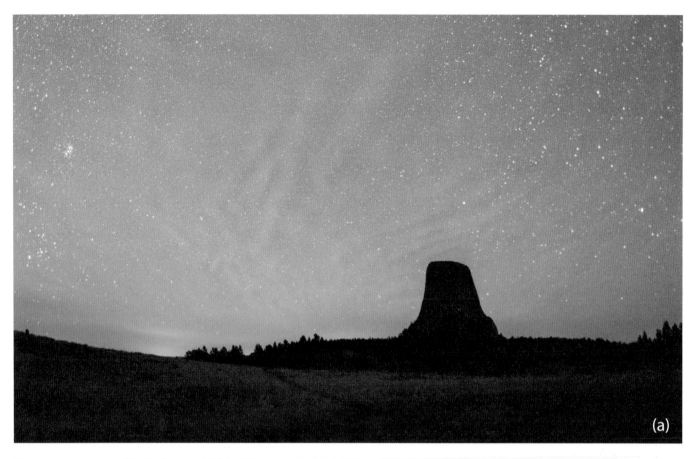

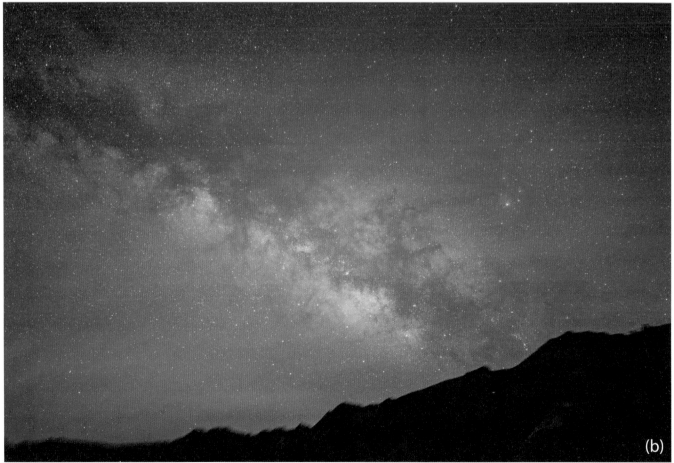

flowing waves that gracefully flow across the sky as seen from the earth's surface. They can be marvelous to observe during accelerated time-lapse video sequences made over the course of several hours.

Bibliography

Dickinson, Terence & Alan Dyer, *The Backyard Astronomer's Guide*, 2010, Third Edition, Firefly Books, Limited, Buffalo, New York

Knight, Randall D., *Physics for Scientists and Engineers*, 2013, Third Edition, Pearson, Glenview, Illinois

Schneider, Stephen E. & Thomas T. Arny, *Pathways to Astronomy*, 2015, Fourth Edition, McGraw Hill Education, New York

www.gi.alaska.edu/auroraforecast

www.spaceweather.com

www.swpc.noaa.gov/

www.swpc.noaa.gov/products/aurora-30-minute-forecast

www.swpc.noaa.gov/products/planetary-k-index

Note

1 Hans Christian Oersted discovered that a magnetic field is produced by an electric current by accident, during a classroom science demonstration in 1819.

facing page

4.7 The ghostly greenish and reddish bands and ripples of airglow, or skyglow, can be seen over Devils Tower in Wyoming (top) and the Sierra Nevada backcountry (bottom).

THE MOON

5

Next to the timing of sunrise and sunset, the phase of the moon is the single most important factor for you to consider in creating your nightscape images. Especially if you're new to landscape astrophotography, the effects of moonlight on nightscapes can be surprising. One reason for this is that both camera sensors and film accurately record moonlit nightscapes in full color, in contrast to human night vision, which perceives them primarily in black and white. The results can be pleasantly disorienting—otherworldly nightscapes that appear to be illuminated by sunlight, yet with skies clearly containing a multitude of stars, Figure 5.1!

Whether the moon is present or absent in the night sky when you make your nightscapes directly affects two of their most important aspects. First, when the moon is visible, it acts like a dim version of the sun, causing the gases in the earth's atmosphere to glow with a bluish tinge, Figure 5.2(a) and (c). However, this glow tends to drown out the dimmer night sky objects, resulting in fewer observable stars and other phenomena. In contrast, when the moon is absent, the earth's atmosphere remains as transparent as window glass, allowing us to see all the way through to the inky blackness of space, Figure 5.2(b) and (d). Such conditions are best for viewing the largest number of dim night sky objects, especially the Milky Way. Second, when the moon is present, its light richly illuminates the objects on the ground, compared to the much darker, nearly featureless foregrounds during moonless nights. Clearly, it is crucial for you to know how to predict whether or not the moon will be visible on any given night.

5.1 Twinkling stars fill the sky under a nearly full moon over the peaceful north shore of Lake Superior.

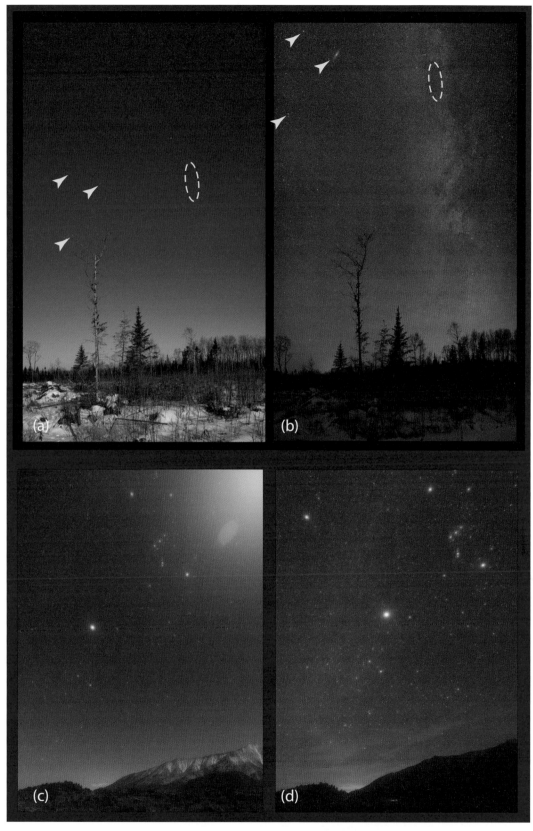

5.2 (a) and (b) Both of these photographs were made three weeks apart in winter, at the same location in northern Minnesota, at approximately the same time of night—nearly 2 hours after the onset of astronomical twilight and over 3 hours after the sun had set. The difference? For the image on the left, the dazzling full moon was brightly illuminating the scene, whereas the image on the right was taken during a new moon, after the moon had set along with the sun hours earlier. The full moon causes the earth's atmosphere to glow, left, obscuring most of the objects that are visible otherwise, right. The moonlight also brightly illuminates the foreground compared to the mostly silhouetted foreground on the moonless night. The arrows indicate the Andromeda Galaxy and two stars visible in both images as reference points; the dashed ellipse highlights a dark cloud of dust within the Milky Way, again as a reference. (c) and (d) Similarly, these images were created a few weeks apart around the same time of night in the foothills of the eastern Sierra near Lone Pine, California. Again, the nearly full moon, left, washes out the sky but gives definition to the foreground. The dark skies of the new moon, right, allow the stars of the sky to be far more visible.

In this chapter, you will join the ranks of those who have acquired the necessary tools to precisely predict and time the phase of the moon for anywhere on Earth; for any date, past, present, and future. You will learn why the moon has phases in the first place, and why the moon looks like it does on each day during its monthly cycle. We will learn about where the moon came from and why its surface appears the way it does.

We will then tie your new knowledge of the astronomy of the moon to its crucial effects on landscape astrophotography. *Most importantly, you will learn how to plan your astrophotography sessions around the phases of the moon, and you will develop a new monthly planning cycle for specific landscape astrophotography targets.* We will see how synchronizing the moment of the rising or setting of the full moon with the moment of sunset or sunrise can create spectacular opportunities for nightscapes but ones that may only occur once, on a single day, during a given year! You will learn about Super Moons, Blue Moons, Harvest Moons, and the like. We will go through the ways in which solar and lunar eclipses take place. You will learn about several striking phenomena that you will encounter related to the interactions of moonlight with surface and atmospheric water and ice—moon halos, moonbows, and different types of moon reflections from water. Finally, we will unravel the "moon illusion."

THE ORIGIN AND APPEARANCE OF THE MOON

Close examination of the moon's surface, even with the naked eye, reveals it to be very rough and irregular, Figure 5.3. Vast, roughly circular darker areas that appear relatively smooth are surrounded by lighter colored regions that are heavily cratered. These differences are the result of the fascinating sequence of events that occurred in the billions of years following the moon's formation. So where did the moon come from, anyway? Did the moon simply form at the same time as the earth? Or was it a wandering object that was lassoed into orbit by the earth's gravity? Was it a part of the earth that somehow became separated during the early days of formation 4 ½ billion years ago?

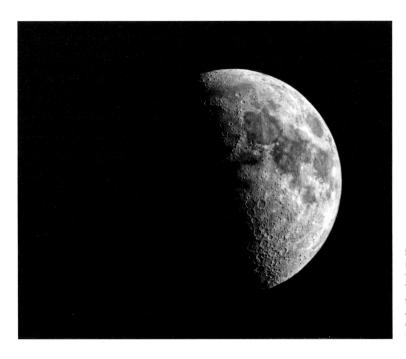

5.3 The heavily cratered surface of the quarter moon is revealed through this view through a telescope fitted to a DSLR (digital single-lens reflex camera). The terminator line, or the boundary between the shadowed and illuminated surface, is a wonderful area to explore through your telephoto lens. Note the dark maria surrounded by the much lighter regions of impact craters.

Results first obtained from the Apollo missions to the moon and by numerous observations thereafter have shown that the moon formed as the result of a collision between an enormous object, Theia, with the already formed earth approximately 30–120 million years after the formation of the solar system. This impact ejected a huge quantity of the nascent earth, which, when combined with remnants of Theia, provided the raw ingredients of the moon. After impact, the ejected mass of mostly liquid magma began to coalesce under its own gravity to form the spherical shape that would ultimately become the moon. Its lighter minerals floated to the outer surface of the sphere, and were the first to harden into a thin solid crust covering the still-liquid magma. The still liquid, heavier and denser minerals slowly settled into the moon's center and continued to cool.

As the moon's liquid interior gradually crystallized into a solid, meteors, large and small, continuously peppered both the moon and the earth. These meteors largely originated from the primordial debris remaining from the formation of the solar system. Although the majority of the meteor impacts created tortured regions of craters in the moon's crust, a few massive meteors punctured the crust and penetrated the still-liquid core. The pressurized magma then oozed through these holes and filled the fresh craters with enormous oceans of glowing, molten rock. Imagine the view from Earth! After the magma oceans cooled and froze into *maria* (plural Latin for *mare*, or sea), we observe them today as the familiar dark regions of the moon's surface. The dark colors of the maria arise from their different chemical makeup compared to the lighter minerals that comprise the rest of the moon's crust. In fact, most of the Apollo missions that landed on the moon did so within maria owing to their relative flatness.

As time progressed to the present day, the frequency of meteor impacts dwindled as the primordial debris was consumed. Today, significant meteor impacts with the moon and earth are almost nonexistent (fortunately!). As a point of interest, examination of the moon's maria through a telephoto lens or telescope reveals smaller impact craters within them, indicating that meteor impacts persisted after their formation. Some of the best targets for viewing through a telescope remain these impact craters and maria, especially along the line dividing the illuminated and shadowed regions of the moon, also known as the *terminator* line.

One curious phenomenon that developed as the moon cooled, and which is generally taken for granted, is that we always see the same side of the moon. Ever wonder why? In fact, this observation has sometimes led to the incorrect notion that the side of the moon facing away from us is perpetually in darkness. The reason is that as the heaviest, densest core material of the moon solidified, the relentless tug from Earth's gravity caused it to shift and settle within the moon slightly closer to the earth and offset from the exact geometric center of the moon. Thus, we actually always see the "heavy side" of the moon as it orbits the earth; it's as if the moon could be compared to a child's toy that can be knocked off balance but always returns to its upright position.

THE CAUSES AND TIMING OF MOON PHASES

Suppose we look out the window this evening around 10 pm and see the familiar sight of the moon, Figure 5.4(a). You happen to know that this particular window generally faces south. Since you're planning an astrophotography outing, there are a few questions you might want to ask yourself. Will the moon *look the same* tomorrow night at the same time? If not, well, how will it change—will the shadowed part be bigger, smaller, or stay the same? Also, tomorrow night at 10 p.m., will the moon be at the same place in the sky? If not, how will its position change?

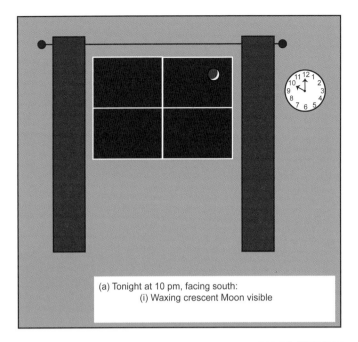

(a) Tonight at 10 pm, facing south:
 (i) Waxing crescent Moon visible

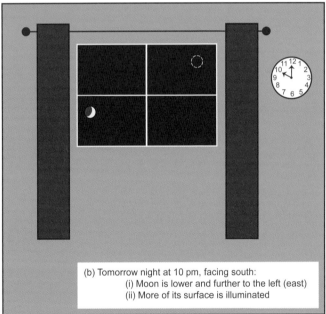

(b) Tomorrow night at 10 pm, facing south:
 (i) Moon is lower and further to the left (east)
 (ii) More of its surface is illuminated

5.4 This schematic illustration shows how a waxing crescent moon (a) might appear around 10 pm through a south facing window in the Northern Hemisphere. At the same time the next night, (b), the moon will appear lower, and to the left, compared to its position the previous night (dashed circle (b)).

The answers are that tomorrow night, at 10 pm (for this particular phase of the moon, which is known as a *waxing crescent* moon), the illuminated part of the moon will have *expanded in size*, and the moon will appear *slightly lower and further to the east—to your left* Figure 5.4(b). How can we predict this with certainty? This chapter of the book shows you how—by describing how the moon orbits the earth and how this orbit is responsible for these and many other regular and predictable changes in the moon's appearance.

First of all, let's just review some background information, beginning with the fact that the light that shines from the brightly lit surface of the moon is reflected light from the sun. In contrast, the dimly illuminated "shadowed" side of the moon reflects light from the earth, termed *earthshine*, Figure 6.3! Second, you might recall that on any given occasion, everyone on Earth will observe the identical phase of the moon; there is no difference in moon phase between hemispheres or sides of the earth. Finally, now and forever banish the thought that the shadow on the moon is the earth's shadow. It's not!

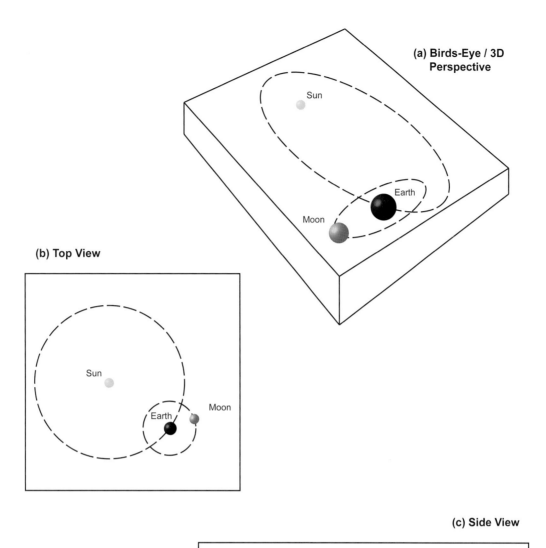

(a) Birds-Eye / 3D Perspective

(b) Top View

(c) Side View

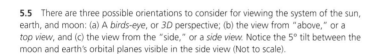

5.5 There are three possible orientations to consider for viewing the system of the sun, earth, and moon: (a) A *birds-eye*, or *3D* perspective; (b) the view from "above," or a *top view*, and (c) the view from the "side," or a *side view.* Notice the 5° tilt between the moon and earth's orbital planes visible in the side view (Not to scale).

Let's start with the model of the system of the sun, earth, and moon shown in Figure 5.5. We see that we have several choices in how we can view our system. We can view it from a birds-eye, or 3D perspective, Figure 5.5 (a). We can look down on it from the top, Figure 5.5 (b), or we can observe it from the side, Figure 5.5 (c). It's important to bear these different views in mind.

We will focus our attention on the top view perspective of the earth and moon system shown in Figure 5.6. This figure bears careful examination—in fact, now might be a good time to get that fresh cup of coffee, a pencil and paper; and turn off your phone's ringer! First, notice how the North Pole is visible near the earth's center. The perimeter of the earth, as seen in Figure 5.6, contains the equator. Also, note that from this perspective, the earth *rotates* daily about its axis in a counterclockwise direction, and it *revolves* around the sun also in a counterclockwise direction. I've drawn in the moon in a few locations within its orbit and from this perspective it, too, *revolves* around the earth in a counterclockwise manner; and *rotates* about its own axis in a counterclockwise direction.

Observe how the halves of the earth and moon facing away from the sun are naturally shadowed; as we peer down on the North Pole, we see that half the Northern Hemisphere experiences some form of daytime, or the left side of Earth, Figure 5.6, while the other half is in shadow and thus experiencing night, or the right side of Earth, Figure 5.6.[1] So for people at different locations on Earth, they are experiencing different times of day; while folks in Los Angeles are enjoying their evening, their friends in Tehran are enjoying early morning, while those in Tokyo are enjoying mid-afternoon.

Next, recall that it takes the moon a synodic *month*, or approximately 29 ½ days, to travel in a complete circle around, or to *orbit*, the earth relative to a fixed position on Earth.[2] Consequently, between any two successive nights on Earth, the moon only travels a small portion (one-twenty-ninth to be exact) of its way around the Earth. *This is a very important point:* that during a given night on Earth, the moon remains essentially glued to its starry background and moves through the night sky effectively at the same rate as its companions. In turn, the slow rate of orbital movement of the moon coupled with the length of the day on Earth are the reasons that moonrise and moonset occur *an hour later* on successive nights;[3] as well as the shift in position of the moon between successive nights at the same time, Figure 5.4.

Now it's time to get down to the business of fully understanding why we observe the different phases of the moon. To do so means we need to include the side view model, Figure 5.5(c), since our view of the moon is from this perspective. Let's break this down further with the help of Figure 5.7 (overleaf), where I've created a series of images simultaneously showing both top and side views of the moon at key stages of its orbit to help you understand how the moon's appearance to us changes as it orbits the earth. I've placed myself in Earth's position and orientation to emphasize our perspective of the moon in this top view illustration.

We will begin our monthly cycle with the new moon—the period of the moon's orbit when it lies exactly between the earth and the sun, Figure 5.7(a). Observe how the part of the moon facing the sun is fully illuminated as seen from above, yet the part facing Earth is in complete shadow, as viewed from Earth from the side. *Being able to understand these differences in appearance of the moon between top and side views is your key to unlocking your understanding of the causes of the phases of the moon.*

Observe how several days later, the moon has orbited to the position shown in Figure 5.7(b). The side of the moon facing the sun always remains fully illuminated as seen in the top view, but as we view the moon from Earth, we now see a crescent moon—i.e. we can now see the extreme right hand side of its illuminated face, as shown in Figure 5.7(b). Several days later, or a full week from the day of the new moon, the moon has orbited to the position shown in Figure 5.7(c). Again, the side of the moon facing the sun stays fully illuminated as viewed from the top, yet as viewed from the side, as from Earth, more of the illuminated side of the moon now has swung into view, so that it appears half in shadow and half illuminated. We call this phase of the moon the first quarter, since the moon has traveled a quarter of its orbit around the earth. Furthermore, the fact that the moon takes 7 days to travel one-quarter of its orbit is the source of the *week*, and since it takes nearly four weeks for the moon to complete its orbit, we have the *month*.

Continuing on a week later, the moon has orbited to the position shown in Figure 5.7(e); we will examine the intervening positions shown in Figure 5.7(d), (f) and (h) shortly. Now the moon

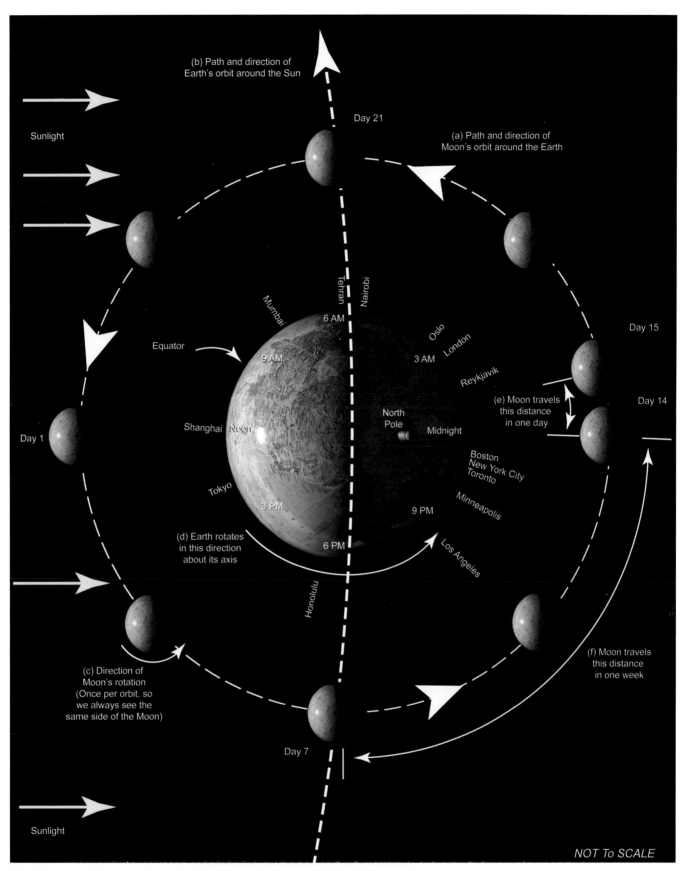

5.6 This top view of the earth and moon has a lot of information that you will find useful. The moon is shown where it would be about every 3 ½ days; or every one-half week during its month-long orbit. The sun is outside the field of view to the far left. Observe the shadows on both the earth and the moon. Notice the orbital path and direction of the (a) moon and (b) Earth, as well as their rotational directions about their axes (c) and (d). Note the different times experienced on Earth for people in the different marked locations. Finally, notice the distance the moon travels in a single day, as shown between Days 14 and 15, (e), compared to the distance it travels over the course of a week, as shown between Days 7 and 14, (f) (Not to scale).

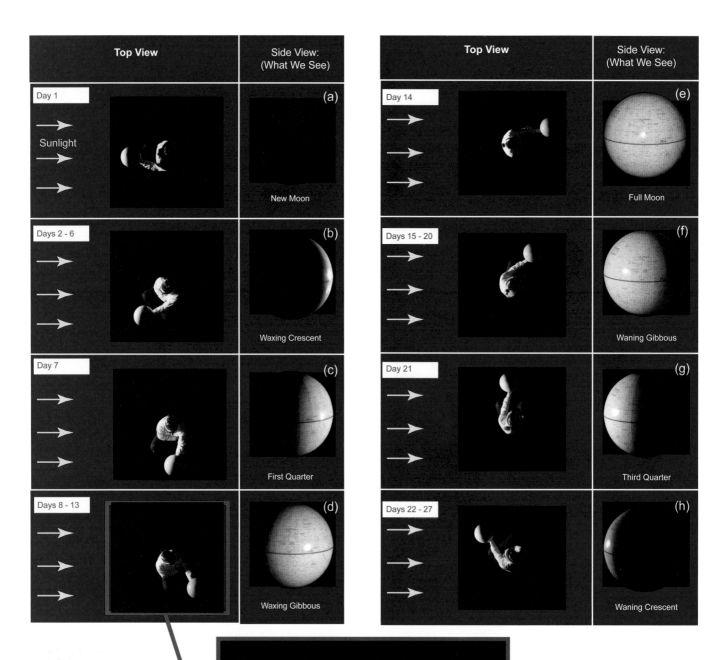

| | Top View | Side View: (What We See) | | Top View | Side View: (What We See) |

Day 1

Sunlight

New Moon (a)

Days 2 - 6

Waxing Crescent (b)

Day 7

First Quarter (c)

Days 8 - 13

Waxing Gibbous (d)

Day 14

Full Moon (e)

Days 15 - 20

Waning Gibbous (f)

Day 21

Third Quarter (g)

Days 22 - 27

Waning Crescent (h)

5.7 This diagram shows how the moon appears *both* viewed from above, or the top view, Figure 5.5(b), as well as from Earth, or the side view, Figure 5.5(c), during each of its eight main phases: (a) new; (b) waxing crescent; (c) first quarter; (d) waxing gibbous; (e) full; (f) waning gibbous; (g) third quarter and (h) waning crescent. I have placed myself in the position of the earth to show you how the moon looks to observers on Earth from this perspective. *Notice how the moon appears to change phase when viewed from Earth, despite always remaining half-illuminated when viewed from above* (Not to scale).

appears completely full—in other words, we are looking directly at the fully illuminated side of the moon since the earth lies exactly between the moon and the sun. Finally, one week later finds the moon in the position shown in Figure 5.7(g), where, once again, the side of the moon facing the sun is fully illuminated (top view), yet the side facing Earth (side view) again appears half in shadow and half illuminated. This phase is designated the third quarter. Summarizing these observations, therefore, we can conclude that whenever we see the moon, day or night, the degree of illumination/shadow that we observe on its surface, or its *phase*, simply depends on our perspective of the moon in its position relative to the sun on that particular day or night. *The phases of the moon simply result from the combination of its natural shadowing coupled with our changing perspective of it each day or night as it orbits the earth.*

Like Galileo, you can easily observe by yourself how moon phases occur on the next sunny day— just go outside, make a fist, hold it up in the air and see how the side of your fist facing away from the sun is naturally shadowed. If you slowly turn in a circle during a "month," you can see how the "phase" of the shadowed part of your fist changes. When Galileo observed a similar shadow on Venus in 1610, and how it changed over time as Venus orbited the sun, he correctly deduced that Venus was not in orbit around the earth and the heliocentric model of the solar system was born!

Let's now formally define the different phases of the moon. A moon with more than 50 percent visible surface illumination is called a *gibbous* moon; with less than 50 percent visible illumination, it's a *crescent* moon. With precisely 50 percent visible illumination, it's a *quarter* moon. With 0 percent illumination, it's a new moon; at 100 percent illumination, we have a full moon. Furthermore, when the amount of visible surface illumination is increasing from night to night, we say the phase of the moon is waxing; when the amount of visible illumination is decreasing from night to night, we say the phase of the moon waning. Consequently, beginning with a new moon, then, we have the following phases: i) new, Figure 5.7(a); ii) waxing crescent, Figure 5.7(b); iii) first quarter, Figure 5.7(c); iv) waxing gibbous, Figure 5.7(d); v) full, Figure 5.7(e); vi) waning gibbous, Figure 5.7(f); vii) third quarter, Figure 5.7(g), and viii) waning crescent, Figure 5.7(h).

Now that you know why the phases of the moon occur, and their names, it's time for you to learn when each phase is visible above the horizon. Recall that our view of the moon undergoes a full cycle of phases every 29 days or so, leading to the sequence of daily changes over the course of a month illustrated by the calendar for July 2019, in Figure 5.8(a). Calendars like these are available online and via apps,[4] and easily enable you to determine the phase of the moon for any date, past, present, or future. In fact, consulting such moon phase calendar tools will soon become one of your very first steps in planning your astrophotography outings. Next, you may recall from Chapter 3 that our outward view into the night is constantly changing as the Earth spins around its axis, so you may appreciate that *we only see the moon during the 12 hours when it's above the horizon in its current position*! For example, while the waxing crescent moon, Figure 5.7(b) rises above the horizon in early morning and sets in the late afternoon or early evening; three weeks later, the moon will have orbited three-quarters of the way around the earth to position (h) in Figure 5.8 and entered the waning crescent phase. Now it rises well after midnight but sets in the afternoon! The schedule for the moon's visibility, including the approximate rise/set times for each phase, are summarized in Figure 5.8(b); quite often people are surprised to learn that each month, there are days when the moon rises in the morning and sets at night, along with the sun!

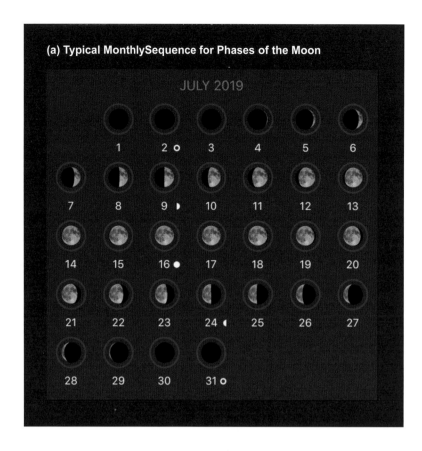

(a) Typical Monthly Sequence for Phases of the Moon

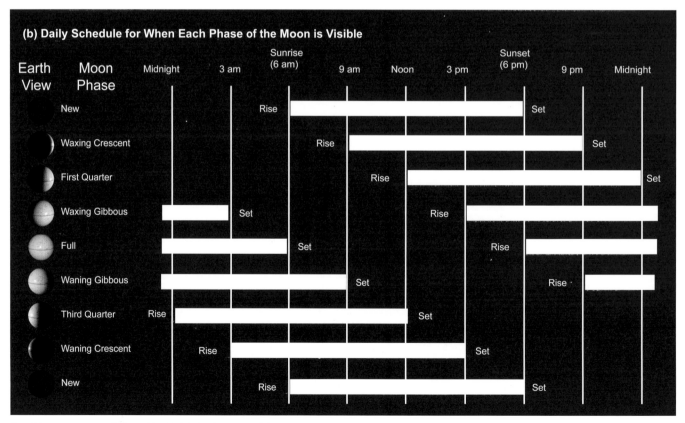

(b) Daily Schedule for When Each Phase of the Moon is Visible

5.8 (a) Here we see a typical monthly schedule for the phases of the moon, in this case for the month of July 2019, which begins with the new moon on July 2, 2019. (b) The approximate times when the moon is above the horizon for each phase is shown here, along with typical rise and set times.

Source: (a) PhotoPills

By the way, if all this doesn't quite yet make perfect sense, don't worry! It usually takes a while and some practice in the field before the full arrangement of the system begins to click. In fact, to facilitate your learning, why not try explaining the causes of the phases of the moon to a friend—I promise you will both learn tremendously during the process of doing so.

To summarize, see if you agree with the following true statements:

i. Half of the moon is *always* illuminated.
ii. There is no permanently dark side of the moon.
iii. The shadowed part of the moon is not the earth's shadow.
iv. The shadowed part of the moon is its own shadow.
v. The phase of the moon seen from Earth only depends on, and is caused by, the moon's orbital position within its 29 ½ day cycle.
vi. The moon rotates about its axis precisely once per orbital revolution around the earth.
vii. Once a month (new moon), the side of the moon facing away from Earth is in full sunshine.

HOW MOON ASTRONOMY IMPACTS THE TIMING OF LANDSCAPE ASTROPHOTOGRAPHY

Now you're ready to apply your new knowledge of the astronomy of the moon in planning your astrophotography adventures. To do so, let's consider five classic nightscape opportunities: (i) a nightscape with starry skies over a well-illuminated foreground, Figure 5.9(a); (ii) a moon halo or corona, Figure 5.9(b); (iii) a nightscape with a crescent moon, Figure 5.9(c); (iv) a dark sky Milky Way nightscape, Figure 5.9(d); and (v) a nightscape with a full moon rising or setting precisely over a specific landmark, Figure 5.9(e). The phase of the moon is absolutely critical in each of these images; attempting them during the wrong phase of the moon would only result in frustration and disappointment.

Starting with a dark sky Milky Way nightscape, Figure 5.9(d), you can now appreciate that we need the moon to be totally absent from the night sky, or well below the horizon, Figure 5.7(a), (b) and (h). Turning to your new understanding of the astronomy of the moon, you see that you must schedule your dark sky astrophotography excursion within 3–4 days of the new moon, as indicated in Figure 5.9(f). Similarly, for a nightscape image with a crescent moon as part of the image, Figure 5.9(c), you can now see that you will need to plan your outing to occur on the same dates, with the exception of the date of the new moon, when the moon will not be visible at all. Furthermore, by examining the position of the *waxing* crescent moon, Figure 5.7(b) in the days immediately *following* the new moon, you can see that it will only be visible setting near the horizon during *late afternoon and early evening*, Figure 5.8(b); the *waning* crescent moon, Figure 5.7(h) will only be visible rising near the horizon in the days immediately *preceding* the new moon during *early morning before sunrise*, Figure 5.8(b).

For a nightscape image showing a fully illuminated foreground and a sky richly populated with stars, as well as a moon halo, adequate lighting from a full, or nearly full, moon is required. Thus we need to select dates that are plus/minus 3–4 days of the full moon, Figure 5.9(f). Again, to select the *time of day* when the moon will appear as we desire, by examining the position of the *waxing* gibbous moon, Figure 5.7(d) in the days immediately preceding the full moon, you can see that it will be visible during *the entire evening and early night*, Figure 5.8(b), whereas the *waning*

5.9 Several classic nightscape opportunities and their corresponding phase of the moon: (a) a nightscape with starry skies over a well-illuminated foreground—best within 3–4 days of the full moon; (b) a moon halo or corona, best within a week of the full moon; (c) a nightscape with a crescent moon—also best within 3–4 days of the new moon, except for the day *of* the new moon; (d) a dark sky Milky Way nightscape—best within 3–4 days of the new moon; (e) a nightscape with a full moon rising or setting precisely over a specific landmark, which must be done on the day before, the day of, or the day after the full moon; (f) These nightscapes can be synchronized with the regular monthly cycle of moon phases, as shown here for the example of July 2020.

Source: (a) Oshin D. Zakarian/DreamView.net/The World At Night; (c) Babak Tafreshi/www.dreamview.net/www.twanight.org/The World At Night

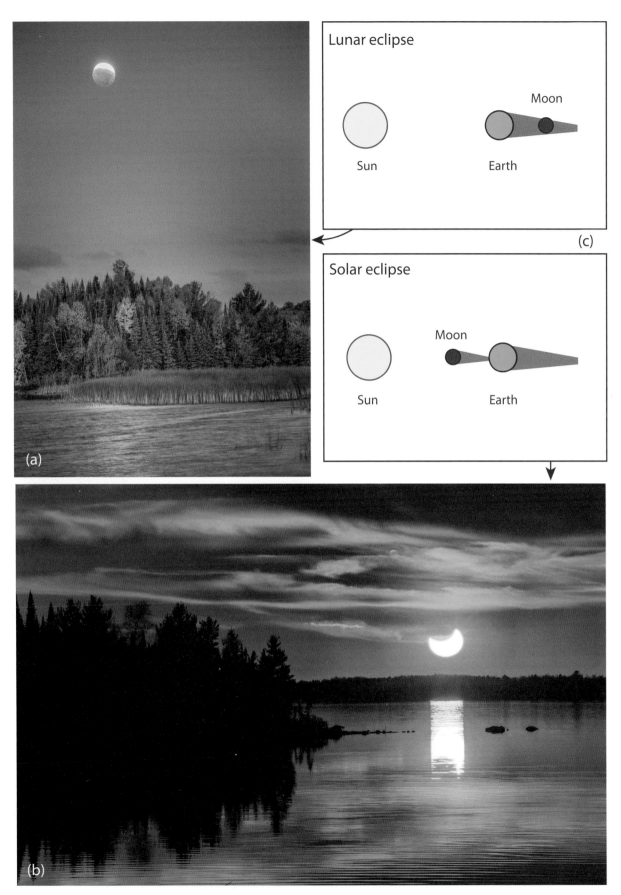

5.10 (a) The deep red shadow of the earth falls on the full Blood Moon during this partial lunar eclipse over colorful birch fall foliage in the lake country of northern Minnesota. (b) The moon partly covers the sun during this partial solar eclipse. (c) This schematic shows the relative orientation of the sun, Earth, and moon during a lunar and solar eclipse. The earth is between the sun and the moon during a lunar eclipse, whereas the moon is between the sun and the earth during a solar eclipse.

gibbous moon, Figure 5.7(f) will only be visible at night in the days immediately following the full moon, and doesn't rise until sometime well after sunset, Figure 5.8(b).

Finally, I'm sure that you can now appreciate that on the one day of the month during which the moon is full, the full moon must rise precisely at sunset and set precisely at sunrise, Figure 5.9(e) and Figure 5.7(e). This is the direct result of its orbital location—the moon is on the side of the earth directly opposite the sun. Similarly, on the dates of the new moon, or the time when the moon passes between the sun and the earth, Figure 5.7(a), the moon sets in the west and rises in the east, respectively, along with the sun and for all practical purposes is invisible. Thus, you can now understand that *lunar eclipses*, Figure 5.10(a), which occur when the earth moves between the sun and the moon and casts its shadow directly on the moon, must occur during the full moon. Similarly, *partial and total solar eclipses*, Figure 5.10(b), during which time the moon moves between the sun and the Earth, occur only on the day of the new moon!

MOONRISE AND MOONSET

A special consequence of the timing of moonrise and moonset relates to the outstanding opportunity to capture the nearly full moon rising the day before or setting on the day of the full moon. At these moments, the moon can appear magically suspended in the earth's shadow, Figure 5.11 or floating between the earth's shadow and the Belt of Venus. Especially for the case of a Supermoon, or Harvest Moon, described next, these photo opportunities can be real prize-winners! A special note of hard-learned practicality however—the actual timing of the moment of moonrise relative to that of sunset/sunrise on these days can differ by 20–30 minutes from month to month, which can significantly impact the moon's position relative to the earth's shadow.

In fact, the specific moonrise/set when the moon rises in a position exactly straddling the boundary between the earth's shadow and the Belt of Venus may only occur once per year! So carefully consult your planning tools to pinpoint that one day when your shot may present itself. Oh, and keep your fingers crossed for good weather!

SUPERMOON, BLOOD MOON, AND HARVEST MOON

You have probably heard of the "Supermoon," or "Blood Moon," and asked yourself what's the big deal? The answers are more societal than scientific. Along with other astronomical phenomena, the full moon has always played a prominent role in human culture, and notable annual events like these have given us a reassuring sense of the regular cycles of nature. As shown in Table 5.1, there are a number of special designations of full moons. Each has its origin in a combination of astronomy and popular culture.

As one example, let's consider the "Supermoon" designation, which in addition to appearing slightly larger than normal, has been credited with triggering natural disasters! Supermoons are full moon that occurs during the part of the moon's orbit when the moon is in the closest physical proximity to Earth, or at its *perigee*. What's that? As shown in the top view schematic of Figure 5.12, the orbit of the moon around the Earth isn't perfectly circular, but is actually an oval, or an *ellipse*. As a natural consequence, there is one point when the moon is closest to (*perigee*) and one point when it is farthest away from (*apogee*) the earth, Figure 5.12(a). The difference in moon-Earth distance between these two points is about 50,000 km, which although not inconsiderable, only leads to a difference in apparent diameter of about 14 percent as well as a difference in apparent brightness of about 30 percent, Figure 5.12(b). This brightness difference isn't especially significant, as you will see in Chapter 12. Nevertheless, each full moon can provide you with an opportunity to link the beauty of astrophotography with increasingly publicized popular culture.

NAME	WHEN OCCURS
Harvest Moon	September
Supermoon	Variable
Blood Moon	October
Hunter's Moon	October
Wolf Moon	January
Worm Moon	March

Table 5.1 Common Full Moon Designations and Their Month of Occurrence

facing page

5.11 The Harvest Moon rises silently within the earth's shadow over the hills of Southern California.

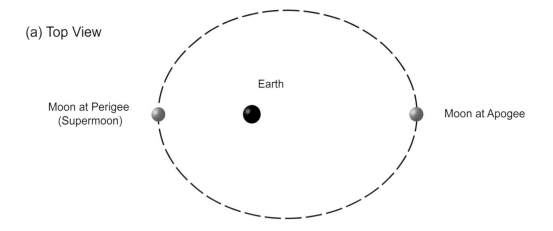

(a) Top View

Earth

Moon at Perigee
(Supermoon)

Moon at Apogee

(b) SideView
(What we see from Earth)

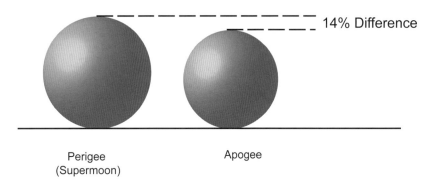

14% Difference

Perigee
(Supermoon)

Apogee

5.12 (a) Schematic illustration (top view) showing the elliptical nature of the moon's orbit around the earth (Not to scale). A natural consequence is that there are two points, apogee and perigee, when the moon is furthest away, and closest, respectively, to the earth (It is easy to remember—apogee = away). (b) The "Supermoon" occurs when the full moon coincides with perigee, but only results in an apparent diameter difference of 14 percent and a brightness increase of only 30 percent, or only approximately one-third EV.

INTERACTIONS OF MOONLIGHT WITH WATER

We have been considering moonlight that reaches us through a transparent atmosphere. What happens if the moonlight hits water droplets or ice crystals along the way? The answers are moonbows and ice halos, respectively! Although relatively uncommon, both provide splendid opportunities to showcase beautiful and unusual sides of landscape astrophotography, Figure 5.13(a) and (b). As will be described in more detail in Chapter 10, moonlight undergoes wavelength-dependent refraction as it passes through suspended water droplets to produce beautiful, ghostly images whose colors are marvelously captured by the sensitive sensors in our cameras.

The ways in which moonlight reflects from standing bodies of water—oceans, lakes, and streams—provides yet another set of opportunities. The height of the moon above the horizon, or its *altitude*, coupled with the choice of lens and object distance can greatly affect the resultant images, Figure 5.14 (a) and (b). Careful planning for the phase of the moon along with knowledge of its location in the sky enables you to target your nightscape image with pinpoint precision.

(a)

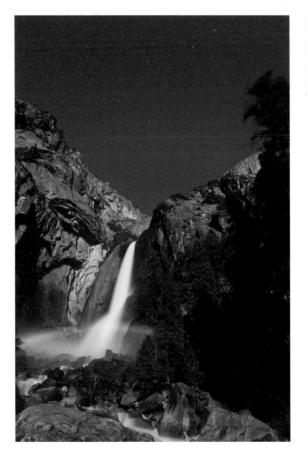

(b)

5.13 Moonlight refracting through water droplets produces beautiful "moonbows": from (a) falling rain in Northern Ireland and (b) spray from Yosemite Falls, California.

Source: (a) Martin McKenna/ www.nightskyhunter.com/The World At Night; (b) Vaibhav Tripathi/The World At Night

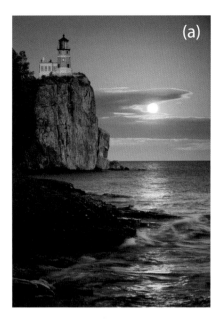
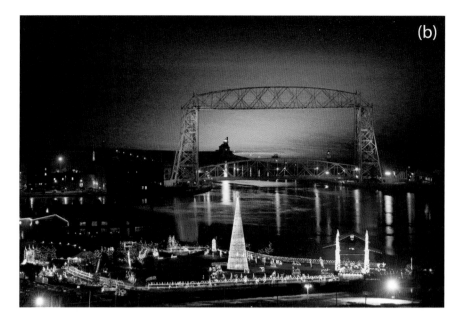

5.14 Light from the full moon reflects off Lake Superior to provide (a) a dramatic highlight to Split Rock Lighthouse along Minnesota's North Shore; and (b) a serene backlight to the Aerial Lift Bridge of Duluth, Minnesota in wintertime. In (a), a wide-angle lens was used compared to the telephoto lens used in (b). These lens choices result in a very different appearance of the reflected moonlight within the composition.

THE MOON ILLUSION

Finally, no discussion of moon astrophotography would be complete without explaining the phenomenon known as the "Moon Illusion." The moon illusion refers to the purely psychological perception that the moon appears larger when it is nearer the horizon than when it has ascended high into the sky, Figure 5.15. When we see the moon next to objects on Earth that decrease in size as they increase in distance from us, we interpret the moon as being enormous! This happens simply owing to the decreasing size of terrestrial objects through parallax. Once the moon has risen into the sky with no reference points, its size appears to shrink.

5.15 The moon illusion is the purely psychological perception of an increase in the moon's size when it nears the horizon. All three circles in this diagram have the same diameter, yet the one at the horizon appears larger simply owing to our minds tricking us. This same phenomenon happens when the moon is just peeking over the horizon; there is an *illusion* that it is unusually large!

You can use an index card with calibrated markings to "measure" the moon's diameter the next time it is full in order to test this phenomenon for yourself, Figure 5.16. Be sure to hold the card at arm's length in order to get a consistent measurement. Now, during this or the next full moon, measure the size of the full moon when it is both next to the horizon and when it is overhead. When you compare measurements, you will see they are the same!

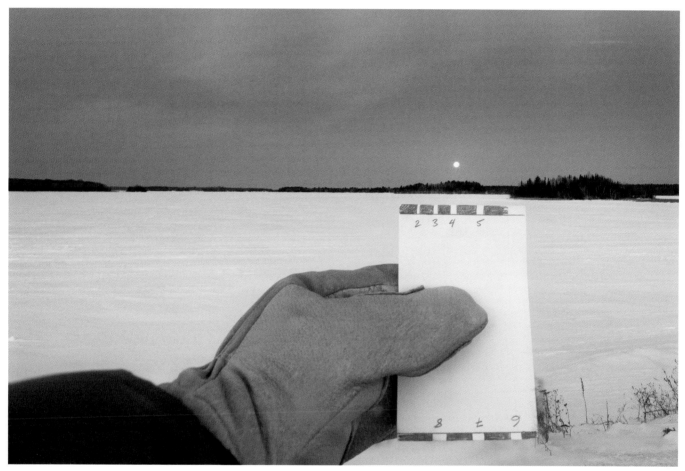

5.16 Use an index card with different white gaps marked to "measure" the moon's diameter the next time it is full. You can use this card with its calibrated measurement of the perceived size of the moon to select objects or the correct size that might be good subjects to juxtapose with the full moon, as in Figure 1.1(c).

An interesting outcome of this exercise is the ability to develop a handy field guide to estimating the size of the moon relative to possible foreground candidates that might be good subjects to juxtapose with the full moon, as in Figure 1.1(c). If you repeat the exercise above but simply with, say, the fingernail of one of your outstretched hands at arm's length, you will be able to develop an estimate of the size in of the full moon in comparison to the width of the fingernail. For example, experience has shown me that the full moon is approximately half the width of the fingernail on the little finger of either hand when held outstretched at arm's length. This knowledge has proved invaluable during day scouting trips in preparation for a rising full moon nightscape image. I simply hold up my hand at arm's length, and compare the size of half the width of my fingernail to the size of the foreground object. If they are roughly the same, then I know that the rising full moon will appear to be of equivalent size.

One last point that should be made concerns the ability to photograph the details of the craters on the surface of the moon. These craters and mountain ranges are generally not possible to resolve even with common 100–300 mm lenses. Much higher focal length lenses, and even a telescope may be necessary. Also, exposure bracketing is often required to simultaneously record images with sufficient surface detail of the full, or nearly full moon but that are badly underexposed for the foreground, and images correctly exposed for the foreground, or stars, but that show the moon as an overexposed, featureless disc.

Bibliography

Bair, Royce, *Milky Way Nightscapes*, 2015, RoyceBair.com (ebook)

Dickinson, Terence & Alan Dyer, *The Backyard Astronomer's Guide*, 2010, Third Edition, Firefly Books, Limited, Buffalo, New York

Dyer, Alan, *How to Photograph Nightscapes and Timelapses*, 2014, Amazing Sky (ebook)

Greenler, Robert, *Rainbows, Halos and Glories*, 1980, Cambridge University Press, Cambridge, England

Kingham, David, *Nightscapes*, 2014, Craft & Vision, Vancouver, Canada

Schneider, Stephen E. & Thomas T. Arny, *Pathways to Astronomy*, 2015, Fourth Edition, McGraw Hill Education, New York

Wu, Jennifer & James Martin, *Photography: Night Sky*, 2014, Mountaineers Books, Seattle, Washington

Notes

1 Yes, I know I'm ignoring the tilt of the earth's rotational axis in this description, but let's tackle one thing at a time!

2 The *sidereal* month (~27.3 days) defines the time required for the moon to complete an orbit *including* the intervening movement of the earth itself around the sun, but that's another story that doesn't really affect us.

3 Since it takes approximately 29 days for the moon to complete its orbit around the earth, the moon travels $360°/29 \approx 12°$ per day. Thus the moon appears in the night sky 12° apart between successive nights. In turn, since it takes 24 hours for the earth to complete one rotation about its axis, the earth rotates at an angular rate of 15° per hour. In other words, it takes the earth about an extra hour each day/night to "catch up" to where the moon was the night day/night before.

4 www.photopills.com

6

SOLAR SYSTEM

It seems incredible that only just over four hundred years ago, all humankind believed in the *geocentric* model, which places the earth at the center of the entire universe. It was only in 1609 that Galileo conclusively recorded the movement of Jupiter's moons around Jupiter, not Earth, proving that the geocentric model was wrong. Of course, we now know that the sun is the center of our solar system, in what astronomers call the *heliocentric* model, Figure 6.1. In this chapter, we will briefly review the characteristics of our solar system to aid in our nightscape quests, including the differences between its eight planets. You will also learn about several new and striking astronomical phenomena associated with the solar system: planetary conjunctions, the zodiacal light, and solar and lunar analemmas.

a) Schematic side view of solar system (*not to scale*); Neptune amd Uranus not shown

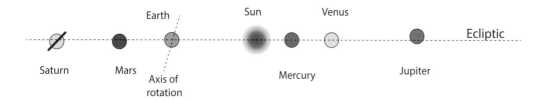

b) Approximate scale drawings of the sizes of the solar system planets and the sun

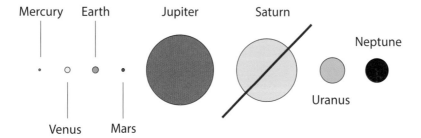

6.1 Schematic illustration of the solar system and its planets:
(a) The orbital planes of the solar system's eight planets all generally coincide, resulting in a "flat" solar system, as shown in this side view. This characteristic is the result of how is the solar system formed from the collapse of an enormous, rotating cloud of interstellar dust. (b) Scale drawing of the relative sizes of the sun and the solar system's eight planets, from left to right: Mercury, Venus, Earth, Mars, Jupiter, Saturn, Neptune, and Uranus. The distances between the planets, and between the planets and the sun are NOT to scale.

ORIGINS AND CHARACTERISTICS OF THE SOLAR SYSTEM

The solar system comprises the sun, the planets, their moons, and all of the asteroids and comets that are held in place by the sun's gravity, Figure 6.1(a, b). It formed from an enormous interstellar cloud of gas and dust left over from the Big Bang. Around 4.5 billion years ago, the dust cloud collapsed into a flattish disc and separated into the sun and individual planets, with the sun at its center. Its age has been determined through measurements of the radioactive decay of elements within the earth, along with separate measurements for the age of the sun. Before and during its collapse, the dust cloud was slowly rotating in space, so that when each of the solar system components formed, they were also all moving in the same direction around the dust cloud's center. This process explains why the solar system is "flat," with all of the planetary orbits lying essentially in the same plane, Figure 6.1(a). This also explains why the planets all orbit in the same direction, and why they generally all rotate about their axes in the same direction.[1] In turn, the flatness of the orbital planes of the planets explains why they form a nearly straight line across the sky whenever several are visible at the same time, e.g. Figure 15.19.

TERRESTRIAL PLANETS VS. GAS GIANTS

The systematic difference in size between the solar system's eight planets is a striking characteristic, Figure 6.1(b). The four, innermost *terrestrial planets* are all relatively small and rocky. They have a relatively thin, gaseous atmosphere or none at all, as in the case of Mercury. In contrast, the four outermost *gas giants* are all four to ten times larger, and contain a thick gaseous atmosphere in both liquid, solid, and vapor form, above what is believed to be a rocky core. The large size of the gas giants, particularly Jupiter and Saturn, allows us to see their reflected sunlight at night without the aid of telescopes or binoculars. We are able to see the reflected sunlight from Mars, Venus, and Mercury since they are relatively close to us, despite their smaller sizes.

The differences in physical structure between the terrestrial planets and the gas giants can actually be explained quite easily based solely on their proximity to the sun. The terrestrial planets *simply receive much higher intensity heat from the sun* then the gas giants. For the case of Mercury, the heat from the sun is so intense it has completely vaporized its atmosphere, just like a kettle that has boiled dry! For Venus, Earth, and Mars, the intensity of heat from the sun is low enough that the planetary atmospheres remain in place, fortunately, in both liquid and vapor form. For Jupiter, Saturn, Uranus, and Neptune, however, their distance from the sun causes the sun's heat intensity to be so low that their enormous, gaseous atmospheres have remained more or less intact, and largely frozen, above their suspected rocky cores.

MOTION OF THE PLANETS

The planets appear to move relative to the stars as well as to each other, partly as the result of their proximity to Earth and partly due to their movements around the sun. These relative movements gave rise to their name, "planets," which is rooted in ancient Greek for "wandering star." Furthermore, while all the planets in the solar system orbit the sun in the same direction, they all have very different orbital periods, or times required to complete a full trip around the sun. The gas giants take much, much longer than the terrestrial planets. For example, Saturn takes almost thirty Earth years to complete a single orbit, whereas Mercury completes over four orbits just within a single Earth year!

6.2 Simulated positions of Venus, Mars, and Jupiter on
(a) October 21, 2015, and (b) October 28, 2015; 7 days apart.
First, notice how all three planets have moved relative to the
(stationary) stars. Second, note how Mars and Venus have
moved much more than Jupiter. This is the result of their relative
proximity to Earth and their greater orbital velocities than Jupiter's.

Source: Distant Suns

The differences in the orbital periods of the planets coupled with their different orbital velocities combine to produce significant differences in their movements as viewed from Earth. Whereas Saturn and Jupiter's night-to-night movement is barely perceptible, the positions of Mercury, Venus, and Mars all change visibly between successive nights. These night-to-night differences may be seen in Figure 6.2, where the simulated positions of Venus, Mars, and Jupiter are shown only 7 days apart on (a) October 21, 2015, and (b) October 28, 2015. Notice how all three planets have moved relative to the stars, but that the change in Jupiter's position is far less than that of either Mars or Venus.

Finally, *planetary conjunctions* occur when two or more planets move into position relatively close to one another, as viewed from Earth, for example, Figures 6.2 and 6.3. Such conjunctions provide a wonderful opportunity to gain often difficult to grasp insights into the geometry of the solar system, as well as being aesthetically pleasing. When three or more planets are simultaneously visible, they form a nearly straight line, for example, as seen in Figure 15.19. When this occurs, it is a magnificent demonstration of the flat geometry of our solar system.

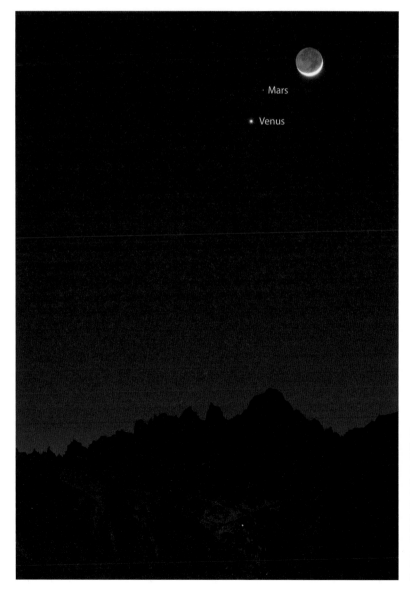

6.3 When two or more planets are very close together, they form a *planetary conjunction*, as seen here also with the waxing crescent moon over Mt. Whitney, California. Earthshine is also visible from the shadowed side of the moon. Note that while Venus lies between the earth and the sun, Mars is on the opposite side of the sun from the earth.

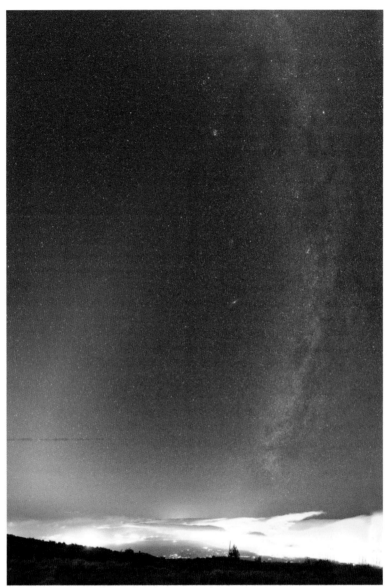

6.4 The zodiacal light (left) and the Milky Way (right) both rise upwards from the horizon approximately an hour after the end of astronomical twilight over Maui, Hawai'i.

ZODIACAL LIGHT

The zodiacal light is a relatively rare phenomenon that is beautiful to behold, Figure 6.4. It is only visible under completely dark skies for an hour or so around when astronomical twilight begins or ends. The zodiacal light is a cone of diffuse, white light emanating upwards from the horizon above where the sun has set or will rise. The zodiacal light, also known as the "false dawn," originates from sunlight reflected from vast fields of dust that lie along the midplane of the solar system, or the ecliptic. These dust fields are thought to be the remnants of comets that originate from far beyond the outskirts of the solar system, rather than leftover remnants of asteroids within the solar system.

The zodiacal light is best seen during the spring equinox during early astronomical twilight in the evening, and during the autumnal equinox during late astronomical twilight in the morning. The zodiacal light is more prominent nearer the equator owing to the nearly perpendicular orientation of the ecliptic at tropical and lower latitudes. It is best photographed with a wide-angle or fisheye lens under extremely dark skies, far from city lights.

SOLAR AND LUNAR ANALEMMAS

A wonderful, but challenging, landscape astrophotography image is that of a *solar analemma*, Figure 6.5. Combining photographs of the sun taken at the same time on regularly spaced, clear days throughout an entire year allows you to create a solar analemma. They are the result of two completely independent features of the earth's motion around the sun: (i) its 23 ½° tilt about its rotational axis; and (ii) the ellipticity of its orbit, Figure 6.5(c). The earth's tilt results in the figure-eight shape of the analemma, while the ellipticity of its orbit causes the asymmetry in the figure eight.

The similar tilt of the moon and ellipticity of its orbit allows the creation of a *lunar analemma* as well, Figure 6.5(b). The main difference between a solar and lunar analemma is that the lunar analemma must be created, on average, 51 minutes later each day during one *lunation*, or lunar month, to result in the moon arriving at equivalent positions, whereas a solar analemma must be created at precisely the same time of day. This is the result of the fact that the moon rises approximately 51 minutes later on successive days.

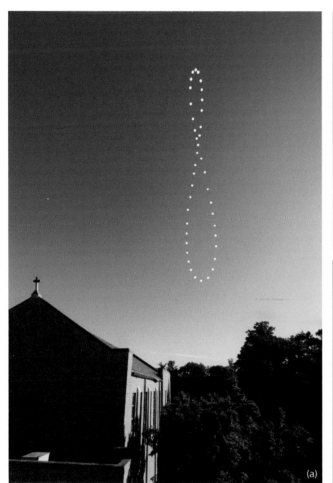

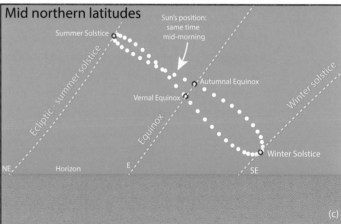

6.5 (a) A solar analemma created over Trinity School in Indiana. The image was created by combining photographs of the sun, taken at the same time (within 5 seconds) on regularly spaced, clear days throughout an entire year, with a separately exposed photograph of the foreground taken near sunset. (b) A lunar analemma created during one lunation, or lunar month. (c) Schematic of solar analemma illustrating how the tilt of the earth's axis of rotation results in the figure eight shape of the analemma while the ellipticity of its orbit causes the asymmetry in the analemma.

Source: (a) Craig Lent/www3.nd.edu/~lent/Astro /The World At Night; (b) György Soponyai/The World At Night

Bibliography

Dickinson, Terence & Alan Dyer, *The Backyard Astronomer's Guide*, 2010, Third Edition, Firefly Books, Limited, Buffalo, New York

Schneider, Stephen E. & Thomas T. Arny, *Pathways to Astronomy*, 2015, Fourth Edition, McGraw Hill Education, New York

Note

1 Venus is one notable exception in that its direction of rotation is opposite most of the other planets. This is most likely the result of an impact with another body that knocked it "upside-down," millions or even billions of years in the past.

METEORS, METEOR SHOWERS, COMETS, FIREBALLS, AND BOLIDES

Meteor showers occur each year on regular dates, and are premier landscape astrophotography opportunities, Figure 7.1(a). This chapter explains the astronomy and characteristics of meteors and meteor showers, comets, asteroids, and the rare but spectacular phenomenon of bolides.

ORIGINS OF METEORS

"To wish upon a shooting star…" evokes romance, nostalgia and hope, all wrapped up into one. If you have ever been fortunate enough to witness a "shooting star," you will likely recall your unexpected thrill at witnessing its fiery trail, brilliantly burning in and out of existence. So exactly what is a "shooting star," and how can we increase our chances of seeing and photographing one of them?

7.1 (a) A lone Perseid meteor streaks across the sky over Badlands National Park, South Dakota, during the 2015 Perseid meteor shower. Care must be taken to distinguish meteors from (b) Iridium flare satellites and (c) the International Space Station. Other objects commonly mistaken for meteors are: satellites and airplanes, as can be seen in Figure 20.6.

To be clear, "shooting stars" aren't stars at all. They're small, interplanetary masses of rock and/ or ice drawn into the earth's atmosphere through mutual gravitational attraction. They are generally much less than a kilogram in mass; most are far smaller. As they pass through the atmosphere, the particles collide with atmospheric gas molecules. These repeated collisions generate heat, just like the heat produced by vigorously rubbing the palms of your hands together. The extremely high speed of the masses results in enough collisions for the temperature of the masses to rise to the point of incandescence. Once this occurs, they become visible to observers on the ground, and become *meteors*.

The intense heat generated through friction generally causes the meteors to vaporize completely in mid-air, at which point they vanish. If, however, any remnant of the mass survives its descent and reaches the ground, it is designated a *meteorite*. If the meteor approximately matches Venus in brightness, it is termed a *fireball*. Fireballs often leave smoke trails visible from the ground owing to their relatively large size; some smoke trails can remain visible for many minutes. The smoke trails can even be briefly illuminated internally by the fireball's heat! Finally, if the mass of the meteor is high enough, it may ultimately explode, at which point it is known as a *bolide*.

COMETS AND METEOR SHOWERS

Most meteors are caused by the collision of the earth with single, lone dust particles randomly drifting through the solar system. Meteor showers, on the other hand, are clusters of meteors that occur on a single night, or over the course of just a few days. What causes them? You may be surprised to learn the meteor showers result from the collisions of the earth with the multiple pieces of rubble left behind in space by comets!

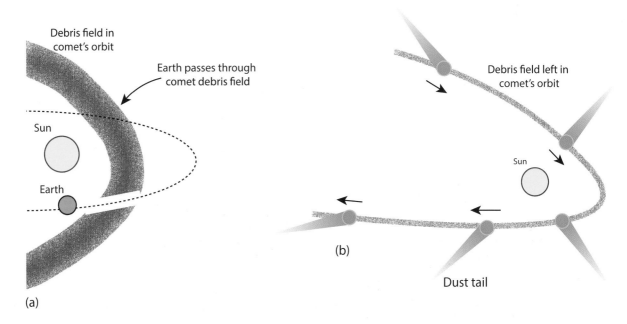

7.2 Illustrations of the relationship between comets and meteor showers. (a) Comets deposit dust and debris fields left behind in their path. When the earth intersects these debris fields, the dust particles become meteors.; their unusually large numbers result in meteor showers. Since the earth encounters the same debris field on the same date each year, meteor showers are very predictable. (b) Illustration of how a comet's 'tail' always points away from the sun, regardless of its orbital position. The result that the tail can sometimes point in the direction of motion has led to the phrase, "like a comet chasing its tail."

Comets are masses of frozen gas and ice that orbit the sun on well-established trajectories. They originate from regions of the Milky Way beyond the edges of the solar system. Comets are much larger, up to a mile or so in diameter, than the smaller pieces of matter that produce most meteors. They continuously eject gas along with small particles of matter as they pass through space, Figure 7.2(a). These mass discharges do not propel the comet along its path; rather, the comet's inertia is solely responsible for its movement through space. They are known, however, to cause the comet to tumble and spin as it moves along its path.

As a comet comes into proximity with the sun, the sun's heat causes the particles to "boil" from the comet substantially, akin to steam rising from boiling water. The particle ejection density thus increases as comets near the sun. The especially concentrated stream of particles immediately adjacent to the comet's body, known as the *comet's tail*, becomes visible from Earth whenever it reflects sunlight. Comets can, therefore, be quite bright, and visible even within dense metropolitan areas, as seen for the Hale-Bopp comet emerging over the New York City skyline in Figure 7.3.

The solar wind pushes the discharged particles in a direction directly away from the sun, regardless of the orientation of the comet's movement, Figure 7.2(b). The directions of the comet's movement

7.3 "World Comet: Comet Hale Bopp visible above the United Nations Headquarters and the New York City Skyline. The variable star Algol is the bright star visible above Comet Hale-Bopp." Dr. Donald Lubowich (Photographer)

Source: Donald Lubowich/The World At Night

and its tail, therefore, are generally misaligned. In fact, the two can be almost diametrically opposite, leading to the phrase, "like a comet chasing its tail," as shown schematically in Figure 7.2(b).

After being ejected, the discharged particles remain suspended in space and form an enormous, permanent path of dust, or debris, like interplanetary breadcrumbs. This debris field surrounds the sun, along the comet's trajectory, Figure 7.2(a). In a few special cases, the comet's trajectory, and hence debris field, intersects the path of the earth's orbit. When the earth reaches these points annually along its journey around the sun, multiple collisions between the earth and the debris particles occur and result in meteor showers. Most meteor showers only last a few days, since it only takes that long for the earth to pass completely through most debris fields. However, meteor showers always occur around the same dates each year, since those are the dates when the earth reaches the same orbital position and thus encounters the same debris field. Fortunately, there are no foreseeable instances when the earth and an actual comet are both predicted to be at the same position in their respective paths, i.e. to collide!

METEOR SHOWERS—WHEN AND WHERE THEY OCCUR

The dates of each meteor shower are determined by the dates when the earth's orbit crosses the debris field of the responsible comet, Figure 7.2(a). These intersection points lie at slightly different positions for each comet relative to the direction of the earth's motion in its orbit. In each case, however, meteor showers appear to originate from the region of the night sky that corresponds to the primary intersection point between the earth's orbit and the comet's trajectory. This point is named the meteor shower *radiant point*. The constellation that hosts the radiant point is used as a helpful reference for the meteor shower: the radiant point of the Orionid shower is thus found within the constellation Orion; for the Perseid shower in Perseus, and so on. The major meteor showers and their annual dates are summarized in Table 7.1.

METEOR SHOWER	DATE(S)
Quadrantid	January 3–4
Lyrid	April 22
Eta-Aquariid *(Halley's comet debris)*	May 5
Perseid *(Usually richest)*	August 11–13
Orionid *(Halley's comet debris)*	October 21–22
Leonid	November 17–18
Geminid *(Usually richest)*	December 13–14

Table 7.1 Major Meteor Showers

Meteor showers are so-named because of the relatively high concentration of meteors that occur compared to the rest of the nights during the year. Most meteor showers produce between several to dozens or more meteors per hour during a good show. On rare, historical occasions, much higher meteor rates have been noted; up to hundreds and even thousands per hour; wouldn't that be a wonderful sight to see!

BEST TIMES TO OBSERVE METEOR SHOWERS

The best time to observe meteor showers is generally between midnight and dawn. Why? First, you may recall from the previous chapter that the direction of the earth's rotation around its axis is in the same direction as its orbit around the sun, as seen in the top view of the earth shown in Figure 7.4. Therefore, the part of Earth whose local time is past midnight is both experiencing night *and* facing directly into the oncoming dust cloud. In contrast, the region of Earth whose local time is before midnight is facing away from the oncoming dust cloud; similar to looking out the rear window of a moving car. Consequently, observers on the side of the earth experiencing night after midnight have the best chance to observe the greatest number of meteors.

7.4 Illustration of why the best time to view meteor showers is after midnight. The part of Earth whose local time is past midnight is both experiencing night *and* facing directly into the oncoming dust cloud. In contrast, the region of Earth whose local time is night, but before midnight, is facing *away* from the oncoming dust cloud.

The phase of the moon is very important in determining the condition of observing meteors in general, and meteor showers in particular. The best moon phases are those that result in the darkest skies, and thus are typically immediately adjacent to the new moon: the waxing and waning crescent moon. Coupled with your knowledge of when these moon phases occur, and when it is visible during the night, you can conclude that *the optimum dates and times for viewing meteor showers are between midnight and dawn on the later dates of the waning crescent moon up to, including, and shortly after the date of the new moon.*

BEST METEOR SHOWER VIEWING DIRECTION

The radiant is generally *not* the best direction to view meteors during a meteor shower, contrary to popular belief. A better direction is roughly between 30° to 150° away from the radiant, in order to see meteors from the "side" as they streak through the atmosphere. The paths of the meteors generally appear longer from this perspective, and thus more prominent. In fact, while the greatest density of meteors does appear to originate from the direction of the radiant, they can appear anywhere in the sky.

ASTEROIDS

In contrast to the primarily icy composition of comets that originate from beyond the solar system, asteroids are relatively large masses of solid rock and generally lie between Mars and Jupiter. They can be hundreds of miles across—some as large as the state of Arizona! However, they are not large enough to be considered dwarf planets. Asteroids orbit the sun in much more circular orbits than comets, but their orbital planes are typically much different than the generally aligned orbital planes of the planets we saw earlier.

If an asteroid were to collide with the earth, the consequences would be severe. Indeed, the prevailing theory for the cause of the extinction of the dinosaurs originates from a direct impact between an asteroid and the earth around 65 million years ago. Fortunately, no asteroids are known to be anywhere near a direct collision with the earth at this time!

Bibliography

Dickinson, Terence & Alan Dyer, *The Backyard Astronomer's Guide*, 2010, Third Edition, Firefly Books, Limited, Buffalo, New York

Schneider, Stephen E. & Thomas T. Arny, *Pathways to Astronomy*, 2015, Fourth Edition, McGraw Hill Education, New York

THE MILKY WAY

The opalescent core of the Milky Way Galaxy often finds its way into prized landscape astrophotography images, as shown by the examples in Figure 8.1. This chapter will explain how to confidently predict when, where, and how it will appear during any night of the year, or even if it will be visible at all! We will begin by examining the Milky Way's origin, shape, and structure, and then explore how its geometry, coupled with that of the earth and solar system, affects what we see. Next, we will explore the Milky Way's appearance from the Northern and Southern Hemispheres, as well as from space. Finally, we will review a few of its notable stars, constellations, and nebulae.

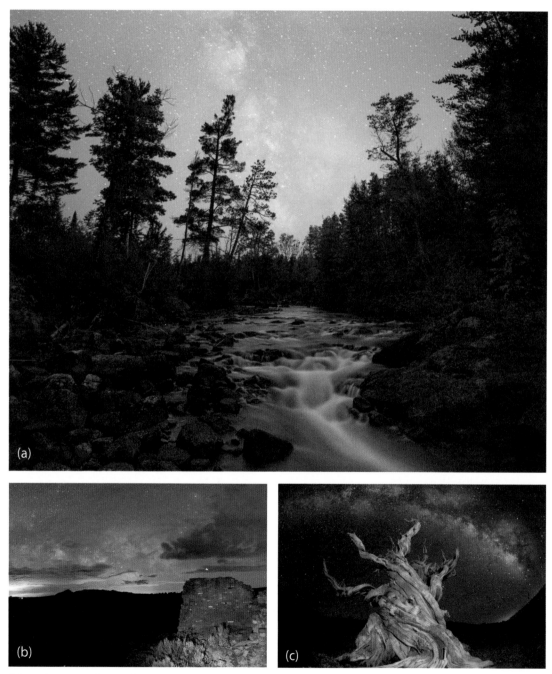

8.1 Landscape astrophotography images including the primary band of the Milky Way. (a) Boundary Waters Canoe Area and Wilderness, Minnesota; (b); Hovenweep National Monument, Utah; and (c), Ancient Bristlecone Pine Forest in California.

THE ORIGIN AND AGE OF THE MILKY WAY

The Milky Way Galaxy is approximately 13.2 billion years old, and formed as the universe cooled following the Big Bang. The Milky Way coalesced from a rotating cloud of dust that collapsed in the same fashion as the solar system, as described in Chapter 6. At its center lies a black hole—an extraordinary object whose gravitational tug is so powerful not even light can escape it, hence the name. The immense gravitational pull from the black hole at the Milky Way's center, or galactic core, provides the anchor for all of its stars, holding them in place as they slowly orbit around it.

A black hole develops during the terminal stage in the life cycle of the highest mass stars; those with masses many times that of our sun. As these larger stars age and eventually deplete their hydrogen fuel supply, a series of violent explosions and physical reactions occur that result in the progressive breakdown of the very structure of their atoms. The final result is the formation of a black hole, which sits at an infinitesimally tiny point in space, yet with much of the mass of the original star!

The Milky Way's black hole was first discovered in the late 1990s by Andrea Ghetz, who observed unexpectedly high orbital speeds of stars near its center. Their speeds were so high that only an object with the mass of the black hole could be responsible, yet the size of the then-unknown object was far too small to conform to any established form of matter. Although we have yet to directly image the region immediately adjacent to the Milky Way's black hole, current research programs are underway to do so with unprecedented resolution.

Other studies have confirmed that most, if not all, galaxies in the observable universe also contain black holes at their centers. Although the precise sequence of events that leads to this arrangement is not yet completely understood, recent studies suggest that the black holes formed first and subsequently led to the presence of the surrounding stars.

THE SIZE AND SHAPE OF THE MILKY WAY

The shape and appearance of the Milky Way is similar to that of an enormous, swirled lollipop—nearly 100,000 light years in diameter,[1] yet only 1,000 light years in thickness, Figure 8.2(a). Its hundreds of billions of stars are distributed within distinct bands, or "arms," along with residual clouds of dust and hydrogen gas. Our sun and solar system lies within the Orion-Cygnus arm and between the Perseus and Sagittarius arms. The solar system sits approximately two-thirds of the way from the galactic core, Figure 2.3, and approximately 90 light years above the Milky Way's midplane.

The density of stars is far greater near the galactic core, Figure 8.2, than at positions further away. Its higher star density is why the galactic core appears to be so bright, and why the regions further away from it appear progressively dimmer. In fact, the uniformly bright appearance of the entire midplane region of the Milky Way to the naked eye is deceiving; just like viewing a sandy beach from a distance and not being able to resolve the individual grains of sand, the galactic core of the Milky Way is so far away that its billions of stars are indistinguishable and simply merge into a uniform glow.

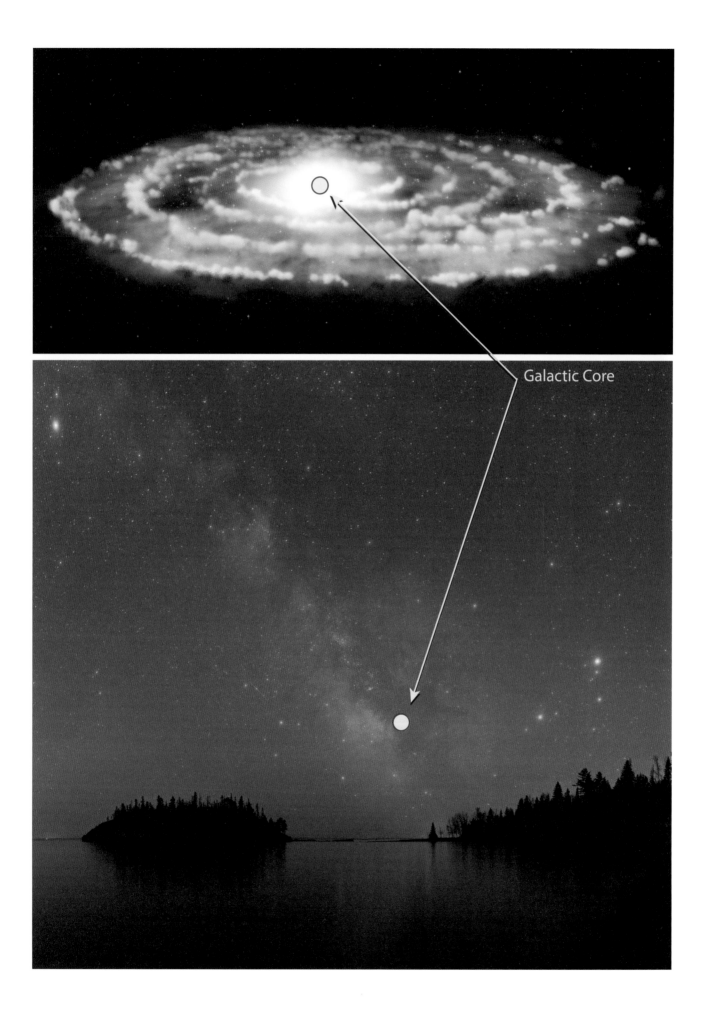

Galactic Core

Its flat, disc-like shape is why the midplane regions of the Milky Way often appear in the form of a bright stripe across the sky, Figures 8.1 and 8.2(b). In fact, its name is also the result of this shape; early Roman viewers likened its appearance to a river of spilled milk across the sky, and gave it the name, "*via lactea*." Yet, as we saw in Chapter 2, the vast majority of all the objects we see at night reside within the Milky Way. Interpreted literally, each photograph of a starry night sky is thus a photograph of a region of the Milky Way Galaxy!

As landscape astrophotographers, we are often interested in the central band of the Milky Way as a photographic subject, and especially the bright, galactic core region. Therefore, to avoid any confusion, when I refer to "the Milky Way Galaxy" in this book, I am generally referring to its central band that, depending on the context, may or may not include the galactic core region. Finally, we will adopt the following viewing perspectives in our subsequent discussions: a "top view" refers to its appearance when viewed from a position above the plane of the Milky Way (of course, no human has ever been able to do so!); a "side view" simply refers to its appearance viewed edge-on.

RELATIVE ORIENTATIONS OF THE EARTH, SOLAR SYSTEM, AND MILKY WAY

Astronomers have determined that the plane of the solar system, including the orbital plane of the earth, is inclined at an angle of approximately 63° to the midplane of the Milky Way, Figure 8.3(a) (overleaf). Coupled with the 23½° tilt of the earth's axis relative to the normal to its orbital plane, the earth's rotational axis is, therefore, aligned within a few degrees of the plane of the Milky Way. This fact explains, then, why the orientation of the Milky Way's central band appears in positions ranging from roughly encircling, or parallel to the earth's horizon, Figure 8.3(b), to arcing directly overhead in a general north to south alignment, Figure 8.3(c), at different times of night; and, as described below, at different times of year.

VIEW OF THE MILKY WAY CORE THROUGH THE YEAR

So why are we only able to see the galactic core of the Milky Way during certain months of the year? The answer is straightforward; our vantage point is constantly changing from month to month, as illustrated schematically in Figure 8.4(a) (overleaf), just as we saw in Chapter 2, for example, Figure 2.10. The months of June, July, and August are by far the best time of the year to view the galactic core since we have a direct view of it at night. In contrast, the night sky view in November, December, and January is facing the opposite direction. During the daytime hours of these months, the sun sits between the earth and the galactic core and blocks our view. It is simply not possible to view the core at this time of year, barring a total solar eclipse. Finally, during the spring and fall, portions of the galactic core may be visible peeking over the horizon for a short time before sunrise and after sunset, respectively. Information for when the galactic core of the Milky Way is visible in the Northern Hemisphere throughout the year is summarized in Figure 8.4(b).

facing page

8.2 The shape and appearance of the Milky Way: (a) the structure of the Milky Way is similar to that of a large, swirled lollipop—nearly one hundred thousand light-years in diameter and one thousand light years in thickness. The center of the Milky Way Galaxy, or "galactic core" is indicated by the yellow dot. (b) Early morning view of the bright, galactic core region of the Milky Way over Ellingson Island in Lake Superior, Minnesota, in the spring. The approximate location of the galactic core is shown.

Source: (a) NASA/CXC/SAO

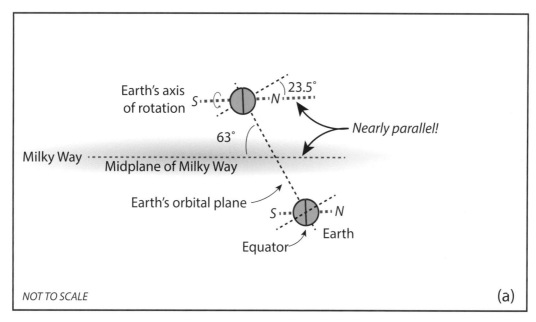

(a)

NOT TO SCALE

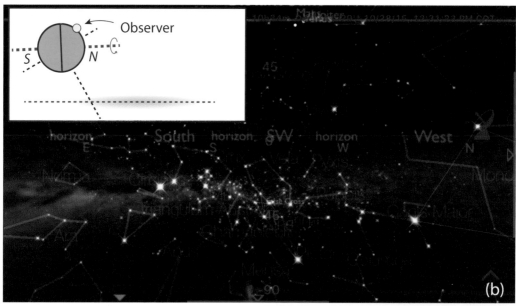

(b)

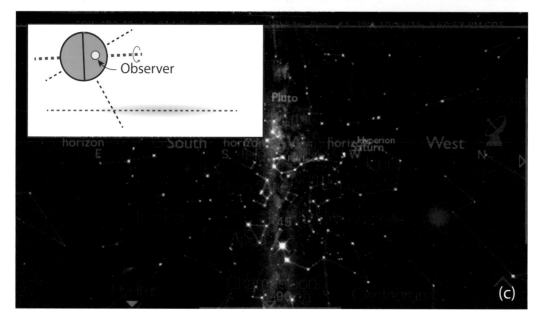

(c)

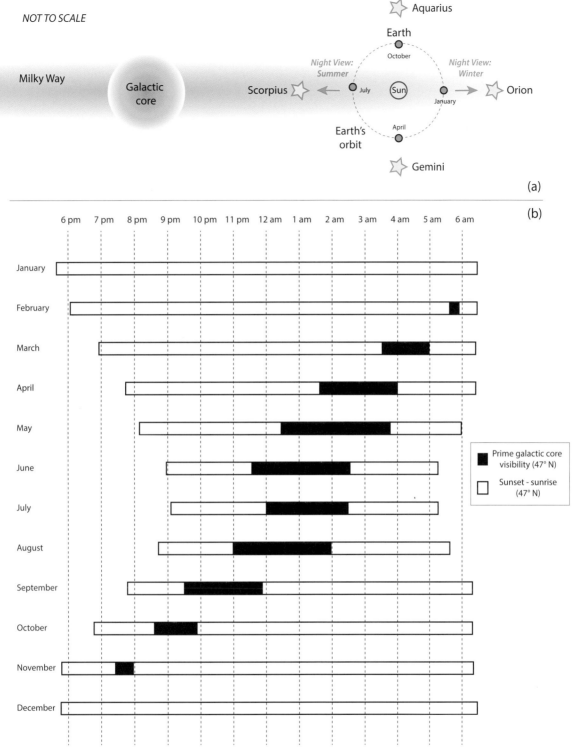

NOT TO SCALE

Milky Way

Galactic core

Scorpius

Night View: Summer

Aquarius

Earth

October

Sun

July

January

April

Earth's orbit

Gemini

Night View: Winter

Orion

(a)

(b)

Prime galactic core visibility (47° N)

Sunset - sunrise (47° N)

facing page

8.3 The relative orientation and inclinations of the earth, the solar system, and the plane of the Milky Way is shown here in (a). The 63° inclination of the earth's orbit relative to the plane of the Milky Way, and the 23.5° tilt of its rotational axis relative to the normal to its orbital plane, combine to result in the earth rotating around an axis that is nearly parallel to the plane of the Milky Way. This phenomenon has the effect of causing the Milky Way's central band to change position from roughly encircling the horizon to arcing vertically overhead in a general north to south alignment at different times of night and at different times of year, for observers at mid to central latitudes. (b, c) Simulated view of the Milky Way, facing southwest, on a date and time when the plane of the Milky Way is (b) parallel to the observer's horizon; and (c) approximately 6 hours later, when the earth has rotated 90°, causing the Milky Way to now appear perpendicular to the observer's horizon. The yellow dots in the inset schematic diagrams indicate the position of the local observer on Earth on this date and for these times. The Milky Way undergoes this change in orientation daily, although we may not be awake or in a position to observe it!

Source: Distant Suns

above

8.4 (a) Schematic illustrating how the changing position of the earth during the year affects our view of the Milky Way's galactic core. The corresponding zodiacal constellations that are visible at night are also shown in relative position to the sun and earth. During the summer, the earth's night sky has a direct view of the galactic core. In winter, however, the earth's night sky view is in the opposite direction, and our view of the core is completely blocked by the sun. Thus, the best months for viewing the galactic core are May through September; in December and January it is never above the horizon at night. (b) This diagram illustrates the times when the galactic core of the Milky Way is above the horizon at mid northern latitudes (here, 47° N). The width of the white bar shows the duration of full darkness; the shaded region within each bar, when present, indicates the times when the Milky Way's core region is best seen. The core is visible during the evening hours in the summer, the early morning hours in the spring, and in the early evening hours in the fall. During the winter, the core is blocked by the sun and not visible at night.

The two sweeping, panoramic images of the primary band of the Milky Way shown in Figure 8.5 clearly demonstrate several dramatic phenomena that are the direct result of the changes that occur in our viewing perspective throughout the year. The two images were made approximately five months apart, both in the Northern Hemisphere. The panorama in Figure 8.5(a) was made during the late summer, while the panorama in Figure 8.5(b) was made in the early winter. First, observe how the *azimuth* of our view of the Milky Way's primary band changes: southeast during the late summer; northeast in the early winter. Next, note how we observe *different portions* of the Milky Way's primary band; the bright galactic core region in the summer, and the fainter, outer fringe during the winter. Finally, and perhaps most revealing, observe how *our viewing perspective has completely flipped*; note the mirror-image relationship between the orientations and positions of the Andromeda Galaxy, the star Mirach, and the two circled dust clouds between the two images. The changes in the position of the earth during the intervening five months have turned our viewing position completely upside down!

So how do we use all this information? While a detailed description of landscape astrophotography planning is covered is Section IV of this book, we can set the stage with reference to Figure 8.6 (overleaf), where the appearance of the galactic core region of the Milky Way in the southern night sky in the Northern Hemisphere is shown for different times during the night, as well as for different months. For example, in the month of June, the appearance of the primary band of the Milky Way first appears angled just above the eastern horizon in the evening, arcs high across the sky as the night progresses and ends up nearly vertical in the western sky as dawn approaches. In contrast, it first appears oriented vertically above the southwestern horizon in the evening in September and then disappears below the western horizon within a few hours. A field example showing this movement during a single night in July is shown in Figure 8.7 (overleaf).

This movement has significant implications in landscape astrophotography images in which the Milky Way is an important feature. For example, you will want to understand it so that you may position yourself correctly relative to prominent foreground objects in order to view the Milky Way in a specific position and orientation. Since its position changes during the night and through the year, it is crucial to know how to account for these variations, as will be seen in Chapter 16.

EFFECT OF LATITUDE ON MILKY WAY APPEARANCE

From terrestrial vantage points, the earth's horizon always blocks part of our view of the Milky Way. Certain regions such as the Coal Sack rarely, if ever, rise above the horizon in the Northern Hemisphere; conversely, the Milky Way regions within Cassiopeia are never visible in portions of the Southern Hemisphere.

Horizon-to-horizon panoramas of the Milky Way at four different latitudes: 47° N, 34° N, 35° S and 45° S are shown in Figure 8.8(a)–(d) (overleaf) to illustrate the different appearance of the Milky Way from different latitudes. The Milky Way in each of these four panoramas, (a)–(d), has been aligned with respect to each other to assist in their direct comparison. As our view moves from north to south across the globe, slightly different regions of the Milky Way becomes visible above the horizon. At 47° N, the galactic core region barely clears the horizon, whereas at 45° S, it is directly overhead. Finally, to obtain a sense of how the Milky Way Galaxy might appear from space, these images from different latitudes and hemispheres are combined into a virtual panorama, Figure 8.8(e).

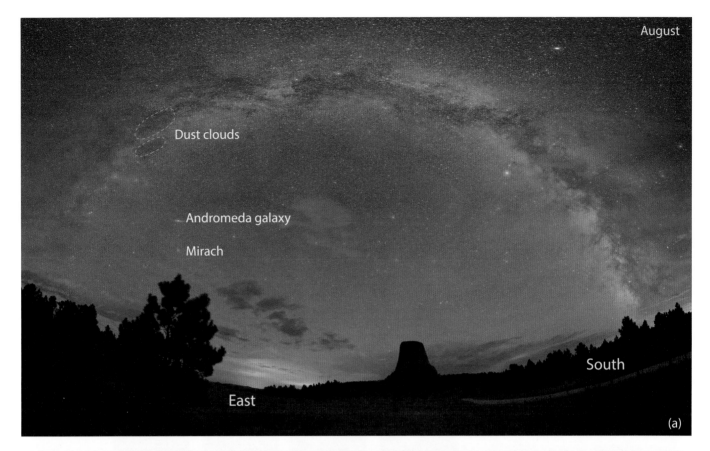

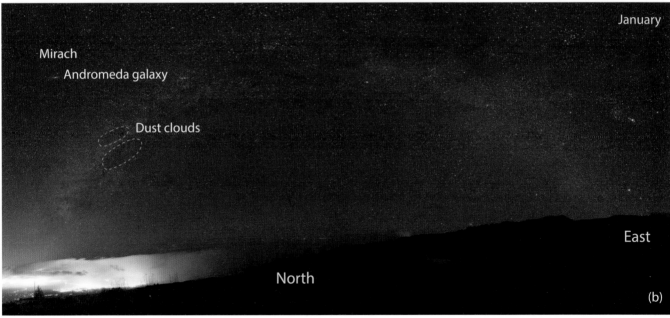

8.5 Panoramic images of the Milky Way made at two different times of year. The panorama in (a) was made during the late summer, while the panorama in (b) was made in the early winter. Observe how the azimuth of our view of the Milky Way's primary band changes between these different times of year: (a) southeast; (b) northeast. Also, note how we observe different portions of the Milky Way's primary band; the bright galactic core region in the summer compared to the fainter, outer fringe during the winter. Finally, observe how our viewing perspective has completely flipped by comparing the mirror-image relationship between the orientations and positions of the Andromeda Galaxy, the star Mirach, and the two circled dust clouds between the two images. The changes in the position of the earth during the intervening five months have turned our viewing position completely upside down!

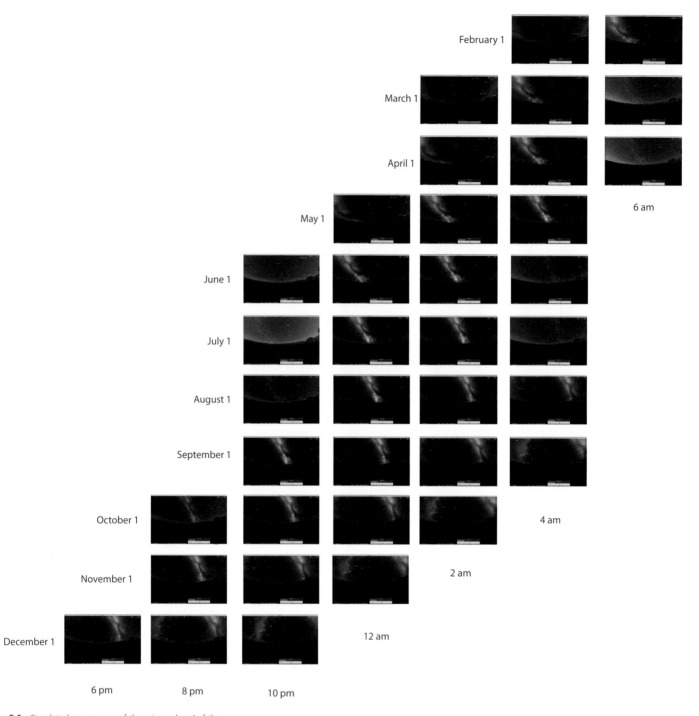

January 1 - Not visible

February 1

March 1

April 1

6 am

May 1

June 1

July 1

August 1

September 1

October 1

4 am

November 1

2 am

December 1

12 am

6 pm 8 pm 10 pm

8.6 Simulated appearance of the primary band of the Milky Way for different times of night and for different times of year, for latitude 47° N in the Northern Hemisphere.

Source: www.stellarium.org

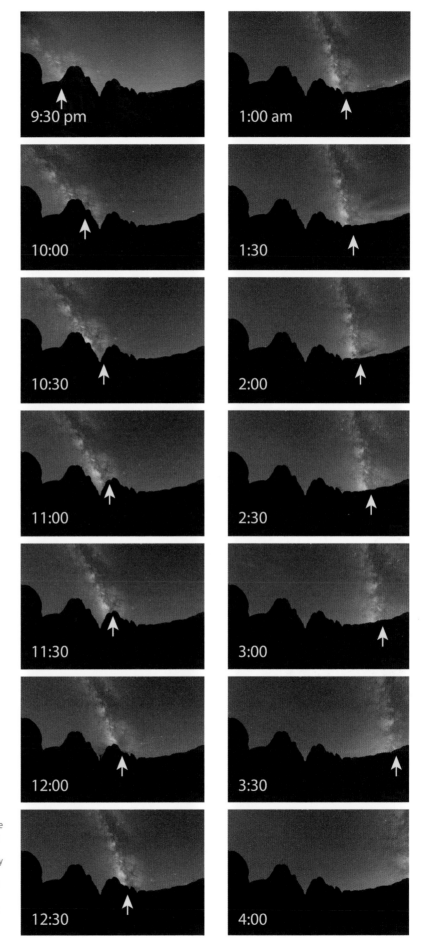

8.7 Actual field photographs of the Milky Way at one-half hour intervals during a single night, and made from a fixed tripod position generally facing south. Note how the point of intersection between the primary band of the Milky Way and the horizon (arrow) steadily moves from east to west, or from left to right above, as the night progresses.

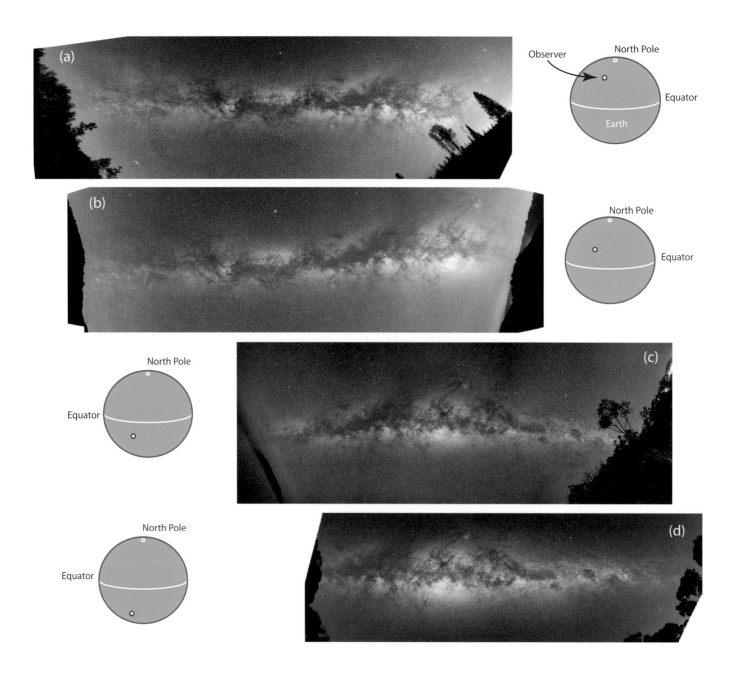

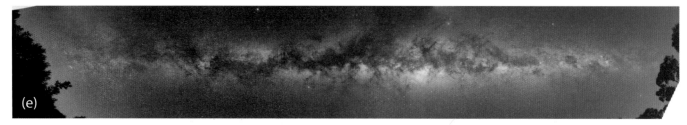

8.8 The appearance of the central band of the Milky Way viewed from different latitudes: from (a) Duluth, Minnesota (47° N), (b) Big Pine, California (34° N), (c) Brisbane, Australia (35° S); and (d) Sydney, Australia (45° S). Note that the Milky Way in each of these four panoramas, (a)–(d), has been aligned with respect to each other. (e) Panoramic view of the core region of the Milky Way obtained by combining these images into a single composite.

STARS, GAS, AND DUST OF THE MILKY WAY

There are several features of the Milky Way worth noting for their photogenic and astronomical interest. The first are the regions of the galactic core containing gas and dust clouds that emit light. These *emission* or *reflection nebula* are either (a) physically hot or (b) located near stars whose light they absorb and re-emit. Several emission nebulae are located within the galactic core region of the Milky Way, including the Eagle Nebula, Swan Nebula and Lagoon Nebula. The colorful reddish light emanating from their rich stores of hydrogen gas often provides a distinctive highlight to Milky Way nightscapes.

In contrast, there are many large, dark areas clearly visible along the central band, Figure 8.9(a) (overleaf). These dark patches are enormous clouds of physically cold interstellar gas and dust that are part of the normal structure of the spiral arms of the Milky Way. They are remnants from the Big Bang and do not emit light; rather, they absorb all the light emitted from stars on the opposite side of them from earth and hence appear dark, as illustrated schematically in Figure 8.9(b). Especially prominent dust clouds or *dark nebulae* are the Great Rift in the Northern Hemisphere, Figure 8.10 (a) (overleaf) and the Coal Sack and Emu in the Sky in the Southern Hemisphere, Figure 8.10(b). Just like clouds blot out the sun, interstellar dust clouds blot out starlight.

Careful study of the dust clouds, however, will reveal a few stars that appear right in their midst, Fig. 8.9(a). These stars are positioned *in between* the dust clouds and earth, so we still are able to see them, as illustrated schematically in Figure 8.9(b). Especially on dark, moonless nights far away from city lights, this tendency of dust clouds to block light from faraway stars while providing a backdrop to intervening stars imparts a wonderful sense of the three-dimensionality of the Milky Way.

COLORS OF THE MILKY WAY

The glowing, central band of the Milky Way generally appears to be a pale white in color to the naked eye. While some regions are brighter than others, their light intensity is too weak to activate the color-sensing parts of the human vision system, as described in Chapter 10. Camera sensors, however, are far more sensitive and easily capture and distinguish between the colors of the different regions of the Milky Way.

The ability of modern cameras to capture the colors of the Milky Way can lead to some unanticipated difficulties. As described in Chapter 21, e.g. Figure 21.5, it is important to decide how you wish to depict these colors. It is generally accepted that the core band of the Milky Way is a pleasant, whitish cream color, not the vivid blues, greens, and even purples that sometimes appear in nightscapes. Ultimately, of course, it is entirely the choice of the photographer how to proceed.

NOTABLE CONSTELLATIONS OF THE MILKY WAY

There are several key constellations/asterisms associated with the Milky Way that should be noted: Sagittarius, Scorpius, Cassiopeia, Orion, Cygnus, and Altair in the Northern Hemisphere; and the Southern Cross in the Southern Hemisphere, as indicated in Figure 8.10. These constellations are often an extremely useful tool in identifying where the Milky Way "ought to be" under less than ideal viewing conditions, and can aid in rapidly orienting oneself to the night sky. In addition, by knowing where the Milky Way lies relative to these constellations, it is occasionally possible to

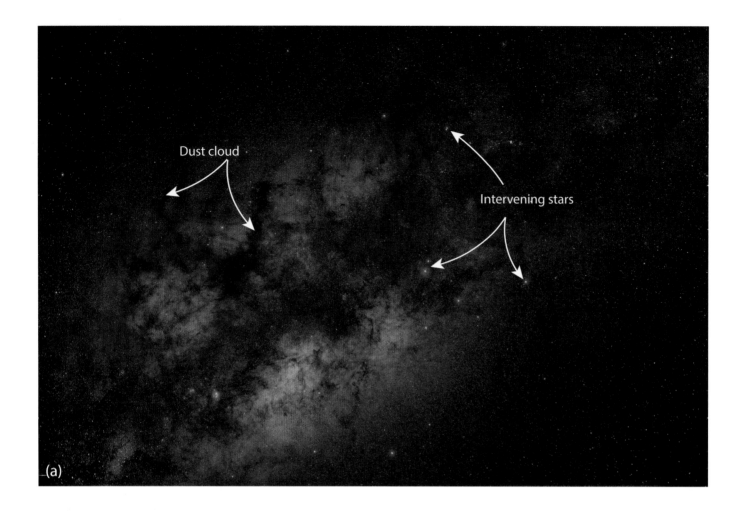

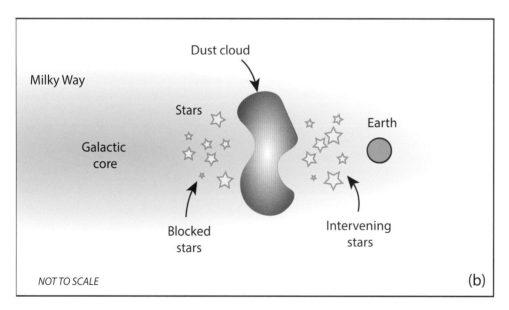

8.9 Dust and gas clouds of the Milky Way: (a) Photograph of the galactic core region of the Milky Way, where several prominent dust and gas clouds are visible; (b) side view schematic illustrating how the spatial arrangement of stars and a single dust cloud can lead to the types of view within (a).

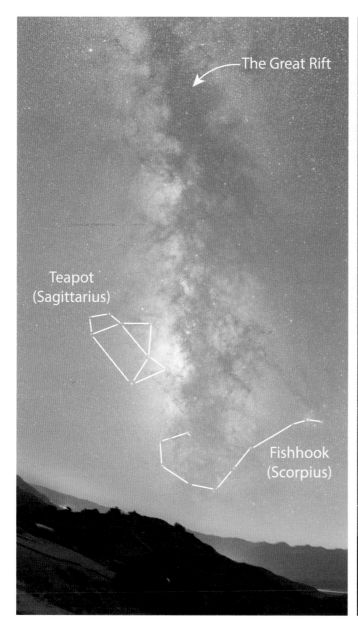
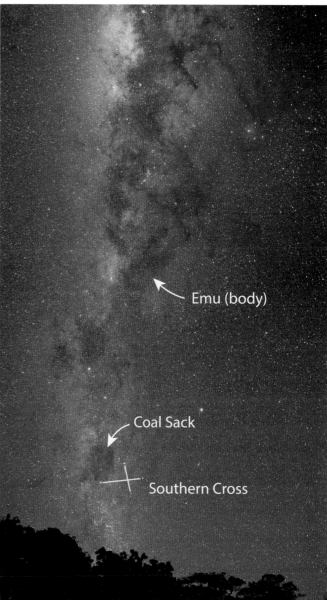

8.10 (a) The Great Rift and prominent summer asterisms, including the Teapot (Sagittarius), and the Fishhook (Scorpius), as viewed from the Northern Hemisphere. (b) Dust clouds of the Milky Way as viewed from 35° S, including the Emu in the Sky and the Coal Sack, along with the Southern Cross.

make an image with your camera that reveals enough structure of the Milky Way to identify it, even though it may only be just barely discernible with your naked eye. Finally, many of the stars in these constellations are quite bright and hence the first to appear during astronomical twilight. They can be invaluable in gauging the precise location of the Milky Way as astronomical twilight deepens into complete darkness.

BEYOND THE MILKY WAY

There are only a few objects lying beyond the Milky Way visible to the naked eye. However, they not only make worthy targets by themselves, they impart a true element of mystery to any nightscape, as seen in Figure 8.11. Notable examples include the Large and Small Magellanic Clouds, Figure 8.11(a), and the Andromeda Galaxy, Figure 8.11(b).

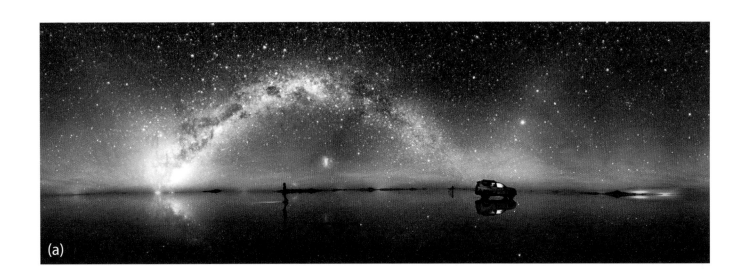

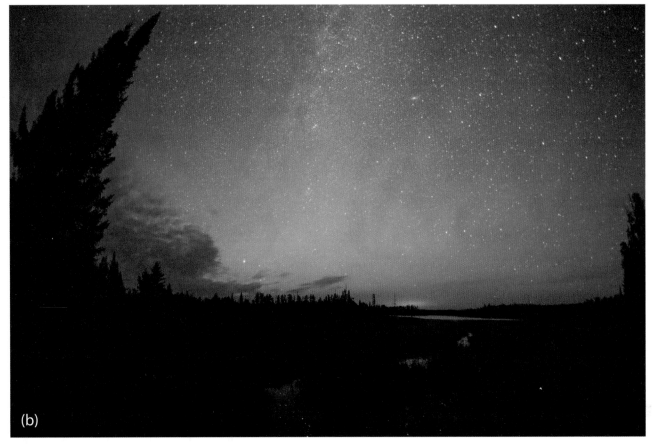

8.11 There are only a few objects lying beyond the Milky Way visible to the naked eye: (a) Magellanic clouds; (b) The Andromeda Galaxy, M31.

Source: (a) Caren Zhao/The World At Night

Bibliography

Bair, Royce, *Milky Way Nightscapes*, 2015, RoyceBair.com (ebook)

Dickinson, Terence & Alan Dyer, *The Backyard Astronomer's Guide*, 2010, Third Edition, Firefly Books, Limited, Buffalo, New York

Dyer, Alan, *How to Photograph Nightscapes and Timelapses*, 2014, Amazing Sky (ebook)

http://twanight.org

Keimig, Lance, *Night Photography and Light Painting*, Second Edition, 2016, Focal Press Taylor & Francis, New York and London

Kingham, David, *Nightscapes*, 2014, Craft & Vision, Vancouver, Canada

Schneider, Stephen E. & Thomas T. Arny, *Pathways to Astronomy*, 2015, Fourth Edition, McGraw Hill Education, New York

Wu, Jennifer & James Martin, *Photography: Night Sky*, 2014, Mountaineers Books, Seattle, Washington

Notes

1 A light year is a measure of distance, not time. One light year is the distance light travels in a year. Since light travels at 670,616,629 miles per hour, and there are 8,640 hours per year, one light year is a distance of 5.8 *trillion* miles.

By way of reference, light takes 8 minutes to reach us from the sun, but only 1.3 seconds to reach us from the moon. Light takes around a one-half hour to reach us from Jupiter and a little over an hour to reach us from Saturn.

Compare this to the amount of time it takes light to reach us from our nearest star, Proxima Centuri: 4.22 years. And the light that we see tonight from Polaris left that star over 430 years ago—well before you, your parents, or even your grandparents were born!

9

WEATHER AND ATMOSPHERIC SCIENCE

Experienced landscape astrophotographers understand the weather. Crystal clear skies set the stage for luminous nightscapes. Just the right amount of cloud cover can produce stunning sunset and sunrise images. Treacherous weather, on the other hand, can range from inconvenient to life threatening.

You can learn to plan your trips and venture into the field with confidence by understanding how and why specific weather patterns develop. Here, we will review the weather basics needed for successful nightscape sessions. We will explore the different types of cloud patterns you will encounter and what they mean. We will discuss humidity, dew point and the conditions that cause fog, dew, and frost to form. This information will help you recognize and interpret telltale signs to know what they portend. Finally, we will investigate a variety of atmospheric science phenomena that are of particular interest for landscape astrophotography, including rainbows, noctilucent clouds, lightning, crepuscular rays, ice halos, sundogs, ice pillars, and the green flash.

CLOUDS

You will most likely want to conduct your nightscape sessions under the cloudless, low humidity skies that accompany large, stable regions of high air pressure. Not surprisingly, desert regions around the world are known for these conditions. When two or more air masses of differing pressures interact, however, clouds and inclement weather can develop within them and along their boundaries. Understanding the characteristics and movements of air masses is thus important, yet we can't "see" air. Instead, we are forced to rely on the features of whatever clouds may be present in order to deduce the characteristics of the prevailing and impending weather.

Clouds can be put into one of three broad, somewhat overlapping classifications based on the altitude range in which they occur: low (surface to 6,500 feet), middle (6,500–25,000 feet) and high (10,000–60,000 feet), Figure 9.1(a). High-level clouds are made up of ice crystals and include cirrus, cirrocumulus, cirrostratus and noctilucent clouds, Figure 9.1(b, c). Mid-level clouds are generally made up of water droplets but can include ice crystals under the right conditions. Examples of mid-level clouds include altocumulus, altostratus, and nimbostratus clouds, Figure 9.1(d, e). Low-level clouds are usually comprised of water droplets and include cumulus, stratocumulus, stratus, and cumulonimbus clouds, Figure 9.1(f, g).

The shape and texture of clouds are affected strongly by whether they are comprised of water droplets, ice crystals, or a combination of both. Wispy, feathery clouds are typically comprised of ice crystals; rounded, billowing clouds are comprised of water droplets. The delicate ice crystals of cirrus clouds are a perfect canvas for the peaceful colors of alpenglow, Figure 9.1(c). Conversely, the soft, water-droplet based undersides of altostratus clouds can yield dramatic images, especially at sunset. In fact, keep an eye out for those occasions when the setting sun may slip into that narrow, open band of sky just below the flat layers of altostratus clouds but above the horizon; stunning images are frequently possible, Figure 9.1(f). Towering stacks of cumulonimbus clouds internally lit by flashes of lightning during late evening thunderstorms can be unforgettable, especially during their transformation from enormous masses of water droplets to gently dispersing drifts of ice crystals, Figure 9.1(e).

The region between two air masses of differing densities is known as a *weather front*. In general, one of the air masses is encroaching upon the other. The temperature of the advancing air mass

(b)

Cirrus

Noctilucent

Altocumulus

Altostratus

Stratocumulus

Stratus

Cumulus

(a)

(c)

(d)

(g)

(f)

(e)

9.1 (a) Types of clouds characterized by altitude. (b, c). High-level clouds are made up of ice crystals and include noctilucent, cirrus, cirrocumulus, and cirrostratus clouds. (d, e) Mid-level clouds are generally made up of water droplets, but can include ice crystals under the right conditions. Examples of mid-level clouds include altocumulus, altostratus, and nimbostratus clouds. (f, g) Low-level clouds are usually comprised of water droplets and include cumulus, stratocumulus, stratus, and cumulonimbus clouds.

Source: (b) P-M Hedén/ www.clearskies.se /The World At Night

is used to describe the front: a cold front occurs when a mass of cold air moves into a region of warmer air, and vice versa. The air masses on either side of a front have differing combinations of air pressure, temperature, and humidity. Clouds develop within frontal regions owing to these differences, and their features are reliable indicators of each weather front's unique characteristics.

Specific clouds form ahead of different types of fronts. They can be analyzed to predict the likely pattern of imminent weather. For example, ice-crystal based cirrus clouds are often early harbingers of deteriorating weather, since they can develop at the initial edges of an incoming warm front. Altostratus and then stratus clouds with possible rain can follow in the hours and days ahead. In contrast, large water vapor-based cumulus and cumulonimbus clouds typically develop along the edges of a cold front and signal imminent precipitation and cooler temperatures.

Other clouds, such as altocumulus and widely disbursed cumulus clouds are reliable indicators of fair weather and imminent clear skies, Figure 9.1(g), especially if they are decreasing in size. As a landscape astrophotographer, it is well worth understanding which ones are which.

Finally, tenuous noctilucent clouds deserve a special mention. These are a relatively rare, yet beautiful phenomenon restricted to relatively high latitudes, typically 50° to 65° north/south of the equator, Figure 9.1(b). Noctilucent clouds sit at altitudes of around 250,000–280,000 feet. They only become visible in the dim light of twilight, well after sunset and before complete darkness, owing to their very low levels of light reflection.

ABSOLUTE HUMIDITY, RELATIVE HUMIDITY, AND CLOUD FORMATION

What are clouds, after all? Some have already been described as being comprised of ice crystals, and others of water droplets. How exactly do they come into existence; why and when do they transform from one form to another? The answers begin with the fact that air always contains a small amount of water vapor, typically between a few tenths to several percent of the total air pressure, depending on its temperature. Water vapor is an invisible gas that is simply part of the air we breathe. Let's establish a few basic concepts and terms that will help us understand how, and under what conditions clouds, dew, and frost develop.

Air at any temperature is able to hold only a certain amount of water vapor before it becomes *saturated*, and unable to absorb, or hold any more. The maximum amount of water vapor that air can hold at a given temperature is called its *saturation water vapor*.

The amount of water vapor contained within a given volume of air is known as its *humidity*, and can be quantified in two different ways. The *absolute humidity* is the actual mass of water vapor within a given volume of air, and can be expressed in terms of grams per cubic centimeter. A more familiar term, however, is the *relative humidity*, which is the ratio of its actual amount of water vapor, i.e. it's absolute humidity, compared to its saturation water vapor.

Once a given volume of air has become saturated, we say that it has achieved 100 percent *relative humidity*. If a comparison volume of air is holding exactly half the quantity of water vapor as a first, saturated volume of air, and is at the same temperature, then we say the second volume has a 50 percent relative humidity; this is because it's only holding half the amount of water vapor it can hold before becoming saturated. Here's a tip from the field to gauge the prevailing relative humidity: try

to see if you can spot any high-altitude airplanes, and if you can, the length and characteristics of their contrails. Long, highly textured contrails generally indicate higher relative humidity; short to absent contrails indicate low relative humidity, the best condition for clear views of the night sky.

The *dew point* is the temperature at which air of a given absolute humidity becomes saturated. Warm air is able to hold more water vapor than cold air before becoming saturated. Air with a high absolute humidity thus has a higher dew point than air with a lower absolute humidity.

If the temperature of air is cooled below its dew point, some of its water vapor condenses into either microscopic water droplets or ice crystals. Alternatively, if a given volume of air is already saturated, or at 100 percent relative humidity, and additional water vapor enters it, say from a second air mass, the additional water vapor is unable to remain as a vapor and instead condenses into either microscopic water droplets or ice crystals. In either case, if these tiny water droplets or ice crystals remain suspended in air, they form a cloud or rain/snow; if they are deposited on surfaces, they form dew or frost. These are the primary mechanisms of cloud, dew and frost formation.

All clouds form as the result of air reaching a temperature below their dew point. Stated alternatively, all clouds form when air exceeds its saturation limit. In either case, you can now see why any natural phenomenon that causes either of these results (cooling or introduction of excess moisture) causes clouds to form. Also, you can understand that the specific features of the clouds that form reflect the details of the manner in which the dew point and/or saturation limit were exceeded. Water droplet-based clouds form at relatively warm temperatures; ice crystal clouds form at colder temperatures.

This understanding can also help you appreciate the mechanisms of the daily cloud formation and ultimate dissipation sequence that regularly occurs over mountain ranges, especially during the summer months. The cycle begins when throughout the day, winds develop and pull warm, moist air from lower altitudes up the mountains to the cooler temperatures of higher altitudes. This process decreases the air's temperature well below its dew point. When this occurs, significant afternoon and evening thunderstorms can quickly develop. These energetic storms often produce dangerous lightning, sudden downpours of rain or snow, and even hail. As the day progresses, the water droplets originally comprising the thunderheads often cool and transform into ice crystals, yielding a pleasant, wispy backdrop to the day's sunset, Figure 9.1(e). Finally, as evening proceeds, the winds typically diminish and die down altogether, bringing an end to the process and allowing the clouds to completely dissipate into clear skies. It is thus not at all uncommon for such cycles to produce spectacular later afternoon and evening thunderstorms, with gorgeous sunsets and alpenglow on the lingering clouds, followed by crystal-clear skies overnight only for the cycle to be repeated the following day.

DEW, FROST, AND GROUND FOG

We can now understand why dew and even ice crystals can form on our camera lenses as night progresses, especially in humid environments. These processes can very effectively end the night's session. As we have seen, dew or frost condenses any time the air temperature drops below its dew point. What makes matters worse is that objects on the ground, like your camera lens, can actually cool to temperatures a few degrees *below* the actual air temperature when they are exposed to the clear night sky. This cooling occurs through radiative heat transfer, which simply

means that the ground object is radiating, or losing heat directly into the night sky, faster than the surrounding air. The consequent decrease in temperature of your camera lens causes the air immediately adjacent to it to cool to a temperature a few degrees colder than the ambient air. This is often enough to trigger dew or frost formation. This local radiative cooling of objects exposed to the clear night sky is the cause of frost formation on patches of grass in an open field during clear nights while grass just a few feet away but under the protective shield of tree branches remains frost-free, even though they both experience the same overall ambient air temperature.

When dew or frost begins to condense on your lens, simply blowing on the lenses is of no help. Doing so simply causes additional dew or frost to condense from the very high humidity of your exhaled air! Instead, the only solution is to gently warm the lenses slightly in an effort to induce any condensed water to evaporate, or frost to sublimate. Commercial lens heaters are available designed specifically for this purpose. Alternatively, a do-it-yourself solution is to attach disposable hand warmers to the camera lens and with rubber bands or tape, as described in Section V. Another do-it-yourself approach is to create an insulating lens hood from elastomeric foam, such as the type found in camping mats, to shield the lens from the night sky. Astronomers frequently use such hoods on their telescopes for just this purpose. However, the very wide-angle lenses often used for nightscape imaging typically preclude the use of lens hoods, which can substantially vignette the field of view.

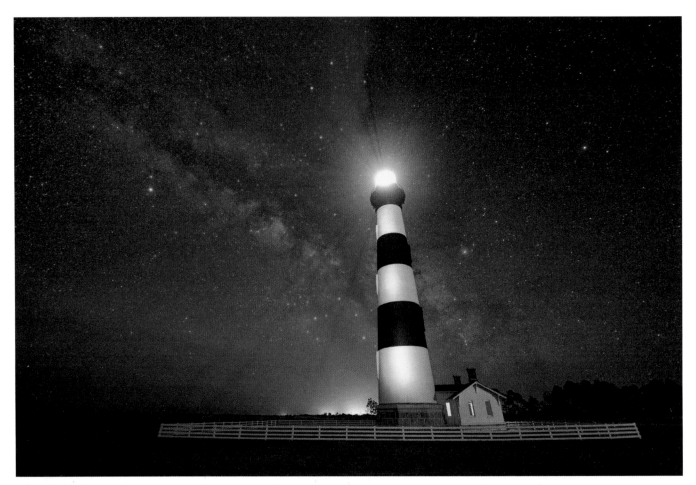

9.2 The beam of this lighthouse in Cape Hatteras, North Carolina, illuminates a hazy ground fog, which typically forms under clear skies with locally high humidity. In such situations, care must be taken to avoid lens condensation.

Finally, ground fog may occur as the result of the cooling of the air as night progresses. Typical conditions for the formation of ground fog are when warm, relatively high humidity air encounters a region that is much cooler. Very common over lakes, ponds, and oceans, ground fog occurs when high humidity air from just above the surface of the relatively warm pond or lake encounters much cooler ambient air, Figure 9.2. Ground fog can also occur at night under clear skies when the ground temperature drops as a result of radiative cooling. Unfortunately, when ground fog strikes the only solution is to seek higher ground or to head home!

RAINBOWS, ICE HALOS, ICE PILLARS, AND SUN/MOONDOGS

Let's now examine a few of the highly photogenic atmospheric phenomena that you may encounter under the right conditions. Specifically, we will explore the atmospheric optics of rainbows, moonbows (Figure 5.13), ice halos, sundogs, and ice pillars. Like most of the other subjects in this book, you will greatly increase your chances of observing them if you are able to understand and intentionally seek out the situations in which they form.

All these phenomena originate from the refraction and reflection of sunlight or moonlight from within floating water droplets or ice crystals, Figure 9.3 (overleaf). As light passes into the water droplets, Figure 9.3(a), or ice crystals, Figure 9.3(b), it *refracts* and *reflects* from the inner surfaces back to the observer on the ground. In doing so, its spectral colors are *dispersed*.[1] Consequently, in order to observe rainbows or moonbows in mist, rain showers, or clouds, it is important to have the sun or the moon at your back, as shown for the case of rainbows in Figure 9.3(a). Second, owing to the geometry of the shallow angles of dispersion, rainbows and moonbows are generally only observed when the sun or moon are close to the horizon, in other words, near sunset or sunrise for rainbows.

While all ice crystals develop as a result of conditions beyond their saturation limit, the precise details of local temperature and ice *supersaturation* greatly affect their ultimate shape and size, Figure 9.4. A few of these specific structures have properties that are highly relevant to landscape astrophotography. Supersaturation is a curious phenomenon that occurs when, under the right conditions, extremely small droplets of water vapor can temporarily persist in the liquid form even though the prevailing combination of temperature and pressure dictates that they should freeze into ice. As these miniscule droplets of water grow larger, they eventually crystallize and allow additional water vapor to condense on them in the solid form, further increasing their size and becoming ice crystals or snowflakes, depending on local conditions.

Under relatively low levels of supersaturation and mild to extremely cold temperatures, short, flat hexagonal plates are the favored morphology to form, Figure 9.4. For temperatures between approximately -3° C to -10° C and colder than around -21° C; and moderate levels of ice supersaturation, elongated ice pillars, become the favored shape to develop instead. Plates and columns are of special interest since these miniature prisms enable the observation of many of the atmospheric phenomena described above. First, their angled shapes allow light oriented at very specific angles, relative to the viewer, to be reinforced or dispersed into the colors of the rainbow, Figure 9.3(b). Second, ice crystals with these shapes tend to become physically aligned as they float suspended in the air, owing to the forces of air resistance acting similarly on their shapes. In doing so, favorably oriented light refracted from all of the ice crystals tends to align, synchronizing and consequently amplifying their effects.

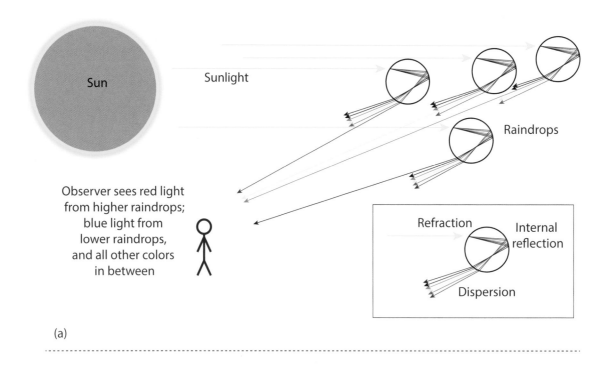

(a)

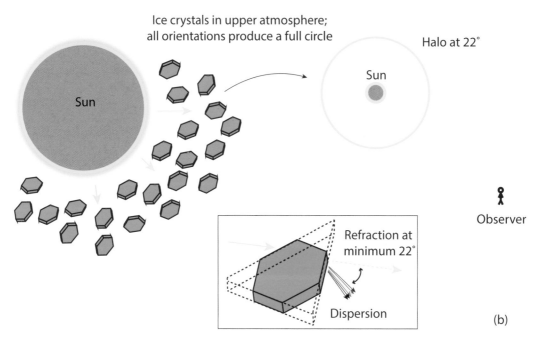

(b)

9.3 (a) Optics of rainbow/moonbow formation. (b) Optics of ice halo formation from either the sun or moon. In both cases, incoming light from the sun or moon is *refracted*, or bent, at the interface between the air and the water or ice, and then the light is *dispersed* within the water or ice into its different colors. The dispersed light is then refracted a second time when it leaves the water or ice. For rainbows or moonbows, the dispersed light is internally reflected in order for it to be redirected towards the viewer. The very specific angles of these processes are what lead to the perception of the different colors of the rainbow or moonbow, as well as the distinctive halo resulting from ice crystals.

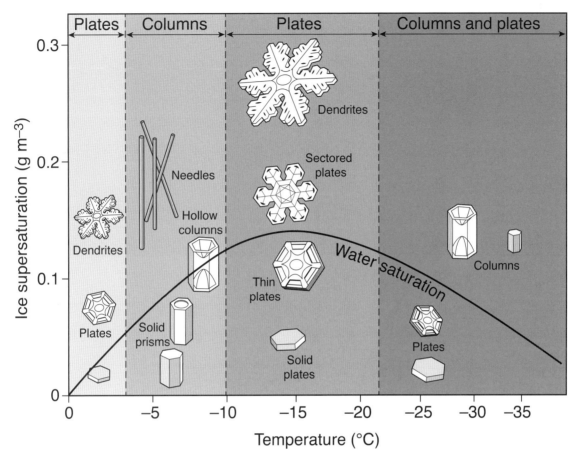

9.4 Different shapes and relative sizes of ice crystals and snowflakes develop for different combinations of temperature and ice supersaturation within the atmosphere, as shown in this schematic. We are particularly interested in the conditions for the formation of (i) flat solid plates and (ii) solid prisms or columns, since they are especially auspicious for the observation of ice halos, moondogs, ice pillars and a variety of arcs and rays, for example, Figure 9.5.

These two reasons are the underlying causes of sundogs and moondogs, ice pillars, and arcs. Namely, enormous numbers of floating, aligned ice crystals refract and reflect light to ground-based observer at the same, very specific angles for each of these beautiful phenomena. These phenomena can be see any time of year, although the fall, spring, and especially winter months are the best for observers in the Northern Hemisphere since these are the seasons when the jet stream, with its treasure troves of these tiny, floating ice crystals, moves further south, bringing rich quantities of these miniscule jewels along with it.

A particularly striking example of these phenomena is shown in Figure 9.5(a), where several moon arcs and rays, including a rare, paraselenic circle, are visible along with prominent moondogs on either side of the moon. The geometry of these striking phenomena is illustrated in Figure 9.5(b).

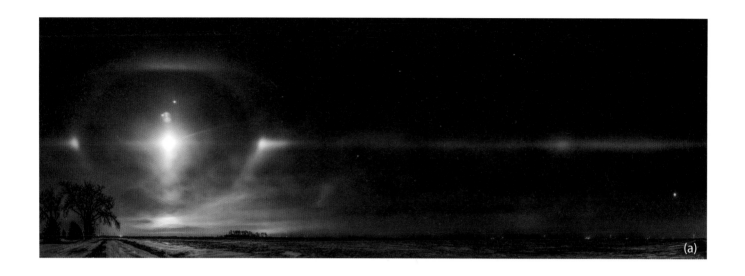

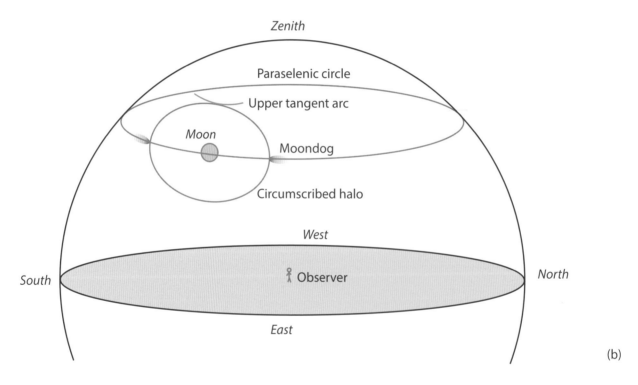

9.5 (a) A circumscribed halo combined with a full paraselenic circle, two moon-dogs, and a 120° parhelion, as illustrated by the schematic in (b). They were photographed on a cold day near Fisher, Minnesota.

Source: Mike Crawford / http://ctkmedia.smugmug.com

facing page

9.6 From the photographer, "Thunderstorm rages against starry backdrop, seen from Haleakala volcanic summit on the island of Maui, Hawaii. Lightning appears in the supercell with the shelf cloud under it."—Babak Tafreshi.

Source: Babak Tafreshi / www.dreamview.net / www.twanight.org /The World At Night

MOON (AND SUN) CORONA

A moon corona, for example, Figure 5.9(b), forms as the result of light diffraction and interference around tiny water droplets. Unlike a halo, coronas do not involve light actually passing through the liquid droplets of water. Instead, owing to the small size of the droplets, light actually bends, or *diffracts* around them in much the same way ocean waves bend, i.e. diffract, around a breakwater or jetty. When light from opposite sides of the water droplets meet and recombine, they produce the colors of the spectrum through the process of *optical interference*. The key requirements are that the moon be directly opposite the clouds from the observer, and that the water droplets comprising the clouds be sufficiently small. Thus, fine, wispy clouds tend to produce more distinct coronas, whereas thicker clouds simply diffuse the moonlight into a uniform glow.

LIGHTNING

The fusillades of lightning and thunder that accompany a rollicking summer thunderstorm can be exhilarating, provided they are viewed from a safe haven! Bolts of lightning both within towering thunderheads, as well as cloud-to-ground lightning strikes are truly one of nature's most humbling spectacles. When they occur during twilight, or even during the night, such displays of nature's immense power can yield incredible, once-in-a-lifetime night photography opportunities, provided the photographer understands how to prepare for and safely capture these elusive moments.

Lightning is simply the flow of electricity through air that has been turned into an electrical conductor. The normally insulating molecules of oxygen and nitrogen that comprise the bulk of our atmosphere are ripped apart and ionized by the lightning. The lightning results from the tremendously powerful electrical fields generated during a thunderstorm, thus turning the air molecules into carriers of electrical charge. This process of splitting and then recombining of air molecules is the cause of thunder. It also produces the flashes of lightning and other electromagnetic radiation, sometimes detectable as static bursts and crackling on AM radio receivers.

There are two primary ways to photograph lightning strikes. The first is to simply set your camera to collect a series of photographs at regular intervals during a storm. Hopefully, one of them will contain a lightning strike! Such sequences can also be stacked to combine multiple strikes into a single, stunning composite image using any of the techniques described in Section VI. The second approach is with the use of a commercially available "lightning trigger" that automatically detects a lightning strike and triggers your camera with no intervention from the operator.

CREPUSCULAR RAYS

Crepuscular rays, or "god-rays," are simply shafts of sunlight that form whenever clouds, mountains, or other objects partially block the sun, Figure 9.1(d), and Figure 11.20. They can be incredible spectacles during sunsets and sunrises, and are worth seeking if the conditions are auspicious. Anti-crepuscular rays, while less frequent owing to their much dimmer appearance, can sometimes also be seen at the same time, although in the side of the sky opposite the setting/rising sun.

THE SUN'S APPEARANCE NEXT TO THE HORIZON AND THE GREEN FLASH

One of the more distinctive phenomena that accompanies sunset, especially over the ocean or sea, is the significant distortion of the sun's appearance, Figure 9.7(a). This has been concluded to result from the stratification of the earth's atmosphere, and the ways in which the sunlight interacts with the individual layers, or strata.

This stratification can lead to the very rare "green flash," a remarkable phenomenon that can accompany the distortion of the sun during sunset or sunrise, Figure 9.7(b). It occurs because of atmospheric refraction of the sun's rays, as described in the next section. While the sun's blue light has been long lost through atmospheric scattering, as described in Chapter 3, the green component of sunlight remains. Owing to the peculiarities of atmospheric refraction, the green light from the sun is refracted at a very slightly different angle than the orange and red colors so that the green sunlight sets approximately 1½ seconds after the last red sunbeam. This phenomenon is called the green flash, owing to its greenish tint and short duration.

(a)

(b)

9.7 (a) The circular shape of the sun can become very distorted under conditions of severe atmospheric stratification. (b) The "green flash" occurs when green light from the sun, which is refracted at a slightly different angle than the orange and red colored sunlight of sunset, appears for only approximately one and one-half seconds after the last red sunbeam disappears in a brief, greenish "flash." Good conditions for viewing the green flash are those of significant atmospheric stratification, as seen here.

Bibliography

Greenler, Robert, *Rainbows, Halos and Glories*, 1980, Cambridge University Press, Cambridge, England

Knight, Randall D., *Physics for Scientists and Engineers*, Third Edition, 2013, Pearson, Glenview, Illinois

Renner, Jeff, *Lightning Strikes*, 2002, Mountaineers Books, Seattle, Washington

Schneider, Stephen E. & Thomas T. Arny, *Pathways to Astronomy*, 2015, Fourth Edition, McGraw Hill Education, New York

Note

1 Sir Isaac Newton, who observed that sunlight separated into its constituent colors after passing through glass, water, and other transparent media, first documented the phenomenon of dispersion. The underlying physical property responsible for dispersion is the wavelength-dependent refractive index of most materials. Since the index of refraction of glass or water is slightly different for each wavelength of light, i.e. for each of the colors of the rainbow, each wavelength "bends," or refracts at a different angle when the sunlight encounters the surface of the transparent media. Upon exiting, the various wavelengths of light comprising the white light of sunlight have thus been separated, or dispersed into the various colors of the rainbow. Interestingly, when Newton then passed, for example, yellow light through a subsequent prism, he found that no further dispersion occurred.

SECTION III
Understanding Photography for Nightscape Images

SECTION III INTRODUCTION
A thorough understanding of photography is crucial to successful nightscape imaging. This section covers all the information you need to know. We start with the basics of light and the human vision system. We then review the key features of camera and lens systems. We explore the foundations of photographic exposure, and what the different camera settings accomplish: ISO, aperture, and shutter speed. We then discuss light painting and light drawing techniques for creative nightscape images and conclude with a brief introduction to nightscape time-lapses.

10

LIGHT AND
THE HUMAN EYE

The ability of the human eye to perceive light is truly one of the wonders of nature. Incredibly complex and delicate, the human eye is sensitive to a remarkable range of light levels and detail. In order to understand how we perceive light and color, let's begin by considering light's basic characteristics—where does it come from and how do we describe it. We will then explore the characteristics of the eye and human vision to better understand the components of compelling nightscape images.

LIGHT

The ability to perceive the different colors of light is surely one of life's greatest joys. Light is the name given to electromagnetic radiation that is perceptible by the human eye, Figure 10.1. You may be surprised to learn this, since light might seem to have nothing to do with either electricity or magnetism. Yet, of all the different wavelengths of electromagnetic radiation, light is the only type that we can detect directly with our eyes. Some creatures, for example, rattlesnakes and ticks, are extremely sensitive to infrared radiation. Our skin is also sensitive to infrared radiation, which is why we hold our palms out to a campfire when they're cold. Others, including certain species of fish, can detect ultraviolet radiation.

10.1 The electromagnetic spectrum, showing how light, or visible electromagnetic radiation, is only a small portion of it.

What a different world we would perceive if we were also able to see in different wavelength ranges of the electromagnetic spectrum! Everything would look completely different—if we could "see" in the X-ray portion of the spectrum, we might perceive people as ghostly skeletons covered with a translucent gel within transparent buildings (provided that there were X-ray sources other than the sun available to illuminate them). Of course that would be normal; our current appearance in the visible portion would then be considered "ghostly!" Alternatively, we might perceive the cell phones we carry as bright sources of light if we "saw" radio waves. Even the night sky would appear different, as can be seen for the region near Orion shown in Figure 10.2 comparing its appearance under (a) full-spectrum and (b) hydrogen-alpha (H-alpha) filtered visible wavelengths.

Electromagnetic radiation outside the visible range is still important for photographers. Infrared radiation permeates the night sky, and while invisible to the human eye, modern digital single-lens reflex (DSLRs) are easily modified so as to be capable of sensing and recording it. Ultraviolet

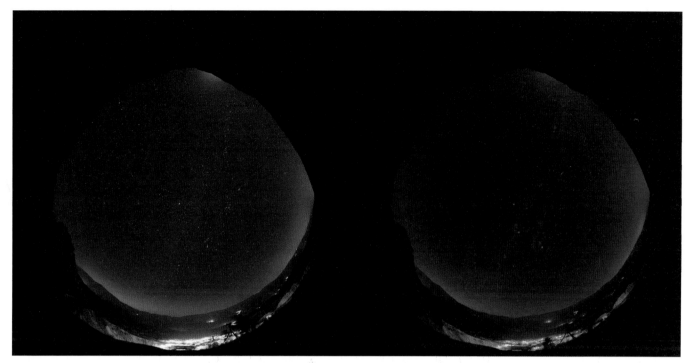

10.2 The night sky region near Orion shown for (left) the full-spectrum of light and (right) light filtered to only allow the hydrogen-alpha (H-alpha) visible wavelengths to appear. Viewing the same region of the sky but with different wavelengths thus reveals a different view. Which one is "real?"

Source: Tunç Tezel/The World At Night

radiation is responsible for the vivid hues and brightness of fluorescent pigments; these materials absorb ultraviolet radiation and then emit light of an entirely different hue. Also, modern fabric "whiteners" contain chemicals that absorb ultraviolet radiation and re-emit light of a bluish hue, which makes fabrics appear whiter and hence cleaner.

Light is created by one of two mechanisms: (i) *incandescence*, in which the source is physically hot and (ii) *luminescence*, in which the source is physically cool and light is produced through a chemical, biological, electrical, or other mechanism. The sun, molten lava, lightning, and fire are examples of natural incandescent sources; flashlights with incandescent bulbs are artificial incandescent sources. Fireflies and bioluminescent algae are examples of natural bioluminescent sources; fluorescent lights, liquid-crystal displays (LCDs) and light-emitting diodes (LEDs) are examples of artificial fluorescent and electroluminescent sources, respectively.

We can understand the color of different light sources by examining their electromagnetic *spectra*, Figure 10.3(a). The spectrum of our sun contains every wavelength of light, Figure 10.3(a), and is referred to as *white light*. Many manufacturers of light bulbs strive to produce light mimicking this spectral distribution. In contrast, light from a source that is predominantly a single color will exhibit a high intensity at that wavelength, and lower intensities at other wavelengths. Most artificial light sources exhibit this trait and thus have a distinct color cast, Figure 10.3(b). Finally, the distinct colors of the aurorae, which originate from specific chemical species, have a spectrum containing only very specific wavelengths, Figure 10.3(a). In fact, spectral analysis can help determine the sources of auroral light. Understanding the spectra of different light sources helps us understand how to control the appearance of images created with each of them.

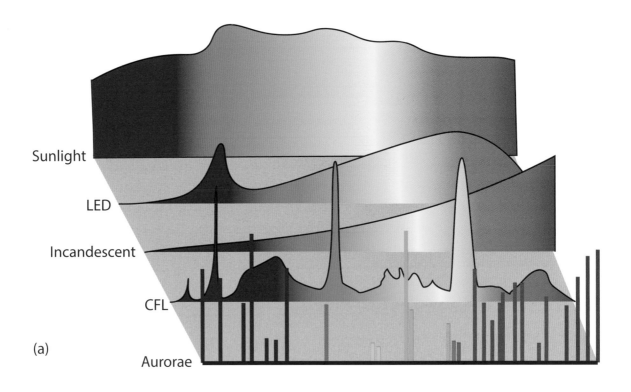

Sunlight

LED

Incandescent

CFL

(a)

Aurorae

(b)

10.3 (a) Characteristic electromagnetic spectra of different light sources.
Incandescent sources, like sunlight or incandescent light bulbs, emit all wavelengths.
Artificial lights, however, preferentially emit only certain wavelengths, which
can result in a distinct color cast. The specific colors in the aurora originate from
particular atmospheric gas molecules, as described in Chapter 4, and are mostly
the result of oxygen and nitrogen. (b) Different light sources have different spectra,
which manifest themselves as different colors. Here, a combination of flashlights,
cellphones, and headlamps are used to creatively spell the word *BRILLIANT*.

HUE, SATURATION AND SCENE LUMINANCE, LV

Photography is the collection and rendering of *ambient light*. Sources of ambient light are either *direct sources*, i.e. objects that emit light, or *indirect sources*, i.e. objects that redirect light produced from direct sources, Figure 10.4. Examples of direct sources include the incandescent and luminescent sources described above. Indirect light source examples include *light scatterers*, like the sky and its atmospheric gases; *light refractors*, like atmospheric ice crystals and water droplets; and perhaps most commonly, *light reflectors*, such as the moon, satellites, planets, comets, people, mountains, lakes, and trees. Light reflectors can be further classified as diffuse reflectors, such as trees, mountains, and people, where the reflected light is sent in random directions, and specular reflectors, such as mirrors, where the incident light rays are simply redirected by reflection.

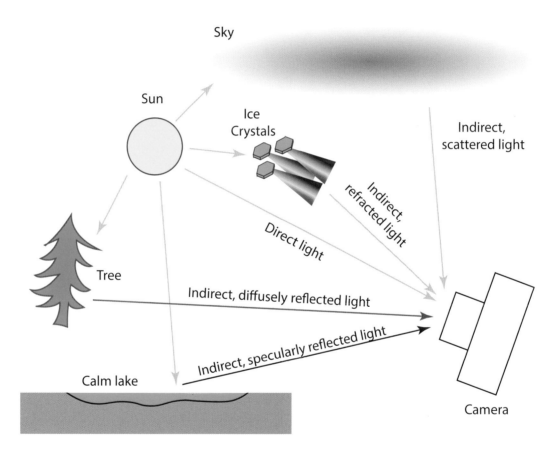

10.4 Direct and indirect sources of light. Direct sources emit light, like the sun, while indirect sources redirect light produced from direct sources. Indirect sources either scatter light, as in the blue sky, refract light, as in rainbows and ice haloes, specularly reflect light, as in the case of a mirror or the calm surface of a lake, or diffusely reflect light, as in the case of a sheet of paper or a person's face.

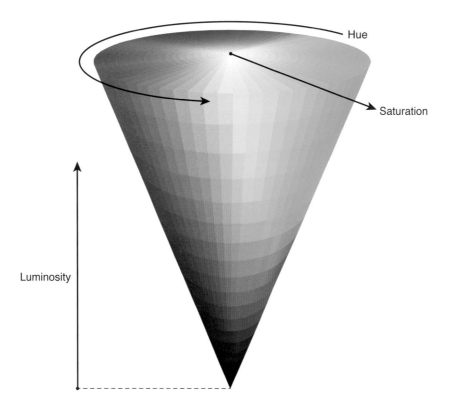

Hue

Saturation

Luminosity

10.5 Schematic diagram illustrating the nature of, and relationships between hue, saturation and brightness/lightness.

The light that enters our camera can be characterized by three main qualities: *hue, saturation, and luminance/lightness/brightness/value/intensity*, Figure 10.5. These, in turn, depend on the specific characteristics of the direct or indirect light sources within the camera's field of view.

Hue is what we think of as the color of light–turquoise water or a red headlamp. Hue has an infinite range of possibilities, depending on the hues of the constituent sources. For example, outdoor subjects in full sunlight have two different hues of light illuminating them: the direct white light from the sun and the primarily blue, scattered light from the sky. This combination is generally unflattering, which is why the best outdoor portraits are made under neutral, cloudy skies.

The brightness of a direct or indirect light source is characterized by its luminance, also termed lightness, value, or intensity. Luminance has nothing to do with color; two red and green objects can have exactly the same luminance. The luminance, S_x, is measured in units of *lux*, which simply indicates the amount of light available per unit area. All the direct and indirect sources of light within a scene contribute to its total, overall brightness. The extraordinary sensitivity of the human vision system allows it to detect and interpret images with luminance levels ranging from less than 0.001 lux to well over 50,000 lux. However, this enormous range makes luminance a completely impractical parameter for photography. The currency equivalent would be to conduct all your purchases, from sticks of gum to groceries to cars to real estate, solely with individual pennies!

Instead, photographers have devised a way to convert the luminance into a much more useful parameter called the *light value* (LV), which only ranges from -12 to +12 or so. A LV of -12 corresponds to near total darkness; a LV of +12 to blazingly intense light. The LV is obtained from luminance simply by taking its logarithm:

$$LV = \log_2\left(\frac{S_x}{C}\right) = 1.44\, Ln\left(\frac{S_x}{C}\right) \qquad \text{(Eq.10.1)}$$

where C is a calibration coefficient for the light-meter used to measure the scene luminance, safely assumed to be approximately equal to the number one. Following the example of currency, the LV would the equivalent of higher denomination coins and paper currency.

The practical interpretation of Equation 10.1 is straightforward—when the ambient brightness, or S_x, doubles, LV increases by one; when S_x quadruples, LV increases by two, and so on, as illustrated schematically in Figure 10.6 (overleaf) and summarized in Table 10.1. The fact that the quantity of light doubles or halves between individual LV levels has led to the designation of a one-LV difference in luminance as being one *exposure stop*, or one *f-stop*. In other words, when the LV changes by one exposure stop, the amount of light either increases or decreases by a factor of two.

ASTROPHOTOGRAPHY TARGET		SCENE LV	SCENE LUMINANCE (LUX)
Sunsets and sunrises			
	At sunset	8	320
Moonlight, Moon altitude > 40°			
	Full	-3 to -2	0.16
	Gibbous	-4	0.08
	Quarter	-5	0.04
Aurorae			
	Bright	-4 to -3	0.08 0.16
	Medium	-6 to -5	0.02 0.04
Milky Way scenes		-8 to -5	0.02

Table 10.1 Approximate Light Values, LV, for Typical Landscape and Astrophotography Scenes

Since each scene contains of a unique set of direct and indirect light sources, each with their own characteristic luminance, each scene will have a unique LV. For example, typical nightscapes will include both direct light sources, such as stars, and streetlights, and indirect light sources, such as the moon, planets, mountains, and other foreground objects that reflect light originating from the direct sources.

A key advantage of using light values as a measure of brightness in determining exposure settings in photography is that scenes with comparable overall lighting will have roughly equivalent LV levels, regardless of minor differences in light levels within the scenes. For example, perhaps we have a scene with relatively abundant ambient light, such as is the case during late evening before the sun has set. It is a safe and practical starting point to assume that this scene would likely have a LV of approximately six to eight, regardless of the details of what's in the scene, or where in the world it's located. Or maybe we are attempting an image an hour after sunset during a waxing gibbous moon, where the foreground is dimly illuminated. In this case, our LV would be lower since there is less light, likely around -4 or so. Or possibly we are seeking an image of the relatively faint

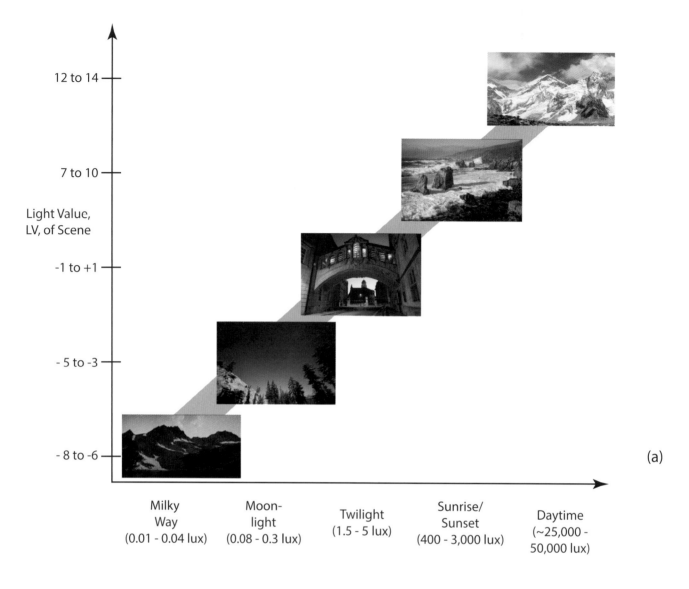

(a)

Light Value, LV, of Scene

12 to 14

7 to 10

-1 to +1

- 5 to -3

- 8 to -6

Milky Way (0.01 - 0.04 lux)

Moonlight (0.08 - 0.3 lux)

Twilight (1.5 - 5 lux)

Sunrise/ Sunset (400 - 3,000 lux)

Daytime (~25,000 - 50,000 lux)

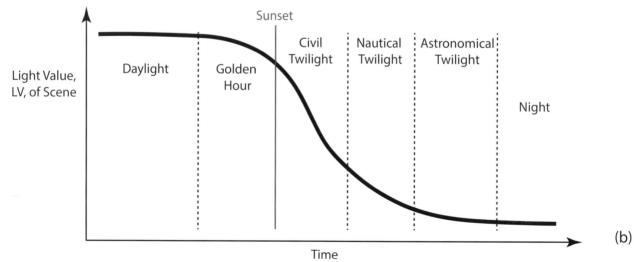

(b)

Light Value, LV, of Scene

Sunset

Daylight

Golden Hour

Civil Twilight

Nautical Twilight

Astronomical Twilight

Night

Time

10.6 (a) Schematic illustration of how the available light, or the light value (LV), of a scene increases with its luminance (Not to scale). A few typical landscape astrophotography scenes are included for reference: moonless and moonlit nights in California's Sierra Nevada; twilight in Oxford, England; sunset along the Big Sur coast in California; and midday at the base of Mt. Everest, Nepal. (b) Schematic illustration of how a sunset scene's LV decreases during the golden hour, sunset, and each phase of twilight.

Milky Way during the middle of the night of the new moon, deep in the wilderness, far away from any city lights. Here, our light value would be even lower, likely around -6 to -5 or so.[1] This ability to characterize most landscape astrophotography scenes in terms of their approximate light value is extremely helpful to the next step of knowledgably setting your camera exposure settings in preparation for creating your nightscape image.

The final parameter of interest used to characterize light is its saturation, which simply refers to the vividness of its hue, Figure 10.5. If two different subjects have the same hue and luminance, but different saturation levels, the one with the lower saturation appears more wan, or "washed-out," than the other.

HUMAN EYE

The human eye has several characteristics worth appreciating from a photographic perspective, especially for night photography. Let's start with its anatomy, Figure 10.7. In many ways, the human eye is roughly analogous to a camera with many of the same features. It has a lens, an aperture stop (the iris), and a sensor (the retina). Missing is the shutter; our eyelids are simply part of a protective and cleansing system. Instead, our vision acquisition system functions in much the same way as a video camera, which also lacks a mechanical shutter. Images are extracted from our retinas approximately twenty times per second and sequenced together by our brains to create the perception of motion.

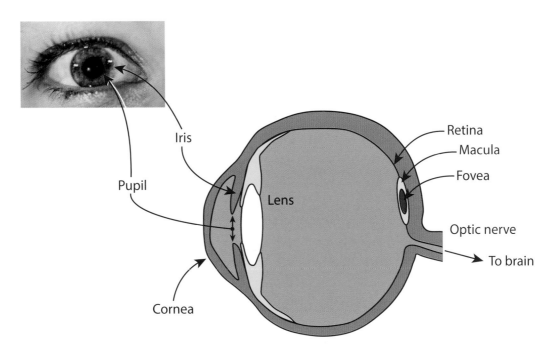

10.7 Schematic diagram of the anatomy of the human eye. The key features include the lens, iris, and retina, analogous to the lens, aperture, and sensor of your camera, respectively. The retina contains color-sensitive cones, and much more sensitive rods, but which are only able to provide black and white vision. The highest concentration of cones is found in the macula, with the very highest concentration in the fovea, found at the macula's center. The highest concentration of rods is found in a doughnut-shaped ring surrounding the fovea, explaining why the best night vision is often obtained by using "averted vision", or by looking just to the side of the area you're trying to see.

This ability provides the basis for motion pictures and video. By sequencing a series of still images at a faster rate than the retinal extraction rate of our brain, we are able to perceive the sequence of images as showing motion. If the sequence is animated at a rate slower than our brain's retinal extraction rate, then we are able to discern the individual images, and we recognize the animation as a sequence of still images rather than fluid motion.

The lens of our eye is truly a miracle of nature. It contains both living cells and inert, structural protein molecules arranged in such a way as to be optically transparent and mechanically flexible. There are relatively few blood capillaries within the lens, owing to the need for optical transparency, which makes its regeneration relatively slow when damaged.

The curvature of the lens is what allows it to form an image on the retina. Since the lens always sits at the same distance away from the retina, its curvature must change to allow it to focus on objects that are at different distances away. This is accomplished through a series of small muscle groups connected between the lens and other regions of the eye. When the muscles contract, the lens stretches and becomes more flat. When the muscles loosen, the lens relaxes and becomes more convex. This process constantly occurs as we focus on objects around us—even as you read these words!

The iris of our eyes is the direct equivalent of the diaphragm in our camera. Both are mechanical systems that open or close depending on the desired quantity of light. The hole in the center of the iris is called the pupil; the hole in the center of the camera's diaphragm is called the aperture. The next time you look in the mirror, take a careful look at your pupil. Did you know that it is actually a transparent opening into your eye? Although obvious in retrospect, it is still amazing to think that with the right equipment you could actually look into your eyes in the mirror and see your retina!

The pigments in the cells that make up the iris are responsible for giving the iris its color. The pupil can range in size diameter from approximately 1.5 mm in bright conditions to 8 mm in dim conditions. It has a range of effective aperture from $f/2$ to $f/11$, with a focal length of approximately 35 mm. A 35 mm camera lens on a full-frame camera is often considered to produce images having equivalent dimensions as human vision.

The eye's retina is the layer of *photoreceptor* cells coating its inner, rear surface that converts light into biochemical signals that can be interpreted by our brain, Figure 10.7. The retina contains two different types of cells: *rods* and *cones*. Both contain *photopigments*, proteins that change form when they absorb light. There are three types of cones, each with peak sensitivity to blue, green, and red light, respectively. Consequently, cones are responsible for color vision, although they are not as sensitive as rods to low luminance scenes. Although rods are much more sensitive to low light levels, they only yield vision in black and white, and have a peak sensitivity to blue light. How different our vision would be if our retina only contained one of these four types of cells!

Both sets of cells are concentrated in the retina in an area near the center of the optical axis of the lens, known as the macula. Within the macula is the fovea—the region of the retina with the very highest concentration of cones. There is a critical difference in how the rods and cones are distributed within the macula that produces important differences between our vision during the day and at night. The very highest concentration of cones is found at the center of the fovea, which helps us see with the greatest clarity of color during the day. The very highest concentration of

rods, however, are found in a donut-shaped ring surrounding the fovea, but approximately 20° away from its center.

This fact has extremely important implications for our vision at night. When we look directly at an object at night, we are relying primarily on the cones within the fovea to create our vision. If, however, we look slightly to one side of an object at night, or about the width of your thumb at arm's length, then the object's image falls onto this donut-shaped area with its extremely high concentration of rods, instead. This process is known as *averted vision*. Since the rods are so much better at resolving images at night than the cones, we are able to achieve much higher image resolution at night using averted vision. Practice this a few times and you will soon appreciate the difference!

Finally, the process of *dark adaptation* by your eyes is a crucial part of night photography. Dark adaptation is the name given to the physiological process by which the rods in your retina increase their level of photopigments until they are nearly a million times more sensitive to light than in full daylight. Dark adaptation takes around twenty minutes to become completely functional, and increases with time after that. However, it only takes a few seconds of exposure to bright lights to reverse your eye's dark adaptation. Also, since rods are relatively insensitive to red light, the use of red headlamps, or red cellophane taped over normal flashlights, allows the cones to function enough to assist with vision and yet maintain the dark adaptation of the rods.

Bibliography

Horenstein, Henry & Russell Hart, *Photography*, 2004, Prentice Hall, Upper Saddle River, New Jersey

http://ncar.ucar.edu

Jacobson, Sidney F., Ray, Geoffrey G. Attridge & Norman R. Axford, *The Manual of Photography*, 2000, Ninth Edition, Focal Press, New York and London

Johnson, Charles S., Jr., *Science for the Curious Photographer*, 2010, A.K. Peters, Ltd, Natick, Massachusetts

Knight, Randall D., *Physics for Scientists and Engineers*, Third Edition, 2013, Pearson, Glenview, Illinois

London, Barbara, Jim Stone & John Upton, *Photography*, Tenth Edition, 2011, Prentice Hall, Upper Saddle River, New Jersey

Sussman, Aaron, *The Amateur Photographer's Handbook*, 1973, Eighth Revised Edition, Thomas Y. Crowell Company, New York

Note

1 You probably have noticed that the LV levels of a scene can range from positive to negative values. There is no special significance to negative LVs; just like a negative temperature, a negative LV simply means one that is low. The zero in the LV scale is simply an arbitrary reference point and also has no special meaning.

11

CAMERA AND LENS SYSTEMS

Modern digital single-lens reflex (DSLR) cameras are truly masterpieces of technological innovation. Steadily improving year after year, today's DSLRs boast powerful sensors, sophisticated controls, and reliable performance at modest cost. The best news is that even entry level DSLRs today are easily capable of capturing the faint glow of the Milky Way, star trails, and the other nightscape images described in this book. The discussion on cameras in this book is confined to those with digital sensors, since they have largely replaced film in landscape astrophotography. This chapter will review the essential features of DSLRs that are the most important in landscape astrophotography. We will review characteristics of camera sensors, focus and metering modes, lens characteristics and selection, and factors that govern image sharpness.

CAMERA SENSOR

The camera sensor is the heart of every imaging system, Figure 11.1. It is your camera's retina. The sensor is responsible for converting the image that the lens produces into electrical signals that are digitally analyzed and stored on memory devices. The sensor is a semiconductor device that has been processed so that its surface contains millions of individual pixels. Each pixel is a tiny optoelectronic device, often measuring only a few micrometers in dimension. Pixels are either etched out of the original silicon wafer, built up with the deposition of additional layers of photosensitive and electronic materials, or both.

11.1 A typical camera sensor in a modern DSLR. The sensor is normally hidden behind the mirror, so it is not usually visible.

Incoming light is converted into electrical signals by each pixel in an analogous manner that the rods and cones in your eye's retina convert incoming light to biochemical signals. Furthermore, sensors contain red, green, and blue pixels, just like the red, green, and blue cones in your retina described in Chapter 10. The incident light upon each pixel is converted into an electrical signal representing the strength of the particular hue of light that the particular pixel received. By

examining the *relative* values of the signals from immediately adjacent red, green, and blue pixels, the actual color of light incident upon the pixels, or its hue, can be reproduced in the same way the light would be perceived by a human retina. The intensity of the light is determined by the *absolute* magnitude of the signals from each of the pixels.

The pixels in the sensors are optoelectronic devices. As such, they are inevitably susceptible to intermittent variations and false positives. Sometimes, they randomly indicate the presence of light when there is none. Other times, a high-energy photon or other cosmic ray may trigger an event that the pixel records as light. In yet other instances, separate measurements of the same light levels can yield slightly different results. In such cases, these artifacts are collectively known as noise, and are an undesirable, yet unavoidable consequence of digital imaging. The goal in imaging is to maximize the signal to noise ratio, or to limit the noise to a level that is so low that it is unnoticeable.

Sensors are characterized by several parameters, including the number of pixels they contain, their physical dimensions, and their signal-to-noise ratio. The number of pixels can be a very misleading parameter by itself, since small sensors can still contain a relatively large number of extremely small pixels. While such sensors can produce acceptable photographs under bright light conditions, they are prone to very noisy performance in low light conditions, and are typically unsuitable for significant enlargements. These sensors typically find their way into consumer electronics such as cell phones and security cameras where noise at low light levels is tolerable, and the need for enlargements rare.

DSLRs with larger sensors that contain a high number of relatively large pixels are best suited for landscape astrophotography. Such sensors are typically referred to as *full–frame*, compared to *crop sensors*, which are roughly two-thirds the size of full-frame sensors. Large, full-frame sensors generally have very good low-light performance with much less noise than smaller sensors with smaller pixels. The best way to evaluate a sensor for landscape astrophotography, other than by price, is by examining its noise levels in images created in low light conditions at high ISO settings, characterizations that are frequently available online.

HELPFUL CAMERA FEATURES FOR LANDSCAPE ASTROPHOTOGRAPHY

There are several helpful and even critical camera features for landscape astrophotography. The most important is the ability to create exposures using manually controlled settings, Figure 11.2(a) (overleaf). Specifically, you need to be able to independently set the ISO, aperture, and shutter speed. The second most important capability is the ability to manually focus the lens, which you will find yourself doing every night, Figure 11.2(b). Productive nightscape sessions are virtually impossible without these two vital camera features.

Having the ability to create quality images at the relatively high ISO settings of 3200, 6400, and even 12,800 is also helpful. Although such high ISOs are rarely used in other environments, they can be extremely valuable in landscape astrophotography. For example, you may find it helpful to create high ISO images of the night sky to blend in with low-ISO images of interesting foreground subjects, as described in Chapter 22.

11.2 Two key camera features you will want to have: (a) Manual exposure settings and (b) manual focus. Landscape astrophotography is nearly impossible without these features.

Many modern DSLRs have the ability to spot focus and spot meter. These are just as they sound; the camera uses a single spot to determine focus as well as to measure the light value of the scene. Some cameras give you the ability to move the spot that is used for focusing and metering within the field of view. The latter capability is helpful when creating blended images that require an in-focus night sky and a second image with an in-focus foreground. Focus can be achieved for both the night sky and foreground simply by moving the spot focus point, eliminating the need to physically move the camera or tripod. The resulting images are thus identical in composition and are easily combined during post-processing.

You will generally have several options available for releasing the shutter in landscape astrophotography: single-shot, continuous, time-delay, mirror-lockup, and interval timer operation. A single shot shutter release is the most straightforward: the exposure is made when the shutter release button is depressed. However, the slight movement, or shake, that inevitably occurs while depressing the shutter release button by hand can lead to a blurry image unless a remote release cable, Figure 18.4, or wireless trigger is used. The time delay feature found on most cameras is one way to avoid this blurriness: there is a 2 or 10 second delay after the shutter release button is depressed before the exposure is made. This delay allows the internal vibration within the camera to dissipate before the shutter opens, resulting in crisper photographs.

The mirror lockup option is a good method for eliminating internal vibration during image exposure in DSLRs, especially when combined with a cable release or wireless trigger. A normal exposure is automatically made in two distinct steps. First, the mirror is lifted out of the way and held there until the shutter is released, at which point the mirror drops back into place. The initial movement of the mirror can introduce internal vibrations and consequent blur during the long exposures of landscape astrophotography. When the mirror lockup option is exercised, both steps are done manually. The advantage is that vibrations introduced during the first step can be allowed to dissipate before the second step is performed. Using the mirror lockup option is worthwhile and should be used whenever feasible.

Finally, both the continuous and interval timer modes allow the creation of a series of exposures at regular intervals. Such images can be used to create star trail images and time-lapse videos, as explained in detail in Chapter 22.

FILE FORMAT

It is a near certainty that the DSLR you will use for landscape astrophotography will allow you to record your images in either a JPEG or RAW file format. I strongly urge you to consider the benefits of always using a RAW file format for your images henceforth, whether or not you also save a second copy in a JPEG format. The fundamental difference between these two file formats is in image quality. Images created in a RAW file format contain the maximum possible image information. The signal from each RGB channel of each pixel is separately measured and saved. In contrast, the vastly smaller size of JPEG files is achieved through significant averaging of values from adjacent pixels with similar signals, in other words, *file compression.* Unfortunately, file compression irreversibly deletes sometimes-valuable information through its process of averaging. While cumbersome and bulky, the extra size of RAW files provides the maximum latitude for post-processing of images.

LENS FOCAL LENGTH

There are a few key lenses that you will want to include in your landscape astrophotography arsenal. Each one has specific features that make it advantageous for specific instances. Lenses are characterized mainly by their *focal length, f.* The focal length is the distance between the center of the lens and the focal point for parallel incoming rays of light, Figure 11.3(a). It is an inherent property of the lens. The focal length should not be confused with the *subject focus distance, o,* which is the distance between the center of the lens and the subject, Figure 11.3(b). The focus distance changes

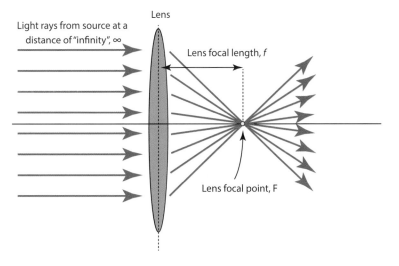

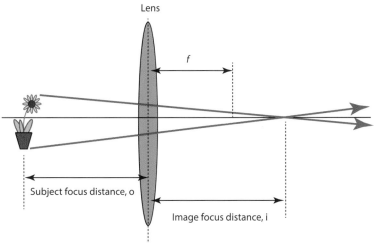

11.3 Ray diagram showing (a) focal length, *f*; focal point F; and (b) subject focus distance, o, and image focus distance, i. *Note the important distinction between subject distance and focal length*; these two terms are frequently confused. The focal length is the distance between the center of the lens and the focus point for parallel incoming rays of light. It is an inherent property of the lens and does not change. The subject distance, o, is the distance between the center of the lens and the subject, and can vary between a few inches to infinity. The image focus distance, i, is the distance between the center of the lens and the image of the subject, and it depends on the subject focus distance, o.

with each subject, and can range from a few inches to infinity, whereas the focal length is a fixed property of the lens and never changes.[1] Put another way, three lenses with focal lengths of 16 mm, 50 mm and 200 mm, respectively, can all have the same subject focus distance of 35 feet for a subject 35 feet away from the center of the lens, even though their focal lengths are all different.

FIELD OF VIEW

The focal length is an extremely important parameter. It controls many other key lens characteristics, including its field of view (FOV), Figure 11.4(a). The FOV is the angle between lines connecting the camera to opposite sides of the image. Telephoto lenses have a very narrow FOV of only a few degrees, while wide-angle lenses can have FOVs well over 100°, Figure 11.4(b). The fields of view of common landscape astrophotography lenses for a full-frame camera are given in Table 11.1. In addition to influencing the overall feel of your composition, Figure 11.5, the FOV can be very important in planning the basic feasibility of a given nightscape project. For example, knowing the FOV of your lens can help determine whether or not a certain combination of constellations will fit into a single image created by that lens, or whether the north star will fit into the same image as the horizon during a star trail composition, e.g. Figure 16.12.

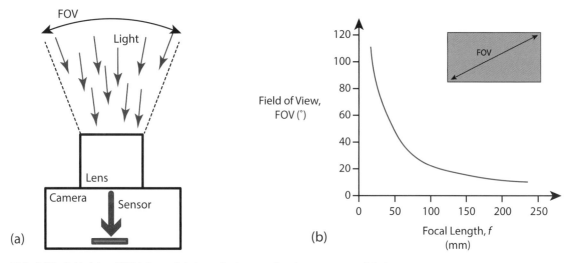

11.4 (a) The field of view (FOV) is the angle between the two opposite edges, or corners, of the image. (b) Graph showing how the diagonal FOV depends on the focal length of the lens. Telephoto lenses have very narrow FOVs; wide-angle lenses, as their names suggest, have very large FOVs.

FOCAL LENGTH (MM)	WIDE (°)	NARROW (°)	DIAGONAL (°)
14	104	81	114
24	74	53	84
35	54	38	63
50	40	27	47
70	29	20	34
100	20	14	24
200	10	7	12

Table 11.1 Field of view (FOV) angles for 4:3 sensors for different focal lengths ($f = \infty$)

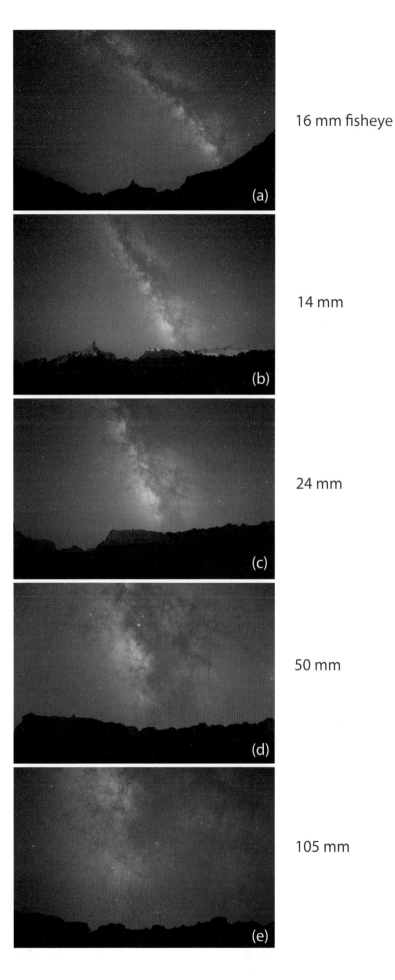

16 mm fisheye

14 mm

24 mm

50 mm

105 mm

11.5 The galactic core region of the Milky Way viewed through lenses with different focal lengths, from a 16 mm fisheye lens to a 105 mm medium-range telephoto. The different FOVs of the lenses result in dramatically different appearances of the Milky Way.

(a)

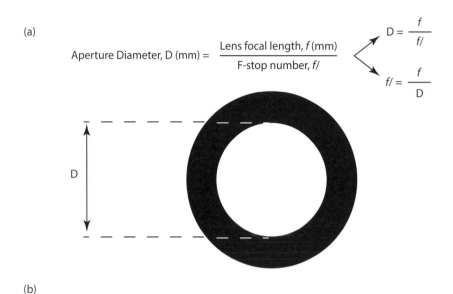

$$\text{Aperture Diameter, D (mm)} = \frac{\text{Lens focal length, } f \text{ (mm)}}{\text{F-stop number, } f/}$$

$$D = \frac{f}{f/}$$

$$f/ = \frac{f}{D}$$

(b)

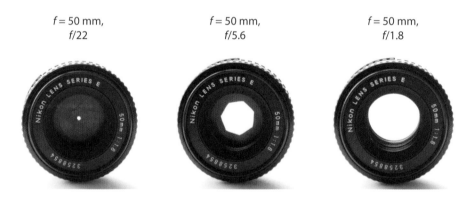

$f = 50$ mm, $f/22$

$f = 50$ mm, $f/5.6$

$f = 50$ mm, $f/1.8$

11.6 Definition of the lens aperture, A, in terms of its f-stop number, $f/$ and focal length, f. (b) Photographs of a 50 mm lens set to apertures of $f/22$, $f/5.6$ and $f/1.8$.

APERTURE

The maximum possible aperture, or the smallest f-stop, of the lens is another key lens criterion. The f-stop is calculated by dividing the focal length of the lens, f, by the diameter of the aperture, D, Figure 11.6(a). For example, a lens with a focal length of 100 mm and an aperture set to a physical dimension of 25 mm will thus have a f-stop of 100 mm/25 mm = $f/4$. The reason behind the nomenclature of the f-stop, $f/$, is now clear; the diameter of the aperture is defined as focal length, f, divided by, or "/", the f-stop number. Thus: $f/$!

You can also now appreciate why lenses that have a smaller minimum f-stop are so much more expensive; they simply use more glass that must be shaped and polished to optical perfection over a larger lens potential opening. To see an example of this difference, let's consider two 35 mm lenses, one with a minimum f-stop of 1.4 and the other with a minimum f-stop of 4.5, such as those commonly sold as a kit lens with entry-level DSLRs. For the first lens, the maximum aperture (minimum f-stop) is 35 mm/1.4 = 25 mm, or approximately one inch. For the second lens, the maximum aperture is 35 mm/4.5 = 7.8 mm, or only about one-third of an inch. The second lens, therefore, uses *much* less glass and thus is inherently cheaper and less demanding to manufacture.

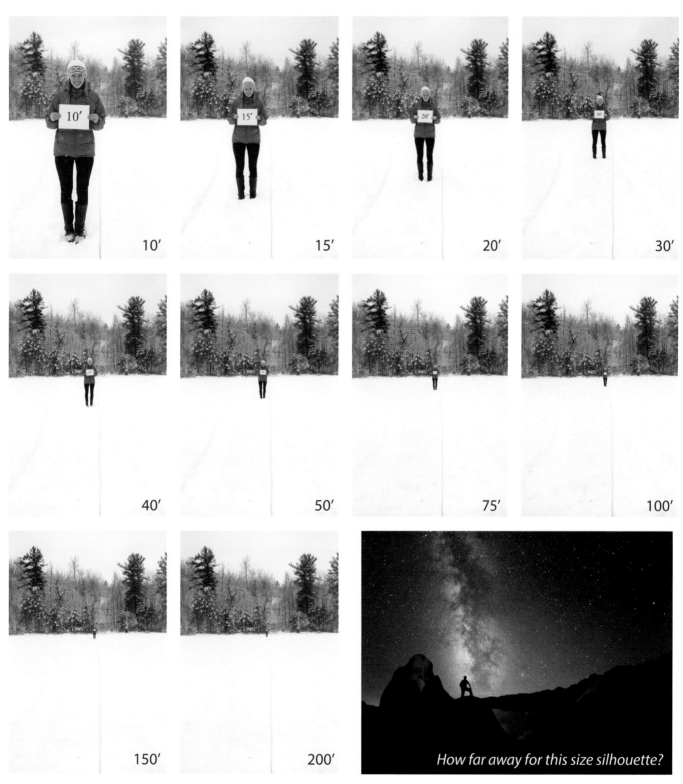

11.7 Illustration of how the subject distance affects the size of a person's silhouette for an image made with a 50 mm focal length lens. Subject distances of 5–200 feet are shown.

SUBJECT DISTANCE

When choosing a lens and subject distance combination for landscape astrophotography, one important issue that bears consideration is the size of your foreground subject within your composition. Here's an example: consider the image of the galactic core of the Milky Way along with a small silhouette of a person shown in Figure 11.7. The key to this image's success lies in positioning the person at the correct subject distance so that their silhouette appears relatively small. But how to know the best distance? To answer this question experimentally, examine the daytime exercise shown in Figure 11.7. Here, I simply photographed a person at different subject distances using the same lens, Figure 11.7. The Milky Way image was then made after selecting the correct subject distance for the appropriately sized silhouette in the composition.

IMAGE SHARPNESS

The aperture setting affects the resultant image's overall sharpness and quality, even when in perfect focus. There are two competing phenomena that cause this result: lens imperfections at minimum aperture and diffraction at maximum aperture.

When the aperture is wide open, i.e. at its minimum value, light passes through nearly the entire body of the lens to reach the sensor. In contrast, when the aperture is set to higher values, for example $f/8$, or $f/11$, we say that the lens is "stopped down" and the physical size of the aperture is smaller. The aperture now blocks incoming light from the periphery of the lens, so that only light that impinges upon the central region of the lens is able to pass into the camera.

The front surface of any lens at its periphery is naturally more curved than its center, which is nearly flat. A number of unavoidable lens imperfections, specifically, *spherical aberrations*, *chromatic aberrations*, and *coma* become important as the result of the greater lens curvature accessed at minimum aperture. Spherical aberration causes a noticeable softening of the focus in the image. It results from the inability of light from the entire front surface of the lens to converge precisely at a single point within the image. Chromatic aberration is an optical phenomenon with its origins in the wavelength-dependent refractive index of optical glass. Images exhibiting chromatic aberration exhibit noticeable colored fringes surrounding bright objects, such as stars. Coma is the result of light sources, such as stars, that are located around the periphery of the images failing to focus in a single point but rather in a flare-shaped area at minimum aperture, and has its origins in the spherical aberration described above. Finally, *lens vignetting* becomes more pronounced at minimum aperture since off-axis light travels through more glass and decreases in intensity, coupled with the tendency of the lens housing to partially block light entering near the lens periphery. Even the very best lenses exhibit these various effects at minimum aperture, although their effects are far more pronounced at the lowest minimum apertures, e.g. $f/1.4$ or $f/2.0$.

In contrast, at the very minimum aperture dimension, i.e. maximum f-stop (e.g. $f/22$), the aperture diagram is now reduced to a narrow restriction, Figure 11.6(b). In this case, *optical diffraction* occurs around the edges of the diaphragm blades, producing noticeable softening of the image focus. Although diffraction occurs at any aperture setting, its effects become minimized by the relative abundance of light from the bulk of the lens far from the diaphragm blades at wider apertures.

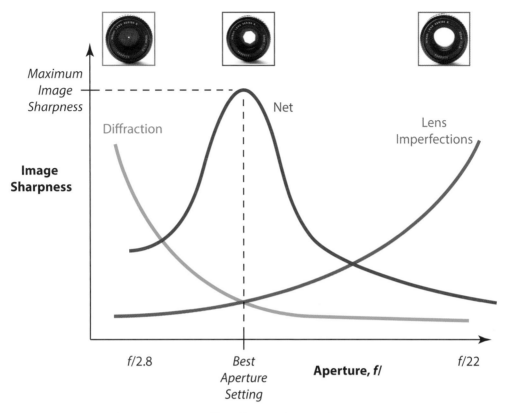

11.8 Schematic diagram showing the competing effects of lens imperfections and diffraction on the overall image sharpness and quality for different aperture settings. The best image sharpness is usually obtained between two and three stops above the minimum aperture setting for the lens; most important for extremely low minimum aperture lenses, e.g. *f*/1.4.

The qualitative effects of lens imperfections, diffraction, and the net result of both on image sharpness for different aperture settings are shown schematically in figure 11.8. The least distortion from lens imperfections occurs at high f-stops, e.g. *f*/22, but is significant at low f-stops. In contrast, the least distortion from diffraction occurs at low f-stops, e.g. *f*/2.8, but is limiting at high f-stops. Consequently, the *overall* sharpest image is achieved somewhere in between, and a good rule of thumb is that it is achieved around two exposure stops above the minimum f-stop. For example, if a lens has a minimum f-stop of *f*/2.8, then the sharpest images will be achieved at an aperture of *f*/5.6; for one with a minimum aperture of *f*/4, the sharpest image will be achieved at *f*/8, and so on. A practical example showing the image sharpness over the complete range of possible aperture settings is shown in Figure 11.9 (overleaf); you may wish to repeat this exercise yourself with your preferred lenses to identify the best aperture for your equipment.

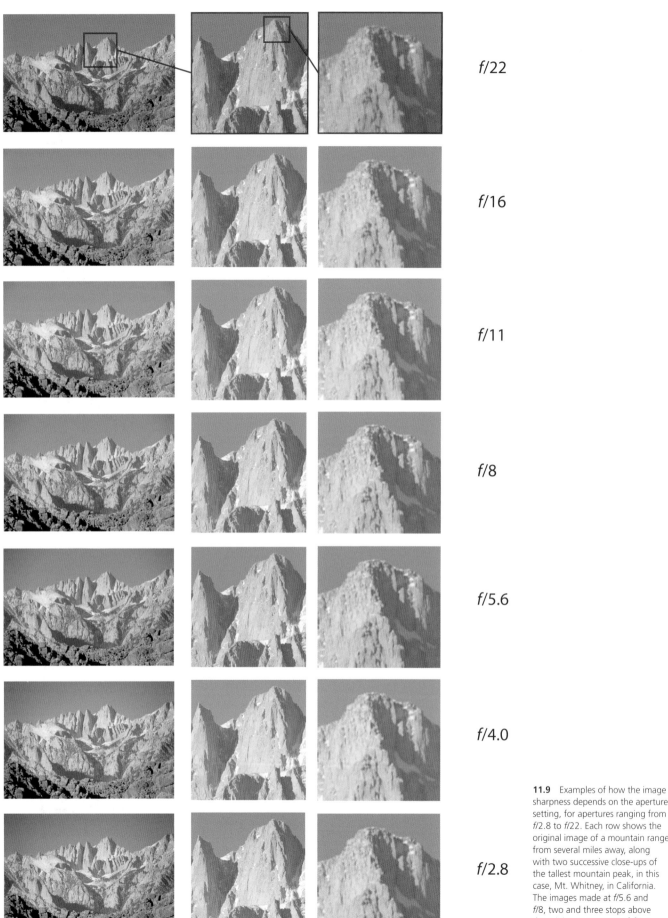

f/22

f/16

f/11

f/8

f/5.6

f/4.0

f/2.8

11.9 Examples of how the image sharpness depends on the aperture setting, for apertures ranging from f/2.8 to f/22. Each row shows the original image of a mountain range from several miles away, along with two successive close-ups of the tallest mountain peak, in this case, Mt. Whitney, in California. The images made at f/5.6 and f/8, two and three stops above the minimum aperture of f/2.8, respectively, are the sharpest.

FOCUSING

Learning how to achieve a good focus in the dark, whether it is on the stars, or on foreground subject, is probably the most difficult challenge to confront landscape astrophotographers. It is very important to learn how to achieve and confirm the best focus possible. While the compressed JPEG image on your camera's rear screen may look perfectly acceptable, examination at full scale on a monitor may reveal an image with visibly out-of-focus stars. The table of brightest targets provided in Table 2.1 may help. Examples of images that all appear to have suitable focus at low magnification but reveal unfocused stars upon closer examination are shown in Figure 11.10. The practicalities of achieving focus in that field are described in Chapter 20.

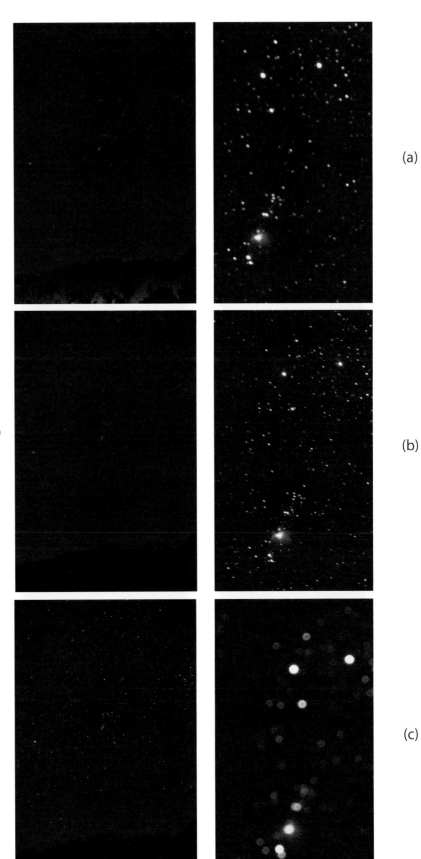

(a)

(b)

(c)

11.10 Three different examples of focus: (left) all three appear to have acceptable focus, yet when viewed at higher magnifications, only the image in the middle had acceptable focus. It is crucial to establish a crisp, tack-sharp focus each and every time to perform your nightscape photography.

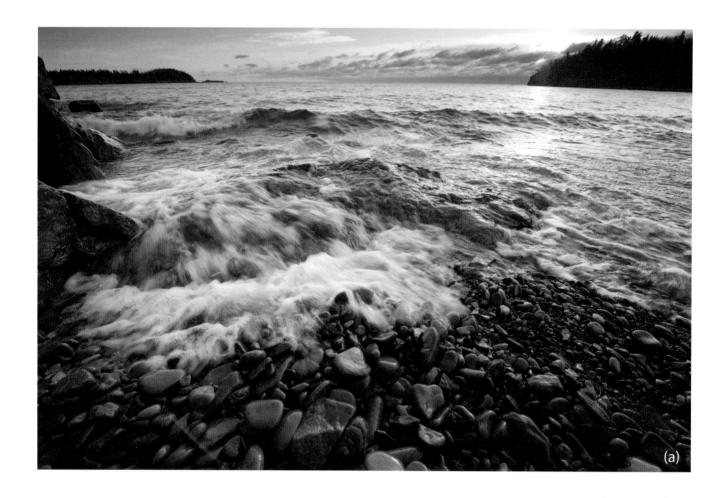

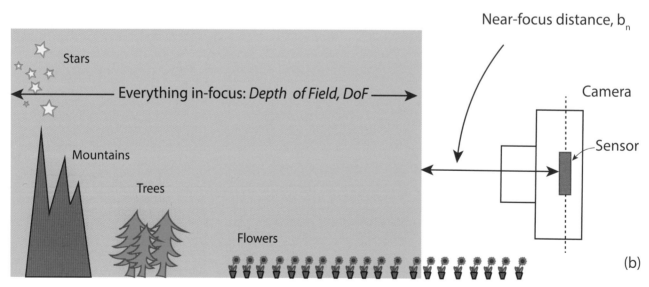

11.11 (a) A quality image has a complete focus from objects close to the camera all the way to the horizon. (b) When focused on the horizon, the limiting factor is the near focus distance, b_n, or the distance between the camera and the closest in-focus object. We are interested in knowing b_n for scenarios in which the night sky is in focus so that we can create images with a sharp focus throughout the entire image. We do this simply by ensuring that the closest foreground object in the image is further away from the camera than the near focus distance, b_n.

OPTICS OF FOCUS

Nightscapes are appealing precisely because of their in-focus foreground coupled with an in-focus night sky. Foreground objects can be out of focus if they are too close to the camera when the lens is focused on the sky, Figure 11.11(a). This section describes the two main approaches to reliably achieving sharp focus across the entire image—what to set and what to guard against.

In order to understand the camera and lens settings that control the near focus distance, let's introduce a few parameters needed to describe the physics behind the optics of focus, Figure 11.12 (overleaf). We've already introduced the *object focus distance*, o, and the *lens focal length, f*. The *depth of field* (*DOF*) is the distance between the *far and near focus points, b_f, and b_n*; Figure 11.12, middle and bottom, respectively.

Second, we will assume the night sky lies at an infinite distance from the camera.

Finally, we need to introduce the term, *circle of confusion* (*CoC*). The CoC is simply the size, or diameter, of the smallest circle that is resolvable by your camera's sensor. Put another way, if a distance corresponding to the CoC separates two tiny dots of light on your sensor, they are distinguishable as two separate dots. If they are moved any closer together, they blend into a single dot.

You may like to think of the CoC as the resolution limit of your camera's sensor. It is roughly equivalent to the pixel dimension, or alternatively, as the approximate size of the rod and cone cells in your eye's retina. Consequently, it makes sense that if two tiny dots of light are incident on a single cone cell, there is no way for that cell to know if there are two dots of light, one dot of brighter light, or even eighteen dots of dimmer light! In contrast, if the two dots of light are placed on two separate cells, then they are easily distinguishable.

Objects appear in focus if each point within them is focused to a spot smaller than the CoC, since they can then be distinguished by separate pixels. They appear blurred, or out-of-focus if their focused spot is larger than the CoC, and thus spread over more than a single pixel. Consequently, the DOF is determined simply by the distance between the closest, and farthest away objects whose images are focused to spots smaller than the CoC, Figure 11.12(middle) and (bottom).

The first approach to achieving sharp focus across the entire image is to focus directly on a star, a planet, or the moon, Figure 11.13(a). These objects are effectively at a subject distance of infinity. The next step is to look up the near focus distance for the relevant combination of lens focal length and aperture setting. Examples of the near focus distance for different combinations of lens focal length and aperture are shown in Figure 11.14 for a typical Nikon DSLR camera with a full-frame sensor. Near focus distances can be readily calculated for other cameras by using the planning apps described in Chapter 17. Being sure that all the foreground elements within your composition are further away from the camera than this distance will ensure that they remain in focus while your camera is focused on the sky.

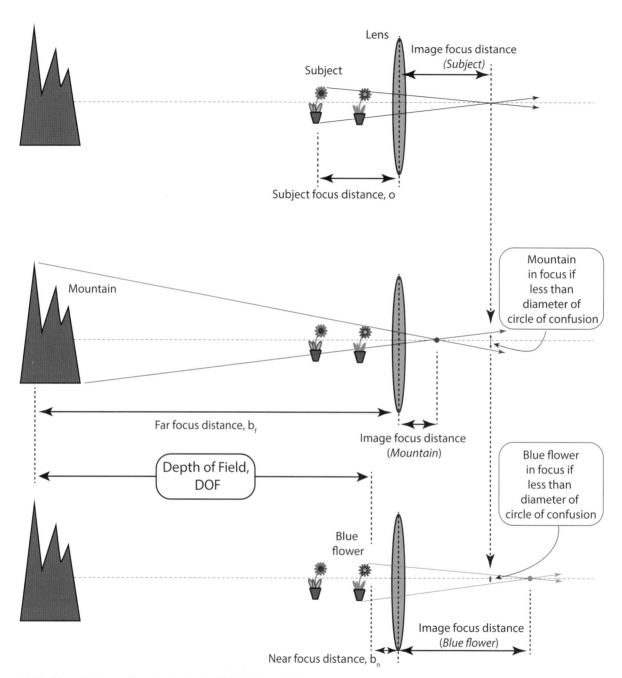

11.12 Schematic diagrams illustrating the depth of field (DOF), or the distance between the *near and far focus distances, b_n and b_f,* respectively. Each of these is determined by the positions of the closest and farthest away subjects whose images are comprised of focused spots smaller in size than the sensor's *Circle-of-Confusion*, or *CoC*, as described in the text.

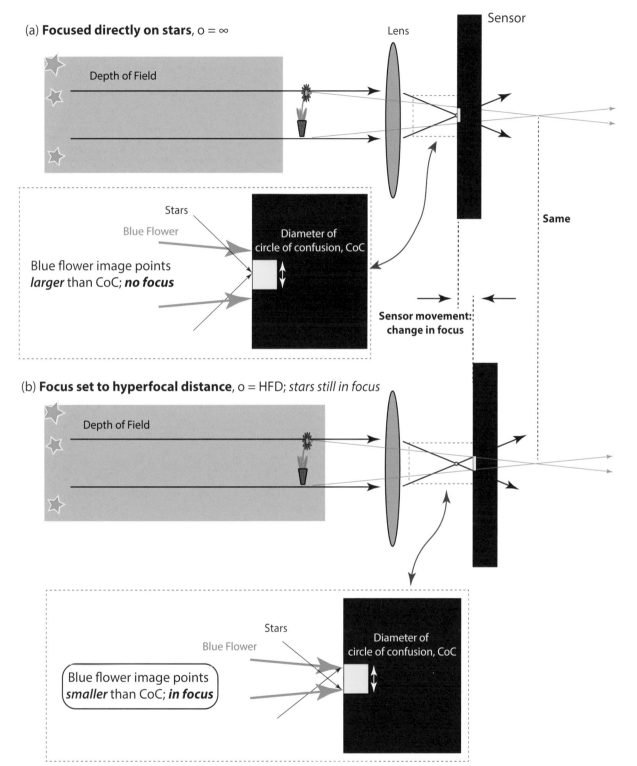

(a) Focused directly on stars, o = ∞

Depth of Field

Lens

Sensor

Same

Stars

Blue Flower

Diameter of
circle of confusion, CoC

Blue flower image points
larger than CoC; ***no focus***

Sensor movement:
change in focus

(b) Focus set to hyperfocal distance, o = HFD; *stars still in focus*

Depth of Field

Stars

Blue Flower

Diameter of
circle of confusion, CoC

Blue flower image points
smaller than CoC; ***in focus***

11.13 Two main methods of focusing: (a) focusing directly at infinity; (b) hyperfocal focusing. The benefit to hyperfocal focusing is that it allows the maximum possible DOF with distant objects *even though the camera is not focused directly on them*. This occurs since their images are all made up of individual points all smaller than the camera's CoC (inset).

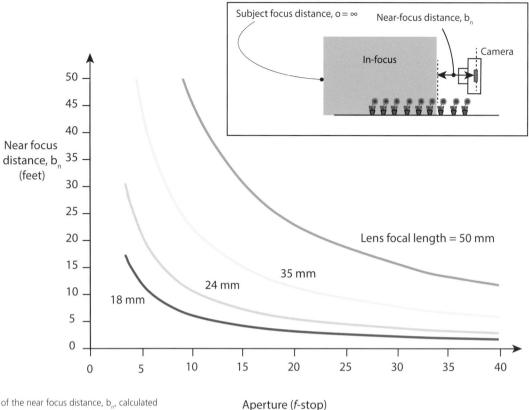

11.14 Graphs of the near focus distance, b_n, calculated for different combinations of lens focal length and aperture settings in a full-frame camera.

You may be interested to observe how the near focus distance decreases significantly as the aperture increases, as can be seen from Figure 11.14. Simply changing from $f/5$ to $f/10$ essentially cuts the near focus distance in half! Unfortunately, much landscape astrophotography is performed at low f-stops with a correspondingly significant near focus distance. Consequently, it is well worth having a good estimate for the near focus distance for the combination of lens and aperture you're using if you follow this method.

The second method is to set your camera's object focus distance, o, to the *hyperfocal distance* for the relevant combination of lens focal length and aperture, Figure 11.13(b). In this method, the near focus distance is exactly one-half the hyperfocal distance. The hyperfocal distance has been calculated and is readily available for nearly every combination of focal length lens and aperture, Table 11.2. This method is referred to as *hyperfocal focusing*.

FOCAL LENGTH (MM)	HYPERFOCAL DISTANCE (FT)							
	f/2.0	*f*/2.8	*f*/4	*f*/5.6	*f*/8	*f*/11	*f*/16	*f*/22
14	11	8	5	4	3	2	1.5	1
20	21	16	11	8	6	4	3	2
24	32	22	16	11	8	6	4	3
35	67	47	34	24	17	12	9	6
50	136	97	69	49	34	24	17	12
70	268	190	134	95	67	48	34	24

Table 11.2

The benefit to hyperfocal focusing is that it allows the maximum possible DOF with distant objects still in focus. The key to hyperfocal focusing is that the far away objects remain in focus *even though the camera is not focused directly on them*. This occurs since their images are made up of individual points all smaller than the camera's CoC. In turn, objects relatively close to the camera remain in focus, since their images also are made up of points smaller than the CoC, as shown by the inset in Figure 11.13(b). In contrast, for the first method of focusing directly on the stars, the near-focus distance increases. Objects that were in focus through hyperfocal focusing, Figure 11.13(b), are now out of focus, as shown by the inset in Figure 11.13(a). Their images are made up of points larger than the CoC, and hence appear blurry.

Hyperfocal distance focusing is a very powerful and helpful method of setting focus for landscape astrophotography. Once the combination of lens and aperture is established, all you need to do is to set the focus distance of your lens to the hyperfocal distance. The near focus distance is just one-half the hyperfocal distance. All that's left is to ensure that the closest foreground object in your composition is further away from the camera than this near focus distance.

LENS SELECTION

My first forays into choosing lenses many years ago were memorable experiences. I was immediately bewildered by the variety of choices! I knew there must be some very important differences between lenses of such different focal lengths, but I had no idea what they were. Only after study and experimentation did I begin to develop an intuitive sense of which lens to select under which circumstance. The set of images shown in Figure 11.15 show one set of experiments exploring different focal length lenses similar to the exercise in Figure 11.5; you may wish to create your own, similar set of images with your own range of focal length lenses. You will develop an immediate sense of the strengths and limits of each focal length lens in doing so.

Several of the more common focal length lenses are described in the following sections. This list is certainly not exhaustive, and as is the case throughout the book, only feature Nikon lenses since those are the ones with which I have the most familiarity. Having owned multiple Nikon, Canon, and Panasonic camera and lens systems over the years, in all cases with satisfaction, my only recommendations are that you should pick the camera system based on your own needs and preferences, without undue influence from anyone else!

The following focal length specifications are for full-frame cameras. These focal lengths should be reduced by a factor of approximately one-third for crop sensor cameras for the purposes of comparison. Thus, a 35 mm lens on a full-frame camera would be the equivalent of a 24 mm lens on a crop sensor camera.

FISHEYE

The fisheye lens stands apart in its ability to pull in the night sky, Figure 11.16. Although it tends to produce significant image distortion, it is unsurpassed in its ability to capture an extraordinary range of the night sky in a single image. With a diagonal FOV that approaches 180°, it is especially useful in photographing the aurorae as well as the Milky Way. The full-circle fisheye lens, e.g. 8 mm, while distinctive, also has many applications within landscape astrophotography: meteor showers, the aurorae, and 360° panoramas.

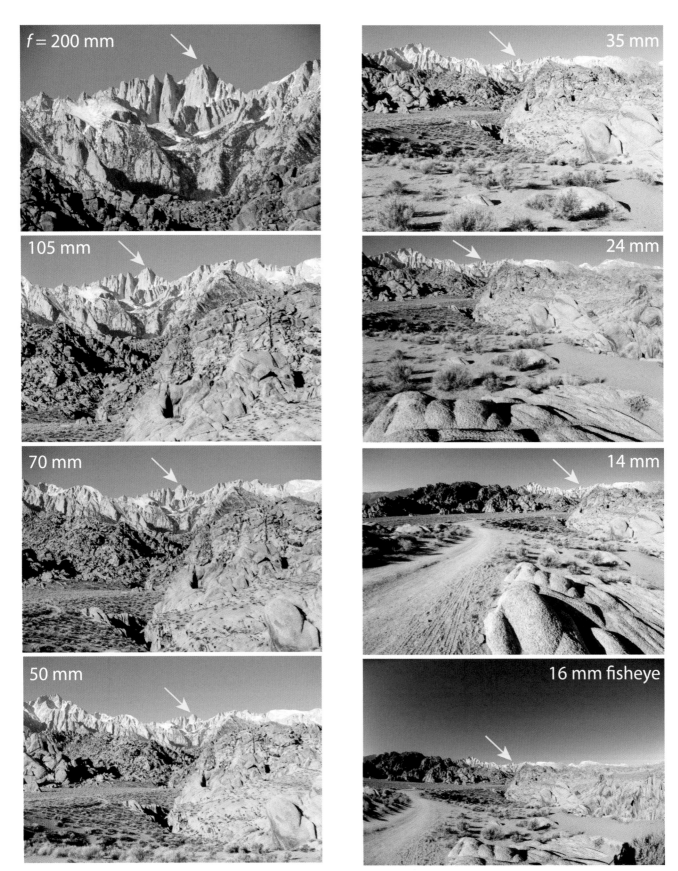

11.15 These images show the results of experiments exploring different focal length lenses. All images were made from the identical tripod position within a few minutes of each other. The yellow arrow depicts Mt. Whitney, visible in each of the images.

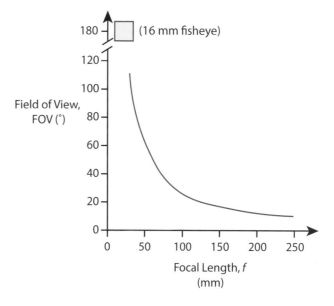

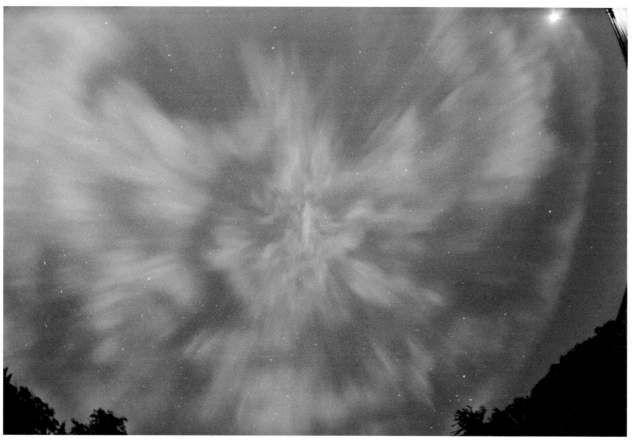

11.16 The fisheye lens. This lens is superb at capturing the widest possible swath of the sky and foreground in a single image, as illustrated here for an auroral corona. The setting crescent moon is visible in the upper right.

WIDE-ANGLE LENSES—14–24 MM

Wide-angle lenses in the 14–24 mm focal length range are favorites of most landscape astrophotographers. Without the major distortion of the fisheye lens, wide-angle lenses can simultaneously capture wide swaths of the night sky and relatively undistorted foreground subjects in a single image, Figure 11.17. They excel at capturing sunsets and sunrises; Milky Way images, star trails, meteor showers, and nightscapes of the aurora. Images involving the rising or setting of the full moon, however, are best shot with longer focal length lenses, since the moon becomes lost in such a wide FOV.

Lenses in this focal length range are available as either prime or zoom lenses. They are also available with a range of apertures, some as low as f/1.4. Depending on your budget, these lenses are excellent investments, and rarely fail to satisfy.

24–70 MM FOCAL LENGTH

Owing to their more restricted FOV, lenses in the 24–70 mm range tend to be chosen when specific night sky objects make up the essence of the composition, Figure 11.18. They make excellent choices for nightscapes involving the rising and setting of the full moon, star trails, and images including the galactic core of the Milky Way. They are also valuable when photographing local regions of the aurora. Finally, they are perfect for creating images used for panoramas.

Another advantage of lenses in this focal length range is that they are widely available as prime lenses with very low minimum aperture, some as low as f/1.2, Figure 11.19. The fully manual versions of these wide aperture lenses are also quite inexpensive and are very well worth considering since you will rarely be using auto focus during your night sky forays. Combining two or more images from such lenses in a panorama can offset the substantial coma distortions that occur at the lowest aperture settings. The central, sharpest regions are preserved, along with the extraordinary light-capturing ability of these lenses.

GREATER THAN 70 MM

Lenses with a focal length above 70 mm are relatively uncommon in landscape astrophotography, Figure 11.20. One reason is that many night sky objects are simply too large to fit into their relatively restricted FOV. Another reason is that relatively short exposure times are necessary to avoid significant streaking or trailing of stars, as described in more detail in Chapter 22.

One area where these focal length lenses excel, however, is in creating nightscapes involving the rising and setting of the full moon. In such compositions, the requisite relatively short exposure times coupled with the need to isolate the area of the full moon rising or setting are both perfectly satisfied by lenses with relatively long focal lengths.

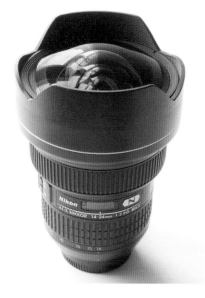

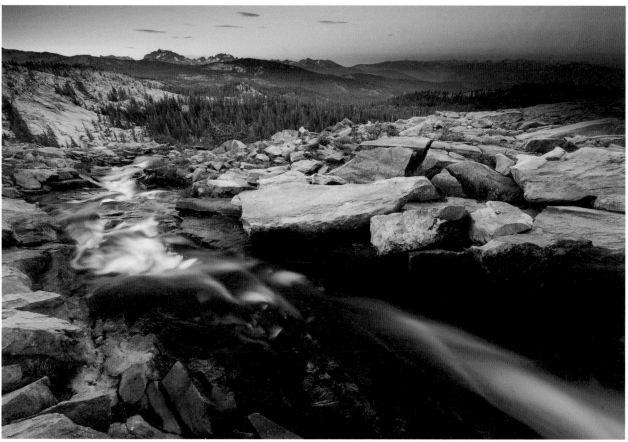

11.17 The wide-angle lens (14–24 mm). This is an incredible lens for landscape astrophotography. It captures an extraordinary amount of the scene with minimal distortion. It will no doubt become one of your favorite lenses.

Field of View, FOV (°)

Focal Length, f (mm)

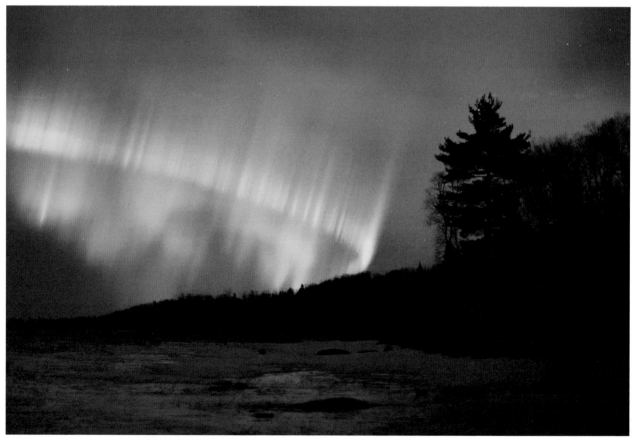

11.18 Lenses with focal lengths in the 24–70 mm range are used somewhat less frequently in landscape astrophotography; limitations more easily arise with star streaking. Yet, they do find application in relatively bright situations, including compositions involving sunsets/sunrises, twilight, the full moon, and aurorae. They are also an excellent choice for creating images used in panoramas.

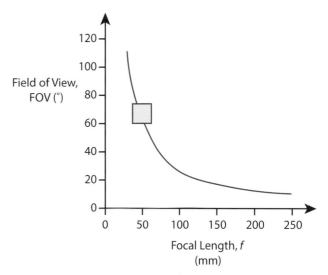

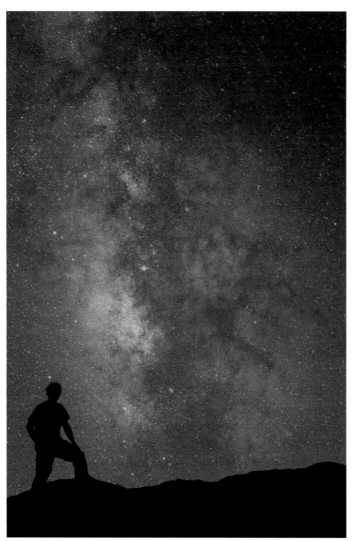

11.19 The 35 or 50 mm prime lens. These lenses are often surprisingly inexpensive, yet available with extremely low minimum apertures: *f*/1.8 or even *f*/1.2! These lenses are excellent at capturing specific foreground subjects set against the night sky and can create terrific input images for multi-image panoramas.

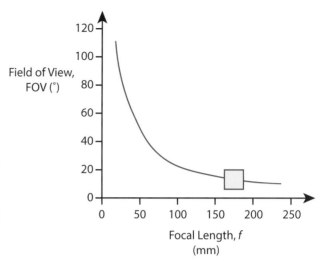

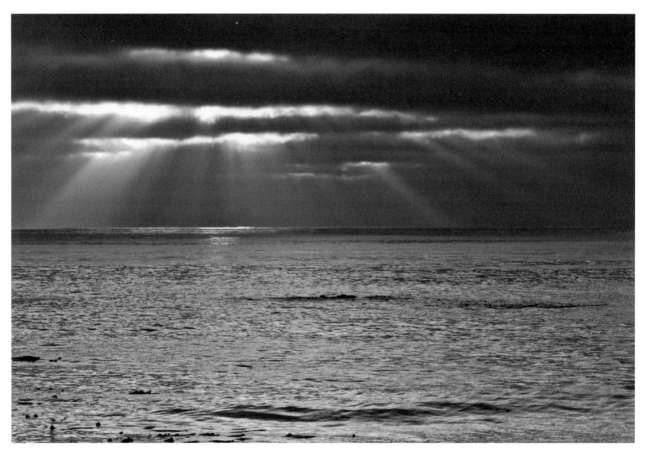

11.20 Lenses with focal lengths above 70 mm, such as the 70–200 mm zoom lens shown here, are rarely used in landscape astrophotography, except for specialized instances in bright conditions, such as sunsets, sunrises, and the full moon rising or setting.

PRIME VS. ZOOM—WHAT'S THE DIFFERENCE?

No discussion of lens selection would be complete without a mention of the choice between a prime lens with the same focal length as with a high-quality zoom lens. The answer has two components. The first is that a prime lens can usually be acquired with a substantially smaller minimum aperture (e.g. *f*/1.0 or *f*/1.4 instead of *f*/2.8) than a zoom lens with the same focal length. This is extremely important for landscape astrophotography, since so much of our work is done at or near minimum aperture settings. As will be seen in the next chapter, the ability of exposing at an aperture of, say, *f*/1.0 instead of *f*/2.8 is the same as being able to expose with an ISO setting of 800 instead of 6400! This can result in a significant difference in image quality.

The other major advantage to prime lenses (as well as small-range zoom lenses, e.g. 14–24 mm), is optical quality. Zoom lenses require substantially more components within the lens in order to function than a prime lens, consequently there simply tends to be slightly more image distortion around the periphery of the images in zoom lenses with the same focal length as a prime lens.

One disadvantage of prime lenses is that they necessitate frequent lens changing in order to alter the focal length of a composition. This can be very problematic in the field, owing to the likelihood of introducing dust and other debris into the camera during the process. Another disadvantage is cost—top quality prime lenses are often not available for as much of a price discount as one would imagine. Finally, an arsenal of prime lenses is expensive, difficult to easily change the composition without moving significantly, and difficult to transport. Personally, I have found that the advantages of a high-quality prime lens to be significant in very specific cases, but certainly not all.

Bibliography

Bair, Royce, *Milky Way Nightscapes*, 2015, RoyceBair.com (ebook)

Dyer, Alan, *How to Photograph Nightscapes and Timelapses*, 2014, Amazing Sky (ebook)

Freeman, Michael, *The Photographer's Eye*, 2007, Focal Press, New York and London

Freeman, Michael, *Perfect Exposure*, 2009, Focal Press, New York and London

Horenstein, Henry & Russell Hart, *Photography*, 2004, Prentice Hall, Upper Saddle River, New Jersey

Hunter, Fil, Steven Biver & Paul Fuqua, *Light, Science and Magic*, 2007, Third Edition, Focal Press, New York and London

Jacobson, Ralph E., Sidney F. Ray, Geoffrey G. Attridge & Norman R. Axford, *The Manual of Photography*, 2000, Ninth Edition, Focal Press, New York and London

Johnson, Charles S., Jr., *Science for the Curious Photographer*, 2010, A.K. Peters, Ltd, Natick, Massachusetts

Kelby, Scott *The Digital Photography Book, Volume 1*, 2007, Peachpit Press, USA

Kelby, Scott, *The Digital Photography Book, Volume 2*, 2007, Peachpit Press, USA

Kingham, David, *Nightscapes*, 2014, Craft & Vision, Vancouver, Canada

Knight, Randall D., *Physics for Scientists and Engineers*, 2013, Third Edition, Pearson, Glenview, Illinois

London, Barbara, Jim Stone & John Upton, *Photography*, 2011, Tenth Edition, Prentice Hall, Upper Saddle River, New Jersey

Peterson, Bryan, *Understanding Photography Field Guide*, 2004, Amphoto Books, New York, New York

Peterson, Bryan, *Understanding Exposure*, Revised Edition, Amphoto Books, New York, New York

Sussman, Aaron, *The Amateur Photographer's Handbook*, 1973, Eighth Revised Edition, Thomas Y. Crowell Company, New York

Wu, Jennifer & James Martin, *Photography: Night Sky*, 2014, Mountaineers Books, Seattle, Washington

Note

1 Not to be confused with the variable focal lengths of a zoom lens, which allows the user to change the focal length of the lens. In this discussion we're keeping the zoom setting, i.e. the focal length, fixed, and allowing the subject distance to change.

EXPOSURE

Knowledgeable exposure is the core skill of quality photography. Achieving the right combination of light and shadow that matches, or even amplifies, your artistic vision is the essence of success. In this chapter, we will focus on what you need to know about photographic exposure to truly master landscape astrophotography.

CAMERA EXPOSURE VALUE, EV, AND MATCHING EV TO LV

The primary photographic challenge, especially in landscape astrophotography, is to collect the right amount of light to produce a properly exposed image, regardless of the amount of light originating from the scene. Historically, a "properly exposed" image is one with an overall brightness that is 18 percent gray, or 18 percent of the way between black and white. When we view scenes with differing light values with our eyes, our vision system handles this light collection and conversion process automatically; for example, our irises dilate/contract and our retinas become more or less sensitive. In photography, however, this process is done by the photographer, and is accomplished by setting the *exposure value* (EV) of the camera to correspond to the light value (LV) of the scene, Chapter 10. The EV depends mathematically on the ISO, I, aperture, A, and shutter speed, T, according to the logarithmic relationship:

$$EV = \log_2 \left(\frac{A^2}{I - T} \right) \qquad \text{(Eq. 12.1)}$$

Several tables of camera EVs calculated for different ISO, aperture, and shutter speed combinations are shown in Figure 12.1. These results make it clear that there are many possible combinations of different exposure settings that result in the identical EV. To summarize, when we match the camera EV to the scene LV, we are assured of obtaining a correctly exposed image, i.e. one that is *on average* 18 percent gray, even if the subject scene is extremely dark or bright. The overall brightness of the resultant image will be the same.

Now, in practical terms, rarely, if ever, will you need (or want) to actually calculate your camera's numerical EV, since your camera's built-in light meter and analysis system does all the work for you. Instead, by taking a light meter reading of the scene of interest, you will be shown whether your current combination of ISO, aperture, and shutter speed is suitable to match the scene LV, or if it is too high or too low and you might wish to make adjustments. However, your understanding of: (a) the LV levels of typical landscape astrophotography scenes and (b) what combinations of ISO, aperture, and shutter speed are available to match them will be of enormous value in planning and avoiding a frustrating night of trial-and-error in the field while your subjects slowly slip below the horizon in front of your eyes!

By way of example, imagine that we want to create a nightscape image with the Milky Way on a moonless night, e.g. Figure 8.1. We know from Table 10.1 that scenes such as these typically have an LV in the range of approximately -8 to -5. Therefore, we know that in order to match this light value to obtain a properly exposed image, we should set our camera to a corresponding EV of approximately -5. If our camera's EV setting is set to correspond to a much dimmer LV, for example -12, the resultant image will be too bright. This is because the camera is set to receive less light than it actually would receive, like walking around in daylight with dilated pupils. On the other hand, if the camera's EV setting is too high, say -2, then the resultant image will be too dark. In this case, the camera requires more light than is available for a properly exposed image. From Figure 12.1, we see that we can choose any of the following combinations; all of which produce a camera EV equal to -5:

Aperture, f/

ISO = 100 — Shutter Speed, t (sec. or min.)

sec/min	2.8	4	5.6	8	11	16	22
0.1 sec	6	7	8	9	10	11	12
0.3 sec	5	6	7	8	9	10	11
0.5 sec	4	5	6	7	8	9	10
1 sec	3	4	5	6	7	8	9
2 sec	2	3	4	5	6	7	8
4 sec	1	2	3	4	5	6	7
8 sec	0	1	2	3	4	5	6
15 sec	-1	0	1	2	3	4	5
30 sec	-2	-1	0	1	2	3	4
60 sec	-3	-2	-1	0	1	2	3
2 min	-4	-3	-2	-1	0	1	2
4 min	-5	-4	-3	-2	-1	0	1
8 min	-6	-5	-4	-3	-2	-1	0
15 min	-7	-6	-5	-4	-3	-2	-1
30 min	-8	-7	-6	-5	-4	-3	-2

ISO = 200 — Shutter Speed, t (sec. or min.)

sec/min	2.8	4	5.6	8	11	16	22
0.1 sec	5	6	7	8	9	10	11
0.3 sec	4	5	6	7	8	9	10
0.5 sec	3	4	5	6	7	8	9
1 sec	2	3	4	5	6	7	8
2 sec	1	2	3	4	5	6	7
4 sec	0	1	2	3	4	5	6
8 sec	-1	0	1	2	3	4	5
15 sec	-2	-1	0	1	2	3	4
30 sec	-3	-2	-1	0	1	2	3
60 sec	-4	-3	-2	-1	0	1	2
2 min	-5	-4	-3	-2	-1	0	1
4 min	-6	-5	-4	-3	-2	-1	0
8 min	-7	-6	-5	-4	-3	-2	-1
15 min	-8	-7	-6	-5	-4	-3	-2
30 min	-9	-8	-7	-6	-5	-4	-3

ISO = 400 — Shutter Speed, t (sec. or min.)

sec/min	2.8	4	5.6	8	11	16	22
0.1 sec	4	5	6	7	8	9	10
0.3 sec	3	4	5	6	7	8	9
0.5 sec	2	3	4	5	6	7	8
1 sec	1	2	3	4	5	6	7
2 sec	0	1	2	3	4	5	6
4 sec	-1	0	1	2	3	4	5
8 sec	-2	-1	0	1	2	3	4
15 sec	-3	-2	-1	0	1	2	3
30 sec	-4	-3	-2	-1	0	1	2
60 sec	-5	-4	-3	-2	-1	0	1
2 min	-6	-5	-4	-3	-2	-1	0
4 min	-7	-6	-5	-4	-3	-2	-1
8 min	-8	-7	-6	-5	-4	-3	-2
15 min	-9	-8	-7	-6	-5	-4	-3
30 min	-10	-9	-8	-7	-6	-5	-4

ISO = 800 — Shutter Speed, t (sec. or min.)

sec/min	2.8	4	5.6	8	11	16	22
0.1 sec	3	4	5	6	7	8	9
0.3 sec	2	3	4	5	6	7	8
0.5 sec	1	2	3	4	5	6	7
1 sec	0	1	2	3	4	5	6
2 sec	-1	0	1	2	3	4	5
4 sec	-2	-1	0	1	2	3	4
8 sec	-3	-2	-1	0	1	2	3
15 sec	-4	-3	-2	-1	0	1	2
30 sec	-5	-4	-3	-2	-1	0	1
60 sec	-6	-5	-4	-3	-2	-1	0
2 min	-7	-6	-5	-4	-3	-2	-1
4 min	-8	-7	-6	-5	-4	-3	-2
8 min	-9	-8	-7	-6	-5	-4	-3
15 min	-10	-9	-8	-7	-6	-5	-4
30 min	-11	-10	-9	-8	-7	-6	-5

Aperture, f/

ISO = 1600

sec/min	2.8	4	5.6	8	11	16	22
0.1 sec	2	3	4	5	6	7	8
0.3 sec	1	2	3	4	5	6	7
0.5 sec	0	1	2	3	4	5	6
1 sec	-1	0	1	2	3	4	5
2 sec	-2	-1	0	1	2	3	4
4 sec	-3	-2	-1	0	1	2	3
8 sec	-4	-3	-2	-1	0	1	2
15 sec	-5	-4	-3	-2	-1	0	1
30 sec	-6	-5	-4	-3	-2	-1	0
60 sec	-7	-6	-5	-4	-3	-2	-1
2 min	-8	-7	-6	-5	-4	-3	-2
4 min	-9	-8	-7	-6	-5	-4	-3
8 min	-10	-9	-8	-7	-6	-5	-4
15 min	-11	-10	-9	-8	-7	-6	-5
30 min	-12	-11	-10	-9	-8	-7	-6

ISO = 3200

sec/min	2.8	4	5.6	8	11	16	22
0.1 sec	1	2	3	4	5	6	7
0.3 sec	0	1	2	3	4	5	6
0.5 sec	-1	0	1	2	3	4	5
1 sec	-2	-1	0	1	2	3	4
2 sec	-3	-2	-1	0	1	2	3
4 sec	-4	-3	-2	-1	0	1	2
8 sec	-5	-4	-3	-2	-1	0	1
15 sec	-6	-5	-4	-3	-2	-1	0
30 sec	-7	-6	-5	-4	-3	-2	-1
60 sec	-8	-7	-6	-5	-4	-3	-2
2 min	-9	-8	-7	-6	-5	-4	-3
4 min	-10	-9	-8	-7	-6	-5	-4
8 min	-11	-10	-9	-8	-7	-6	-5
15 min	-12	-11	-10	-9	-8	-7	-6
30 min	-13	-12	-11	-10	-9	-8	-7

ISO = 6400

sec/min	2.8	4	5.6	8	11	16	22
0.1 sec	0	1	2	3	4	5	6
0.3 sec	-1	0	1	2	3	4	5
0.5 sec	-2	-1	0	1	2	3	4
1 sec	-3	-2	-1	0	1	2	3
2 sec	-4	-3	-2	-1	0	1	2
4 sec	-5	-4	-3	-2	-1	0	1
8 sec	-6	-5	-4	-3	-2	-1	0
15 sec	-7	-6	-5	-4	-3	-2	-1
30 sec	-8	-7	-6	-5	-4	-3	-2
60 sec	-9	-8	-7	-6	-5	-4	-3
2 min	-10	-9	-8	-7	-6	-5	-4
4 min	-11	-10	-9	-8	-7	-6	-5
8 min	-12	-11	-10	-9	-8	-7	-6
15 min	-13	-12	-11	-10	-9	-8	-7
30 min	-14	-13	-12	-11	-10	-9	-8

ISO = 12,800

sec/min	2.8	4	5.6	8	11	16	22
0.1 sec	-1	0	1	2	3	4	5
0.3 sec	-2	-1	0	1	2	3	4
0.5 sec	-3	-2	-1	0	1	2	3
1 sec	-4	-3	-2	-1	0	1	2
2 sec	-5	-4	-3	-2	-1	0	1
4 sec	-6	-5	-4	-3	-2	-1	0
8 sec	-7	-6	-5	-4	-3	-2	-1
15 sec	-8	-7	-6	-5	-4	-3	-2
30 sec	-9	-8	-7	-6	-5	-4	-3
60 sec	-10	-9	-8	-7	-6	-5	-4
2 min	-11	-10	-9	-8	-7	-6	-5
4 min	-12	-11	-10	-9	-8	-7	-6
8 min	-13	-12	-11	-10	-9	-8	-7
15 min	-14	-13	-12	-11	-10	-9	-8
30 min	-15	-14	-13	-12	-11	-10	-9

Typical scene LV = -5

Examples of Equivalent Exposure Settings for Camera EV = Scene LV = -5

ISO	Aperture	Shutter
200	2.8	2 min.
1600	4	30 sec
12,800	8	15 sec

12.1 Tables of camera exposure values (EVs) for different combinations of ISO, aperture and shutter speed. Note that there are many different combinations of ISO, aperture, and shutter speed that result in the identical EV. For example, an EV of -5 (purple), or -8 (yellow) which would be appropriate to match the LV of a typical Milky Way nightscape, can be achieved with any of the different combinations shown. The multiple different ways of setting the camera to an EV of nine, which would be more appropriate for the LV of a sunset scene, are highlighted in gold.

- ISO = 100, *f*/4 for 8 minutes
- ISO=800, *f*/4 for 1 minute
- ISO=800, *f*/11 for 8 minutes
- ISO = 6400, *f*/4 for 8 seconds
- ISO=6400, *f*/11 for 1 minute
- ISO = 6400, *f*/2.8 for 4 seconds

Okay, so the identical EV can be achieved from different combinations of ISO, aperture, and shutter speed. By now, I'm sure you're asking the obvious question – out of all these possible combinations, which one is *the* best? In other words, which is the single, best combination of settings that will result in a trophy image worthy of enlarging for framing? Note there are some significant differences—for example, exposure times that range from 4 seconds to 8 minutes. Are they really all the same? My answer is that *the precise manner in which the EV of the camera is chosen to correspond to the LV of the scene is perhaps the most foundational technical skill in photography.*

MATCHING CAMERA EV TO SCENE LV—THE FIREFLY ANALOGY

If this all seems confusing, don't despair. My favorite way to understand the process of matching the EV of the camera to the LV of the scene is with the help of an adaptation of an analogy originally created by Bryan Peterson. Imagine that the light given off by the scene every second may be represented by individual "light fireflies," as illustrated in Figure 12.2. For brighter scenes, more fireflies are given off per second than dimmer scenes, equivalent to the higher lux for brighter scenes shown in Table 10.1.

The goal is to allow the requisite number of fireflies to enter the camera to achieve a correct exposure. This goal is achieved by adjusting the combination of ISO, aperture, and shutter speed to set the camera EV to match the LV of the scene, regardless of its actual value at any given time. In doing so, you ensure that the camera will receive the correct number of fireflies for a correct exposure, every time, regardless of how many of them are being emitted by the scene.

Let's go through a practical example. Imagine that we have determined that the LV of our scene is nine. For this exercise, we will thus say that we have nine fireflies per second being emitted from the scene, Figure 12.3(a). In this example, you may consider each firefly to represent one LV of scene brightness. In order to create a properly exposed image, therefore, we must set our camera's EV to receive nine fireflies. How shall we do this?

Consider each of the three camera exposure settings: ISO, aperture, and shutter speed, to represent three categories, or buckets, into which any of the fireflies may be placed. In order to set the camera EV to nine, we need to distribute the nine fireflies between each of the three buckets. One possibility might be to put four fireflies in the ISO bucket, one in the aperture bucket, and four in the shutter speed bucket, Figure 12.3(b, left). Alternatively, we may elect to put two fireflies in the ISO bucket, five in the aperture bucket, and two in the shutter speed bucket, Figure 12.3(b, middle). Finally, we may choose just one firefly in the ISO bucket, two in the aperture bucket, and the rest in the shutter speed bucket, Figure 12.3(b, right). In each case, the overall image will have the same exposure—nine; what will differ will be the attributes resulting from the effects of the different camera settings. Let's now examine some of the differences that arise in our landscape astrophotography images as we make the selections.

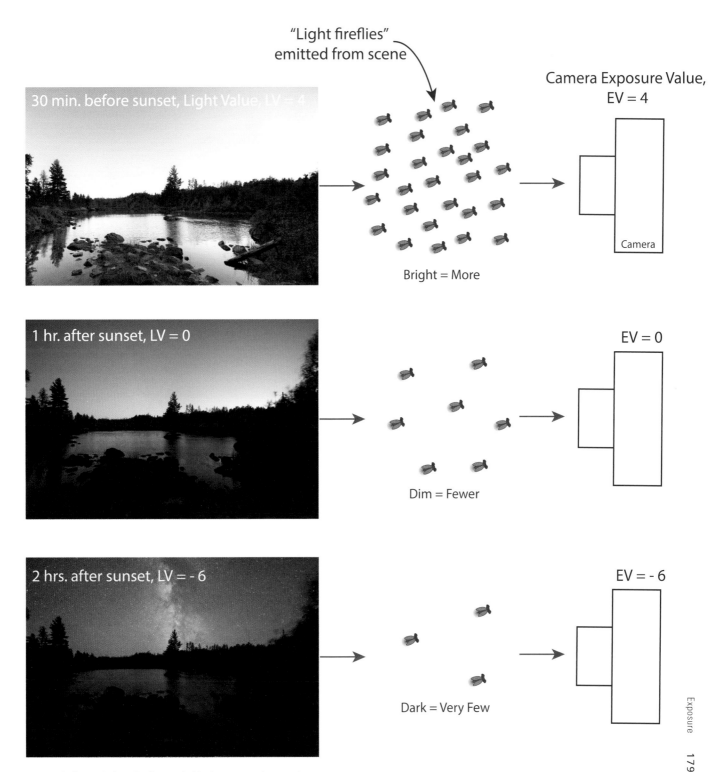

12.2 "Firefly" equivalents for three typical landscape astrophotography scenes. Brighter scenes have more fireflies given off per second compared to dimmer scenes. The scene LV and corresponding camera EV for a correct exposure are also shown.

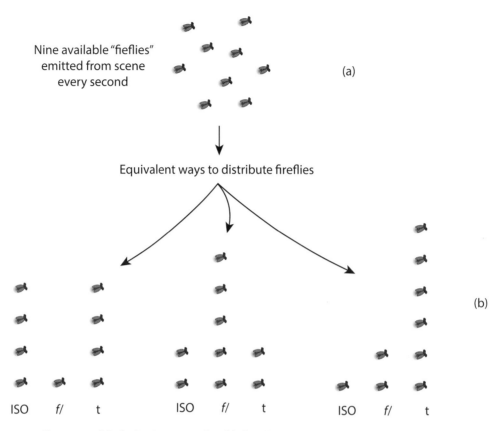

Nine available "fieflies" emitted from scene every second

(a)

Equivalent ways to distribute fireflies

(b)

| ISO | f/ | t | | ISO | f/ | t | | ISO | f/ | t |

12.3 Different ways of distributing the same number of fireflies, (a), between the categories of ISO, aperture, and shutter speed (b). This process ensures that we set the camera EV to match the scene LV, in this case, nine.

APERTURE

In the vast majority of cases, you will want to set as low an aperture number, or f-stop, as is feasible. Notice I did not say as low as possible but feasible. There is an important difference. A low f-stop corresponds to an aperture that is physically large or wide open. So why not simply set the aperture to its minimum value, for example, $f/2.8$ or even $f/1.4$ to allow as much of the ambient light from the scene into our cameras as possible? You will recall from Chapter 11 that one reason is that an aperture set to its minimum value can allow lens imperfection effects, especially apparent in astrophotography. Also, images made at minimum aperture can appear noticeably softer, which, for example, can impact the appearance, or crispness, of the Milky Way.

An example of coma and how the choice of aperture affects its onset is shown in Figure 12.4. Note the clearly visible coma at minimum aperture—coma has the effect of distorting stars from round points of light into "flying seagulls." Consequently, the best compromise between coma and a too-restricted aperture is generally to set your aperture to one to two stops above the minimum aperture of the lens: for a lens with a minimum aperture of $f/2.8$, that would be $f/5.6$; for one with a minimum aperture of $f/4$, that would be $f/8$.

facing page

12.4 Photographs of the constellation Orion at equivalent camera EV but different combinations of aperture and shutter speed, shown here in the left column. All four photographs were made with a 50 mm lens and an ISO setting of 6400.

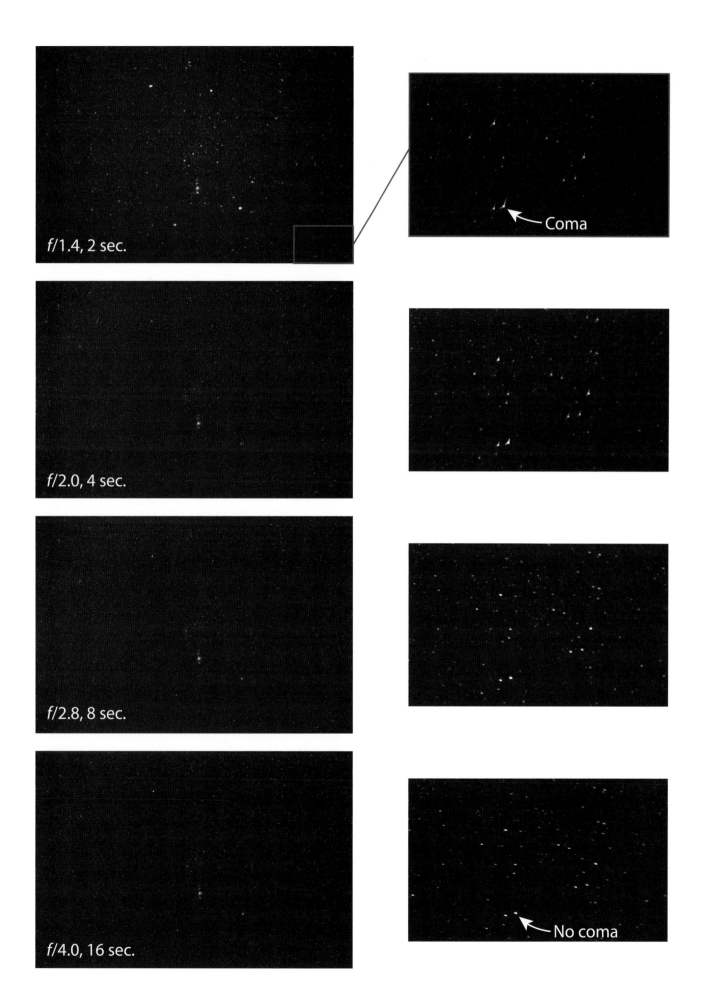

f/1.4, 2 sec.

Coma

f/2.0, 4 sec.

f/2.8, 8 sec.

f/4.0, 16 sec.

No coma

SHUTTER SPEED

The only real limitation on shutter speed, or exposure duration, in most landscape astrophotography images relates to undesirable effects of moving subjects. Distracting artifacts can manifest themselves as either unwanted streaking/trailing of stars or blurred foreground objects resulting from wind or other motion. In either case, keeping the shutter speed below a certain value will eliminate the appearance of movement. However, owing to restrictions on aperture such as coma, it may be necessary to keep the shutter open long enough to obtain a correct exposure. So, how long a shutter speed is too long?

For years, the practical "Rule of 400/500/600" has been the go-to guide for estimating the maximum exposure length that can be implemented without noticeable star trails. The idea is simple; just divide the number 400, 500, or 600 by the focal length of the lens (in millimeters) to obtain the maximum shutter speed (in seconds) that may be safely used. Using the number 400 gives the most conservative estimate and is my recommendation for those with higher-resolution cameras; using the number 600 may suffice for less critical audiences. Note: for users with crop sensor cameras, you will need to multiply the lens focal length by the crop factor (generally 1.5 or 1.6) to arrive at the correct focal length to use in the Rule of 400/500/600.

An example of the application of this rule is given in Figure 12.5, where six photographs of the constellation Orion are shown, all made with equivalent EV using a 50 mm lens but with different exposure times: 4, 8, 15, 30, 60, and 120 seconds. According to the Rule of 400/500/600, star streaking should be insignificant with exposure times less than 400/50 = 8 seconds, and likely to be starting to be noticeable after 600/50 = 12 seconds. Close inspection of the 15-second exposure shows barely discernible elongation of the stars; the 30-second image shows clearly visible distortion. Exposures of 60 and 120 seconds reveal more extensive streaking. The exposures made at 8 and 4 seconds show no signs of streaking, as predicted by the Rule of 400/500/600.

Finally, it is important to recognize that the relative motion of stars depends strongly on the compass direction you're facing. For example, when facing north in the Northern Hemisphere, the apparent speeds of the stars is relatively less than the speeds of stars along the ecliptic, or when facing south. This is because the stars along the eclectic have to travel a greater distance (horizon–overhead–horizon) in the same amount of time as stars circling the celestial poles. This means that the maximum exposure time to avoid star trails can be longer when facing north than when facing south.

ISO

The ISO setting refers to the overall sensitivity of the camera sensor to light, and dictates how much light is needed to obtain a properly exposed image, or one that has an overall gray level of 18 percent. With reference to the firefly analogy, the camera EV is a measure of how many fireflies need to land on the sensor in order to make the image. Low ISO settings require enormous numbers of fireflies to produce a correctly exposed scene, whereas high ISO settings require far fewer fireflies. So why not simply set the ISO to the maximum possible setting?

Images made with a low ISO setting need lots of light. The results are images with very high resolution, in other words, images that can be enlarged without losing detail or revealing pixel noise or grain, Figure 12.6(a). In contrast, images made with high ISO generally suffer from distracting

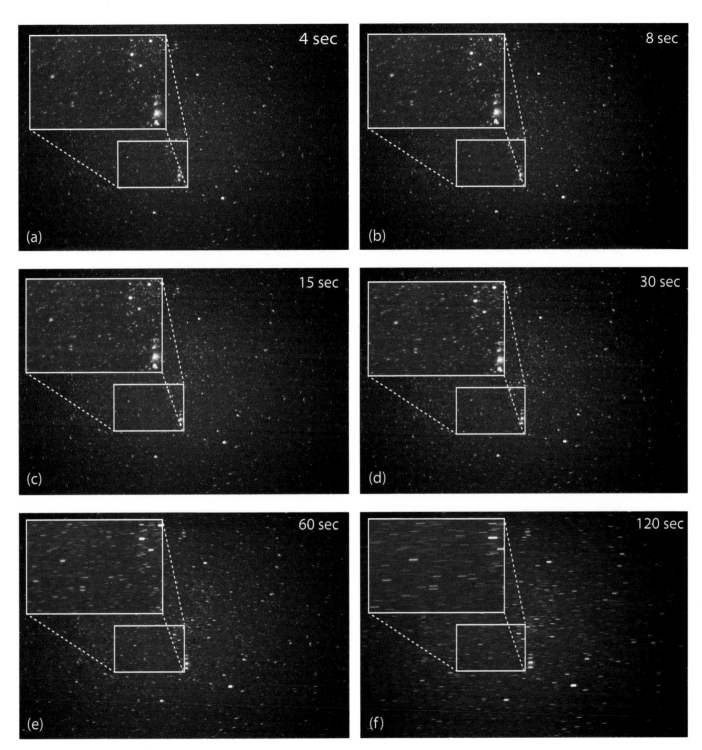

12.5 Photographs of the constellation Orion made with equivalent EV but different exposure times: 4, 8, 15, 30, 60, and 120 seconds, from top to bottom. The onset of noticeably streaked stars becomes evident at around 15 seconds, and pronounced by 120 seconds. All six photographs were made with a 50 mm lens (minimum aperture of *f*/1.4). The region indicated by the white box is enlarged in the inset of each image to allow better visualization of the details of the images.

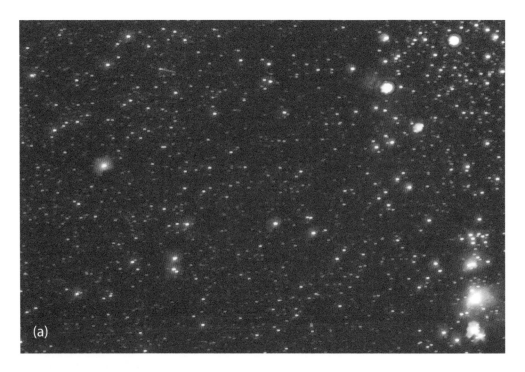

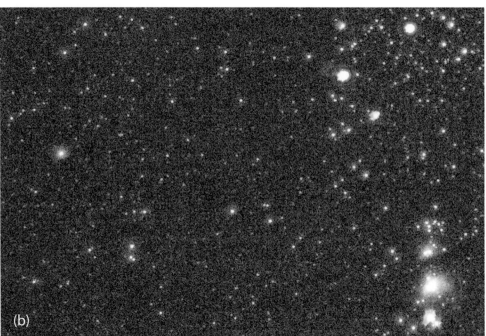

12.6 Photographs of stars taken with a 50 mm lens at equivalent camera EV but different ISO: (a) ISO = 3200; (b) ISO = 25600. Note the distinct graininess and color noise in the high ISO image (b) compared to the lower ISO image (a). Images made at even lower ISO have even better grain and color noise quality than (a).

graininess and often visible color noise, Figure 12.6(b). Why is this the case? Think of it as if you were making a painting made up of individual dots of paint. With high ISO images, you're only allowed to use, say, 1,000 individual drops of paint to make up your painting, and so you have to use a fairly coarse brush. With a low ISO image, you would need 1,000,000,000 drops of paint and thus you are able to use an exceeding fine brush capable of exquisite detail. Herein lies the origin of the higher inherent quality of low ISO images, and their ability to be enlarged significantly without a loss of detail. Finally, images made at higher ISO settings exhibit less dynamic range and less color contrast, and have less capability for significant adjustments during post-processing.

SELECTING ISO, APERTURE, AND SHUTTER SPEED FOR OPTIMUM IMAGE QUALITY

It's time to synthesize this knowledge into a cohesive strategy for producing the best possible landscape astrophotography image given the local conditions. Here are the key points so far:

- Matching camera EV to scene LV is the priority for a correctly exposed image
- Low ISO is better than high ISO, to minimize graininess and color noise
- The shorter the shutter speed the better, to minimize star trailing and foreground blur
- Best aperture is two stops above the minimum, to produce distortion-free images

We are now prepared to see how this knowledge is applied in the field.

Since we know what settings produce the highest quality images, why not just set the ISO to its lowest value, say, ISO = 100, set the aperture two stops above the minimum, say f/5.6 for a lens with a minimum aperture of f/2.8, and the shutter speed of the longest value needed to avoid star trailing, say 30 seconds for a 20 mm lens? With reference to the EV table in Figure 16.2, these settings result in a camera EV of EV = 0. Unfortunately, a great many landscape astrophotography scenes have much, much dimmer LVs, such as LV = -6 for scenes involving the Milky Way on moonless nights. This is a very significant difference; a camera set to an EV of 0 will unacceptably underexpose such a scene and will not work.

Consequently, we enter the arena of intentional trade-offs in camera settings. Suppose we bump up the ISO… how far can we go before the graininess is noticeable? How about the aperture… can we open it up more without terrible effects? And so on. Let's go through an example to demonstrate the logic behind these tradeoffs. Once you have experienced this process a few times under night-sky conditions, you will develop your own set of references to refine and return to time after time. Remember, the goal is to maximize the time in the field acquiring images and minimizing the amount of time adjusting the exposure settings!

Four images were made for this optimization exercise, as shown in Figure 12.7. They were all produced using a 24 mm lens and a variety of exposure settings. The subject was the constellation Orion during a clear, moonless night. I wanted to compare three ISO settings: 1600, 3200, and 6400. I knew that an ISO higher than 6400 would just be too noisy for my liking and anything below 1600 was likely to result in an image that was so badly underexposed to be beyond salvaging. Then, I wanted to try two different apertures: f/2.8 and f/4. The minimum aperture for this lens was 2.8, so I knew there would be significant coma at the 2.8 aperture. The f/4 aperture, which was one stop above the minimum aperture would be better; I just wasn't sure an aperture of f/5.6 would allow in enough light in a short enough time to avoid streaking of the stars. Finally, in order to set the exposure time, I turned to the Rule of 400/500/600 and calculated that as long as I kept the exposure time less than around 17–25 seconds with the 24 mm lens there shouldn't be appreciable streaking of the stars. The settings of each of the four images is provided in Figure 12.7, along with the firefly analogy showing how the same overall number of fireflies are distributed amongst the three categories of ISO, aperture, and shutter speed.

Upon close examination of the images in Figure 12.7, as shown in the enlarged regions in the middle row, several trends are immediately apparent. Both exposures taken with a shutter speed of 30 seconds show an unacceptable level of streaking, which is consistent with the prediction of the Rule of 400/500/600 that any shutter speed greater than 17–25 seconds would show streaking.

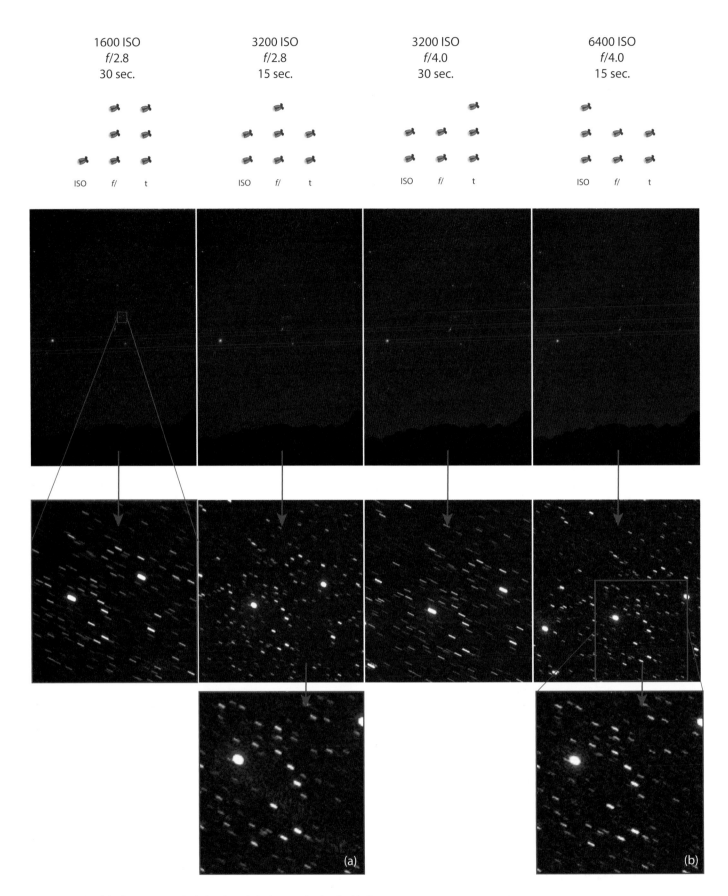

1600 ISO
f/2.8
30 sec.

3200 ISO
f/2.8
15 sec.

3200 ISO
f/4.0
30 sec.

6400 ISO
f/4.0
15 sec.

ISO f/ t

ISO f/ t

ISO f/ t

ISO f/ t

(a)

(b)

12.7 Example of the four images made during the optimization exercise described in the text. Also shown along the top is the manner in which the same total number of "fireflies" were distributed between the various exposure settings.

Of the remaining two images taken at 15 seconds, one with ISO = 3200 and the other at ISO = 6400, the 6400 image appears slightly crisper, albeit with a small increase in noise visible at this extreme magnification. However, the 6400 image was also made with an aperture of *f/*4, which we saw previously would result in less coma at the image periphery. Thus, my conclusion was that the optimum settings for this image would be ISO = 6400, *f/*4 for 15 seconds. Returning to the EV tables in Figure 12.1, we see that these settings produce a camera EV = -6, a result exactly suited to the LV of the dark sky conditions we are capturing.

To emphasize the significance of this outcome, recall that all four images in Figure 12.7 were collected at the same camera EV, yet only one of them produced "the best" image quality. It is very well worth your time studying this process and practicing a few of your own optimization experiments to really understand the tradeoffs.

A final example of how your choice of exposure settings can affect the resultant image appearance is shown in Figure 12.8 for the case of the Aurora Borealis. The overall exposure of both images in Figure 12.8 was adjusted through post-processing to result in the same EV in the final image. Changing the shutter speed from 30 seconds to 2 seconds dramatically increases the definition and structure seen in the auroral curtains. This is the result of the relatively rapid motion of the aurora. A 30-second exposure causes the individual structures to blur together, but a 2-second exposure maintains their definition.

EXPOSE TO THE RIGHT (ETTR)

The preceding example demonstrates a somewhat counterintuitive result that has become widely accepted in landscape astrophotography, namely, that higher ISO settings of 6400 or even 12,800 are preferable in many cases. One might imagine that the goal would always be to keep the ISO set to a low value and avoid the seemingly noisy higher ISO at all costs. Why is this? There are at least two reasons – the first relating to the ability to minimize star streaking by keeping the exposure time relatively short, as we saw in Figure 12.8. The second reason is that the downside of the minor degree of noise introduced at higher ISO levels is less than the amount of noise that would be seen by underexposing the image and then raising the exposure of the image in post-processing, illustrated in Figure 12.9. The reason for this is that slightly overexposed images have far more tonal values to work with than underexposed images. This result has led to the conclusion that it is best to *expose to the right* (*ETTR*), a reference to the typical shape of the image histogram when exposed at higher ISOs at constant aperture and shutter speed than lower ISOs.

On many occasions, I have found myself at the start of a long night of shooting with an underexposed initial image, faced with tough decisions regarding which camera settings to change and by how much. Only by spending some time understanding these tradeoffs, gaining experience in making these changes, and then studying their actual impact does one really become proficient. As you progress, you may wish to note down a few initial settings for whatever scene LV you expect to encounter, and then use these as a starting point in the field. As we will see in Chapter 20, there are so many other things that can go wrong in the field that fiddling with exposure settings is the last way you will want to spend your time!

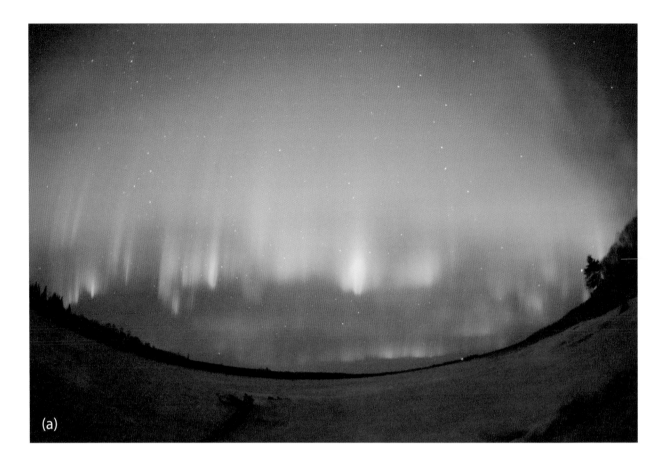

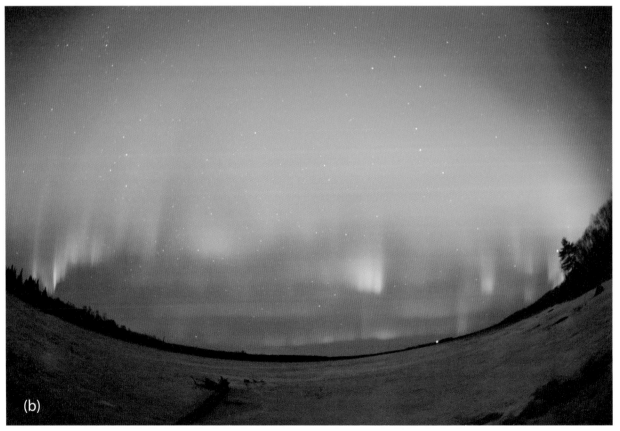

12.8 Comparison of exposure time on the appearance of the Aurora Borealis. Both images were made with an ISO setting of 6400 and an aperture of *f*/2.8. The image in (a) was made with a 2-second shutter spend and (b) a 30-second shutter speed. Both images were then adjusted using procedures described in Chapter 21 to have the identical final image brightness. The image made with the shorter time, (a), has much more clearly defined pillars and edges within the aurora than the image made with the longer time, (b).

ISO 12,800
f/4.0
20 sec.

ISO 1600
f/4.0
20 sec.

ISO 800
f/4.0
20 sec.

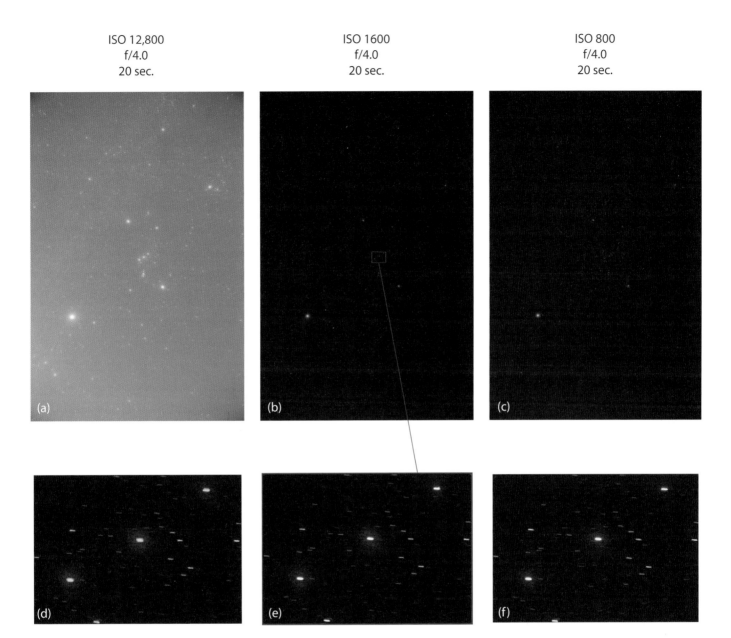

12.9 The three images at the top were all collected with the same aperture and shutter speed but different ISO settings: (a) 12800, (b) 1600, and (c) 200. Each successive image thus differs from the preceding one by 3EV. An enlargement from the region including Orion's Belt from each image is shown in (d) to (f) after compensating for the differences in exposure. Although subtle, the image made with an ISO setting of 12800 exhibits a noticeably better resolution and lower color noise in the background.

Bibliography

Freeman, Michael, *The Photographer's Eye*, 2007, Focal Press, New York and London

Freeman, Michael, *Perfect Exposure*, 2009, Focal Press, New York and London

Horenstein, Henry & Russell Hart, *Photography*, 2004, Prentice Hall, Upper Saddle River, New Jersey

Hunter, Fil, Steven Biver & Paul Fuqua, *Light, Science and Magic*, 2007, Third Edition, Focal Press, New York and London

Jacobson, Ralph E., Sidney F. Ray, Geoffrey G. Attridge & Norman R. Axford, *The Manual of Photography*, 2000, Ninth Edition, Focal Press, New York and London

Johnson, Charles S., Jr., *Science for the Curious Photographer*, 2010, A.K. Peters, Ltd, Natick, Massachusetts

Kelby, Scott, *The Digital Photography Book, Volume 1*, 2007, Peachpit Press, USA

Kelby, Scott, *The Digital Photography Book, Volume 2*, 2007, Peachpit Press, USA

Knight, Randall D., *Physics for Scientists and Engineers*, Third Edition, 2013, Pearson, Glenview, Illinois

London, Barbara, Jim Stone & John Upton, *Photography*, Tenth Edition, 2011, Prentice Hall, Upper Saddle River, New Jersey

Peterson, Bryan, *Understanding Photography Field Guide*, 2004, Amphoto Books, New York, New York

Peterson, Bryan, *Understanding Exposure*, Revised Edition, Amphoto Books, New York, New York

Sussman, Aaron, *The Amateur Photographer's Handbook*, 1973, Eighth Revised Edition, Thomas Y. Crowell Company, New York

13

LIGHT PAINTING AND LIGHT DRAWING

Light painting is one way to create a strong focal point for your nightscape images. Light painting involves intentionally illuminating part or the entire foreground object. It is so-named owing to its similarity to "painting" specific objects within the scene, except with a beam of light instead of a paintbrush. There are many tools that you may use to accomplish this: a flashlight, headlamp, fire, or even candles! Two examples are shown in Figure 13.1.

The effect of light painting can be profound, and can transform an otherwise dull image. To see the effect of light painting on the feel of a scene, compare the two versions of the identical scene in Figure 13.2 (overleaf), one taken with light painting and the other without.

EFFECT OF LIGHT SOURCE TEMPERATURE ON APPEARANCE

The color temperature of the light source used to paint the foreground object can dramatically affect the resulting image. Examples of the same scene light-painted with six different sources are shown in Figure 13.3 (overleaf). My preferred light source is a small, handheld flashlight with a beam-focusing head. I usually tape one or two sheets of a CTO (color-temperature orange) gel across the beam to slightly warm the color temperature of the light, Figure 13.3(c). In dark sky environments, the light from this flashlight can be surprisingly effective, especially when coupled with high ISO settings (e.g. 3200 and higher) and 20 second or longer exposure times. By the way, you will note that I never use the on-camera flash; its light is far too bright and its position leads to unacceptably flat-appearing subjects.

facing page

13.1 Light painting of: (a) a Chumash 'Ap in the Santa Monica Mountains National Recreation Area near Los Angeles, California; and (b) the sandstone rocks of the Alabama Hills in California with the Milky Way rising overhead. A flashlight with an orange gel taped over the light was used in both cases. Both foreground objects would have been all but invisible without the light painting.

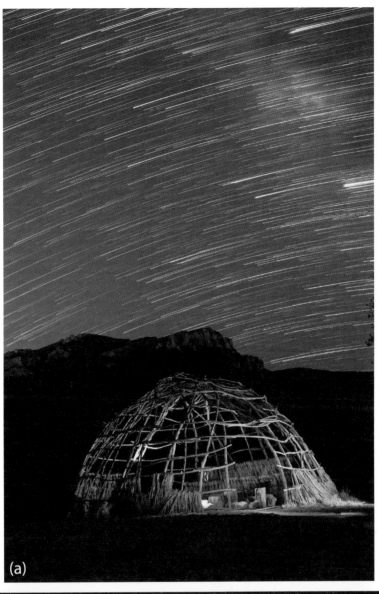

(a)

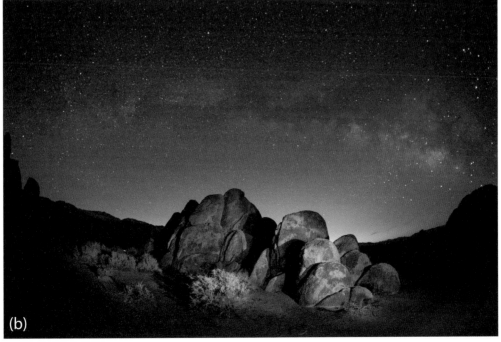

(b)

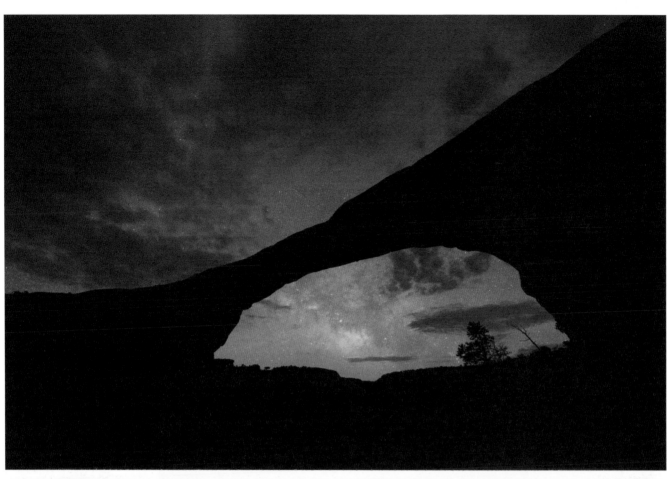

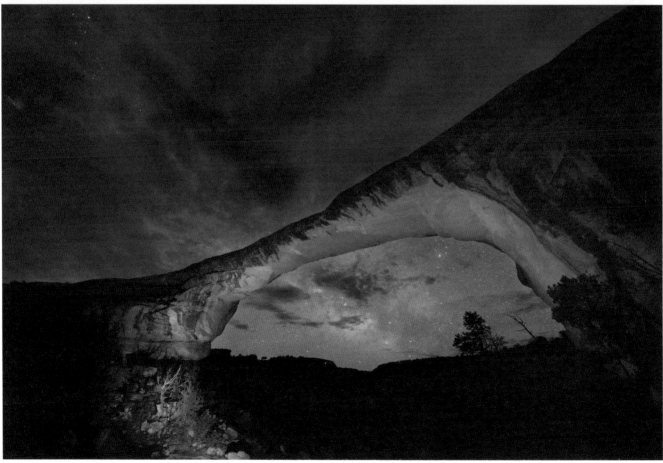

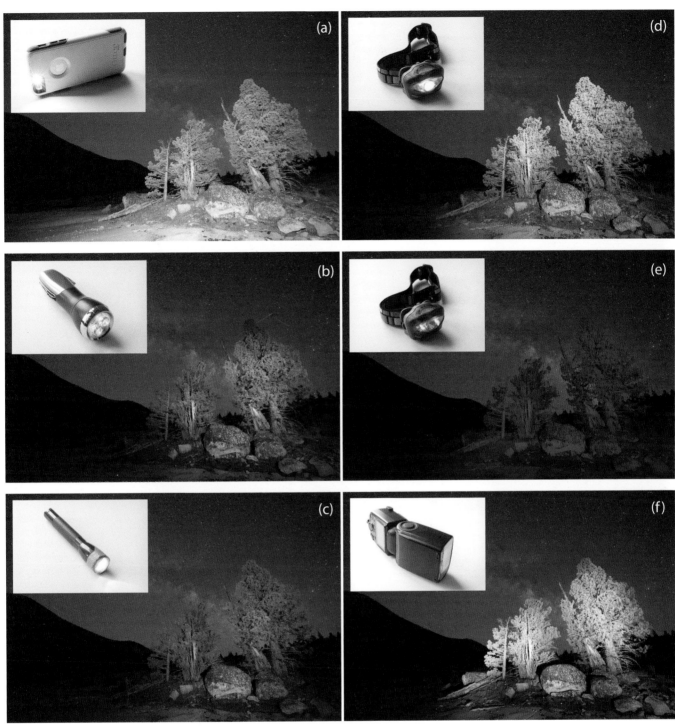

13.3 Several images of the same scene made near Florence Lake, California, showing a stand of trees on a granite dome beneath the summer Milky Way. The only difference between the images was the source, and hence colors temperature, of the light used to illuminate the stand of trees. Each light source is shown as an inset within each image. The light sources included: (a) a cellphone's flashlight, handheld flashlights (b) without and (c) with an orange gel, headlamp with (d) normal and (e) red bulbs and (f) an off-camera, manually operated flash.

facing page

13.2 The effects of light painting on the foreground in a scene are illustrated here, by comparing the same image without (top) and with (bottom) light painting. These images were made just minutes apart in Natural Bridges National Monument, Utah, an International Dark Sky Site.

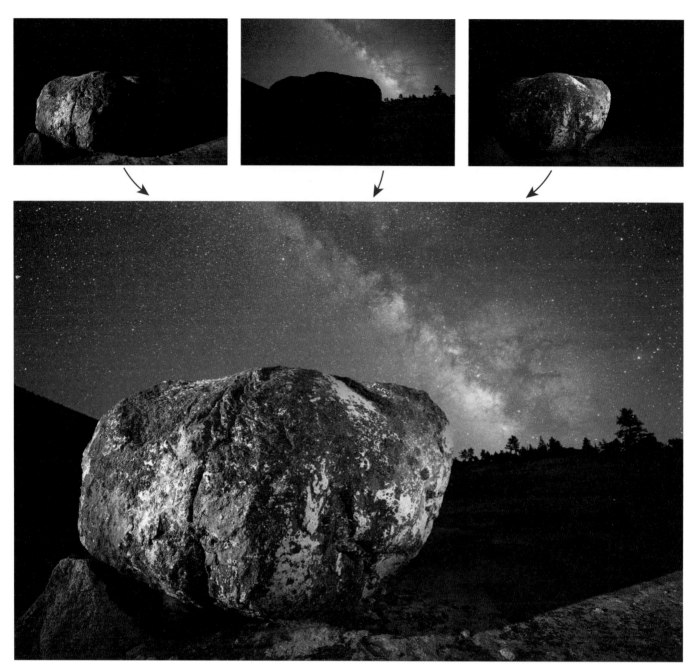

13.4 Side lighting is a very effective technique to enhance the texture, and hence compositional interest, of many foreground subjects. Here, this "glacial erratic," or boulder, deposited by retreating glaciers after the most recent Ice Age, is lit separately from both sides. The light-painted images were made at low ISO with the focus adjusted to lie specifically on the boulder. These two side-lit images were then combined with a third, high-ISO image, re-focused on the Milky Way, and with no foreground light painting. These three images (top row) were then combined to produce the final, composite image (bottom) using the techniques described in Chapter 22.

LIGHT DIRECTION

The direction of the light from the source can play a key role in the appearance of the light-painted subject. Front lighting is best avoided, as the lack of shadows and resultant lack of contrast results in flat, uninteresting foreground subjects; akin to using the on-camera flash. It is far better to illuminate the subject from either side, or even slightly or completely from the rear. Images can also be created by blending two or more images with different degrees of light painting, as described in more detail in Chapter 22 and illustrated in Figure 13.4. Here, a high-ISO image of the Milky Way is blended with two low-ISO, side-lit images of the foreground subject.

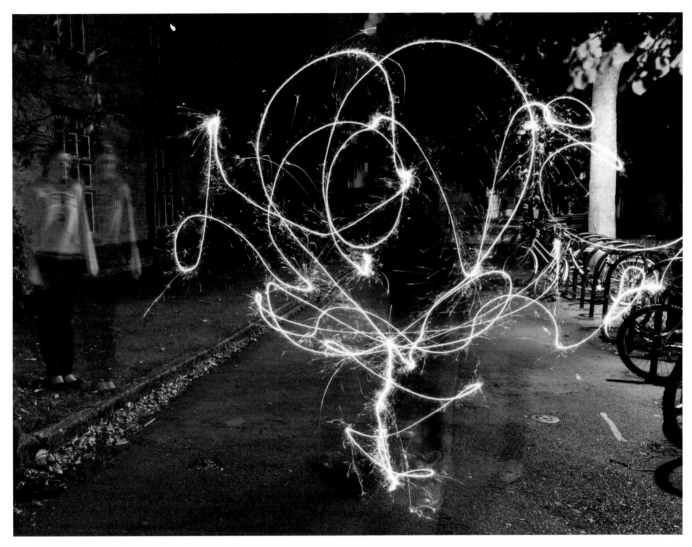

13.5 Light-drawing involves directing the light from the source directly into the camera, in contrast to light painting in which the source is outside the field of view. Here, this was done using simple sparklers—and if you look carefully, you might be able to see the word "*LOVE*" drawn in light! Made in Oxford, England.

LIGHT DRAWING

In contrast to light painting, where the light source is outside the field of view, *light drawing* involves shining light directly into the camera from the light source within the field of view, for example Figure 13.5. This technique has boomed in popularity, and many incredibly creative examples can be found. A wide variety of light sources can be used: sparklers, flashlights, light sticks, and even lighters!

Bibliography

Bair, Royce, *Milky Way Nightscapes*, 2015, RoyceBair.com (ebook)

Hunter, Fil, Steven Biver & Paul Fuqua, *Light, Science and Magic*, 2007, Third Edition, Focal Press, New York and London

Keimig, Lance, *Night Photography and Light Painting*, Second Edition, 2016, Focal Press/Taylor & Francis, New York and London

Kingham, David, *Nightscapes*, 2014, Craft & Vision, Vancouver, Canada

Knight, Randall D., *Physics for Scientists and Engineers*, Third Edition, 2013, Pearson, Glenview, Illinois

Wu, Jennifer & James Martin, *Photography: Night Sky*, 2014, Mountaineers Books, Seattle, Washington

VIDEO, TIME LAPSE, AND MOTION PRODUCTION

14

If a picture is worth a thousand words, then a video must be worth a million pictures! A well-done video production, with sound, can transport the viewer to a different time and place altogether. Time-lapse videos of nightscapes can impart a sense of awe at the incredible wonders of the universe, and how we fit into it.

Recent developments in both image acquisition and image processing, along with steady improvements in personal computers, have placed time-lapse video creation well within the capabilities of most landscape astrophotographers. This chapter describes how to prepare for and collect images suitable for processing into nightscape time-lapse videos. We will review methods for imparting motion into the final video. Methods for creating the final videos are described in Chapter 22.

COLLECTING IMAGES FOR TIME-LAPSE VIDEOS

Collecting images for a time-lapse video is straightforward and very similar to the method of creating images for star trails described in Chapter 22. The basis for the technique is to acquire images at set, repeated intervals, as shown in Table 14.1. Of course, this interval needs to be equal to or longer than the shutter speed! Methods for creating the sequential exposures include repeated manual exposures (not recommended!), using the in-camera intervalometer and using an external intervalometer, as described in more detail in Chapter 22.

SUBJECT	INTERVAL (SECONDS)
Sunset/sunrise; Moonset/moonrise	1–10
Star movement	10–30
Clouds	1–20
Milky Way	10–30
Aurora Borealis/Australis	5–20
City streets with pedestrians	1–10
Traffic	1–5
Cityscape lights during twilight	10–30

Table 14.1 Recommended Intervals for Nightscape Time-Lapse Video Subjects

Once the composition and interval are set, the camera settings are adjusted and the exposures started, there is little to do other than sit back, relax, and enjoy the scene unfolding before your eyes! There are a couple of things that you will want to confirm before you start the sequence; let's go through those now.

The importance of having a stable, locked down tripod can't be overestimated. Even a minor shift of position midway through the collection of a nightscape sequence can effectively ruin it. As always, it is imperative to confirm that the tripod legs are fastened securely in position, and that all of the knobs and fixtures are as tight as possible. Hanging a heavy bag from the bottom of the tripod's post to add inertia is always a good idea, especially if there are even light to moderate

(a)

(b)

14.1 (a) Hanging your camera bag or other heavy object, such as a fabric or plastic bag filled with rocks or sand, can add much-needed stability to your tripod. While important for single images, the requirement for absolute stability is even greater during the many hours needed to create images used for time-lapse videos. (b) Carabiners make it easy to attach and remove your weights from your tripod.

winds, Figure 14.1. I often carry a sturdy fabric bag to fill with rocks for just this purpose. I also carry carabiners clipped to my camera bag for the same purpose, Figure14.1. If your tripod doesn't have a hook at the bottom of the central post from which to hang such weights, they can often be purchased as an accessory. It is not recommended to drape a bag or other weight over the entire tripod, as doing so will generate an inwardly directed force on the tripod legs. This force may cause unwanted shifts in position of the tripod legs during the night.

Camera power is also an important issue to consider, since it is unlikely that a single battery will have enough charge to operate your camera for the entire duration of your image collection sequence. If your camera allows the use of an external power supply, and if this is a feasible option, then this is the way to go. Some cameras have modified battery packs available that can be inserted into the normal position for the battery and then attached to an external power source. Alternatively, an external battery grip is a very useful addition, Figure 14.2, since it can significantly prolong the time-lapse duration. Also, for some camera models, e.g. Nikon, the battery in the grip can be changed throughout the shoot without affecting the overall position or movement of the camera. When doing so, the primary battery inside the camera's main compartment continues to operate the camera.

14.2 An external battery grip can greatly extend the shooting duration, critical for time-lapse image creation. In addition, the battery within this Nikon grip can be swapped-out, mid-shoot, further extending the shooting time. This is possible provided the battery in the camera's main compartment retains enough power to keep the camera operating during the battery swap.

Many nightscape videos are created with essentially the same exposure settings of the camera, although one or more adjustments in exposure time or ISO might be required. As described in Chapter 22, such sequences are readily converted into a video with only minor post-processing in Lightroom. Such time lapses include motion of the Milky Way across the sky, the flickering lights of the aurora, or billowing clouds of the pre-sunset hour.

"HOLY GRAIL" TIME-LAPSE VIDEOS

Nightscape time-lapse videos that begin before sunset and continue all the way through civil, nautical, and astronomical twilights into full darkness (and the same in reverse for sunrise) experience an enormous range of exposure values (EVs); often over twenty EV! This range is far beyond the capabilities of any camera to collect correctly exposed images with a single set of exposure settings. Instead, the operator is forced to change the exposure settings of the camera significantly, multiple times, during the collection of the sequence. The many abrupt changes in exposure in images made immediately before and after such changes in camera settings can become highly distracting in the final time-lapse video unless steps are taken to mitigate their effects. The difficulty in doing so has led to these types of nightscape videos being dubbed the "Holy Grail" of time lapses.

One method for performing these adjustments, as described in detail in Chapter 22, is with the LRTimelapse software. This powerful program makes it straightforward to smoothly adjust the exposures of all the images in the holy grail sequence to produce a single, pleasing video, from pre-sunset all the way through to complete darkness.

ADDING MOTION TO TIME-LAPSE IMAGES

The ultimate feature in time-lapse video creation involves steady movement of the camera during image collection. The result is a heightened sense of drama and discovery in the final production. The downside is a substantial increase in complexity, power requirements, and transport logistics. Also, the images resulting from a time lapse with motion cannot be combined later into a star-trail image.

Panning is the main type of movement during nightscape time-lapse video production. It can be accomplished by moving the camera along a straight rail held up at either end by supports, or by slowly rotating the camera about that head of a fixed tripod. One relatively inexpensive way to accomplish panning is with the Polarie head, Figure 14.3. Designed for equatorial tracking during long exposure images of the night sky, Chapter 22, it makes an excellent mount for slowly panning across the scene during the collection of images intended for a time-lapse video.

14.3 Here, the Polarie Star Tracker Mount is used as a panning head. Its slow rotation provides a steady, rotating motion, highly suitable to adding movement during time-lapse image creation.

Bibliography

Dyer, Alan, *How to Photograph Nightscapes and Timelapses*, 2014, Amazing Sky (ebook)

www.lrtimelapse.com

SECTION IV
Planning Successful Landscape Astrophotography Images

SECTION IV INTRODUCTION

Successful landscape astrophotographers have a plan. While it's occasionally possible to create noteworthy images on the spur of the moment, there are just too many variables to do so consistently. Instead, spend a little time in the comfort of your warm, well-lit home to consider the key points we've covered so far: the phase of the moon, what night sky objects will be visible on the dates you'd like to go and at what time, the orientation of your foreground, the times of civil, nautical and astronomical twilights, likely exposure settings, and so forth. In doing so, you will find yourself at the right place at the right time, and with the right equipment and skill level needed to spend your energy fine-tuning your masterpiece rather than battling physical, photographic, and astronomical elements beyond your control.

Some might say that extensive planning is a waste of time, or that it somehow robs the result of artistic inspiration. I would argue the opposite; that in many ways, planning, preparation, and execution comprise the essence of artistic expression. Think of the cellist who spends thousands of hours perfecting her craft. Or the dancer that repeats the same movements over and over until they become ingrained, reflexive fluidity. I think most would agree that the process of creating masterpiece nightscape images is challenging, and requires practice and study.

The chapters in this section integrate the knowledge of the preceding sections on astronomy and photography into a single cohesive strategy and plan for each of your nightscape photo sessions. You might say that your plan will have four components: what, when, where, and how. We will start by reviewing the best subjects in landscape astrophotography with an example, a brief summary of suggested camera settings and schedules for each one. We will then develop the specifics of your concept through pre-visualization (*what*). We will narrow down a few good dates and times (*when*); and map the general destination area to pinpoint potential sites to best position the camera (*where*). We will identify the likely lens, range of exposure settings and sequences of images we wish to obtain based on our knowledge of photography (*how*). We will summarize our plan for the nightscape photo session in the form of a workflow timeline and checklist to confirm we have ample time for all our planned shots (*how*). Finally, we will ensure we have all the right equipment, including the appropriate lenses, ample empty memory cards and fully charged batteries, along with plenty of practice for whatever ventures we have in mind (*how*). With adequate preparation, your nightscape photo session will simply require arriving at the scene, assembling your camera and tripod at a known, pre-determined location, and at the correct time, pressing the shutter release and enjoying the results!

15

THE 25 BEST LANDSCAPE ASTROPHOTOGRAPHY TARGETS

(AND HOW TO PHOTOGRAPH THEM)

This chapter presents the top twenty-five landscape astrophotography targets in alphabetical order. An example of each one is given along with a brief summary of suggested camera settings. Detailed descriptions of most of these subjects can be found elsewhere in the book. The suggested best times of night to shoot with respect to sunset/sunrise and the various stages of twilight are also noted. By doing so, you can easily make any necessary adjustments to account for your specific geographical locations or seasons. The number of images typically involved are also included, along with the suggested lens(es) that you might find appropriate. The majority of these images can be made anywhere in the world, with a few notable exceptions, so understanding these parameters can quickly get you up to speed.

ALPENGLOW

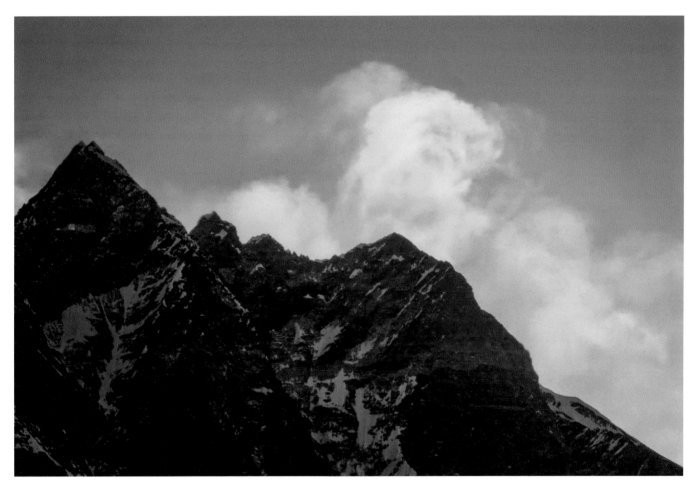

15.1 Alpenglow lights up luminous plumes of icy spindrift blown from
the peak of Mt. Everest in the pre-dawn twilight.

LENS (MM)	All	START	Early civil twilight
ISO	Low: 100–500	END	Mid- to late civil twilight
APERTURE	Sharpest (minimum + 2 stops)	NO. IMAGES	Variable
SHUTTER (SEC)	Adjust as needed	COMMENT	Alpenglow fades rapidly—act quickly

AURORA BOREALIS/AUSTRALIS

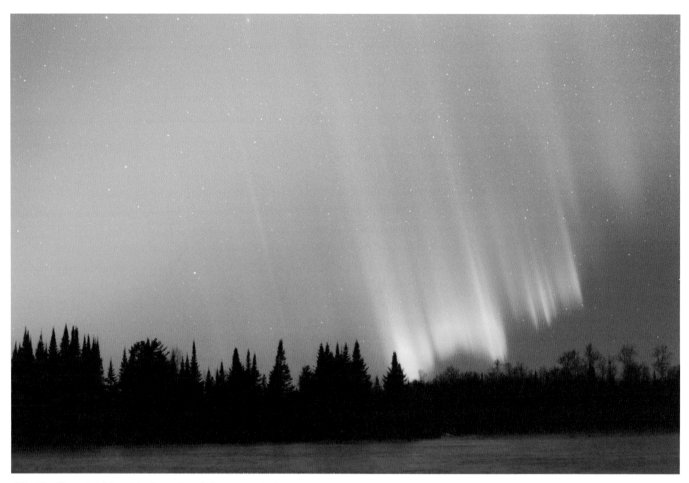

15.2 The shimmering lights of the Aurora Borealis have mesmerized people for generations. Here, intense curtains of light descend upon the shoreline of a frozen lake in northern Minnesota.

LENS (MM)	Fisheye, 14–50	START	Late astronomical twilight to full darkness
ISO	1600–12800	END	Early astronomical twilight (pre-dawn)
APERTURE	Minimum—sharpest	NO. IMAGES	Variable
SHUTTER (SEC)	Adjust as needed	COMMENT	Keep shutter speed low to retain structure

BELT OF VENUS

15.3 The soft pinks of the Belt of Venus gently blend into the serene blues of the earth's shadow. Both make beautiful backdrops to a variety of scenes.

LENS (MM)	All	START	Sunset/early civil twilight (sunset) Mid- to late civil twilight (sunrise)
ISO	Low: 100–500	END	Mid- to late civil twilight (sunset) Early civil twilight/sunrise (sunrise)
APERTURE	Sharpest (minimum + 2 stops)	NO. IMAGES	Variable
SHUTTER (SEC)	Adjust as needed	COMMENT	The Belt of Venus changes rapidly—act quickly

BIOLUMINESCENCE

15.4 The glowing lights of bioluminescent algae add an
unearthly dimension to landscape astrophotographs.

Source: Alex Cherney / www.terrastro.com / The World At Night

LENS (MM)	Fisheye, 14–50	START	End of astronomical twilight (post-sunset)
ISO	1600–12800	END	Beginning of astronomical twilight (pre-dawn)
APERTURE	Minimum—sharpest	NO. IMAGES	Variable
SHUTTER (SEC)	Adjust as needed	COMMENT	Rare; requires careful planning

BLUE HOUR

15.5 The intense sky colors during blue hour provide the perfect backdrop to the warm colors of this capstone kiva in Utah's desert southwest.

LENS (MM)	All	START	Evening: End of sunset
			Morning: Beginning of astronomical twilight
ISO	Low: 100–500	END	Evening: End of astronomical twilight
			Morning: Beginning of sunrise
APERTURE	Sharpest (minimum + 2 stops)	NO. IMAGES	Variable
SHUTTER (SEC)	Adjust as needed	COMMENT	Easy image to make; good silhouette opportunity

CITYSCAPES

15.6 "As the Moon rose and the Sun set on October 8, a lunar eclipse was in progress seen from Chongqing, China. Trailing through this composite time exposure, the rising moon began as a dark reddened disk in total eclipse near the eastern horizon. Steadily climbing above the populous city's colorful lights along the Yangtze River, the moon trail grows brighter and broader, until a bright Full Moon emerged from the earth's shadow in evening skies."—Yannan Zhou (photographer)

Source: Zhou Yannan /www.flickr.com/photos/zhouyannan/ The World At Night

LENS (MM)	All; generally wide-angle	START	Golden hour (sunset)
ISO	100–1600	END	Golden hour (sunrise)
APERTURE	Sharpest (minimum + 2 stops)	NO. IMAGES	Variable
SHUTTER (SEC)	Adjust as needed	COMMENT	Good FLW filter opportunity during civil/nautical twilight

CONSTELLATIONS

15.7 The stars of Boötes and Ursa Major glow over this remote lake in Minnesota's Boundary Waters Canoe Area and Wilderness (BWCAW).

LENS (MM)	Fisheye, 14–35	START	Mid-astronomical twilight (post-sunset)
ISO	1600–12800	END	Mid-astronomical twilight (pre-dawn)
APERTURE	Minimum—sharpest	NO. IMAGES	Variable
SHUTTER (SEC)	Focal length (mm)/ 500	COMMENT	Good fog filter opportunity

CRESCENT MOON

15.8 The waxing crescent moon and a crescent Venus (lower right) set gracefully over the Cologne Cathedral in Germany.

Source: Bernd Pröschold / www.sternstunden.net / The World At Night

LENS (MM)	50 mm and higher	START	Mid-civil twilight (post-sunset)
ISO	100–1600	END	Mid-civil twilight (pre-dawn)
APERTURE	Sharpest (minimum + 2 stops)	NO. IMAGES	Variable
SHUTTER (SEC)	Adjust as needed	COMMENT	Easiest when close to horizon and next to foreground subjects

FULL MOON

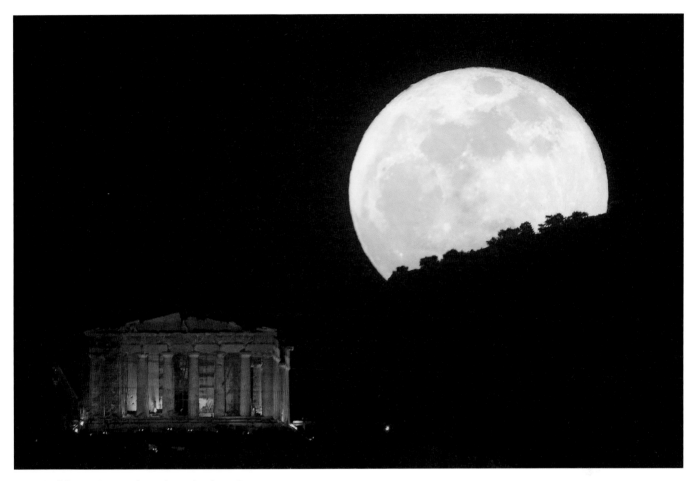

15.9 The full moon rises over the Parthenon in Athens, Greece.

Source: Anthony Ayiomamitis / www.perseus.gr / The World At Night

LENS (MM)	50 mm and higher	START	Late golden hour—sunset Mid-civil twilight—sunrise
ISO	100–1600	END	Mid-civil twilight—sunset Early golden hour—sunrise
APERTURE	Sharpest (minimum + 2 stops)	NO. IMAGES	Variable
SHUTTER (SEC)	Adjust as needed	COMMENT	Easiest when close to horizon and next to foreground subjects

GOLDEN HOUR/SUNSET/SUNRISE

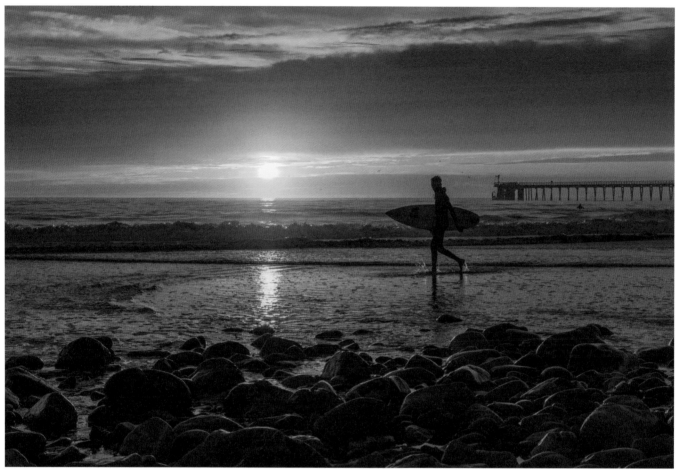

15.10 The warm hues of the golden hour are a reliable time to make beautiful images, such as this classic scene of a surfer getting ready to catch some waves in the last light of the day in Southern California.

Source: Scott Freeman

LENS (MM)	14–50	START	Golden hour (sunset)
ISO	100–1600	END	Golden hour (sunrise)
APERTURE	Sharpest (minimum + 2 stops)	NO. IMAGES	Variable
SHUTTER (SEC)	Adjust as needed	COMMENT	Good silhouette opportunity

LIGHT PAINTING/DRAWING

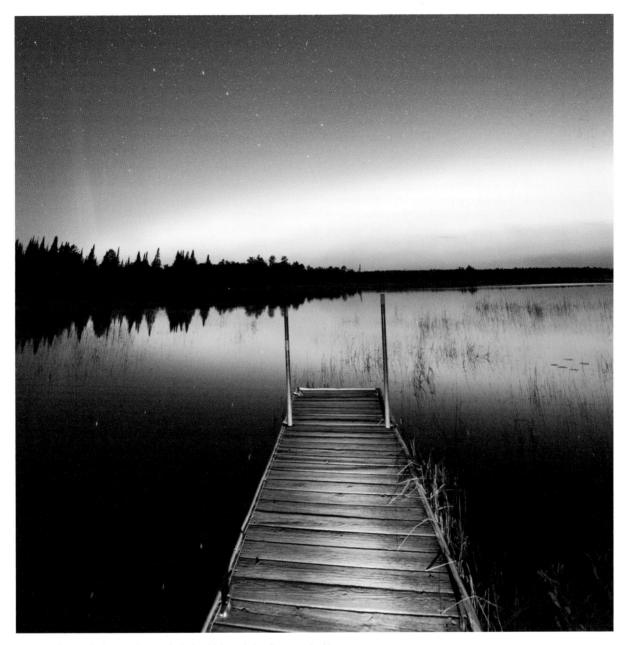

15.11 Light painting is a good way to include a high-resolution foreground subject, light-painted at a low ISO setting, with a nightscape created at a much higher ISO.

LENS (MM)	14–50	START	Mid-astronomical twilight (post-sunset)
ISO	100–1600	END	Mid-astronomical twilight (pre-dawn)
APERTURE	Sharpest (minimum + 2 stops)	NO. IMAGES	Variable
SHUTTER (SEC)	Adjust as needed	COMMENT	Wide variety of light sources available

LUNAR ECLIPSE

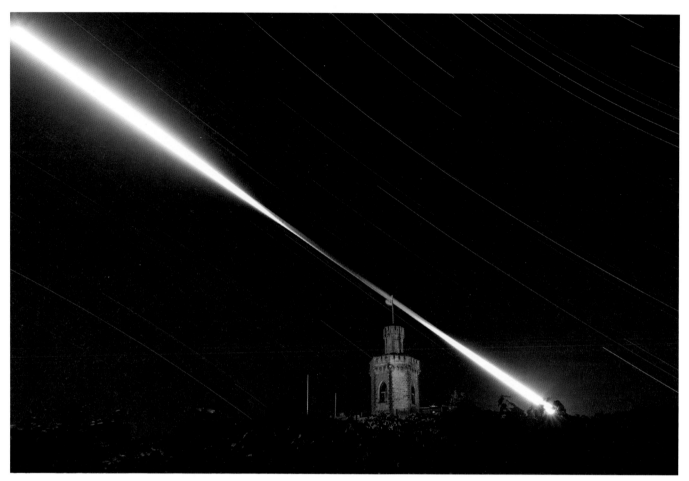

15.12 The movement of the moon through the earth's shadow during a lunar eclipse is seen clearly in this beautiful time-lapse image.

Source: Uli Fehr / www.fehrpics.com

LENS (MM)	24 mm and higher	START	Mid-civil twilight (post-sunset)
ISO	100–1600	END	Mid-civil twilight (pre-dawn)
APERTURE	Sharpest (minimum + 2 stops)	NO. IMAGES	Variable
SHUTTER (SEC)	Adjust as needed	COMMENT	Requires planning

MAGELLANIC CLOUDS

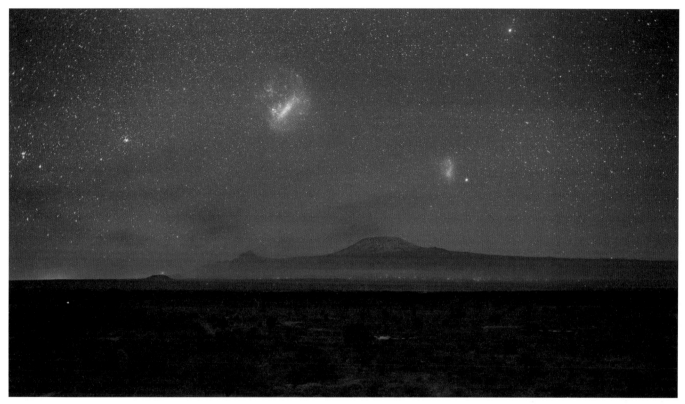

15.13 Both the Large and Small Magellanic Clouds are seen in this image of Mt. Kilimanjaro, as seen from Amboseli National Park, southern Kenya.

Source: Steed Jun Yu / NightChina.net / The World At Night

LENS (MM)	14–50	START	Mid-astronomical twilight (post-sunset)
ISO	1600–12800	END	Mid-astronomical twilight (pre-dawn)
APERTURE	Wide open (minimum f-stop)	NO. IMAGES	Variable
SHUTTER (SEC)	Focal length (mm)/ 500	COMMENT	Southern Hemisphere only

METEOR/METEOR SHOWER

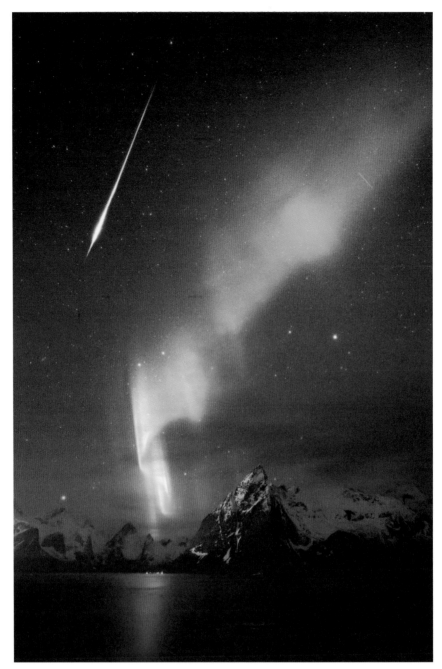

15.14 "You might say it's a matter of luck to get nice Northern Lights and an amazing fireball. Well, it's not quite true. When you shoot the Lights every clear night, chances increase by a good factor. So, as in many other fields, dedication gets your job done in night sky photography. During the three or four nights before the shot, I observed many bright meteors and I just felt this one coming."—Alex Conu (photographer)

Source: Alex Conu / alexconu.com

LENS (MM)	Fisheye, 14–50	START	Mid-astronomical twilight (post-sunset)
ISO	1600–12800	END	Mid-astronomical twilight (pre-dawn)
APERTURE	Largest opening	NO. IMAGES	Variable
SHUTTER (SEC)	Focal length (mm)/ 500	COMMENT	Requires planning

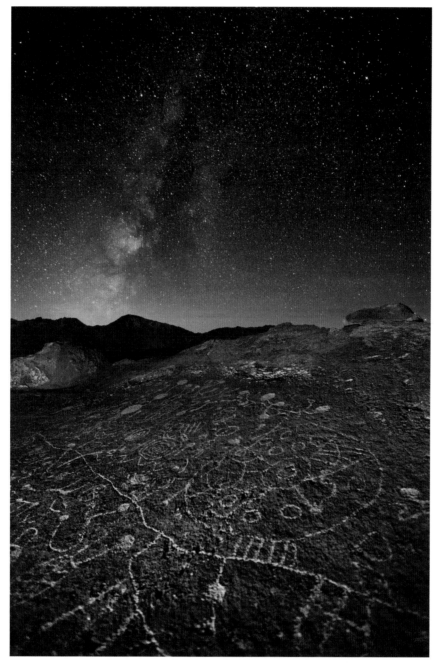

15.15 The Milky Way galactic core sets behind ancient petroglyphs in California's high desert.

Source: Grant Kaye / http://grantkaye.com

LENS (MM)	14–50	START	Mid-astronomical twilight (post-sunset)
ISO	1600–12800	END	Mid-astronomical twilight (pre-dawn)
APERTURE	Wide open (minimum f-stop)	NO. IMAGES	Variable
SHUTTER (SEC)	Focal length (mm)/ 500	COMMENT	July, August best months

MILKY WAY — PANORAMA

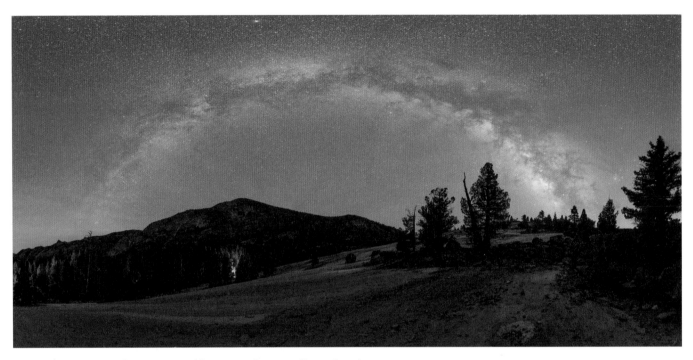

15.16 The mid-summer Milky Way arcs gracefully over campsites next to Florence Dome in California's High Sierra. This panorama image is comprised of two rows of thirteen images, or twenty-six images in total.

LENS (MM)	Fisheye, 14–50	START	Mid-astronomical twilight (post-sunset)
ISO	1600–12800	END	Mid-astronomical twilight (pre-dawn)
APERTURE	Wide open (minimum f-stop)	NO. IMAGES	Variable
SHUTTER (SEC)	Focal length (mm)/ 500	COMMENT	June, July, August best months; panorama head valuable

MOONLIT LANDSCAPE WITH STARRY SKIES

15.17 "Night arrives in the remote Saharan Desert of Tassili National Park; a World Heritage Site in southern Algeria. While the Sahara man (Taureg people) prepares their traditional mint tea, stars of Scorpius rise from the east, the Centaurus shines in the southeast, and the Southern Cross barely rise above the cliffs in south. The view is made in adventure The World At Night (TWAN) trip to the heart of Sahara. Prehistoric skygazers surely witnessed a similar sky. Tassili region is noted for rock paintings and archaeological sites dating to neolithic times."—Babak Tafreshi

Source: Babak Tafreshi/ www.dreamview.net / www.twanight.org /The World At Night

LENS (MM)	All	START	Mid-nautical twilight (post-sunset)
ISO	100–3200	END	Mid-nautical twilight (pre-dawn)
APERTURE	Sharpest (minimum + 2 stops)	NO. IMAGES	Variable
SHUTTER (SEC)	Adjust as needed	COMMENT	Wide opportunity for creativity

PANORAMA

15.18 The Aurora Borealis arcs gracefully over one of Minnesota's thousands of lakes in this panorama image, comprised of three rows of eight images, or twenty-four images in total.

LENS (MM)	24–50	START	Golden hour (pre-sunset)
ISO	1600–12800	END	Golden hour (post-sunrise)
APERTURE	Wide open (minimum f-stop)	NO. IMAGES	Variable
SHUTTER (SEC)	Adjust as needed	COMMENT	Wide opportunity for creativity, planning helpful. Act quickly to avoid changes in exposure.

PLANETARY CONJUNCTIONS

15.19 A relatively rare, four-planet planetary conjunction (five if you include Earth!), clearly illustrates the flatness of the solar system.

LENS (MM)	14 and higher	START	Mid-civil twilight (post-sunset)
ISO	100–1600	END	Mid-civil twilight (pre-dawn)
APERTURE	Sharpest (minimum + 2 stops)	NO. IMAGES	Variable
SHUTTER (SEC)	Adjust as needed	COMMENT	Rare; requires planning

ROCKET LAUNCH

15.20 A rocket launch is a stunning nightscape subject, as seen here for this Atlas 5 rocket launch from Cape Canaveral, Florida.

Source: Ben Cooper / www.launchphotography.com

LENS (MM)	14 mm and higher	START	Golden hour (pre-sunset)
ISO	100–6400	END	Golden hour (post-sunrise)
APERTURE	Sharpest (minimum + 2 stops)	NO. IMAGES	Variable
SHUTTER (SEC)	Adjust as needed	COMMENT	Requires travel; only in very specific locations

SOLAR ECLIPSE

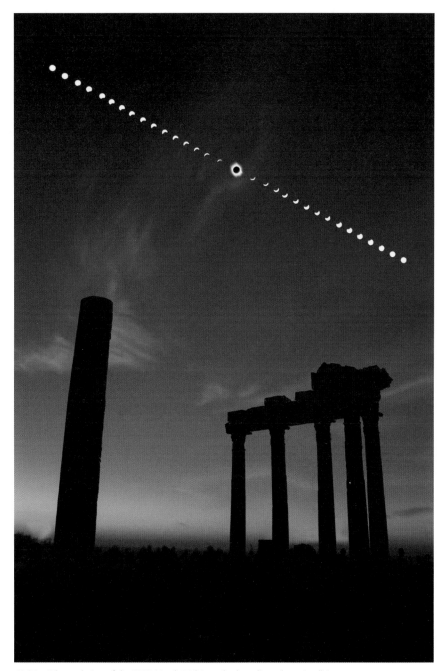

15.21 "The evolution of the 2006 March 29th's total solar eclipse above Apollo's temple in Side, Turkey."—Cristina Ţintă (photographer)

Source: Cristina Ţintă / www.flickr.com/photos/cristinatinta/ The World At Night

LENS (MM)	14–50; telephoto for just eclipsed sun	START	Sunrise
ISO	100–1600	END	Sunset
APERTURE	Sharpest (minimum + 2 stops)	NO. IMAGES	Variable
SHUTTER (SEC)	Adjust as needed	COMMENT	Extremely rare; requires planning and travel. Note: totality only lasts a few minutes!

STAR TRAILS

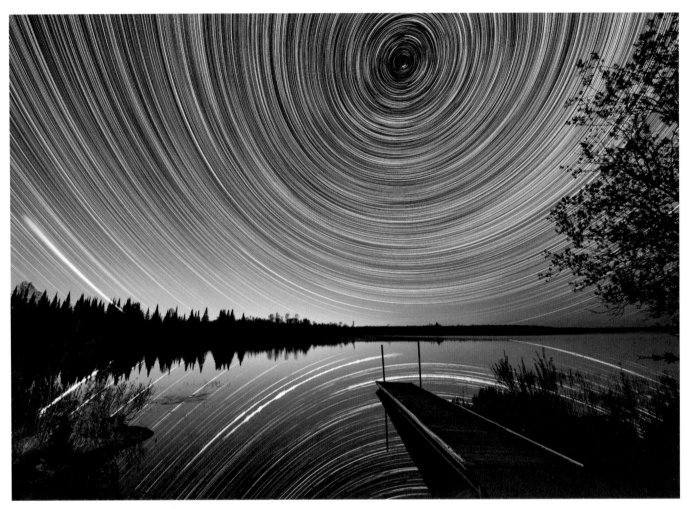

15.22 Over three hours of star trails combine in this mesmerizing composite image made in northern Minnesota.

LENS (MM)	Fisheye, 14–50	START	Late nautical twilight (post-sunset)
ISO	1600–12800	END	Early nautical twilight (pre-dawn)
APERTURE	Wide open (minimum f-stop)	NO. IMAGES	Hundreds
SHUTTER (SEC)	Adjust as needed	COMMENT	Easy image once learned

TIME-LAPSE

15.23 Dusk blends into complete darkness over Hovenweep
National Monument in southern Utah.

LENS (MM)	Fisheye, 14–50	START	Golden hour (pre-sunset)
ISO	1600–12800	END	Golden hour (post-sunrise)
APERTURE	Wide open (minimum f-stop)	NO. IMAGES	Hundreds
SHUTTER (SEC)	Adjust as needed	COMMENT	Easy once learned; new frontier of nightscapes

VOLCANO

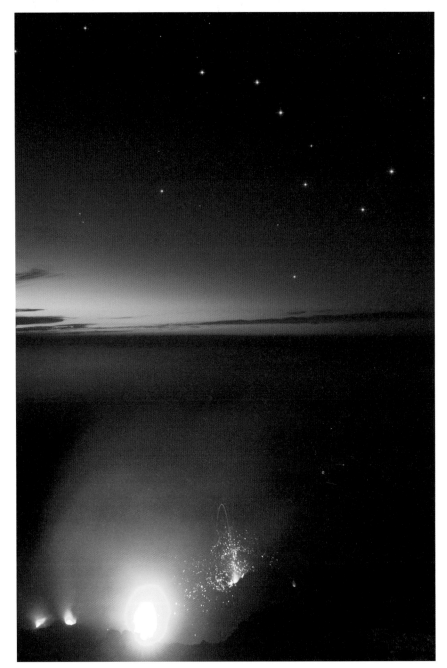

15.24 "This image was made on the 1st of October 2008, on the summit of the volcanic island of Stromboli. I wasn't expecting to make such an image, as time was very limited. You can't climb the Stromboli volcano on your own these days, so it's always a guided climb. But it turned out to be just at the right moment: shortly after sunset, already dark enough to see the Big Dipper, but not quite too dark to lose the foreground."—Philippe Mollet (photographer)

Source: Philippe Mollet / The World At Night

LENS (MM)	14–50 mm	START	Mid-astronomical twilight (post-sunset)
ISO	100–1600	END	Mid-astronomical twilight (pre-dawn)
APERTURE	Sharpest (minimum + 2 stops)	NO. IMAGES	Variable
SHUTTER (SEC)	Adjust as needed	COMMENT	Extremely rare; requires extensive planning and availability

ZODIACAL LIGHT

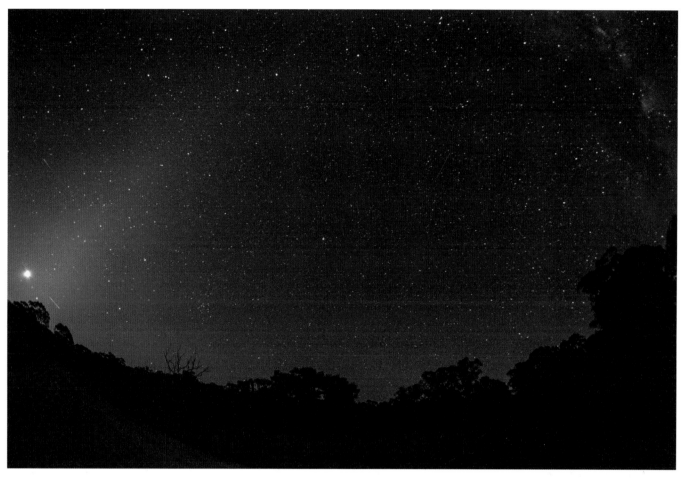

15.25 The faint cone of zodiacal light reaches upwards from the horizon (left) to intersect the arc of the summer Milky Way (right) in this fisheye lens view created in a dark location just outside Sydney, Australia.

LENS (MM)	Fisheye, 14–50	START	End of astronomical twilight (post-sunset)
ISO	1600–12800	END	Beginning of astronomical twilight (pre-dawn)
APERTURE	Wide open (minimum f-stop)	NO. IMAGES	Variable
SHUTTER (SEC)	Focal length (mm)/ 500	COMMENT	Elusive but stunning

16

DEVELOPING YOUR ASTROPHOTOGRAPHY SESSION PLAN

This chapter helps you develop a detailed plan for your nightscape session based on your understanding of astronomy and photography. It includes a pre-determination of your shooting location, a detailed schedule and suggested camera settings, along with the appropriate lenses and any specialized equipment that you might need for all your shots. Sounds good, right? Spending the time beforehand to clearly think through your objectives will help you stay on track when you are in the field. It will allow you to concentrate on the creative aspects of your session instead of getting bogged down in technical details and distractions that could have been minimized or avoided altogether. Having a plan will make the difference between being unpleasantly surprised by the unexpected appearance, or lack thereof, of a crucial night sky object; or enjoying the confirmation of observing an anticipated sequence of astronomical events unfolding on schedule before your eyes.

The general sequence of steps for developing a comprehensive plan for a nightscape photo session is shown in Figure 16.1. There are six main steps: (1) developing the concept, Figure 16.1(a); (2) choosing the shooting location and date, Figure 16.1(b); choosing the shooting time, Figure 16.1(c); selecting the appropriate lens, Figure 16.1(d); choosing the appropriate exposure settings, Figure 16.1(e); and summarizing your plans and timeline for the session, Figure 16.1(f). It's easier than it sounds! The main reason for laying out each of these steps explicitly is to make sure we don't overlook anything. Also, this structure helps provide a logical sequence to the many decisions that you may wish to make. We will now go through each step in detail.

PRE-VISUALIZATION AND DEVELOPING THE CONCEPT

Begin your planning process with a specific concept in mind; be it star trails, an image of the Milky Way, a meteor shower, or perhaps the full moon rising, Figure 16.1(a). Chapter 15 is full of great ideas, as is the Distinguished Guest Gallery! Better yet, *pre-visualize* your nightscape image—close your eyes and think carefully about the image you'd like to create. Be as detailed as possible; is there a specific foreground subject in your image like a particular mountain peak or a well-known rock arch; or more general subjects like patches of wildflowers or a lake with a fishing pier? How are the night sky objects positioned relative to the foreground; does the Milky Way appear to rise directly upwards out of a river or waterfall; or does it arch horizontally across the sky? If you are creating star trails, how exactly are they oriented relative to the horizon—do they angle upwards, curve across the horizon, or form complete circles? How well illuminated is the foreground; are you looking for dark silhouettes, or is a well-lit foreground important? Is the moon rising over, or next to some historic or natural landmark? While it may sound obvious, pre-visualizing your images gives you the answers needed to narrow down your choices of dates, times, locations, lens choices, camera setting, and exposure strategies to those that will practically guarantee that you'll return home with memory cards chock full of exciting images!

Having a pre-visualized scene in mind also helps enormously as you scout your destination during both the day and at night. I have experienced déjà vu many times as I've come across scenes that uncannily match their pre-visualized version; the process of pre-visualization can help in "knowing" when you've arrived at a good spot. Also, it is always surprising how many unexpected distractions develop in the field to pry your attention away from the subtleties of composition. For example, mosquitoes, thick brush, ticks, incipient clouds, incipient moonrise, cold, wind, difficulty in achieving focus, lights from other people, dying batteries, dehydration, not getting lost and even sleepiness can all interfere with the creative process of landscape astrophotography. Having a well

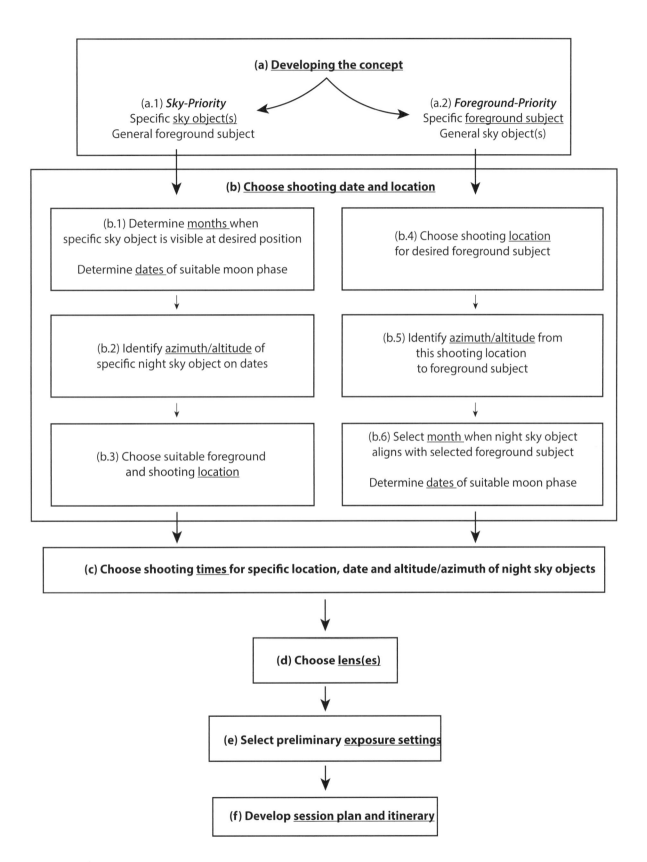

(a) Developing the concept

(a.1) *Sky-Priority*
Specific <u>sky object(s)</u>
General foreground subject

(a.2) *Foreground-Priority*
Specific <u>foreground subject</u>
General sky object(s)

(b) Choose shooting date and location

(b.1) Determine <u>months</u> when
specific sky object is visible at desired position

Determine <u>dates</u> of suitable moon phase

(b.4) Choose shooting <u>location</u>
for desired foreground subject

(b.2) Identify <u>azimuth/altitude</u> of
specific night sky object on dates

(b.5) Identify <u>azimuth/altitude</u> from
this shooting location
to foreground subject

(b.3) Choose suitable foreground
and shooting <u>location</u>

(b.6) Select <u>month</u> when night sky object
aligns with selected foreground subject

Determine <u>dates</u> of suitable moon phase

(c) Choose shooting <u>times</u> for specific location, date and altitude/azimuth of night sky objects

(d) Choose <u>lens(es)</u>

(e) Select preliminary <u>exposure settings</u>

(f) Develop <u>session plan and itinerary</u>

16.1 The six main stages of planning a nightscape photo shoot. (a) Developing the concept; (b) choosing the shooting location and date, (c); choosing the shooting time; (d) selecting the appropriate lens; (e) choosing the appropriate exposure settings; and (f) summarizing your plans and timeline for the session.

thought out, pre-visualized image in mind, with all the critical elements clearly identified, helps keep you on track.

It is often helpful to draw inspiration from the work of others in developing your concepts. I am continually motivated at the creativity, imagination, and skill of fellow landscape astrophotographers. Online communities such as The World At Night (TWAN) and those on Google+, Instagram, Flickr, Pinterest, and Facebook are especially inspirational and educational. There may be some aspect of an image from a different part of the world that you can apply to a scene right in your backyard, whether it has to do with composition, lighting, or something else.

Finally, once you arrive at your destination, be sure to visit local visitor centers and gift shops. They are often stocked with scenic postcards, maps, and guidebooks with images of popular and lesser-known photo destinations. I usually make a point to visit visitor centers of nearby National Parks, US Forests and State Parks, along with the local AAA office and the public library.

You might find it helpful to keep a small notebook easily available to jot down any photo ideas or sketches that may come to mind. I find that I am struck with inspiration for images at the most unpredictable of times, visions often triggered by scenes I may stumble upon unexpectedly. When you review the notes you've accumulated over the course of months and years, you will likely spot trends or themes in the types of images you wish to create. These themes are your personal style, and can be very helpful in orientating yourself in new shooting situations.

You may also develop a library of what I like to call "favorite images" and "favorite places." One example of a favorite image might be a scene with the Milky Way rising vertically from the horizon with an internally lit tent in the foreground, Figure 16.2(a). An example of a favorite place might be the edge of a wilderness area that allows you to position specific objects at the center of star trails encircling the celestial pole, Figure 16.2(b). As you create your own repository of images, you may find it beneficial to keep a library of ones that especially resonate with you filed away either digitally in "the cloud" or via prints. It is often possible to gain fresh perspective and motivation by reviewing them from time to time, especially when you're in the field looking for inspiration.

The next step is to turn your concept into a rough sketch to help fill in as many details as possible. One of my own examples is shown in Fig. 16.3 (overleaf). It shows a scene with the Milky Way rising from the intersection of a river and mountains along the horizon. The river is flanked by trees on either side, and is flowing toward the viewer. This was the concept sketch drawn months in advance of the actual image shown in Figure 8.1(b). In it, I've attempted to capture what I felt to be the essence of the image; the curving flow of the Milky Way seamlessly merging with the flow of the river. The benefits of drawing such sketches are many, but most importantly they serve as a helpful source of answers during your planning. You may even surprise yourself by discovering key elements that had previously been hidden only in your subconscious!

In preparing your sketches, it is worth following basic rules of photographic composition. For example, creating your composition in accordance with the Rule of Thirds often yields visually pleasing results. Positioning a leading line coming into the composition from the lower left corner helps guide the eye of the viewer into the scene. Creating a sense of tension between contrasts—in color, texture, shape always imparts dynamism to the scene. Much has been written elsewhere on the subject of composition in photography and you are urged to explore it in more detail.

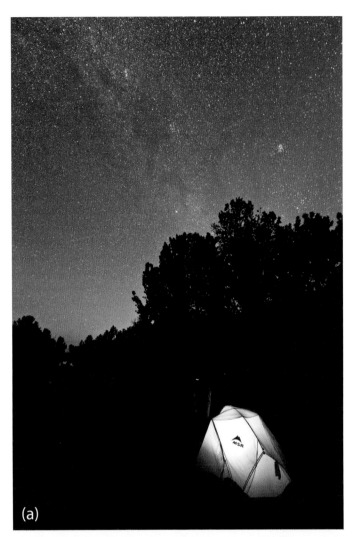

16.2 Examples of two of the author's "favorites:" (a) A "favorite image:" a scene with the Milky Way rising vertically from the horizon with an internally lit tent in the foreground. (b) A "favorite place:" the edge of a wilderness area that allows you to position specific objects at the center of star trails encircling the celestial pole.

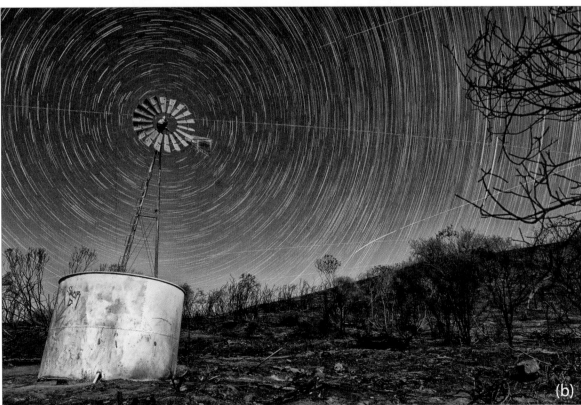

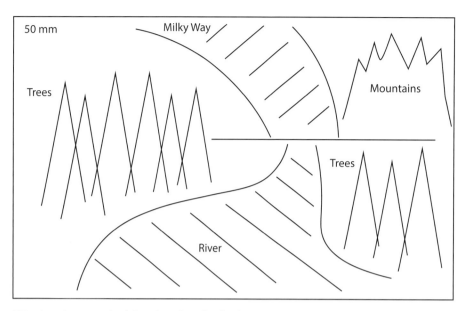

16.3 A rough concept sketch from the author's files showing a scene with the Milky Way rising from the intersection of a river and the horizon. The river is flanked by trees and perhaps mountains on either side, and is flowing toward the viewer. This was the concept sketch drawn months in advance of the actual image shown in Figure 8.1(a).

Once you've developed a series of sketches for your planned shots, one image per page, try organizing them into categories. My typical categories include, "Partial Moon Shots," for images created with a waxing crescent or waning crescent moon illuminating the foreground; "Dedicated All-Nighters," for images that require a dedicated camera body/lens/tripod/power system for the entire night; "Milky Way Shots," for those that require the Milky Way; "Dark Sky Shots," that simply require dark skies with no particular foreground or night sky subject needed. I find this process helps me focus on my priorities for a given session. It also allows me to organize the shots within each category in terms of their significance and lens usage, together with the expected visibility window of night sky objects. This categorization process also helps when developing the schedule for the nightscape session.

As you review your image concepts and categories, you will likely find that all your nightscape concepts, regardless of category, will have one of two broad themes. The first necessitates a very specific feature of the night sky coupled with a less stringently defined foreground subject. We will designate these as *sky-priority* nightscapes, Figure 16.1(a.1). For example, in images of star trail circles over a lake, or of a vertical Milky Way rising above a waterfall, what is important is the vertical Milky Way and the circular star trails; almost any properly oriented lake or waterfall will do the job. In contrast, the second type emphasizes a very specific foreground object in conjunction with a general night sky object. We will designate these types of concepts *foreground-priority* nightscapes, Figure 16.1(a.2). Examples of foreground priority images include a very specific mountain peak, for example Mt. Rainier, next to the Milky Way; or a very specific lighthouse, for example Split Rock Lighthouse along the north shore of Lake Superior with the full moon rising directly over its top. We'll go through the planning process for sky-priority images first, followed by a description of how to plan for foreground-priority images.

CHOOSING CANDIDATE DATES AND SHOOTING LOCATIONS —SKY-PRIORITY NIGHTSCAPES

Now that we've identified our nightscape concept and prepared a rough sketch, the next step is to choose a few candidate dates and possible shooting locations based on our knowledge of what will be visible in the sky throughout the year, Figure 16.1(b). The details of this process differ depending on whether we are considering a sky-priority or a foreground-priority image. Specifically, *for sky-priority images, the date is chosen first*, which then affects the choice of shooting location and foreground subject, Figure 16.1(b.1–b.3). For *foreground-priority images, however, the reverse is true: the shooting location and foreground subjects are chosen first*, which then determine the optimum dates, Figure 16.1(b.4–b.6).

We will start with sky-priority images, Figure 16.1(b.1–b.3). For some, the dates are already set: solar eclipses, meteor showers, and the nights of the full moon. For others, your knowledge of astronomy will guide you in selecting the best general viewing months. For example, May through September would be the months to view the Milky Way's galactic core, whereas November through May would be the months to view the constellation Orion. At this stage of the planning process, we are only interested in the months when the night sky subject is visible; we will narrow the dates in the next steps.

We now want to consider the dates of the appropriate moon phases within each of the candidate months for your specific night sky subject—new, gibbous, crescent or full, Figure 5.8. Here is where your pre-visualized concept and rough sketch will help: do they indicate a well-lit foreground or one that is in silhouette? Each month will likely have only a few dates with the suitable moon phase.

CHOOSING AZIMUTH AND ALTITUDE OF THE NIGHT SKY SUBJECT

The next phase of planning involves identifying the general compass direction, or *azimuth* of your night sky subject on the selected dates, along with its height above the horizon, or its *altitude*, measured in degree, Figure 16.4 (overleaf). While you may recall correctly from Chapter 2 that the azimuth and altitude of night sky objects change during the night, we only need to assess their general range at this stage.

You may obtain the azimuth and altitude of your night sky subjects at various times on your candidate dates with the help of the star charts, planispheres, and planetarium described in Chapter 2, Figures 2.11 and 2.12. Monthly publications of star charts are available online, and also appear in magazines such as *Astronomy* or *Sky & Telescope*. Several useful apps and programs are also available, as described in the next section, such as Distant Suns, Star Walk, Stellarium, and Google Sky.

CHOOSING THE LOCATION

We can now explore a few locations where we might set up our equipment for the night, provided a suitable foreground subject is available. Start with a location with the darkest possible skies, free from cities and other sources of light pollution. Even if your general destination is dictated by other constraints, it is worthwhile driving a short distance if it can help alleviate light pollution levels.

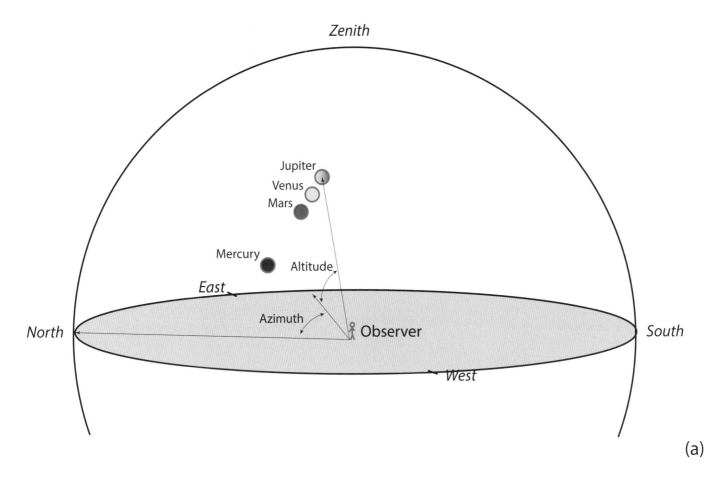

16.4 Schematic illustrations of the azimuth (compass direction) and altitude (angular height above the horizon) of the subject, in this case a planetary conjunction, in our sky-priority image. The planets are positioned at an azimuth of approximately 95° E with an altitude of approximately 12°, shortly after sunrise on October 28, 2015.

Source: http://vitotechnology.com/star-walk.html

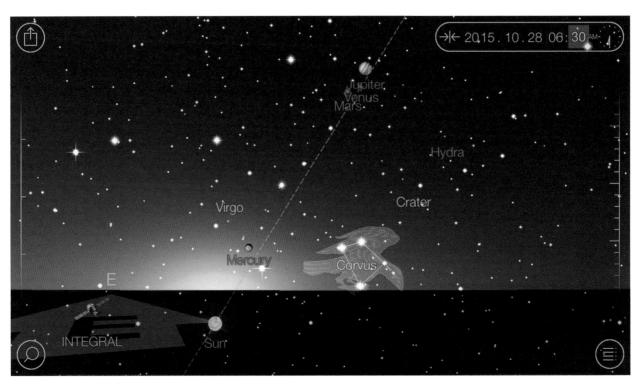

My go-to source for dark sky information is the excellent website: https://djlorenz.github.io/
astronomy/lp2006/overlay/dark.html, which integrates with Google Earth. An example is shown
in Figure 16.5 for the area around Moab, Utah. I have used this site on many trips and found it
invaluable. In addition to giving precise levels of darkness surrounding known metropolitan areas,
it also reveals light pollution from unexpected sources. For example, during the planning stages of
a trip through the Australian outback, I was surprised to find significant light levels indicated in a
nominally unpopulated area of significant size. Closer examination revealed the presence of several
large surface mines that were no doubt the source of the light. Thus I was saved the unpleasant
surprise of traveling to what would appear to be a dark sky area only to find the night sky light
levels to be equivalent to those of a metropolitan suburb!

If you are considering a trip far from home, a helpful step at this stage is to consult the treasure
trove of historical and forecast weather information for your candidate destinations from websites
like the Weather Underground for sites around the world. You can use such sources to determine

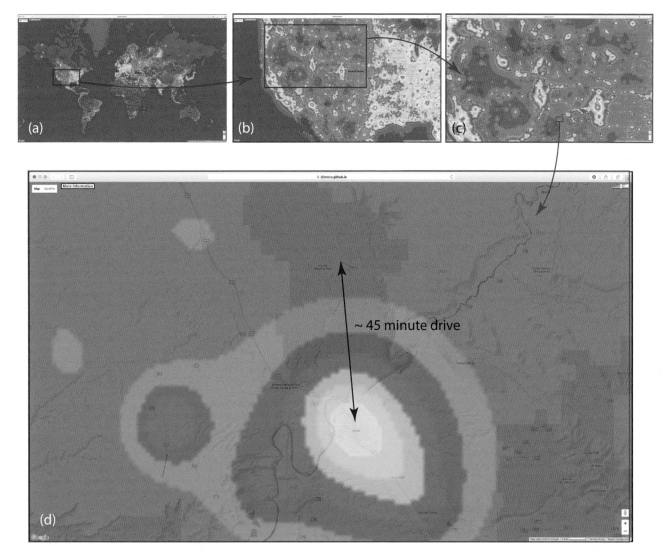

16.5 Example of light pollution maps with an emphasis on the area around Moab, Utah.
Successive areas of zoom are shown in (b), (c), and (d). Note that simply by driving approximately
45 minutes to the north of the city, (d), the light pollution levels are reduced dramatically.

Source: https://djlorenz.github.io/astronomy/lp2006/overlay/dark.html

16.6 An example of historical data from Weather Underground for the month of August in Centennial, Wyoming. This information can be used to anticipate general trends in future weather. Average daily rainfalls of over, say, 0.5 inches suggest inclement weather is reasonably likely.

Source: wunderground.com

which of your candidate dates and locations are more or less prone to clear or cloudy skies by looking at historical levels of average rainfall, Figure 16.6. If your trip is commencing within the next week or two, a reliable short-term weather forecast is essential and can also be obtained from Weather Underground, Figure 17.7(b), as well as the U.S. National Weather Service and other sources. Finally, if your session is planned within the next 36 hours, the hour-by-hour predictions for the expected viewing conditions found on the Clear Dark Skies website can be extremely accurate, Figure 17.7(c).

Once the general area of the session location has been identified, the next stage is to pinpoint the exact destination based on the requirements of your pre-visualized image or theme. Here, Google Earth is my standby—its ability to explore distant lands from a virtual, aerial perspective is incredibly helpful, especially when coupled with its built-in ruler, which allows the determination of precise distances and orientations of objects. Being able to tilt and rotate the scene is icing on the cake! The 7.5-minute topographical quadrangles from the U.S. Geological Survey are my other primary tool. These may be printed or ordered ahead of time. They may also be purchased locally from outdoor or wilderness supply shops.

Let's see how to do this by way of an example. Consider the situation shown in Figure 16.7, where we have decided we wish to photograph the Milky Way over some spectacular rock arches in Arches National Park. We have already determined that we need to locate our tripod generally at an azimuth of 100° E in order to be able to view the Milky Way band arcing upwards at an altitude of

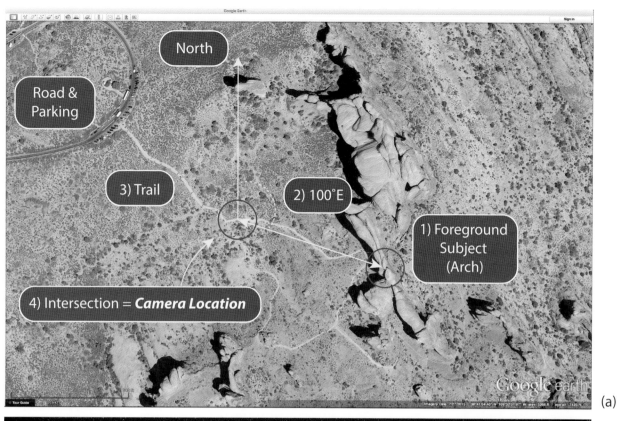

(a)

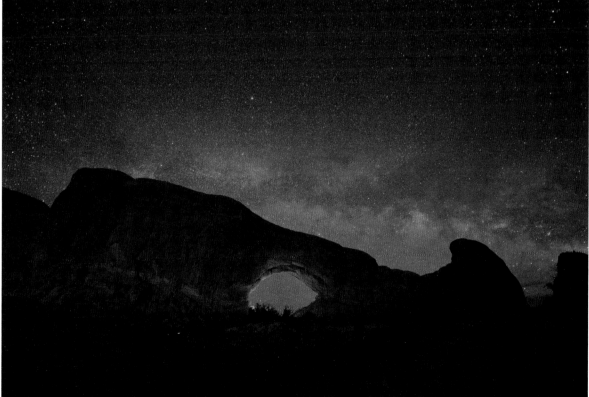

(b)

16.7 This figure illustrates the process of determining precisely where to set up our tripod for our sky-priority image. We know that we need to locate our tripod generally at an azimuth of 100° E in order to be able to view the Milky Way band arcing upwards at an altitude of approximately 30° around 11 pm in late June, which is when we will be visiting the area. (a) We see that there is a trail that runs alongside our foreground subject, so we just need to find out where along the trail we should stand. We accomplish this by positioning a line oriented at our required azimuth, e.g. 100° E, with one end intersecting our foreground subject and the other end intersecting the trail at the exact location where we should assemble our tripod for (b) the resultant shot!

Source: (a) http://app.photoephemeris.com/

16.8 Virtual exploration of a prospective shooting location with, for example, Google Earth, can yield surprisingly accurate results, as seen here in this comparison of an (a) actual and (b) virtual view of the same region within the Santa Monica Mountains National Recreation Area in California. Such virtual explorations can save you immense effort and valuable time in the field at your actual location.

Source: (b) Google Earth

approximately 30° around 11 pm in late June, which is when we will be visiting the area. We need to find a location that simultaneously keeps the Milky Way at our desired azimuth (sky-priority) while positioning a suitable rock arch within the foreground.

So where precisely should we position our tripod? We see that there is a trail that runs alongside a potential foreground subject, so we need to find out where along the trail we should stand. We accomplish this by positioning a line oriented at our required azimuth, e.g. 100° E, with one end intersecting our foreground subject, Figure 16.7(a). The point where the other end intersects our trail is the precise location where we should assemble our tripod. The results, Figure 16.7(b), agree quite well with expectations!

We can now examine our location at closer range within Google Earth to explore various compositions. For example, we can tilt and rotate our view, zooming in and out, and the results are often in remarkable agreement with reality, Figure 16.8. This type of advance planning can be enormously valuable in preserving precious time and energy in the field.

This sky-priority planning example teaches us several valuable lessons that are worth emphasizing. First, suppose that we had done no planning at all, and that we simply went to the destination on a random date hoping to photograph the Milky Way. What are the chances that it would be visible during dates of when the skies had no moon? If we visited during the late fall and early winter months, we would be totally out of luck. Even if we were lucky enough to visit when the Milky Way is perfectly positioned during the prime days in July or August, without planning or foreknowledge, we would be forced to scramble around in near total darkness amidst rough terrain trying to find somewhere to set up, meanwhile with the Milky Way slowly moving across the sky as time passes. Clearly, and as described further in Chapter 19, advance planning not only greatly increases the efficiency of the process but often can save a nightscape photo outing from being disappointing.

CHOOSING CANDIDATE DATES AND SHOOTING LOCATION —FOREGROUND-PRIORITY NIGHTSCAPES

Let's see how the process of choosing candidate dates and shooting locations changes when we're planning foreground-priority images, Figure 16.1(b.4–b.6). The only real difference is in the order in which we perform our planning steps; otherwise the steps remain the same. *For foreground-priority images, we begin by choosing the foreground subject and shooting location first.* These choices then dictate the optimum shooting dates, rather than the dates governing the choices of foreground subject and shooting location as was the case of sky-priority images. Again, let's see how this works by way of example.

Suppose we wish to create an image with the Milky Way in immediate proximity to Mt. Banner in the Ansel Adams Wilderness in California's High Sierra, Figure 16.9(a). We study the map of the location and determine a suitable location to set up our camera and tripod; in this case, across Thousand Island Lake, Figure 16.9(b) (overleaf). Having established the shooting location, Figure 16.1(b.4), the next step is to find the azimuth to Mt. Banner, Figure 16.1(b.5), which turns out to be 206° E, Figure 16.9(b).

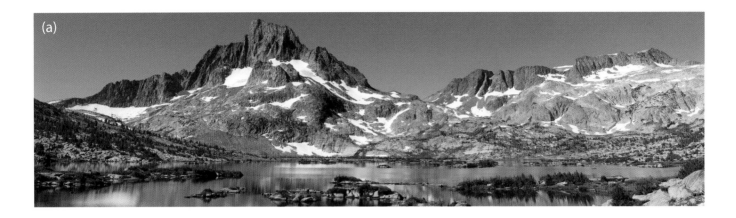

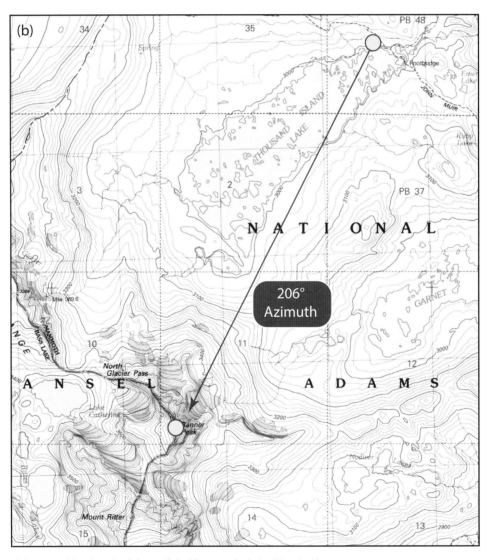

16.9 Determining the azimuth for our desired foreground-priority object, in this case, Mt. Banner (a) in the Ansel Adams Wilderness in California's High Sierra. We see that the azimuth is 206° E if we position ourselves across Thousand Island Lake (b).

Source: www.usgs.gov

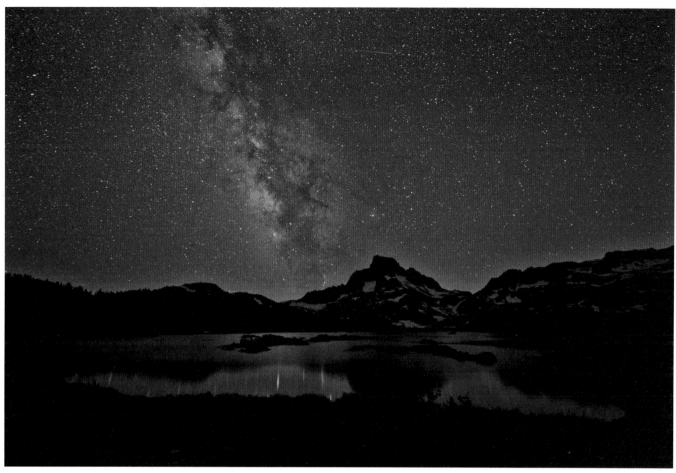

16.10 The final image resulting from our foreground-priority subject planning, showing the Milky Way positioned immediately adjacent to Mt. Banner.

The only remaining step in our plan is to find the approximate dates and times when the Milky Way will be positioned at the required azimuth of 206° E, Figure 16.1(b.6). This is easily accomplished with any of the previously described tools: a planisphere, home planetarium, planning app, or software. The outcome of our plan is shown in Figure 16.10, and, as desired, features the Milky Way positioned immediately next to Mt. Banner.

ESTABLISHING SHOOTING SCHEDULES

So far we have gathered approximate dates, times, and azimuths for our nightscape session. These three parameters go hand-in-hand, as you may recall from our study of the movements of the night sky objects covered in Chapter 2. For example, if you wanted to photograph the constellation Orion at an azimuth of 138° and an altitude of 32°, you may find that it appears at that position at 10 pm on one date, but at the same position at 8 pm a month later. Or you might wish to make an image with the primary band of the Milky Way Galaxy intersecting the horizon at an azimuth of 206° as shown in Figure 16.10, in which case you could select from the following dates and times: April at 4 am; May at 2 am; June at midnight, July at 10 pm, and August at 8 pm. Partly dependent upon the night sky object visibility, partly depending on the specific foreground objects from your image concept, partly dependent on site accessibility; your selection of the best date and time for your

photo shoot is usually an iterative process whose final outcome ultimately depends on the unique characteristics of the individual situation.

Another important parameter to check before embarking on your night photography session concerns the exact times of the various twilights, as described in Chapter 3. If your goal is to make your images with the darkest sky possible, you will want to schedule your session after the end of astronomical twilight in the evening and before its beginning the following morning. Alternatively, you may wish to synchronize the beginning of your session with civil, nautical, or astronomical twilight, depending on the color of the sky that you seek for your particular subject; several useful examples are given in Chapter 15.

A summary of the best, approximate times to create common nightscape images is shown in Figure 16.11. The importance of the moment of sunrise/sunset, and the twilight transition times, is clear. Be sure to note that depending on the time of year, and your latitude, the relative lengths of each of the stages of twilight and darkness will vary significantly. For example, during June in Los Angeles, California, full darkness lasts almost exactly 4 hours, whereas on the same dates in Ely, Minnesota, only fourteen degrees to the north, it only lasts for an hour and a half!

CHOOSING LENS AND CAMERA SETTINGS

The last stage of preparation before we summarize our overall plan is to select the appropriate lens and exposure settings, Figure 16.1(d, e). Lens selection can be done with reference to the lens field of view (FOV) tables in Chapter 11. Namely, you will want to select the appropriate lens needed to create your pre-visualized image based upon the azimuth and altitude requirements of your night sky subject(s) as well as the necessary FOV needed to include your foreground. For example, if you wish to create a star trails image with trails encircling the North Star with land-based foreground objects also visible, then the angular FOV of the lens must be wide enough to exceed the angular position of the North Star above the horizon, which you may recall is approximately equal to your latitude, as illustrated in Figure 16.12(a) (overleaf). Alternatively, if you wish to create a Milky Way image similar to the one depicted in Figure 11.19, you will want to select a lens with a narrower FOV; e.g. one with a focal length of 35 mm or greater. Finally, if you wish to create an image containing a specific range of constellations, for example, Sagittarius and Scorpius, then you'll need to match the FOV of your lens to the required FOV of the constellations, which can be obtained from the simulation apps described in Chapter 17, as illustrated in Figure 16.12(b). Choosing and mounting the correct lens ahead of time avoids the significant hassle and time wastage associated with the necessity of changing lenses in the field owing to an inappropriate FOV; something easily avoidable with proper preparation. Note that we will confirm our choice of lens selection during our day scouting exercise, described in the next section.

Next, you can identify a good starting point for each of the camera's exposure settings, Figure 16.1(e): ISO, aperture and shutter speed with reference to the information in Chapters 10 and 12. The specific settings you will settle upon once you're in the field will undoubtedly change; the estimated initial values nonetheless reduce the number of decisions you need to make when you're setting up in the dark with many other distractions likely competing for your attention.

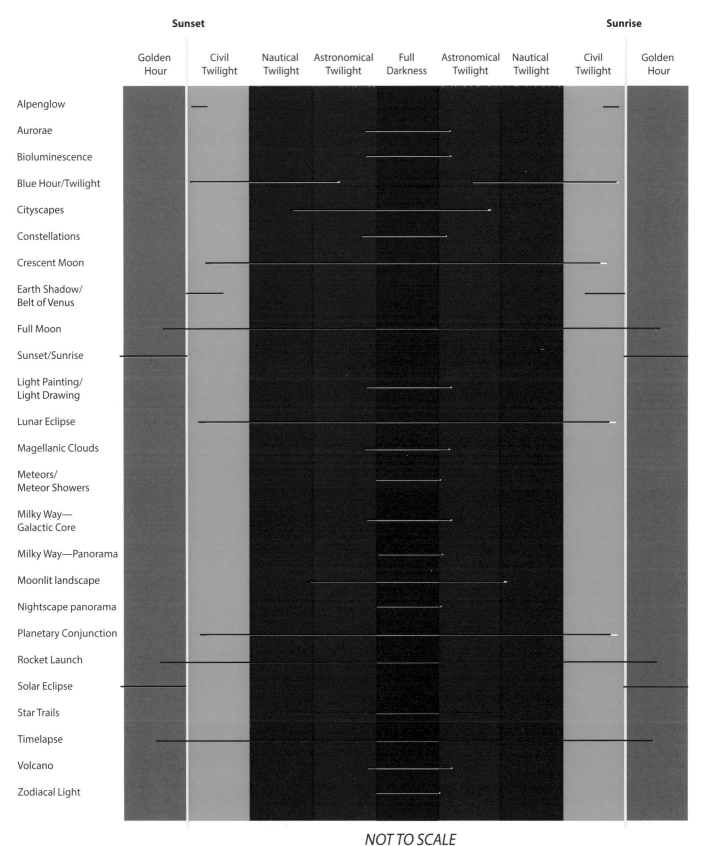

Sunset

Sunrise

Golden Hour	Civil Twilight	Nautical Twilight	Astronomical Twilight	Full Darkness	Astronomical Twilight	Nautical Twilight	Civil Twilight	Golden Hour

Alpenglow

Aurorae

Bioluminescence

Blue Hour/Twilight

Cityscapes

Constellations

Crescent Moon

Earth Shadow/
Belt of Venus

Full Moon

Sunset/Sunrise

Light Painting/
Light Drawing

Lunar Eclipse

Magellanic Clouds

Meteors/
Meteor Showers

Milky Way—
Galactic Core

Milky Way—Panorama

Moonlit landscape

Nightscape panorama

Planetary Conjunction

Rocket Launch

Solar Eclipse

Star Trails

Timelapse

Volcano

Zodiacal Light

NOT TO SCALE

16.11 Guide to the best times to create different nightscapes. Be sure to note that the actual durations of each phase of twilight and night varies significantly according to latitude and season.

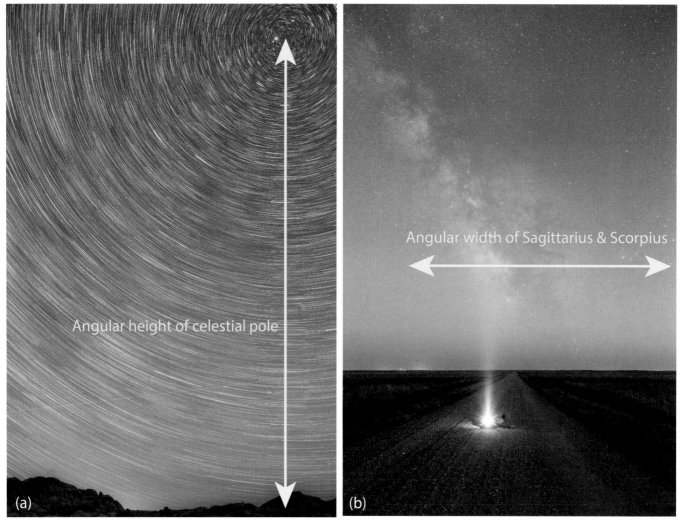

16.12 Example of lens selection based on field of view (FOV) for two common images: (a) one with star trails encircling a celestial pole with land-based foreground objects also visible, such that the angular FOV of the lens must be wide enough to exceed the angular position of the North Star above the horizon, and (b) an image containing a specific range of constellations, for example, Sagittarius and Scorpius, in which case you'll need to match the FOV of your lens to the required FOV of the constellations, which you can obtain from the planetarium simulation software described in Chapter 17.

Equipped with the likely lens and aperture combination suitable for your nightscape image, one final parameter to check is the near-focus distance of the chosen lens and aperture combination. This will be the case either with a focus distance of infinity or through hyperfocal focusing. You will recall from Chapter 11 that the near-focus distance dictates the closest distance an object can be from the camera and still remain in focus. If, however, part of the foreground is still too close to the lens despite your best efforts, all is not lost. All that is needed, as described in detail in Chapter 22, is to take a second image with just the foreground objects in focus, and to blend both images to create a final image with perfect focus throughout.

DEVELOPING THE LANDSCAPE ASTROPHOTOGRAPHY WORKFLOW AND PLAN

The culminating stage of our planning process is to summarize our ideas in the form of a worksheet and overall schedule for the astrophotography session, Figure 16.1(f). This schedule will include a time estimate for all the images we wish to acquire. This is extremely important since many of the images and image sequences can consume a surprising amount of time. For example, a multi-image Milky Way panorama comprised of twelve 2-minute apiece exposures will take

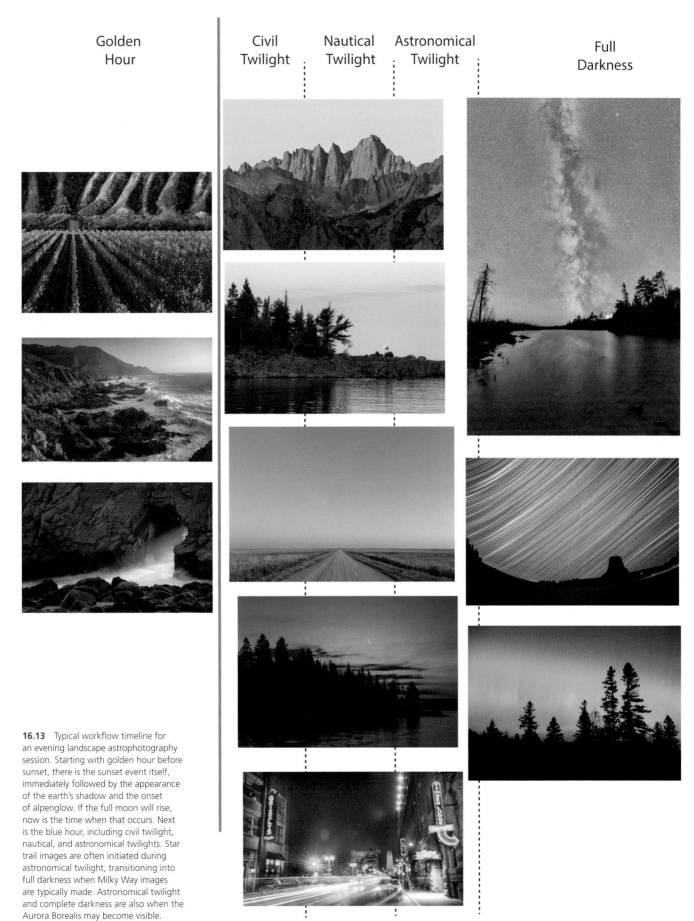

Sunset

Golden Hour **Civil Twilight** **Nautical Twilight** **Astronomical Twilight** **Full Darkness**

16.13 Typical workflow timeline for an evening landscape astrophotography session. Starting with golden hour before sunset, there is the sunset event itself, immediately followed by the appearance of the earth's shadow and the onset of alpenglow. If the full moon will rise, now is the time when that occurs. Next is the blue hour, including civil twilight, nautical, and astronomical twilights. Star trail images are often initiated during astronomical twilight, transitioning into full darkness when Milky Way images are typically made. Astronomical twilight and complete darkness are also when the Aurora Borealis may become visible.

approximately one-half hour. And that's just for one (really good!) image. A single star trail image can take 4 or 5 hours! Furthermore, you may wish to change lenses midway through your shooting session; something that is best kept to an absolute minimum when you're in the field. Finally, different images may necessitate specialized equipment that you will want to ensure you have before heading into the field for the night, such as intervalometers, panoramic heads, lens filters, tracking heads, and so on. Clearly, scheduling and prioritizing the sequence of what images to take with which lenses, is critical.

Let's go through the timeline of a typical evening astrophotography session to appreciate the range of nightscape image possibilities, as shown in Figure 16.13. Starting with golden hour approximately an hour before sunset, there is the sunset event itself, immediately followed by the appearance of the earth's shadow, then by the onset of alpenglow upon clouds and mountain peaks. If the full moon will rise, now is the time when that occurs. The next hour or so is the so-called blue hour within civil twilight, followed by nautical and astronomical twilights. Star trail images are often initiated during astronomical twilight, transitioning into the period of full darkness when Milky Way images are typically created. These latter stages of astronomical twilight into the time of full darkness are also when the Aurora Borealis may become visible.

The landscape astrophotography worksheet template that I use to plan my nightly shooting schedule is shown in Table 16.1. As is always the case, the defining point in time is the moment of sunset and the immediate onset of civil twilight, followed by nautical twilight, astronomical twilight, and then full darkness. You may notice that I have included suggestions for the camera, lens, any specialized equipment, such as intervalometers, tracking mounts and panoramic heads. I have found this worksheet to be especially helpful on-location after having awoken in the middle of the night in preparation for the astrophotography session and barely being able to think! I have also found it helpful to note the file number(s) for the specific subject during the photo session; it's helpful to have this confirmation for later review.

My process for completing the worksheet is to take the stack of hand-drawn sketches created earlier, and in which I've organized the shots into categories and priority within each category, and use these to write down the sequence of images I wish to take. My goal is to condense my plan on a single sheet of paper that I can use as a reference during the evening. This allows me to direct my attention to safety and the process of creating the images, without losing precious time in the field trying to decide what images I should take, in which order and with what lens.

If I am out in the field for multiple nights, I often create a second worksheet, or log, that summarizes my planned/completed images during the trip, Table 16.2. This way I can keep track of the flexibility I have to take advantage of local opportunities in weather and composition to adjust the shooting sequence developed earlier. It also keeps me on track to be sure I complete all the shots I wish to attempt during a given trip.

DATE:

LOCATION:

SUNSET/SUNRISE TIME:

SUNSET/SUNRISE AZIMUTH:

MOON PHASE:

MOONSET/MOONRISE TIME:

MOONSET/MOONRISE AZIMUTH:

CIVIL TWILIGHT BEGINS/ENDS:

NAUTICAL TWILIGHT BEGINS/ENDS:

ASTRONOMICAL TWILIGHT BEGINS/ENDS:

DEPARTURE TIME FROM HOME/HOTEL/CAMP/PARKING LOT/TRAILHEAD:

SUBJECT (EXAMPLES)	CAMERA BODY	LENS	TRIPOD	SPECIAL EQUIPMENT	ORDER OF SHOT	START TIME
STAR TRAILS OVER ROCK						
MILKY WAY —PANO OVER VALLEY						
M'WAY LENS EFFECT						
FULL SKY PANO						
TIME-LAPSE—LAKE						

Table 16.1 Landscape Astrophotography Session Plan

IMAGE (EXAMPLES)	THURSDAY	FRIDAY	SATURDAY	SUNDAY
MILKY WAY/LAKE	✓			✓
MILKY WAY/FLOWERS		✓		
STAR TRAILS/TENT		✓	✓	
SCORPIUS/MOUNTAIN			✓	
COMPLETE SUNSET TIME-LAPSE TRANSITION	✓			✓

Table 16.2 Example Concept/Image Log (Depends on Conditions)

Bibliography

https://djlorenz.github.io/astronomy/lp2006/

Kingham, David, *Nightscapes*, 2014, Craft & Vision, Vancouver, Canada

Patterson, Freeman, *Photography and the Art of Seeing*, 2004, Third Edition, Key Porter Books Limited, Toronto, Ontario, Canada

Rowell, Galen, *Galen Rowell's Vision*, 1995, Sierra Club Books, San Francisco, California

Rowell, Galen, *Inner Game of Outdoor Photography*, 2001, W.W. Norton & Company, New York, London

www.app.photoephemeris.com/

www.distantsuns.com/products/

www.google.com/earth/

www.photopills.com

www.stellarium.org

www.vitotechnology.com/star-walk.html

www.weather.gov/satellite

www.wunderground.com/

17

ESSENTIAL SOFTWARE AND APPS

Today's landscape astrophotographers are fortunate to have access to a large and ever increasing variety of sophisticated, free, or low cost software and apps specially tailored to their needs. These tools have revolutionized landscape astrophotography, especially when used on mobile devices. For example, it is now possible to pinpoint the precise location, within a few *feet* in the field where you should assemble your camera and tripod to capture the full moon rising directly over a distant landmark hours, or even days, before the actual event!

This chapter describes a few of the software programs, apps, and websites that have been developed specifically with the landscape astrophotographer in mind. They are divided into three main sections: (i) astronomy; (ii) photography; and (iii) planning. The list is by no means exhaustive, nor is it an endorsement. The tools listed here are simply representative of the types of tools you may find helpful. The ones that are described here are ones that I have personally used at home and in the field on many occasions.

ASTRONOMY

Astronomy software programs and apps allow you to explore the night skies in virtual reality for any date, past, present, or future. Many are freely available and have an extraordinary level of detail. They generally include clickable objects linked to further information or databases. Many apps include an augmented reality capability for use on mobile devices, where the app will display the night sky view corresponding to the orientation of the mobile device.

These simulation programs are valuable for many reasons. First, they allow you to gain an appreciation of the visible objects during different times of the year. You can search for specific objects to determine the best times to observe them. They allow you to simulate the movement of objects in the night sky, so you can quickly gain an appreciation of the direction of their motion and how it depends on azimuth and altitude. Many have built in databases for the orbital trajectories of the International Space Station and major satellites.

Two popular simulation programs for desktop or laptop systems are Stellarium, Figure 17.1, and Starry Night. Both allow you to create a virtual planetarium and explore the night sky in detail. You can determine what objects are visible in the night sky for any place on Earth. You can estimate the field of view (FOV) necessary to photograph the objects of interest, allowing you choose the appropriate lens (recall Figures 11.4, 16.12). Both programs allow you to simulate the passage of time in order to assess how the night sky objects move during the night, as well as over the course of days, months, and even years! Having this knowledge before you venture into the field can save you immeasurable amounts of time, energy and frustration. Also, there is something almost magical about watching night sky objects emerge from twilight precisely as predicted.

There are a number of apps for mobile devices that function in an equivalent manner. In addition to Stellarium, the ones that I use most frequently are Distant Suns and Star Walk, Figure 17.2(a) and (b), respectively. Both use the local coordinates of the user obtained from the GPS sensors of the device to calibrate the current view of the night sky. All also give you the option of manually entering an observing position anywhere on Earth to assess how the view of the night sky will appear from that location. This feature is very useful for exploring the appearances of the night

17.1 Stellarium allows you to explore the night sky and determine what objects are visible in the night sky for any place on Earth and on any date—past, present, or future. You can estimate the field of view necessary to photograph night sky objects, allowing you choose the appropriate lens for your image. You may also simulate the passage of time in order to see how night sky objects move during the night, as well as over the course of days, months, and years.

Source: Stellarium

skies while planning a trip to distant locations. Finally, you have the option of setting a "Night Vision" mode, in which the mobile device screen is lit with red light, as shown in Figure 17.2(a), to help protect your night vision, instead of its normal bluish tints.

As an example, we might begin our session by opening the app, confirming the correct location, and then scrolling around the horizon and zenith to see what night sky objects will be visible that evening at different times. We might visit the southern or northern horizons to view the Milky Way and determine its azimuth at different times of night. As we have seen for both sky-priority and foreground-priority images, we are often interested in determining the times when the Milky Way is positioned at a specific azimuth or with a certain orientation. We might also change the date and/or location to explore their effects. Finally, the PhotoPills (PP) and The Photographer's Ephemeris (TPE) apps both deserve mention in this section owing to their wealth of astronomical data, including a moon phase calendar, Figure 17.3. Making these assessments before heading into the field saves time and allows you to position yourself in prime locations.

(a)

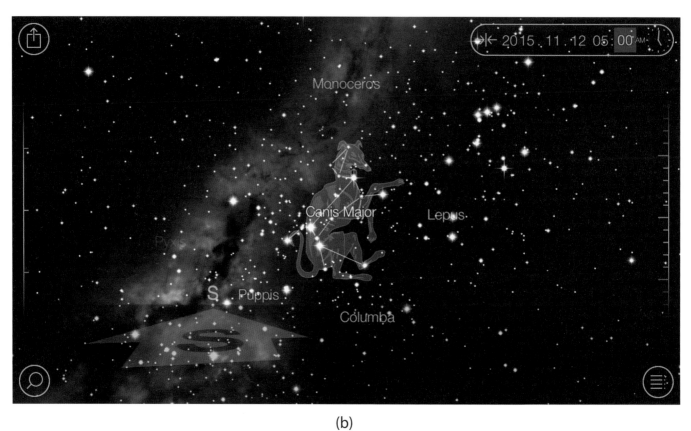

(b)

17.2 (a) Distant Suns and (b) Star Walk are two virtual planetarium apps that I often use on my cellular devices. They function in a similar manner to Stellarium, Figure 17.1.

Source: http://distantsuns.com; http://vitotechnology.com/star-walk.html

17.3 An example of the moon phase calendar available on PhotoPills, shown for the month of January 2019. The date of the full moon, January 20, 2019, is circled in yellow. This calendar is one of my first stops any time I consider an upcoming trip or photography session.

Source: http://www.photopills.com

Distant Suns offers a very useful feature called "What's Up," which fits the entire night sky into a single rectangular screen. This allows you to immediately see which prominent night sky objects, such as constellations, the moon, or planets, are visible. Scrolling through the time control allows you to see how they appear and disappear during the night. Although the view of the rectangular display is distorted compared to the appearance of the hemispherical dome of the sky, this feature is nonetheless very helpful during the initial planning stages of a nightscape expedition.

PHOTOGRAPHY—PROCESSING TOOLS

By far the dominant software for image post processing are Adobe Photoshop and Adobe Lightroom. The fundamental reason both programs have gained such widespread use is their inherent ability to allow you to make non-destructive editing adjustments to your images without permanently affecting the original image. Many other software tools, or "plug-ins," have been developed to perform specialized functions within Photoshop and Lightroom, as described in Chapter 21.

PHOTOGRAPHY—GENERAL PLANNING TOOLS

Many apps have been developed for planning both general photography as well as landscape astrophotography, especially on mobile devices. These are introduced here; more thorough illustrations of their use, including examples, are given in Chapter 19.

In particular, PP has a number of very helpful tools for planning just about every imaginable aspect of an image. It has options for estimating the FOV of different lenses, Figure 17.4(a), and the depth of field (DOF), Figure 17.4(b), for different combinations of subject distance, aperture, and lens

(a) (b) (c)

17.4 Three of the planning tools available from PhotoPills (a) Field of view (FOV) calculator; (b) Depth of field (DOF) calculator and (c) DOF augmented reality tool, showing the near and far focus distances, b_n (near shaded boundary) and b_f, (black line) for a specified subject distance, o, of 50 feet (orange line), cf. Figure 11.12, for, in this case, a 24 mm lens set to an aperture of f/2.8. The blue line indicates the hyperfocal distance for this lens and aperture combination.

Source: http://www.photopills.com

focal lengths, as described in Chapter 11. Perhaps most helpfully, PP integrates these tools with its augmented reality capabilities to greatly assist photographers in the field, for example, Figure 17.4(c).

PLANNING—WHERE TO SET UP

The planning process for creating trophy landscape astrophotography images has never been easier. Recent years have shown the development of an array of software tools and apps that allow an unprecedented level of insight into what you might experience when you venture into the field. Several of these tools have already been mentioned, namely, PP, TPE, Google Earth, ClearDarkSky and the Weather Underground. Here, we will briefly review the key features of several of these tools. Their application is described in detail in Chapters 16, 19, and 23.

Both TPE and PP have completely revolutionized the planning process of landscape astrophotography, Figure 17.5. With no exaggeration, their ability to predict the best shooting locations, dates, and times can literally save you thousands of dollars, months and even years of wasted effort.

As just one example, let's consider a scenario in which you wish to photograph the rising of a blue moon right next to a lighthouse, somewhere along the north shore of Lake Superior. You have visited the area and are aware that there are several lighthouses that you may choose as your

17.5 The Photographer's Ephemeris—one of the most valuable planning tools you might like to use. The image shown here is from a planning exercise to determine the best place to set up (red pin) to photograph the image shown in Figure 5.9(e) of the full moon rising immediately adjacent to Ellingson Island in Lake Superior, Minnesota (gray line).

Source: http://app.photoephemeris.com/

subject. The difficulty is that more than one-half hour's drive separates them, and you know the moonrise takes place within a matter of minutes. If you pick the wrong lighthouse, you know you won't be able to relocate to a more optimally situated lighthouse in time, and the next time such a moonrise occurs won't be for years. This means you only have one opportunity to get the shot! Fortunately, you now know how to plan ahead to pick the best place to set up your tripod. As described in detail for the case study in Chapter 23 on the full moon-rise, a short time spent with either TPE or PP will give you the precise location to set up.

Google Earth is a ubiquitous app with many features you will find to be helpful as you plan and execute your night photography outings. In addition to the ability to "virtually" scout the general area from the sky, the "Street View" option in Google Earth allows you to gain immediate perspective of how various terrains actually appear, for example, Figure 16.8. Having taken advantage of this feature along roads, streets, highways, and the occasional dirt path in countries around the world, I can personally attest to its accuracy and value.

Another feature in Google Earth that is especially useful during the planning stage of landscape astrophotography expeditions is the built-in ruler tool. I use this often to measure the distances between off-trail objects; to estimate the distance between a trailhead or parking lot and a shooting location; or to determine the distance from a potential foreground subject to a proposed shooting location to see if it will fit into the in-focus region when my lens is focused at infinity.

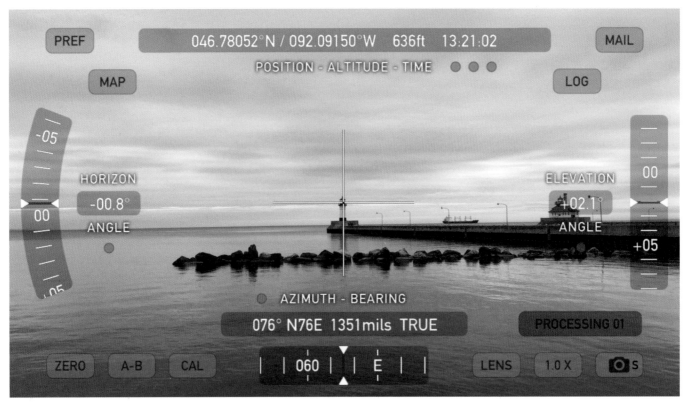

17.6 Theodolite—an augmented camera app that overlays a wealth of useful information on the view through the camera of your mobile device. Valuable during scouting trips.

Source: hrtapps.com/theodolite

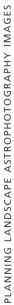

Theodolite is an incredibly helpful app that provides a data-rich, augmented reality overlay on images created with your mobile device's camera, Figure 17.6. The information that is recorded in the photograph made with Theodolite includes the GPS coordinates, and camera altitude (orientation/tilt) and azimuth (bearing). This information is valuable both during the day scouting exercises described in Chapter 19 as well as during reconnaissance of potential new sites. Images obtained in the field can be extremely valuable references for local conditions and views during subsequent planning exercises at home.

PLANNING—AURORA BOREALIS

There are many apps and websites to predict imminent potential displays of the Aurora Borealis/Australis, as described in Chapter 4; Figures 4.5 and 4.6. The color-coded maps on the National Oceanic and Atmospheric Administration (NOAA) and University of Alaska's site are perhaps the most straightforward to read, and simply summarize the overall likelihood of a display in the upcoming days. There are also many apps, such as Aurora Forecast, that analyze and summarize key measures of geomagnetic activity. Taken together, such sources can help significantly improve your chances of viewing aurorae.

PLANNING—SHORT-TERM WEATHER FORECASTS

There are two excellent, free sources for short-term predictions of weather conditions, both of which have apps that are loaded onto my mobile device. The first is ClearDarkSky, which gives a highly accurate forecast over the next 36 hours, Figure 17.7(a). The second is the Weather Underground site for weather predictions up to 10 days in advance, Figure 17.7(b). Taken together,

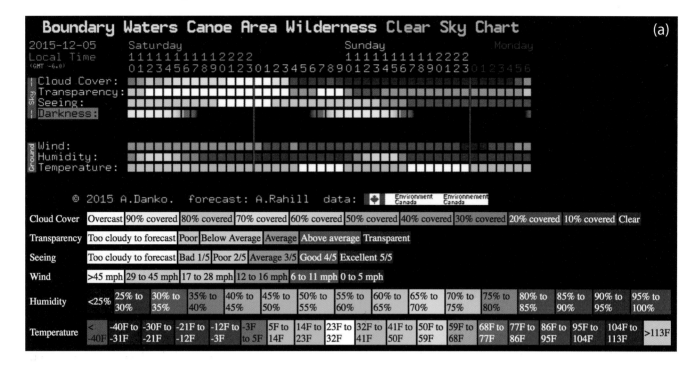

Cloud Cover	Overcast	90% covered	80% covered	70% covered	60% covered	50% covered	40% covered	30% covered	20% covered	10% covered	Clear
Transparency	Too cloudy to forecast	Poor	Below Average	Average	Above average	Transparent					
Seeing	Too cloudy to forecast	Bad 1/5	Poor 2/5	Average 3/5	Good 4/5	Excellent 5/5					
Wind	>45 mph	29 to 45 mph	17 to 28 mph	12 to 16 mph	6 to 11 mph	0 to 5 mph					

Humidity	<25%	25% to 30%	30% to 35%	35% to 40%	40% to 45%	45% to 50%	50% to 55%	55% to 60%	60% to 65%	65% to 70%	70% to 75%	75% to 80%	80% to 85%	85% to 90%	90% to 95%	95% to 100%

Temperature	< -40F	-40F to -31F	-30F to -21F	-21F to -12F	-12F to -3F	-3F to 5F	5F to 14F	14F to 23F	23F to 32F	32F to 41F	41F to 50F	50F to 59F	59F to 68F	68F to 77F	77F to 86F	86F to 95F	95F to 104F	104F to 113F	>113F

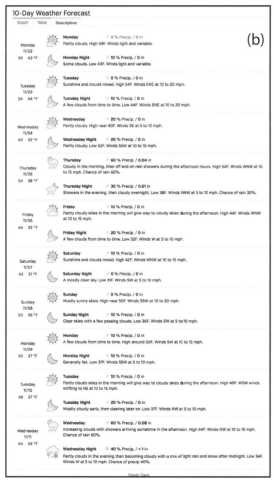

17.7 Short-term weather forecasts for nightscapers: (a) ClearDarkSky.com; (b) Ten-day forecast from Weather Underground; and (c) the sky quality forecast from NOAA.

Source: ClearDarkSky, WU, NOAA

both predictors are usually very reliable. ClearDarkSky is also available as a desktop tool and its value and uncanny accuracy to predict highly local conditions can't be overstated.

Finally, the websites maintained by the NOAA of the U.S. government contain a wealth of data, including valuable information relating to cloud cover, Figure 17.7(c) and the possible presence of smoke from forest fires. These sites contain a wealth of up-to-date data, potential warnings, and can potentially save your life!

PLANNING—INTERNATIONAL SPACE STATION

The International Space Station orbits the earth approximately every 1 ½ hours. In many locations, one or more of these orbits can place it overhead each day. There are several websites that predict its likely visibility for specific locations on Earth, including Heavens Above, Figure 17.8. This site also includes predictions for the visibility of a number of other satellites, as well as the potential to see the brief flash of reflected sunlight known as an "Iridium flare" from one of the remaining Iridium satellites.

ISS - Visible Passes

Home | Info. | Orbit | Close encounters

Search period start: 24 December 2019 00:00
Search period end: 03 January 2020 00:00
Orbit: 398 x 409 km, 51.6° (Epoch: 05 December)

Passes to include: ● visible only ○ all

Click on the date to get a star chart and other pass details.

Date	Brightness (mag)	Start Time	Alt.	Az.	Highest point Time	Alt.	Az.	End Time	Alt.	Az.	Pass type
24 Dec	-2.1	18:26:19	10°	WNW	18:28:36	32°	NNW	18:28:36	32°	NNW	visible
25 Dec	-3.0	17:00:42	10°	W	17:03:33	47°	NW	17:06:35	10°	ENE	visible
25 Dec	-1.7	18:35:20	10°	WNW	18:37:09	27°	NW	18:37:09	27°	NW	visible
26 Dec	-2.7	17:09:45	10°	WNW	17:12:32	37°	N	17:15:10	12°	ENE	visible
26 Dec	-1.4	18:44:15	10°	WNW	18:45:42	23°	NW	18:45:42	23°	NW	visible
27 Dec	-2.5	17:18:47	10°	WNW	17:21:31	33°	N	17:23:44	15°	ENE	visible
27 Dec	-1.1	18:53:06	10°	WNW	18:54:17	21°	NW	18:54:17	21°	NW	visible
28 Dec	-2.6	17:27:42	10°	WNW	17:30:29	35°	N	17:32:21	18°	ENE	visible
28 Dec	-0.8	19:01:53	10°	WNW	19:02:53	19°	WNW	19:02:53	19°	WNW	visible
29 Dec	-2.9	17:36:32	10°	WNW	17:39:24	41°	NNE	17:41:02	22°	ENE	visible
29 Dec	-0.5	19:10:42	10°	WNW	19:11:34	17°	WNW	19:11:34	17°	WNW	visible
30 Dec	-3.4	17:45:17	10°	WNW	17:48:16	57°	NNE	17:49:48	26°	E	visible
30 Dec	-0.2	19:19:37	10°	W	19:20:21	15°	W	19:20:21	15°	W	visible
31 Dec	-3.6	17:54:01	10°	WNW	17:57:02	89°	SW	17:58:44	25°	ESE	visible
31 Dec	0.1	19:28:52	10°	W	19:29:18	12°	WSW	19:29:18	12°	WSW	visible
01 Jan	-2.7	18:02:46	10°	WNW	18:05:43	50°	SSW	18:07:55	17°	SE	visible
02 Jan	-1.4	18:11:40	10°	W	18:14:18	27°	SW	18:17:02	10°	SSE	visible

Developed and maintained by Chris Peat, Heavens-Above GmbH. Please read the FAQ before sending e-mail. Imprint.

Hosted by DLR/GSOC

17.8 Predictions for visible passes of the International Space Station for the 10-day period encompassing New Year's Day, 2020, from the site operated by Heavens Above. Similar predictions from the same site are available for Iridium satellite flares, as well as passes of other known satellites.

Source: http://www.heavens-above.com

PLANNING—ROLES OF THE INTERNET AND SOCIAL MEDIA

Finally, the Internet and social media keep us awash in constantly updated images and information from all corners of the world. I frequently search online for nightscape images of the Milky Way, star trails, and other possibilities from candidate destinations to gain a sense of what others may have been able to accomplish during the initial planning phases of an upcoming trip. I find work done by those before me both inspirational and motivating, confident in knowing that my own images from the same area will reflect my personal creative vision.

The World At Night (TWAN), Figure 1.2, is my go-to site for a tremendous wealth of extraordinary nightscape images made from diverse locations around the world. Many times I will view an image made far away from my location and imagine ways I could re-create it at home. Other times, when I am planning a trip abroad, or even choosing between possible destinations, TWAN will have example images made at the various candidate locations that will guide me one way or another. Finally, TWAN is searchable by topic and geographical location, making it very easy to explore.

Instagram, Flickr, Tumblr, Twitter, and Google+ have communities dedicated to rapidly sharing images, tips, and other information related to landscape astrophotography, both for enjoyment and constructive criticism. You might find it beneficial to explore and contribute to these communities as a way to develop a network of colleagues and to receive helpful feedback. Finally, Facebook has a number of groups dedicated to specific aspects of night photography. Such groups are very helpful in sharing information and useful tips on techniques, shooting locations, and times. Specific groups that I belong to include the Great Lakes Aurora Hunters, Sky at Night, The World At Night, and the International Dark-Sky Association.

Bibliography

http://djlorenz.github.io/astronomy/lp2006/

https://itunes.apple.com/us/app/theodolite/id339393884?mt=8

www.app.photoephemeris.com/

www.distantsuns.com/products/

www.google.com/earth/

www.heavens-above.com

www.photopills.com

www.stellarium.org

www.twanight.org

www.vitotechnology.com/star-walk.html

www.weather.gov/satellite

www.wunderground.com/

ESSENTIAL HARDWARE
AND EQUIPMENT

HMC 77mm FL-W MADE IN JAPAN

This chapter reviews equipment that can make or break an evening photography session. Some are critical and should be carried with you every time you venture out, while others are optional and simply provide the opportunity to enhance the experience. We will review general field gear as well as equipment specific to astronomy and photography. None of the items shown here are intended as endorsements; there are many products available with equivalent capabilities. They are simply shown to represent the types of items that you may wish to consider. Complete checklists of suggested equipment are provided in Appendix I.

GENERAL FIELD GEAR

There are two items I never leave behind whenever I venture into the field for a nightscape photo session: (i) a reliable headlamp equipped with a red light setting, Figure 18.1(a) and a compass, Figure 18.1(b). No other pieces of equipment are so important to your personal safety.

(a)

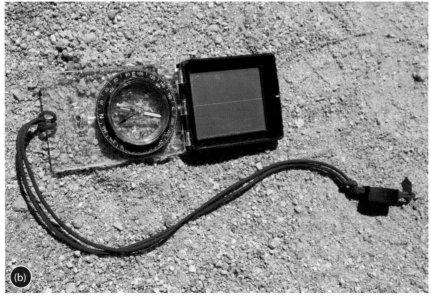

(b)

18.1 The two items I never leave behind: (a) A portable headlamp ideally suited to landscape astrophotography. Note the red light-emitting diodes (LED) critical to preserve night vision. The headband keeps both hands free and always points the light right where you're looking. Some models have the useful ability to adjust the angle of the light. (b) Orienteering compass that allows you to correct for magnetic declination. The mirror allows you to view the horizontally oriented compass while aligning the bearing target through a sighting notch in the top of the housing.

If you've never used a headlamp, you'll be astonished at how useful they are—both hands are kept free and the light always shines right where you're looking. In fact, you should always carry a spare! You may also want to bring a second hand-held flashlight as well. It is helpful for lighting the trail, light-painting projects, and a myriad of other tasks. Finally, don't forget duplicate sets of spare batteries.

A compass is invaluable at getting oriented in new surroundings, Figure 18.1(b). I frequently use mine during the day to estimate the future locations of night sky objects, thus narrowing down choices of scene composition. Be sure to choose one that allows you to correct for the difference between true and magnetic north, or the *magnetic declination*. A magnetic declination adjustment is helpful since the earth's magnetic North Pole is offset slightly from its physical North Pole. Such models are often described as orienteering compasses. Correcting your compass for magnetic declination allows you to take readings directly from its dial while allowing the compass needle to point to magnetic north.

Your cellphone can also be invaluable in the field, even without coverage, Figure 18.2(a). Used with the apps described in Chapter 17, it can provide times of sunset/sunrise, moonset/moonrise and twilights, photography settings, as well as the positions and orientations of sky objects. A small, rechargeable power supply can be a helpful accessory if its power runs low, Figure 18.2(b). Finally, it may be able to summon emergency services, although coverage in remote areas is unreliable and often nonexistent.

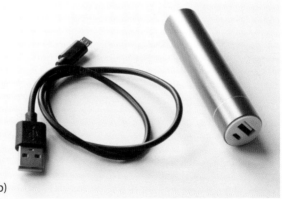

(b)

18.2 (a) Map/cellphone /GPS screen from a mobile device showing accurate GPS positioning even though the phone is in "airplane mode." Its GPS sensors function independently from the cell and wireless services. (b) Rechargeable, external power supply useful for recharging your mobile devices when afield.

Source: (a) Google Maps

Another vital device to carry into the field is a dedicated GPS device. Most of the time it's not needed, but it can make an enormous difference if you become lost. Such devices are also invaluable at navigating in areas with limited coverage by cellphones, and have the added benefit of providing precise position coordinates for pinpointing your position. Many models feature a "go-to" capability, which allows you to navigate to a specific destination, for example, your car, or camp at the end of the session. I have relied on this feature on several occasions to return from a nightscape session in dark, featureless surroundings.

A roll of gaffer's tape—photographer's "duct tape", Figure 18.3, is a surprisingly useful accessory to keep in your camera bag. There are innumerable uses for it, from securing loose cables, to serving as a shim for a loose lens cap, taping handwarmers to your camera… you will be glad you brought it along.

18.3 Gaffer's tape: the duct tape of photographers. You will find countless uses for it, from attaching, securing, propping up, labeling, marking, repairing, bundling… the list seems endless. A must-have item.

A simple chair has the ability to transform an evening of nightscape photography from a battle of endurance to a relaxing night in the outdoors. Backpack chairs are perfect for carrying equipment and supplies a short distance, and also help whenever a brief (or long!) nap is needed. A dedicated camera backpack, however, is your best option for longer hikes. Camera backpacks typically have myriad padded and zippered compartments for all your gear along with a carrying pouch for your tripod. You can use them to carry a surprising amount of gear quite a long distance.

In cold-weather destinations, any of the available handwarmers are a wonderful way to stave off chilly, damp night air. They can also be used to keep your camera and batteries warm either by taping them in place with gaffer's tape, attaching them via rubber bands, or even elasticized bandage wraps. Attached to your lens body, they can also help avoid dew formation and frost.

Reusable devices that use liquid fuel and disposable devices that use solid fuel work well. The disposable warmers can be attached to the lens and camera body with rubber bands or elasticized tape to assist in very cold weather operation. The liquid fuel variety should be kept way from camera lenses, however, owing to the possibility of contamination from the liquid fuel or deposits from its fumes.

A variety of plastic bags are also indispensable. I always carry at least one large (in the range of 13 gallon) trash bag whenever I venture outdoors into the night. These have a variety of uses, ranging from an all-out emergency, keep-everything-dry bag in case of unexpected rain, to a clean surface to lay out your gear in dusty or wet environments, to an emergency shelter in case of becoming lost. You will also find an assortment of one-quart and one-gallon zip lock type plastic bags to be very helpful in organizing smaller pieces of gear and electronics; and protecting them from the environment.

There are several miscellaneous items that are worth considering. I often keep a few energy bars, trail mix, or pieces of fruit inside my bag for a late night energy boost. A thermos of hot chocolate, tea, or coffee can also make a world of difference. I generally keep a fleece hat, gloves, nylon windbreaker, and a bandanna on hand in case temperatures drop unexpectedly. You may wish to create a dedicated waterproof bag of sunscreen, insect repellent, and antibacterial disposable hand wipes; you never know when annoying insects can suddenly materialize and cause mischief. Earplugs and a headscarf or bandanna are also great at keeping insects and cool breezes at bay. I always keep a small roll of toilet paper and a backpacking hand shovel tucked inside my bag in case a restroom isn't nearby, and I'm on suitable public land. Finally, in bear habitat, a can of bear spray is good insurance. While this book is no substitute for a complete course in bear safety, good bear-safety habits are vital for the bear's health, as well as your own, and must be adopted whenever you travel in bear country, especially areas inhabited by North American grizzly bears.

ASTRONOMY GEAR

I always carry a planisphere with me when I venture into the night, Chapter 2, preferably one with glow-in-the-dark markings. Not only does it allow me to readily confirm the identity of specific objects, it helps in understanding how they move throughout the night. I also carry a green laser pointer (5 mW or less) to help in identifying night sky objects to others.

PHOTOGRAPHY GEAR

The absolute necessities are your camera, tripod, memory cards, and batteries. It is a good practice to confirm that your camera actually contains its memory card and battery before leaving for your destination. While it may seem obvious, on more than one occasion, I have hiked into a pre-dawn location only to find an empty memory card slot in my camera and no spare memory cards in my pack—I had simply overlooked them and failed to check! Other essential gear, described below or elsewhere in the book, includes a remote shutter release or an intervalometer, Figure 18.4, a color correction tool, a flashlight for light painting, a handheld loupe to assist in focusing on the stars, and a dust blower to keep the lenses clean. Beyond these basics, I will occasionally bring along assorted filters, a panoramic head, a flash, and wireless remote triggers. If I intend to perform very long exposure star trails, I will bring the external battery pack for the camera and/or an external camera power supply. Small patches of Velcro and tabs attached to the upper legs of my tripod can help keep the intervalometer and other cables in order and untangled.

(a)

(b)

18.4 Remote shutter releases: (a) manual, with a locking capability and (b) an intervalometer for sequential and/or very long single exposures.

PHOTOGRAPHY GEAR—FILTERS

There are several lens filters you may wish to consider. Although some of the effects can be mimicked through post-processing, several cannot. The filters attach to the lens body in one of two ways—they either screw directly onto the front of the lens or they come as flat glass or plastic plates that slide into a separate holder that screws into the front of the lens. A key advantage to the plate version is that, owing to the characteristics of the filters themselves, it is often desirable to adjust the vertical or horizontal position of the filter at a certain point. In contrast, filters that screw directly onto the lens have no way to make such precise adjustments. In addition, many of the filters are difficult, if not impossible, to see through, so it's much easier to compose, focus, and then slide the filter into position rather than to have to screw in the filter before each exposure and risk losing focus or composition, to say nothing of time.

The *circular polarizing filter* almost doesn't qualify as a filter for nightscape astrophotography since its primary function is to block polarized sunlight. When light becomes "polarized," it simply means that it has acquired an orientation of maximum intensity. A polarizing filter simply allows light oriented in one direction through but blocks light of all other orientations.

This effect is helpful in landscape astrophotography in that light both scattered from the sky and reflective surfaces becomes polarized, and is affected by the action of a polarizing filter, as demonstrated in Figure 18.5(a, b). The polarizing filter darkens the sky and blocks water reflections, shifting attention to the rest of the landscape. The effect is most pronounced when viewing regions of the sky oriented at right angles to the sun, for example, facing south when the sun is in the west. It is, therefore, helpful during, sunsets and sunrises, as well as scenes with bright moonlight and clouds.

The polarizing filter is also very effective in enhancing the contrast of rainbows and moonbows owing to its ability to block the light reflected from the front surfaces of the water drops and thus enhance the relative intensity of the internally reflected light. However, care must be taken not to block the rainbow completely! This tendency is the same reason that colors in general become slightly more saturated when viewed through a correctly oriented polarizing filter, as the diffusely reflected light becomes more dominant owing to the specularly reflected light being blocked.

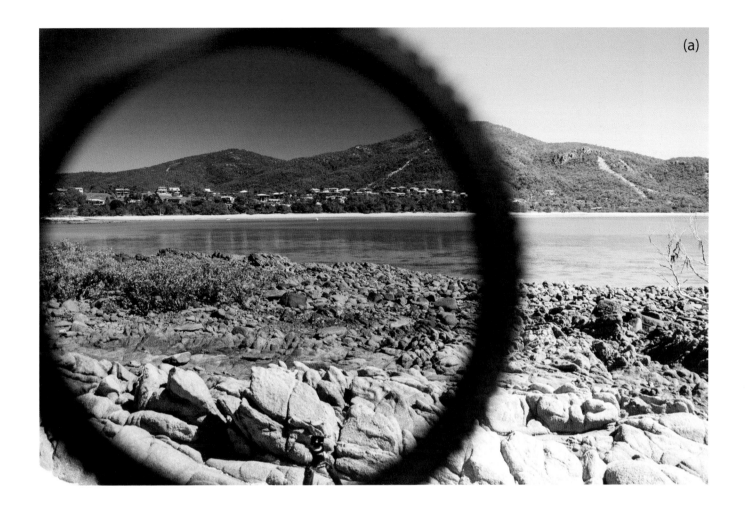

18.5 Circular polarizer showing darkening of the sky and removal of the surface reflection from the water. Useful during sunsets and sunrises; also for enhancing the contrast of moonbows and rainbows.

(a)

(b)

Source: Kirsten Larson

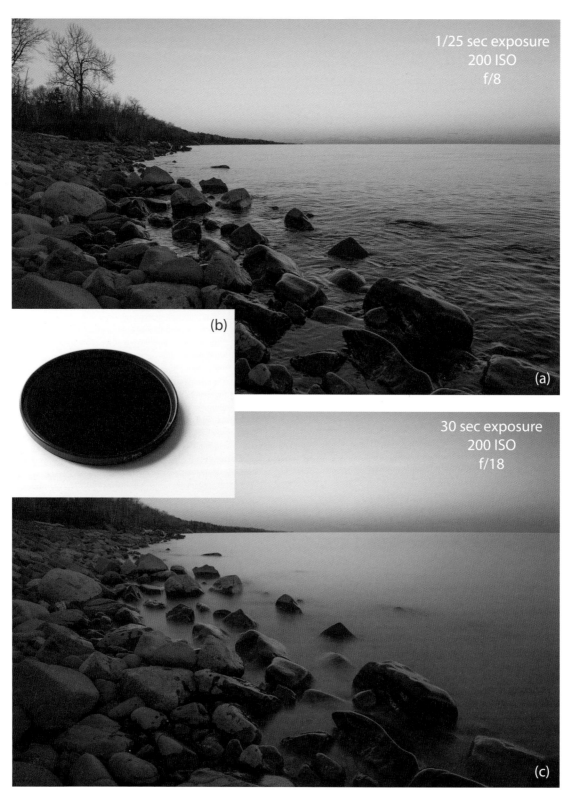

1/25 sec exposure
200 ISO
f/8

(a)

(b)

30 sec exposure
200 ISO
f/18

(c)

18.6 Example of a sunset scene, (a), without a ten-stop neutral density filter, (b), and with the filter, (c).
A far-longer shutter speed can be used with the filter, which has the effect of smoothing out the ripples
in the water seen in (a) to produce the effect in (b).

The *neutral density* filter blocks light without imparting a color shift. It allows you to create images
with much longer exposure times than otherwise, for example, several seconds in daylight or near
sunset. This ability causes moving water to become blurred, Figure 18.6. It also allows you to
create images that lack the presence of any moving object within them, like walking people or cars.
Having a range of densities, from one-stop to ten-stop is helpful.

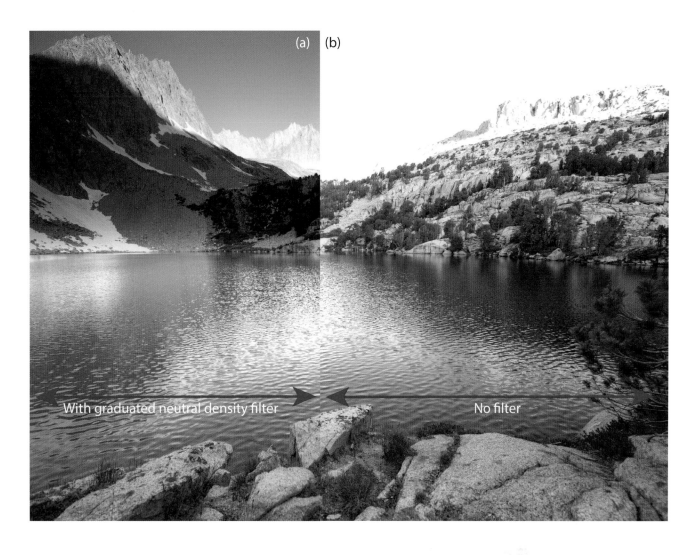

(a) (b)

With graduated neutral density filter No filter

(c)

18.7 Example of using a graduated neutral density filter: (a) with and (b) without (c) the filter. The darkened half of the filter is positioned to block the bright, sky portion of the scene, allowing the darker, lower portion of the scene to be properly exposed. An inverted graduated neutral density filter is also helpful in situations with strong light pollution or in cityscapes, and can help in reducing the light intensity along the brighter bottom of the image while allowing the night sky light to pass through unimpeded.

A variation is the *graduated, or split neutral density filter*. The graduated neutral density filter is split into a neutral density half and a clear half, Figure 18.7(c). The neutral density half can then be positioned so as to block the light from the sky, while the clear section allows the foreground light to pass into the camera unimpeded, as shown in Figure 18.7(a). Grad-ND filters are very helpful during sunrises and sunsets, owing to the extreme differences in light values between the sky and the foreground, Figure 18.7(b). While grad-ND filters are available in a form that can be physically screwed into the lens, this is one filter that is best used in the plate form, owing to the nearly constant need to adjust the position of the split within the composition.

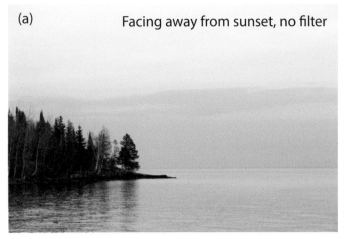
(a) Facing away from sunset, no filter

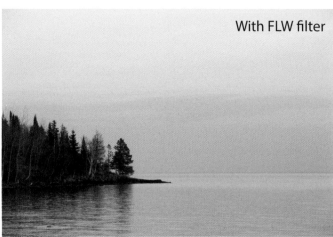
With FLW filter

(b) FLW filter

18.8 Sunsets and sunrises can be beautifully enhanced using the simple FLW filter (b). In (a), the exposures were made facing away from the sunset, and in (c), facing towards the sunset. In both (a) and (c), comparison images were made seconds apart with and without the FLW filter.

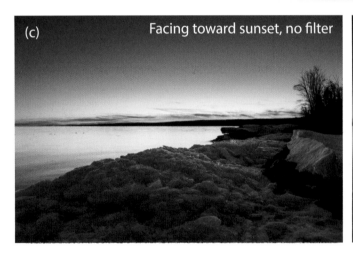
(c) Facing toward sunset, no filter

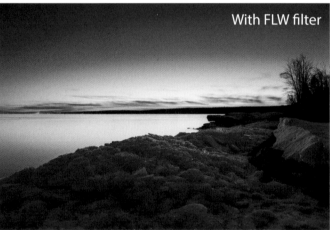
With FLW filter

The graduated neutral density filter also finds use in landscape astrophotography for scenes involving city skylines and other regions of significant light pollution in the foreground. Here, the filter is inverted so that the dark side is along the bottom. It thus blocks the bright foreground regions of the scene and allows the relatively dim light from the sky to pass into the camera.

The FLW filter, Figure 18.8, is especially helpful during sunrises and sunsets. It tends to accentuate the magenta hues of these transitional times, and can create very pleasing color contrasts.

Another filter that you may wish to consider for starlit scenes is the fog filter, as shown in Figure 18.9. The fog filter tends to diminish the brightness of dimmer stars while enhancing the brightness of the brighter stars. While not to everyone's tastes, the effects can sometimes be quite pleasing. Owing to the overall softening effect in the foreground, nightscapes involving fog filters typically combine an unfiltered image of the foreground with a filtered image of the night sky.

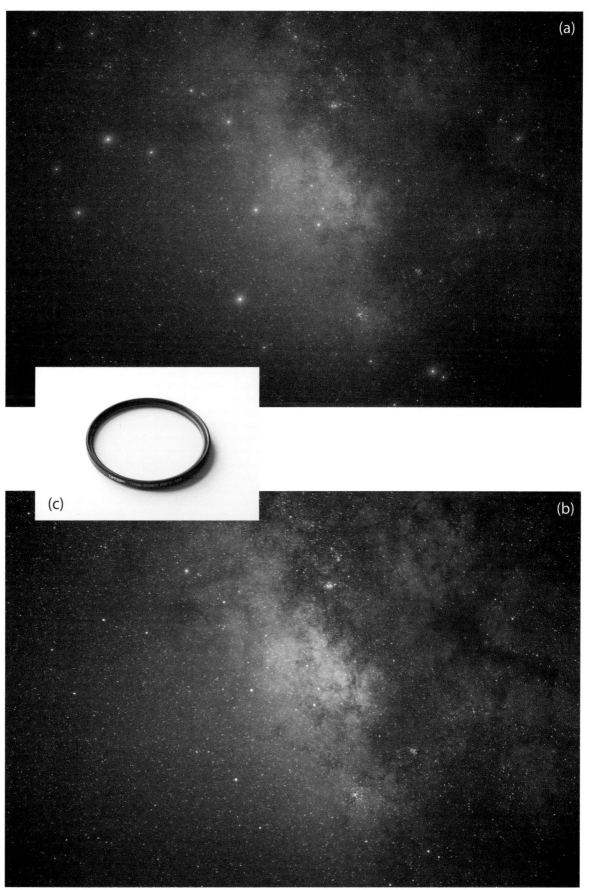

18.9 The Tiffen fog filter, (c), is a wonderful tool for really bringing out the more prominent stars while de-emphasizing the dimmer ones. In (a), the Teapot within Sagittarius really jumps out of the image when the filter is used in contrast to the more subdued version, (b), without the fog filter.

An alternate method to use the fog filter in the field is to simply position it in front of the lens by hand for a portion of the exposure, typically a few seconds, and then carefully withdrawing it.

Star effect filters are available to create diffraction spikes, or rays of light, emanating from point sources of light. They can be assets in scenes with several prominent stars. They may have a more natural effect than the plugins described in Chapter 21 since they produce the effect on all stars, rather than selectively as can be the case in post-processed images, which can appear artificial.

Although I carry an ultraviolet (UV) filter to attach to my lenses in the event of rain, I never use it otherwise. There is no need to remove the UV portion of the spectrum from your images. Careful handling of your gear will preclude damage to the lenses, especially compared to the glare and lens flare introduced through an extraneous layer of glass. My UV filter only goes on my lens during rain, or in areas where water spray is a possibility and frequent drying and cleaning of the filter is necessitated. If you are shooting in dry areas, consider leaving yours behind; your images will thank you.

Finally, you may wish to explore the use of newly available clip-filters that mount directly in front of the sensor, within the camera body. An example of an image created with such a filter is shown in Figure 10.2. While these are currently available for Canon at the time of printing, they are designed to alleviate the effects of light pollution and enhance the contrast of the image.

SPECIALTY TRIPOD HEADS

A panoramic head is invaluable for creating single-row or multi-row panoramas described in Chapter 22, Figure 18.10(a). These systems allow the camera to rotate about their *nodal point*, meaning that parallax errors are minimized.

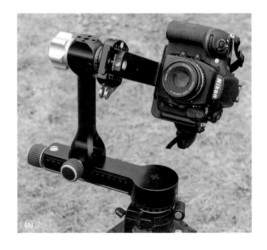

Another specialty tripod head is a tracking system, like the Astrotrac or Polarie, Figure 18.10(b). With its external power supply, tracking heads can be indispensable for creating exposures of a longer duration than the limit imposed by the Rule of 400/500/600 described in Chapter 12. Such

18.10 There are two broad categories of accessory heads for your tripod worth considering. (a) Panoramic heads make creating images used for single- or multi-row panoramas a breeze. Their clearly marked rotational axes allows for the precise positioning of sequential images. They also allow for the calibration of the camera's nodal point, or the axis around which parallax between adjacent images is minimized. (b) Equatorial mount tracking heads, used to counter-rotate against the earth's natural rotation. These heads allow for pinpoint images of several minutes in length. Shown here are two popular heads: (left) Astrotrac and (right) the Polarie Star Tracker. Both allow operation in either the Northern or Southern Hemisphere. The Polarie Star Tracker also has a one-half speed setting, which allows for a single, long exposure of both foreground and sky. The need to blend two images, as shown in Figure 22.6 is thus eliminated, as the exposure times with no star streaking from the Rule of 400/500/600 are effectively doubled. With sufficiently wide-angle lenses, say below 24 mm on a full-frame camera, the increase in foreground blur is usually insignificant.

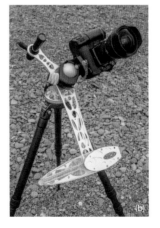
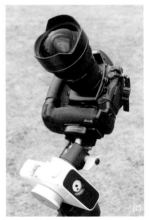

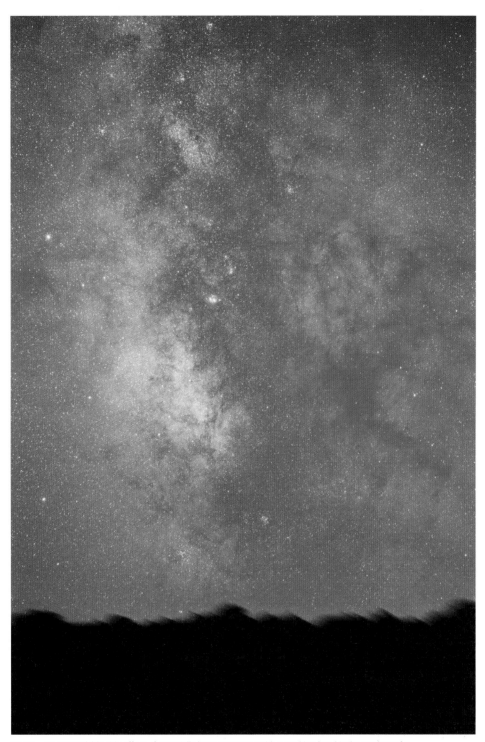

18.11 An unavoidable side effect of especially long exposures with a tracking head is the tendency for the foreground to become blurred, as shown here. The way to mitigate this problem is to shorten the exposure time. Alternatively, a second, untracked exposure of the foreground made with the same shutter time can be blended with the exposure made of the sky, as demonstrated in Figure 22.6.

systems are a basic *equatorial mount*, which means that after being aligned with the earth's axis of rotation, they physically rotate in the opposite direction and at the same rate as the earth. A camera mounted on them can then follow a single area of the sky as the sky moves overhead, while the foreground appears to move underneath, Figure 18.11. These systems can easily be calibrated to the user's latitude for accurate results; just be sure to do so ahead of time. A secondary benefit for the case of the Polarie mount is that it can easily convert to a panning head for use in image acquisition for time-lapse videos.

18.12 This image illustrates my daytime battery recharging and image management setup when I am far away from civilization. It provides indefinite, free electrical power. It all begins with a set of three, fifteen-watt solar panels along with a 12-V marine battery coupled with a 12VDC/115VAC power inverter and power conditioner. These can be used to charge camera batteries, as well as my laptop and its charger, a memory card reader, and two portable 3-terabyte external hard drives.

ELECTRONICS AND POWER

For nightscape sessions longer than a single night, I usually bring my laptop and its charger, a memory card reader, and two portable 3+ terabyte (TB) external hard drives, Figure 18.12. These allow me to copy and backup the images in the field. They also allow me to perform a detailed image review for issues like focusing, compositional tweaks, and depth of field that can be done at a higher resolution than possible on the camera display. The external hard drives also provide the option of emptying memory cards after each night to create room for new images. Preliminary versions of multiple shot projects, like panoramas, star trails and time-lapses can also be tested and verified so that any necessary adjustments can be made during subsequent nights. Two related accessories that can also make the world of difference: an outlet expander and a three-prong adapter.

A set of three, fifteen-watt solar panels along with a 12-V marine battery coupled with a 12VDC/115VAC power inverter provides free, limitless power while on the road, Figure 18.12. An alternative, shorter-term supply of electrical power is a portable, rechargeable 12VDC jump-starter. Although it can only power a laptop for an hour or 2, it holds enough energy to easily charge a cellphone overnight. And, of course, it can also provide an emergency jumpstart for your car when fully charged. Finally, an excellent alternative is to find the local public library, and if permissible, avail yourself of its quiet environment to plug in your electronics and catch up on your tasks.

SECTION V
Creating Landscape Astrophotography Images

SECTION V INTRODUCTION

Thus far in the book, we have learned about astronomy and photography. We have seen how to apply this knowledge to develop a plan for our landscape astrophotography session. We have acquired all the equipment necessary to carry it out and we are ready to go! In this section, we will explore the practical aspects of performing landscape astrophotography in the field, with specific suggestions to increase your efficiency and overall success rate. Finally, we will describe several common problems and obstacles that you may encounter, along with ways to overcome them.

Safety First

Safety in the field is *always* your first priority, for both yourself and anyone else you may encounter. While it may seem obvious, there are several common hazards that you must be vigilantly on guard against, especially since you will largely be working in the dark. Landscape astrophotography is often performed in remote, physically rugged environments, where there are plenty of opportunities to trip and fall over unseen obstacles. Cellphone coverage is frequently nonexistent. Many prime vantage points are on rocky points, or worse, the edges of cliffs or riverbanks where a fall could be disastrous. For many people, the decrease in mental acuity and simple balance that goes along with the lack of sleep from staying up well past their normal bedtime, coupled with the stresses of being in unfamiliar surroundings and the desire to obtain specific images further compounds the potential for accidents. The fact that you're working in the dark, and often in cold conditions exacerbates the difficulty of even the simplest of tasks.

It is important to always be aware of your surroundings and the potential for serious harm. A basic first aid kit containing light sticks, a whistle, compass, wound dressings, penknife/razor, tweezers, and pain medication should always accompany you when you venture afield. Finally, before each nightly outing, leave a note behind in your car or room describing your planned destination(s) for the night, when you expect to return and who to call in case of emergency. Also, leave an overall trip schedule with family and friends at home including a specific time for when they should invoke emergency services if they haven't heard from you.

Getting Lost and Found

Each night when you venture into the field for a nightscape session, especially in a wilderness setting, there is always a distinct possibility of becoming completely disoriented and lost. You may find yourself with no alternative to spending the night outdoors. While you have probably heard these words before, I can assure you from first-hand experience that totally losing your bearings, alone and in the dark, far from your car and the comforts of civilization can suddenly become a very real, startlingly disconcerting experience. Especially during periods of the new moon, the complete, utter darkness of the deep wilderness can be shocking and overwhelming. Even moderately strong headlamps are only able to project a beam so far; relying on landmarks several hundreds of feet away may prove fruitless. I have personally become totally lost several times, and each time only have been able to find my way out using my portable GPS device and hand-held compass. It is very worthwhile acquiring these devices and practicing with them well ahead of your trips afield. You may also wish to consult any of the excellent references on basic back country navigational skills.

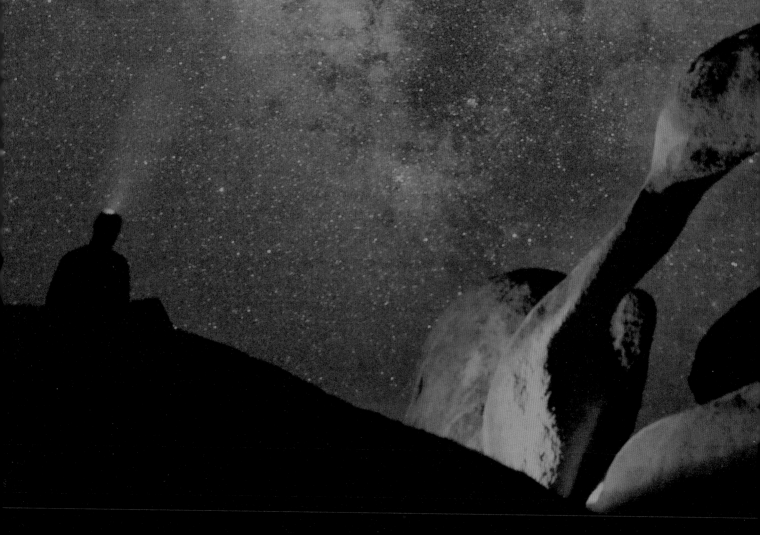

19

THE LANDSCAPE
ASTROPHOTOGRAPHY
CLINIC

At long last, the moment has arrived! You've reached your shooting destination with all your knowledge of astronomy and photography, your equipment, empty memory cards, freshly charged batteries, and, of course, your detailed plan. Let's describe how you might prepare for the night's events, Figure 19.1. *The most important thing you can do is to visit your prospective shooting site during the day.* I can't emphasize the importance of this step enough! You'll be able to confirm the orientation and predicted appearance of night sky objects relative to actual foreground subjects. You can test foreground compositions from specific shooting positions. You can explore the effects of different tripod heights and lens focal lengths. Also, you'll have the opportunity to carefully review your shots prior to the evening to select those that best fit your pre-visualized image. Finally, you will gain an appreciation for the time required to travel from your car to the shooting location, and the degree of physical exertion required to do so. Daytime reconnaissance will allow you to greatly speed up the process of setting up later that night or the following morning, since you will already know precisely where to go, and how to set up your equipment.

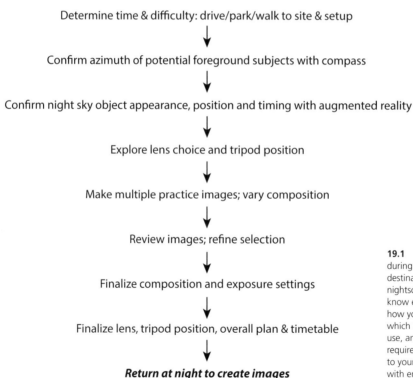

Visit Shooting Location During the Day

Determine time & difficulty: drive/park/walk to site & setup

↓

Confirm azimuth of potential foreground subjects with compass

↓

Confirm night sky object appearance, position and timing with augmented reality

↓

Explore lens choice and tripod position

↓

Make multiple practice images; vary composition

↓

Review images; refine selection

↓

Finalize composition and exposure settings

↓

Finalize lens, tripod position, overall plan & timetable

↓

Return at night to create images

19.1 Typical sequence of events performed during the day, after arriving at your destination and before beginning the nightscape photo session. The goal is to know exactly where you will go at night, how you will set up your tripod and camera, which lens and exposure settings you will use, and the time and degree of difficulty required to get from your point of departure to your shooting destination so you can leave with enough time to travel in comfort.

Throughout the steps that follow, you may wish to record your thoughts and field observations in a small, pocket-sized notebook, such as the variety commonly found at drugstores or bookstores. I fondly refer to these as my, "Books of Knowledge." They have become a valuable gold mine of details and sketches of specific photo opportunities and concepts, foreground subject possibilities and local azimuths; hidden parking spots and trailheads, mile markers, and more. What may seem obvious and memorable in the field can fade into obscurity over the course of a few years. Whenever I re-visit past locations, I consult my notebooks for pertinent tips and ideas.

19.2 Scouting with a hand-held orienteering compass during the day to confirm the azimuth, or overall compass bearing for the image, in this case, 180° due south. Note that the compass has been adjusted for the local magnetic declination of 14° E, so that the compass needle doesn't point due north when the compass is adjusted to a bearing of 180°.

DAYTIME RECONNAISSANCE

Once you've arrived at the general area of your shooting destination, you might like to start by confirming the overall orientation of your composition with the aid of a small compass, as shown in Figure 19.2. This will give you confidence in knowing how the night sky will generally appear, and how you expect night sky objects to move relative to actual foreground subjects. Specifically, your knowledge of astronomy tells you that in the Northern Hemisphere, objects will rise in the east, arc over the southern horizon from left to right, and set in the west. Objects to the north will circle the North Star in a counterclockwise direction. In the Southern Hemisphere, objects will still rise in the east and set in the west, but they will arc over the northern horizon from right to left, and to the south, circle the southern celestial pole in a clockwise direction. This information will help as you begin the process of selecting your foreground objects and fine-tuning your composition(s).

Daytime scouting also lets you gain familiarity with the terrain of your shooting location, noting any obstacles or hazards not evident from far afield. As just one example, I frequently visit the deserts of the southwestern United States, which are populated with rather robust cacti of various species. The cacti blend in inconspicuously with their surroundings and are nearly invisible at night. It is very helpful indeed to scout the locations of specific cacti hazards during the day, so I can be sure to avoid them once night descends!

The next step is to explore, on-site, how the night sky objects will generally appear later that night. Here is where significant advances in augmented reality coupled with mobile devices have totally revolutionized landscape astrophotography planning. To illustrate by example, the screen appearance of the PhotoPills Night Augmented Reality (Night AR) mode along with the overall appearance of the same scene are shown in Figure 19.3 (top). You can see the position of the Milky Way predicted for a specific time overlaid on the actual view seen in real time during the day by the camera. This remarkable capability allows you to explore the effects of different compositions and makes it easy to gauge how night sky objects will appear from different shooting positions with varying foreground orientations. Just be sure to pre-load your precise location and maps in PhotoPills (PP) on your phone or tablet while you have Internet access before venturing out for the evening, especially if you have traveled a significant distance to arrive at your destination.

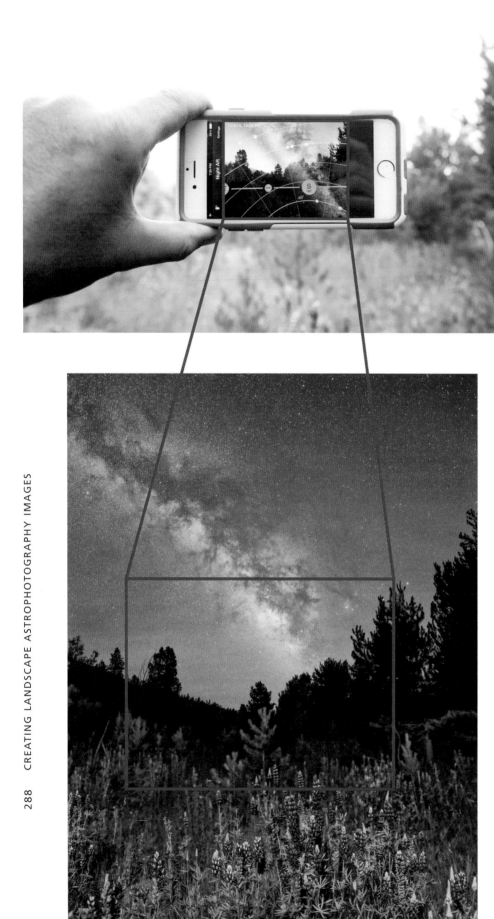

19.3 This example illustrates how to use PhotoPills' Night Augmented Reality (Night AR) mode to plan and fine-tune your shot. The Night AR mode combines what's visible through the phone's camera with an overlaid version of the night-sky at times specified by the operator, in this case, 10 pm (top). The built-in compass and GPS system of the phone automatically calibrates the night sky appearance correctly for the observer's latitude and longitude. The results agree extraordinarily well with the actual position of the Milky Way (bottom) observed later the same evening at the same position and time as shown in the top image.

Source (screen, a): http://www.photopills.com

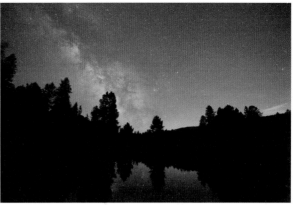

10:00 pm

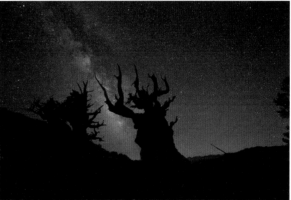

11:00 pm

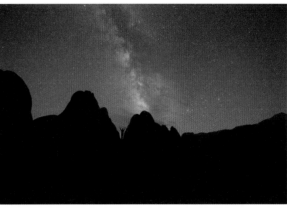

12:00 am

19.4 Three examples of using the incredible augmented reality capability of PhotoPills to match the appearance and orientation of the Milky Way at specific times. The images on the left are screenshots of what the camera actually viewed during the day at three different locations, with an overlaid, predicted appearance of the Milky Way from PhotoPills for later that same night at the same location at the identical time. The images on the right are actual images made at the same location and at the time corresponding to the predictions on the left. This ability to predict, visualize, and finesse the appearance of your image during the day has revolutionized landscape astrophotography.

Source (screenshots): http://www.photopills.com

The corresponding image made later that same evening from the same location, and at the precise time as the simulation shown in Figure 19.3(a) is shown in Figure 19.3(b). Three other examples of actual night sky images made at the precise time and field location as corresponding images made earlier in the same day using the Night AR mode of PP are shown in Figure 19.4. What incredible agreement!

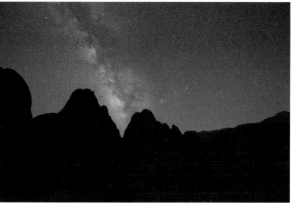

11:00 pm

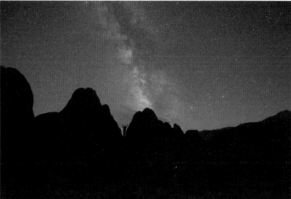

12:00 am

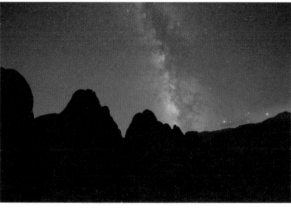

1:00 am

19.5 Examples of how PhotoPills accurately depicts the movement of the Milky Way during the course of an evening, cf. Figure 8.6. The images on the left are screenshots of what the camera actually viewed during the day at a fixed location, with the predicted appearance of the Milky Way later that same night at the same location at three different times an hour apart: 11 pm, 12 am, and 1 am. The images on the right are actual images made at the same location and at the same times corresponding to the predictions on the left.

Source: http://www.photopills.com

The other significant capability of the augmented reality tools of PP is that it allows the user to explore the effects of different times and dates on the appearance of the night sky objects. As we have seen, e.g. Figure 8.6, the position of the Milky Way constantly changes throughout the night, so what may be the perfect composition at one time of night may be completely uninteresting only an hour later! For example, three nighttime images are compared with the daytime, augmented reality counterparts for the precise corresponding times: 11 pm, 12 am, and 1 am in Figure 19.5. Notice how the primary band of the Milky Way moves from east to west, or left to right in this south facing view. The augmented reality of PP makes selecting precise locations and compositions nearly error-proof.

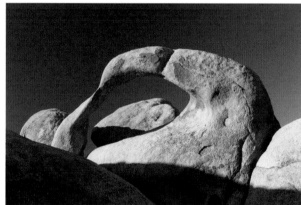

19.6 Exploring different focal length lenses and compositional options during the day for review and selection to aid in nightscape creation at night. Several different vantage points and lens focal lengths were explored. You never know which one will hit the sweet spot!

Now that you've selected a few promising foreground subjects and shooting locations, it's time to try a few practice compositions with a range of candidate focal lengths, Figure 19.6. I will frequently shoot dozens of such shots during my daytime site reconnaissance. It can be crucial to establish the limits of depth of field, what focal length lens to use and precisely where the tripod and camera should be placed. This is especially important for wide-angle lenses and the frequent need to locate the camera physically close to key foreground objects. Making these decisions can be time-consuming—so why not invest your daylight hours in doing so and preserve the valuable hours of darkness for creating images?

Now is the time to really fine-tune your composition. Pay close attention to distractions along the borders of your image, for example, trees or bushes that might be in the way. Try both portrait and landscape orientations. You may also come across a beautiful foreground subject that wouldn't be easily seen at night owing to the limited range of your headlight, yet could make or break the image. It is often surprising how much a nightscape image composition can change simply by moving a few feet in either direction. Spending time during the day exploring different compositions will free up valuable time later at night. Plus, it can be difficult and even hazardous to relocate your tripod and camera in the dark. This knowledge and experience will allow you to return at night directly to now-familiar territory and immediately set up your gear without wasting any time, confident in your choice of location.

Once you have completed your day scouting mission, I recommend that you take the time to review the images you created at high magnification, preferably on a device (laptop, tablet, desktop) with a reasonably large screen. After all, this is the test for your final image; why not eliminate obvious problems ahead of time?

When possible, you may also wish to consider planning on spending two or more consecutive nights at the same location. The significant insights you will undoubtedly gain during the first night can really hone your efforts on the subsequent night(s). Only rarely do the images I make on my first night at a new location meet or exceed the quality of images made on the second or third night. You will be able to ascertain the precise appearance of foreground and night sky objects. New, unexpected photo opportunities will likely present themselves. You may even make some new acquaintances who inspire you to try novel compositions or techniques!

When you return at night to create your images, consider turning off your camera's image review feature; the battery will thank you. Also, dim the liquid-crystal displays (LCD) display brightness to its lowest level to also save battery life as well as your night vision. As you set up your camera, use your camera's virtual horizon feature, if available. It can be invaluable in ensuring a level horizon. Finally, be sure to frequently monitor the histogram of your images as you make your exposures. What can seem like an acceptably bright image on your camera's LCD display in the complete darkness of a moonless night can in fact be badly underexposed. Keeping the histogram to adhere to the "Expose to the Right" principle elaborated in Chapter 12 will ensure the best possible image quality.

Finally, after completing all your planning, day scouting reconnaissance, image review, last minute fine-tuning of your session plan, and setting up and leveling of your camera and tripod, all that remains is the wonderfully satisfying experience of actually creating your nightscape images. It is a simultaneously humbling and fulfilling experience to stand under the night sky while your pre-visualized concept slowly comes to life, Figure 19.7.

Bibliography

http://www.photopills.com

facing page

19.7 (a) Daytime, on-site selection of the position and appearance of the pre-visualized Milky Way expected to be visible at specific times using the augmented capabilities of the PhotoPills. (b) The final shot resulting from the completion of all the planning steps illustrated in Figures 16.1 and 19.1, with a little light painting thrown in to boot.

Source: (a) http://www.photopills.com

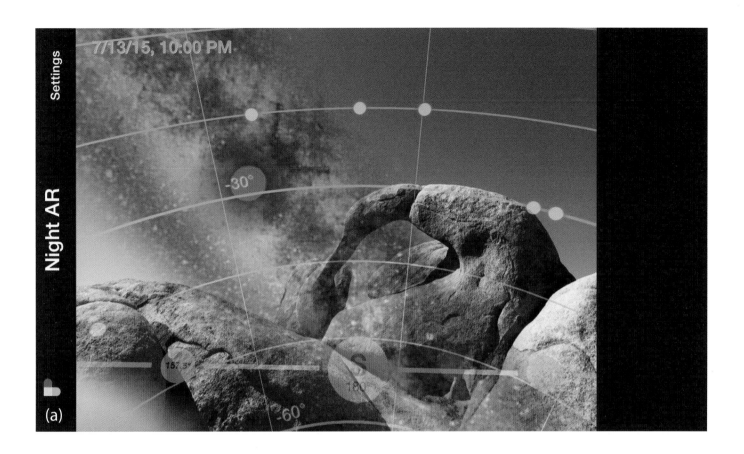

(a)

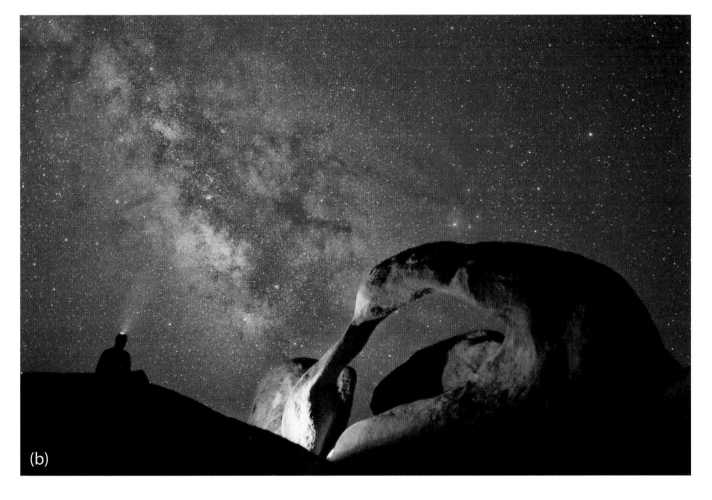

(b)

OBSTACLES AND
COMMON UNEXPECTED
PROBLEMS

This chapter aims to describe the most common obstacles you're likely to encounter in your nightscape quests, and ways to mitigate them. The goal is to help you maximize your enjoyment by developing strategies ahead of time for coping with the inevitable challenges and potential frustrations that accompany any outdoor activity. With patience, perseverance, skill, and good luck, you will be rewarded with one or more high-quality images that you will be proud to hang for display or videos you will be excited to share. Although challenging, landscape astrophotography is a rewarding pursuit that you can learn and improve through practice, provided you give yourself enough time.

LOGISTICS—TIME, TRAVEL, AND COSTS

There are several fundamental logistical challenges to nightscape astrophotography. There can be major time investments involved in planning, traveling, and creating beautiful images. Objects move inexorably across the night sky. The costs of landscape astrophotography equipment and travel can add up. It is important to recognize these time and potential cost logistics so you make appropriate decisions and suitable preparations.

The large number of extraordinary nightscape images that we constantly see on social and commercial media, art exhibitions, television, and film documentaries have spoiled us. They make it easy to underestimate how difficult and time-consuming it is to actually create them. Planning and completing a successful landscape astrophotography session can take far longer than one might think. In many cases, we need to book airline tickets, rental cars, hotel accommodations, spend a day flying, and then driving hundreds of miles to reach our ultimate, unfamiliar destination. Once there, we need to unpack and prepare for the evening's events. We need to carry our equipment to the shooting location and set it up during our scouting explorations during the day as well as our shooting expedition at night. Then, provided the weather holds, we will likely spend several more hours collecting images before returning home and spending, yet more hours post-processing them.

Night sky objects move with a seeming relentless consistency. There is no rewind button. Once the moon has crossed the horizon there is no going back. Once the Milky Way has begun to set, that's it for the evening. Try measuring the time it takes for the sun to completely disappear beneath the horizon after first touching it. You might be surprised to find it is only a few minutes. The moon takes even less time.

On more nights than I can remember, image possibilities have slipped away as I have dithered, unsure of which image or image sequence I should take next! It really pays to have carefully thought through which images you wish to shoot during a given evening, and in what order, and with which camera and lens combination. Having even a cursory written plan can be remarkably helpful late at night when you are cold and tired; having the detailed plan we developed can really pay off. It can make the difference between coming home with memory cards full of images or coming home imagining what might have been possible if only there had been more preparations or time available.

By now you realize that I am a firm believer in the value of thoroughly pre-planning your trips. In addition to assessing the logistics discussed above, you may wish to estimate how much time you will need to create your image(s)—and then double it. Now you will have a reasonable buffer to

deal with all the inconvenient realities of working in the field—airplanes and satellites flying through your shot, headlights from a car ruining a time-lapse sequence, needing to re-focus, changing a dead battery, trying a second composition…the list is endless.

Extraordinary landscape astrophotography images can be created with an entry-level digital single-lens reflex (DSLR) and a basic tripod. The inherent image quality, however, improves with more sophisticated sensors, lenses, and support equipment. As seen in Chapter 18, gadgets abound to make your life simpler and your images easier to create, and with higher quality. Post-processing and image archiving are facilitated with software and computers that all come at a price. Finally, the expenses of travel can quickly add up. There is almost no end to the ways in which you can spend money in pursuit of landscape astrophotography; it is up to you to determine whether the benefits are worth the cost.

There are a number of do-it-yourself (DIY) approaches within the realm of landscape astrophotography. When feasible, the author is an ardent fan of such methods. Care must be taken, however, not to sacrifice the benefits of your overall investments in an effort to pinch a few pennies. As one example, once you arrived at your destination, the incremental cost of a locally available map, guidebook, or knowledgeable guide may be almost insignificant compared to the overall cost of your travel and equipment budget. Yet, armed with this resident knowledge, you will almost certainly discover hidden destinations and other little-known photo opportunities that you otherwise might have simply driven past.

SETTING UP AT NIGHT

You may find it helpful to arrive on-site at least an hour before your earliest shooting time. In addition, be sure to allow ample time to park, load up your gear, and hike in to the destination. Even though you have scouted the site, determined the best tripod location and reviewed your images from the day and chosen your favorites, *everything takes longer than you might think!* Simply setting up the tripod, acquiring focus, fine-tuning the composition, and setting exposures all take time. The worst feeling in the world is to be late to an event that simply can't be replayed.

FOCUSING IN THE DARK

Focusing in the dark is probably the biggest technical challenge to those beginning in landscape astrophotography. Since it is done with your camera and/or your lens set to a manual focus setting, Figure 11.2, it is entirely up to you to achieve the best focus possible. You may spend all of your first night, or two, or even three or more mastering this vital skill. A sharp focus is critically important; blurry, out-of-focus stars will ruin an otherwise perfect image. It is important to be patient and give yourself time to learn this skill. Practicing at home will save you great frustration when you are in the field.

Many higher-quality lenses have a marking on the barrel that indicates a focus distance of infinity, ∞, Figure 20.1(a). While it would seem straightforward to simply set the focus ring to the setting, pinpoint focus of night sky objects is rarely achieved by doing so, most certainly so for zoom lenses. Changes in temperature, for example, can cause dimensional changes in lens components that lead to tiny, yet noticeable, focus imperfections. Changes in the lens zoom setting can discernibly shift the focus position as well, Figure 20.1(b).

I prefer to always focus directly on the stars themselves, thus ensuring the sharpest and most reliable focus of the night sky. Since stars are too dim to see clearly through the viewfinder, however, you must rely on the live-view feature of your camera. This process can be *extremely* challenging to perform in the field. Searching for the brightest stars in the sky can help, Table 2.1 and Figure 2.7. A handheld loupe can assist in viewing the stars on your camera's liquid-crystal display (LCD), Figure 20.1(c). An alternative is to focus on the distant horizon, instead of the stars, before the end of civil twilight, and simply maintain this focus setting throughout the night. Another approach is to find a distance light on the horizon and to use it as a focusing target, again instead of the stars. Once you have achieved focus, you might like to tape the focus ring in position with gaffer's tape, Figure 20.1(d).

20.1 Examples of where perfect focus lies for a Nikon 14–24 mm zoom lens set to a focal length of: (a) 14 mm and (b) 24 mm. (c) A hand-held loupe can greatly aid in focusing on stars visible on your camera's liquid-crystal display (LCD) and (d) once set, gaffer's tape is a great way to keep the focus ring in place.

If your camera lacks both a live-view option and/or a lens barrel infinity marking, don't despair. You can always achieve sharp focusing through trial-and-error. While more time-consuming, trial-and-error is a reliable method for acquiring sharp focus under any condition. First, increase your camera's ISO to 6400 or so for the duration of the focusing effort—you don't care about image quality at the moment. Once you've established a sharp focus, you can change the ISO setting back to your preferred level. Next, with your camera and/or your lens set to manual focus, adjust your focus ring so that the lens is nominally set to an infinite focus distance. You may need to

determine this approximate position during the day. Finally, make an image of the night sky and inspect it closely to assess the quality of the focus. If the stars are out of focus, make a minute adjustment to the focus ring and make a second exposure. When you inspect it, check to see if the focus of the stars has improved or deteriorated. If it has improved, adjust the focus ring a tiny bit more in the same direction and make another exposure. If the stars in this image are now less in focus, return the ring to the previous position. Continue with this process until you have achieved a satisfactory focus. Having done so, again, you might like to tape the focus ring in position with gaffer's tape, Figure 20.1(d).

THE NEED FOR SPARES

I will never forget waking up on the morning after my very first night of a weeklong, out-of-state trip and retrieving my high-end DSLR from its position atop the tripod. It had been set to collect a night-long time-lapse sequence of the Milky Way's motion across the horizon. I eagerly tried to review the images, but the camera was dead. Okay, I thought, it just needs a fresh battery. Installing one, however, didn't help. Instead, I was now confronted with a blinking "Err" message on the LCD display. Not good, I thought. Bottom line—the camera went into the shop and the rest of the trip was successfully completed with my backup camera. Moral of the story: bring backups of *everything*.

It may seem silly when you are packing it in the comfort of broad daylight, but an extra allen key to tighten a loose tripod fixture can be worth its weight in pure gold. This is especially true when you are an hour up the trail and the Aurora Borealis just roared into life on the last and only clear night of a weeklong expedition abroad. Or knowing just where to find that extra headlamp nestled in your pack in the moonless dark when it's time to return to the car along the cliffside trail at 2 am and the headlamp you wore walking in just died. How about an extra car key to replace the one you just fumbled into 4 feet of powder snow? Or a spare lens cap for your delicate wide-angle lens? Repeat moral of the story: bring backups of *everything*.

MEMORY CARDS AND BATTERIES

Multiple spare camera batteries and memory cards should *always* accompany you into the field. Just like all equipment, both can occasionally malfunction. You will always want to have an extra empty memory card and fully charged battery on hand, just in case. Nothing is worse than being in the middle of an exciting shoot, only to realize that you have exhausted your memory, or drained your battery, and if only you had a spare replacement, the shoot could go on. They are such small objects, yet they have the potential to enable or completely end an entire night's shooting. Finally, always check that your camera actually contains its memory card and battery before venturing into the field. All of us, at one time or another, have driven to our night's destination, excitedly hiked up the trail to reach our shooting location, pulled out our camera only to realize its battery is still at home, plugged into the battery charger!

There are a number of methods for carrying spare memory cards, including wallets, sleeves, and plastic cases. One important reminder: be careful to *never* touch the gold-colored metal contacts on camera memory cards with any part of your body. Doing so inadvertently may trigger a discharge of static electricity from your body through the card. This electrical discharge may then interfere with and corrupt the data stored on the card, and ultimately the entire card itself.

Batteries generate electricity via internal chemical reactions. The strength of the reactions depends strongly on the ambient temperature. If the temperature is too low, then the rate of the chemical reactions slows, significantly reducing the level of electrical output. This reduced output is manifested as a shortened battery life. Solutions to this potential problem all involve keeping your camera batteries as warm as possible. On many occasions, I have successfully revived seemingly dead batteries simply by warming them in my hands or in a trouser pocket for several minutes. Attaching portable handwarmers to the camera body with tape, rubber bands, or other methods can prolong the battery life in the camera. Handwarmers also help keep the inner mechanisms of the camera working smoothly; I have one camera body that stops functioning after it cools below a certain sub-freezing temperature without them.

MAINTAINING LENS CLEANLINESS

Lens dryness and cleanliness are two issues that must be maintained. As mentioned in Chapter 9, under the wrong conditions, dew, and/or frost will condense on everything, including your lens. Unfortunately, other than using handwarmers taped to the lens, Figure 20.2, or a dedicated lens heater, there is little that can be done to prevent dew or frost formation during a shoot. Lens cleanliness, however, is a maintenance issue that is easily kept to satisfactory levels. Other than dew, frost, and precipitation, lens contamination arises from two primary sources: particulates and liquids. Particulate contamination includes dust, dirt, lint, hairs, etc.; liquid contamination includes random droplets from the sprays from waterfalls, mists, and the like.

20.2 Disposable handwarmers attached to your camera can help stave off dew and frost.

The first line of defense against particulate contamination is the lens cap, Figure 20.3(a), and a hand-operated, portable blower, Figure 20.3(b). Every photographer should carry these, especially when in the field. Avoid blowing directly on the lens from your mouth; your exhalations carry moisture that can condense on the lens and further contaminate it. A great deal of lens contamination can be removed through judicious application of such portable blowers. Their great advantage is that it is nearly impossible to damage the lens by using one, unless of course you accidentally touch the tip of the blower to the lens.

Another tool I use to gently remove larger particles of dust and dirt from not only the lens surface but also the camera body, eyepiece, and dial areas is a small camel hair artist's paintbrush, Figure

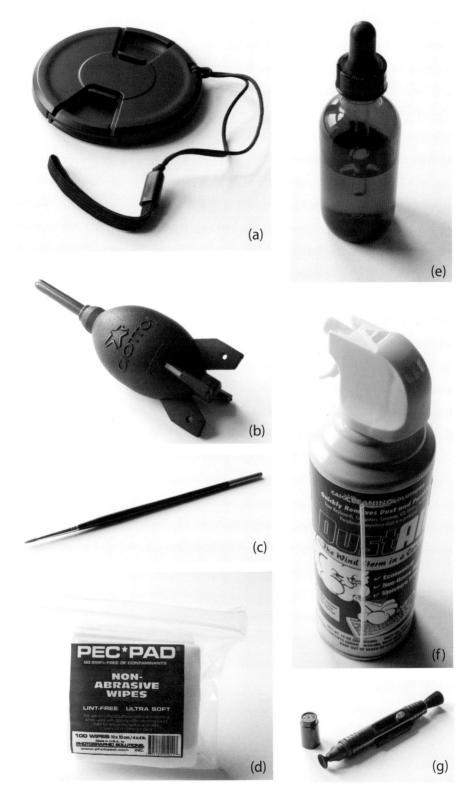

20.3 Tools for helping with lens cleanliness: (a) A lens cap on an elastic band ensures it never falls off and gets lost by accident; (b) hand-operated air blower; (c) camel hair artist's brush for dislodging stubborn grains of dust or sand; (d) lint-free Pec Pads; (e) 99.9 percent alcohol for cleaning lens surfaces; (f) compressed air—always use short bursts of compressed air, never long blasts, and *never* invert the can while operating or else extremely cold, liquefied gas can emerge; and (g) a lens brush for final touch-ups of minor lens smudges.

20.3(c). This tool is very helpful in prying loose tiny grains of sand and dirt that have become wedged into little recesses throughout the body of the camera, and resist even the strongest puffs of air from the air blower. Finally, on very rare occasions, I may resort to very short bursts from a can of compressed gas, Figure 20.3(f). I use this approach with extreme care, since there is a significant risk of inadvertently spraying the object I'm trying to clean with the extremely cold, compressed liquid instead of gas, especially if I invert the can of compressed gas.

Once all the particulate debris has been removed from the surface of the lens, any remaining particulate contamination can be removed in a couple of different ways. It should be emphasized that, unless you are completely confident in your abilities, a professional cleaning service might be the route to go, since the following methods have the potential to scratch and even ruin a camera lens. *Do not proceed if you are uncomfortable doing so!*

My next step is to simply exhale half a dozen or so times onto the surface of the lens, intentionally fogging the entire surface. Next, a dry, absorbent cleaning wipe, Figure 20.3(d)[1] is used to very gently clean the surface of the lens. The wipe is folded into quarters and used to wipe the surface of the lens; use the minimum pressure possible. I never actually press on the lens through the wipe directly with my finger; instead, I push on the folded wipe, which then transmits only a mild pressure onto the lens surface. The idea is to use the exhaled moisture deposited onto the lens to help very gently detach and/or dissolve any remaining contamination, and flush them from the surface without scratching it.

The motion of the lens wiping is in an outwardly spiraling pattern, starting at the center of the lens and moving outwards. Each wipe is only used once and then immediately discarded; there is thus no danger of accidently scratching the lens be re-using a wipe that was just used to pick up dirt and dust particles. After repeating this process with three or four wipes, I might then re-fog the lens surface with my breath and repeat the wiping process until I am convinced all the particulate contamination has been removed, leaving the lens surface covered only with residual droplets of water.

These remaining water droplets are removed by again folding a new wipe into quarters, wetting one corner of the folded wipe with a few drops of 99 percent ethanol,[2] Figure 20.3(e) and repeating the gentle, spiral wiping motion, again moving from the center towards the periphery of the lens surface. The water dissolves into the alcohol and is gradually removed from the lens surface, leaving behind a thin film of ethanol which rapidly evaporates. After repeating this process several times, the lens surface should appear completely clean and devoid of any visible particulate or liquid contaminants. Never apply alcohol directly to the surface of the lens; it can easily spread under the fittings and leave a residue within the inaccessible interior of the lens.

After completing the cleaning procedure described above, there may be a few spots on the lens surface where there remains a stubborn streak or deposit of some kind. I then might use a specially designed lens-cleaning tool, Figure 20.3(g), to remove these final contaminants. With care, the lens can be returned to its original, pristine condition.

MAINTAINING SENSOR CLEANLINESS

The sensor in your camera will inevitably tend to collect small particles of dust, lint, and dirt every time you expose it to the ambient environment. This is a simply unavoidable byproduct of changing lenses. The attraction of dust to the sensor is promoted by the electrical charge developed by the sensor during operation. The force of this attraction is very strong; attempts to physically remove the dust through in-camera, ultrasonic "sensor cleaning," and even direct puffs of air from the hand blower shown in Figure 20.3 can be in vain.

Contamination on the sensor of your camera can be a serious problem. It can manifest itself as pesky, dark, out-of-focus specks and blobs on each and every one of your images, especially at high aperture settings, e.g. $f/16$ and $f/22$. Removal of these imperfections during post-processing is exceedingly time-consuming, and sometimes impossible if the contamination occurs in a critical part of your image. For example, it is very difficult to remove such defects from regions of images that contain the day and twilight sky. This is because the sky's color constantly and subtly changes throughout the image. The eye of the observer is very sensitive to artifacts introduced during the removal and replacement of regions of the sky containing a spot; efforts to do so are hard to disguise.

Here is an easy way to check your own camera for contamination of your camera's sensor. The results may shock you; don't panic if your camera has a significant level of contamination. Instead, take this opportunity to consider having your camera's sensor cleaned before your next major photography project. First, set your lens or camera to manual focus. The image you are about to collect does not need to be in focus; sensor contamination looks the same regardless of the degree of focus of the image. Next, set your camera to aperture priority (A or Av), and adjust the aperture to the maximum f-stop: $f/22$, $f/28$, or higher. The ISO doesn't matter, nor does the shutter speed. Now go outside and aim the camera at a patch of clear blue sky and make a couple of exposures. If the sky is overcast, simply aim the camera at a featureless section of the sky, or even the center of a blank sheet of white paper outdoors and use these to create the exposures.

Load the images onto your computer and inspect them carefully for any visible spots or other signs of sensor contamination. Any dark specks that you see in precisely the same locations between successive images are from sensor contamination, and should be cleaned. If you really want to search for all the possible sensor contamination, open up the candidate image in Photoshop, Figure 20.4(a), and then open up the "Adjustments" tab, click on "Levels," then click on "Auto," Figure 20.4(b). This process changes the image settings to those that will highlight the presence or absence of sensor contamination. As you can see in Figure 20.4(b), the results can be shocking!

While there are many commercially available methods on the market designed to allow you to clean the sensor in your camera, my advice is to send your camera out to a professional for sensor cleaning. Although costly and time-consuming, the very real risks of permanently damaging your sensor or internal workings of your camera far outweigh the benefits of taking a DIY approach to this extremely delicate task.

You can now appreciate that it is well worth the efforts to minimize the collection of dust by the sensor by only changing lenses in controlled, dust free environments. First, always switch off the camera power before changing lenses to minimize the attraction of dust by the sensor through buildup of an electrical charge. Next, although inescapable, try to minimize the number of times

20.4 Images demonstrating the effects of severe sensor contamination: (a) An as-shot, unfocused image of the blue sky with an aperture setting of *f*/22; (b) the same image after auto-leveling in Photoshop. The sensor dirt revealed after auto-leveling can be shocking! Repetition of this procedure after sensor cleaning can help ensure that all sensor contamination has been removed.

needed to change lenses in the field, yet another reason to carefully plan the evening's shooting sequence to avoid having to continuously swap lenses during the night. Whenever necessary, try to at least change lenses from inside a car, or better yet, inside a closed building.

Develop your own method of changing lenses that keeps the time during which the cavity containing the sensor is exposed to the ambient environment to less than a couple of seconds. My own method is to, while comfortably seated, position the replacement lens on my right knee with its body cap loosened, but still in place, and its alignment marker clearly visible. Next, I position the camera with its existing lens on my left knee, with the lens facing upwards. I then depress the lens release button on the camera body and slowly loosen the lens so that it is ready to be removed but still in place. I then remove the body cap from the replacement lens on my right knee and place it to one side. Holding the replacement lens in my right hand, I use my left hand to quickly remove the existing lens. I then immediately install the replacement lens and rotate it into position. As quickly as possible, I then install the body cap from the replacement lens on the newly removed lens, and place it carefully into storage. When done correctly, the time during which the body cavity of the camera is exposed to the air is for much less than a second.

OTHER ISSUES

There are several camera settings that can pose problems if neglected. Here are just a few examples; it is always a good idea to create a list of these and other potential problems *that you actually consult in the field*, so as to ensure smooth operation and a successful outing:

- Ensure your camera/lens is set to manual focus.
- Adjust the zoom setting of your lens before establishing focus.
- Be sure to turn off the long-exposure noise reduction setting during the collection of star trail images, otherwise the star trails will be dashed lines, with the gaps corresponding to the periods when the noise reduction was being performed.
- When conducting a sequence of images using an internal or external interval timer, it is important that the image collection period be longer than the shutter speed.
- Be sure to monitor the ISO so that it is not higher than necessary.
- Monitor the focus throughout the shoot; it is all too easy to accidentally and unknowingly bump the lens during the night, knocking it out of focus.
- Depending on the complexity of your night's operation, you may end up with a number of electrical cables attached to your camera. It is important not to accidentally snag one and unintentionally shift the camera and tripod.
- If you are using a tracking head for the tripod that requires external power cables, take care to ensure they have enough slack to allow for the tracking head's movement as the night progresses.
- Be sure each section of the tripod and head is fully secure.
- Adjust your camera's LCD brightness to its minimum level to preserve your night vision and the camera battery life.
- Turn off your camera's image review feature to also preserve battery life.

INTERVALOMETER OPERATION

Setting up an interval timer can be frustrating, especially since different manufacturers of intervalometers can have different ways of accomplishing the same goal. It is wise to thoroughly practice indoors beforehand, including a sequence of test exposures. You will want to be completely confident you can set up whatever is required in the field without hesitation or uncertainty.

As described in Chapter 22, basic intervalometer operation is quite simple. The main choices pertain to: (i) the length of time during which the shutter is open for each exposure; (ii) the length of time during which the shutter is closed to allow for image storage; and (iii) the total number of exposures. You will want to know how to change each of the settings independently, along with the appropriate exposure settings on the camera itself. For example, you may wish to practice at home by collecting: (i) a hundred images, each twenty seconds in length separated by a one second gap and (ii) two hundred images, each five seconds in length separated by a two second gap. Finally, adhesively backed Velcro fasteners can help secure your intervalometer to the top of a leg of your tripod for easy access and to prevent it from dangling.

COLD

Many nightscape images are created in conditions where the air temperature is well below 0° F. Frostbite becomes a real possibility, and camera, cellphone, and even car batteries become less dependable. Cables used to power or otherwise control your camera will become stiff and even brittle. Care must be taken not to damage them, their fasteners or the camera. Finally, extreme cold may also affect your tripod, especially if it is made from a carbon fiber composite material. Such tripod legs have been known to break, especially when inserted into deep snow that can exert an outward force on the legs as they are inserted. Metal tripod legs, while sturdier, can inflict painful contact burns from the cold in subzero temperatures, since the cold metal is able to conduct heat away from your bare skin so efficiently. Care must be taken not to touch bare metal with exposed skin under these conditions.

There is no need to avoid such conditions, provided you follow certain precautions. It is imperative to travel in a reliable vehicle that you know can bring you safely home. It is also of vital importance to stock your vehicle with a warm sleeping bag, some emergency provisions, flares, and a shovel to help extricate yourself in an emergency. Finally, bring a large, sealable plastic bag with you into which your camera and lens can fit. You can use this bag to eliminate the condensation that otherwise might occur when you bring your cold camera indoors. Simply place your camera inside the bag, seal it, and leave it inside while you wait for the temperature to return to room temperature before opening the bag.

HUMAN FACTORS

There are a number of human factors worth considering ahead of time that can make your nightscape field experiences more enjoyable and rewarding. The first of these is to appreciate that you will be working long hours, late at night, outside, and in the dark. You should expect to experience drowsiness and fatigue. You may find that your interest and motivation may dwindle. You may even find yourself rationalizing why it is not so important after all to stick around for that late night shot. That comfortable, warm bed can seem mighty appealing!

By anticipating such feelings, you can guard against succumbing to their temptations. Any account of extreme alpine mountain climbers will reveal thoughts of uncertainty, doubt, and temptations to return before reaching the summit. Those who succeed are able to overcome these feelings and push through to achieve their goal that has been so long in the making. Here is yet a further instance of how your pre-planning will pay off. By having a written list of objectives for the evening, it is much more difficult to rationalize why you should quit and head home.

The sheer fact that you will be working late at night will most likely produce feelings of sleepiness and lethargy, and make you prone to error. I recall a specific instance several years ago when a friend and I had backpacked into a remote wilderness area and set up our cameras for a night of star trail image collection. We made sure our cameras were correctly focused and in manual mode, the ISO, shutter speed and aperture were set properly, the tripod and ball head were secure, and the compositions were good. Everything was set to collect images with a delayed start a couple hours after we had retired for the night to allow the waning gibbous moon to rise. When I woke the following morning, I noticed that my friend had put his lens cap on his camera, but my lens cap was still off. I was a little surprised, since this was somewhat out of character; we were usually quite good at looking after each other's equipment. I thought that if my friend had put on his lens cap for some reason, he would have done the same for mine. Not thinking much more about it, I went about my business, and only later, mid-morning, did I hear roars of laughter when my friend realized he had forgotten to remove his lens cap in the first place the prior evening, and none of his images had been exposed! This story has two morals: i) be sure to be on your guard against late-night errors and ii) pick your backpacking buddies with care; you want to keep company with those who have a good sense of humor, as I was so fortunate to have done!

On occasion when one is out in the field, especially when alone, many people, including myself, will suddenly experience an unexpected, irrational fear of the dark. You may even feel goose bumps rising on the back of your neck! Whether it harks from our ancestral past, or too many movie thrillers, most people at some point just don't feel completely comfortable being alone outside in the dark. This is perfectly normal and should be expected. Again, by anticipating the onset of such feelings you can minimize their effects. Whether it's by playing music, thinking positive thoughts, or anything else that works for you, having a pre-thought out defense against a basic fear of the dark will undoubtedly come in handy at some point in time.

The very act of working in the dark just by itself can add to the overall level of stress that naturally accompanies the excitement of landscape astrophotography. It is always a surprise to realize how much we depend on our vision to accomplish basic tasks. Even with the illumination provided by red headlamps, working in the dark simply takes longer then one might think. I find myself relying on my sense of touch to identify and retrieve objects from my camera bag in the dark. It helps to know how to work all the controls of my camera in the dark. It simply takes time to adapt to the dark, and you should give yourself plenty of time to do so.

It is very important to stay properly hydrated and nourished. Not drinking enough water can lead to headaches. A lack of food can lead to mental confusion and lethargy. I always carry a small container of water along with a high-energy snack to consume during the night.

Although the causes and effects of night vision and dark adaptation were described in Chapter 10, it bears repeating that it takes your eyes at least 20 minutes to fully adjust to the dark; try to

eliminate all sources of light other than your red headlamp. Be sure to dim the LCD display of your camera. Some camera models also have small green or red light-emitting diodes (LEDs) on their back; the best way to block their light completely is to cover them with a small piece of aluminum foil taped in place. You may also wish to use averted vision as you study specific objects in the night sky, both with your naked eye as well as through the viewfinder of your camera.

In my years of experience exploring nature, camping, and creating photographs on continents across the globe, I have come to realize that the gear I carry can be divided into one of the following two categories: i) *Used Every Day* and ii) *Nice to Have But Only Used Occasionally*. Whenever I venture out on an expedition, I'm sure to confirm and re-confirm that I have all the equipment on my "Used Every Day" list. As you gain experience, however, you may decide to leave behind the "Nice to Have But Only Used Occasionally" items to save weight, distractions, and clutter. While it's nice to have an extra pair of socks, or even a toothbrush, the absence of either won't prevent you from returning with images.

Finally, I can think of several separate instances when the success of an entire trip literally hinged on the presence or absence of a group of physically small and almost weightless physical objects such as these. For example, it is always amazing to me how much power is contained in the small piece of metal shaped in the form of a car key. The absence of a spare car key when yours has slipped out of your pocket as you sat on a bridge over a river at midnight on the first day of a weeklong trip… such a small object, yet so important! The same goes for a memory card, camera battery, or container of insect repellent. They are small, yet have such value!

Finally, practice patience. Give yourself time to enjoy your surroundings. Sometimes it takes a while to work through technical or other issues, try not to hurry yourself.

OTHER PHOTOGRAPHERS

You will encounter other landscape astrophotographers in the field, especially at popular destinations on favorable dates. The word is out. It is not uncommon to have half a dozen or more photographers clustered around iconic foreground objects, each working to fulfill their artistic vision. Most, if not all, have each traveled considerable distances, and invested significant amounts of money and time in arriving at the spot for the night. Their family and friends eagerly await their images when they return.

Not surprisingly, I have witnessed tensions arise on many occasions, as I have watched individual photographers unintentionally, or worse, deliberately pursue their own vision without regard to the desires of others. As just an example, I was recently present at a well-known location to photograph the Milky Way on the night of the new moon. Three other parties were also present. We all arrived before sunset; we set up our equipment and waited for darkness to fall. As we chatted, it became apparent that one of the groups was creating an all-night time-lapse video sequence, and expected the others to refrain from any light painting or use of our headlamps once darkness fell, as the stray light would understandably interfere with their project. Another of the groups had extensive, detailed plans for elaborate light painting of the same scene. As darkness fell, while the light-painters withheld from their plans, they darted out brief flashes of light to obtain a couple images, despite repeated objections and requests for moderation from the group of videographers. Do you see where this is going? Raised voices ensued, and harsh words were

exchanged. The videographers were upset that their time-lapse was ruined. The light painters were upset that their extensive nightscape shooting plans were being strongly condemned. Ironically, the groups of videographers and light painters were the first to depart, leaving myself and the other group to hours of collegial astrophotography.

The resolution of such a situation is unclear. Is it first-come, first-served? Or should the largest number of votes prevail? Or should the group who has traveled the farthest have a special say? My thoughts in such situations are to always remember the Golden Rule, "Do unto others as you would have them do unto you." Respectfully, communicate with the others who are present, and work out a system for when to expose, and when to use your headlamps. I have been part of countless situations where the night is filled with shouts of, "Are you ready to expose?" followed by, "Exposing!" followed by, "Done!" at which point headlamps click into life in unison and we all excitedly chatter about the results and share information and suggestions. It is unreasonable for one individual or group to expect to monopolize an evening at the expense of others, and for them to prevent others from fulfilling their artistic vision. When two parties are on a direct, collision course, if possible, there is always the coin toss!

Finally, always keep your personal safety, and the safety as others, as your primary goal. No image is worth suffering injury or death. There are a number of hazards and risks associated with any outdoor activity, let alone one done at night, and without the benefit of lights! Always be aware of your surroundings, bring a first aid kit and know how to use it, and anticipate the possibility you may be forced to stay out all night if you become lost or seriously injured.

SECURITY

Landscape astrophotographers typically carry a lot of visibly expensive gear. We generally need to park our vehicles at remote trailheads and parking lots where theft can occur. Maintaining your personal safety and security is your foremost concern. Unfortunately, since much of landscape astrophotography is performed in dark, remote areas, we can be especially vulnerable to the possibility of robbery or worse. Always be aware of your surroundings, and minimize the visibility of your equipment, when possible. I often use inconspicuous duffel bags and suitcases when traveling to avoid drawing attention to the valuable equipment inside. When parking my car at trailheads, I always ensure that absolutely nothing of value is in sight. When I am staying at a campsite, I try to refrain from flaunting my camera and electronic gear as much as possible. Finally, I often use a rather beat-up daypack to carry my equipment during the day in an attempt to disguise its contents.

NEED FOR PRACTICE

The very process of creating an exposure requires several steps that are greatly aided by the presence of light. Composing the image, focusing on the night sky or foreground objects, adjusting your exposure settings, all of these processes become exponentially more difficult in the dark. Only practice will help in developing proficiency and ease in doing so. Consider spending several nights at home, in a nearby park, or even your back yard setting up your camera, focusing on night sky objects such as the moon or bright planets, and making and reviewing test exposures. Think how much more confident you will feel having done so once you reach your destination!

During the photography classes and workshops I teach, there is occasionally a student who arrives with a brand new camera still wrapped up in the box. It has never been used, and has a battery that may or may not be charged! Or an intervalometer that has never been used before—not even once! I have been guilty myself of unwrapping a new piece of equipment on the trail for the first time and then having to learn how to use it. Why do we procrastinate so? Although I don't have the answers, I can say that to the degree that you are able to practice ahead of time, it will *always* pay off!

NUISANCES—LIGHT POLLUTION AND SATELLITES/AIRPLANES

Light pollution is the bane of landscape astrophotography, Figure 20.5. Excess light spilling into sky causes the phenomenon of light pollution, which tends to drown out the light of dimmer stars. The result is the dual combination of an artificially colored sky coupled with a greatly reduced number of visible stars. The effects of light pollution on the appearance of an image with the Milky Way are illustrated by comparing the brightly lit horizon near Los Angeles, California, Figure 20.5(a), with the dark horizon of a site a couple hundred miles to the north, Figure 20.5(b).

Airplanes and satellites can wreak havoc on nightscape images, especially in star trail images where they tend to accumulate. Their blinking green and red warning and navigation lights have cluttered more images than one can imagine, Figure 20.6(a). Worse, during the periods shortly after sunset and before sunrise, light from the now-set sun can brightly reflect from the polished metal fuselage of high-altitude airplanes and create highly distracting and very bright streaks. Unfortunately, there is no simple way to avoid having aircraft in the skies above you except to travel to locations unfrequented by airplanes, something of a catch-22.

Similarly, once you begin your nightscape quests in earnest, you will likely be astonished at the prevalence of satellite trails crisscrossing the sky, Figure 20.6(b). As in the case of airplane reflections, reflected sunlight from the satellites is the culprit. There is very little that can be done to avoid satellite trails, and their appearance is unfortunately likely to only intensify.

There are two main approaches for eliminating the nuisance of aircraft and satellite lights. The first is to create two images in quick succession, and as shown in the next section, mask and blend the necessary regions to eliminate the aircraft and satellite lights. The second approach is to use the photo-editing tools of Photoshop or an equivalent program to selectively remove the lights, also as shown in the next section. Both approaches work well and, while time-consuming and laborious, can remove most, if not all traces of both aircraft and satellite lights.

IMMEDIATE IMAGE REVIEW IN THE FIELD

Many issues that can arise in the field and potentially wreck your images can be detected simply by reviewing your images in the field immediately after creating them. Indeed, this capability is one of the main reasons that landscape astrophotography has gained such popularity in recent years. The ability to instantly review your images and make any necessary corrections on the spot has enabled new generations of nightscape photographers.

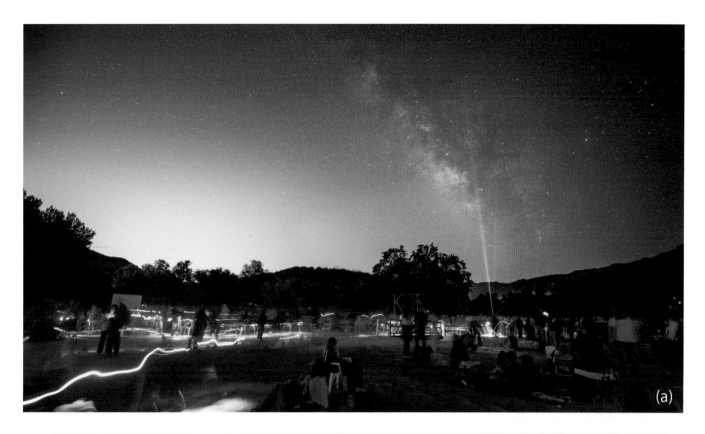

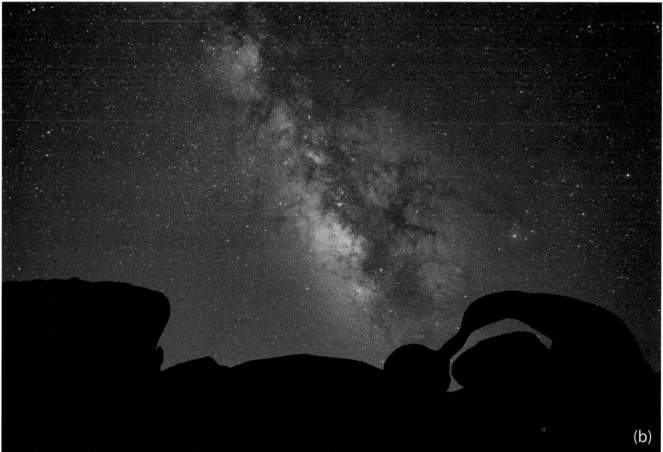

20.5 Light pollution can be a real problem, and often is unnoticeable while shooting. The effects of light pollution on the appearance of Milky Way nightscapes can be pronounced, as seen by comparing (a) the brightly lit horizon near Los Angeles, California, with (b) the dark horizon of a more remote site only a couple hundred miles to the north.

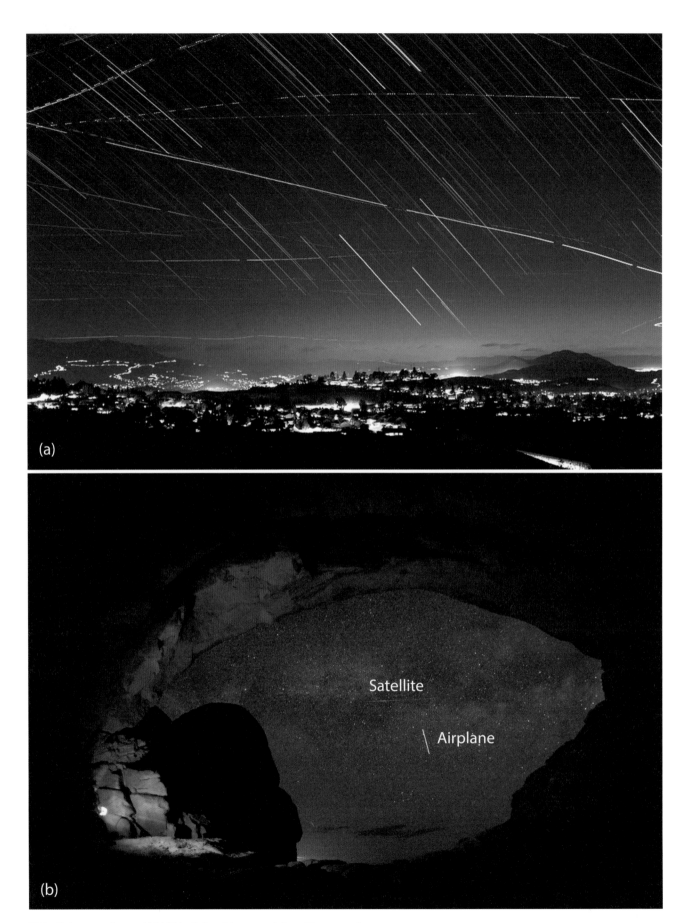

20.6 Nightscape nuisances: (a) Multiple airplane lights appear in busy skies over southern California even after only an hour or so in this star trail image. (b) A satellite and an airplane streak across the middle of this Milky Way shot in Arches National Park in Utah.

When you review your images in the field, the main features you might like to examine include:

- The degree of focus of the stars
- The shape of the histogram
- The degree of focus of the foreground objects
- The presence of any unexpected light sources
- The overall composition
- The presence of any unexpected foreground objects.

As one example of the latter, during on-the-spot review of the first few images created during a recent Milky Way photo shoot in southern Utah, I was surprised to find a group of six people casually reclining and enjoying the night sky amidst a large rock formation that I had prominently placed as my foreground subject. They were completely invisible to me in the dark, but clearly visible in the image as the result of the high ISO setting I was using! Had I not checked my image in the field, I would not have noticed their presence until I was home and it was too late to make a change. Fortunately, I was able to quietly change location, and continued on my way to create a series of people-free Milky Way images.

Bibliography

Fletcher, Colin, *The Complete Walker III*, 1984, Third Edition, Alfred A. Knopf, New York

Greenler, Robert, *Rainbows, Halos and Glories*, 1980, Cambridge University Press, Cambridge, England

Harvey, Mark, *The National Outdoor Leadership School's Wilderness Guide*, 1999, Fireside, New York

Randall, Glenn, *The Outward Bound Map & Compass Handbook*, 1989, Lyons & Burford, New York

Renner, Jeff, *Lightning Strikes*, 2002, Mountaineers Books, Seattle, Washington

Rowell Galen, *Galen Rowell's Vision*, 1995, Sierra Club Books, San Francisco, California

Rowell Galen, *Inner Game of Outdoor Photography*, 2001, W.W. Norton & Company, New York, London

Notes

1 Pec Pads—a wipe especially designed for cleaning optical surfaces. Available through camera supply stores and online.

2 Available at most drugstores.

SECTION VI
Processing Landscape Astrophotography Images

SECTION VI INTRODUCTION

Now that we have acquired our nightscape images, we turn to the decisions about how to manage them and whether to alter their appearance in any way. In many cases, the images straight off the camera are perfectly acceptable. Most of the time, however, even minor tweaks can result in dramatic improvements and can bring the images more in line with your perception of the scene.

There will always be a debate about the "authenticity" of making changes to images once they've been recorded. Some would argue that changes to images straight from the camera somehow violate their accuracy, or legitimacy. In response, I might suggest that the camera sensor is in no way equivalent to the human eye. Changes are often required to bring the photographic image in line with what the human eye perceives. Furthermore, as an artist, you have total control over your images; there is no one looking over your shoulder! So feel free to make or not make any changes that you feel are appropriate, and enjoy the results. The only exception might be in contests with rules restricting the amount of editing that may be done on submitted entries.

This section contains two chapters; the first deals with image management and editing, or adjustments, that you might wish to consider to *single* images. These can be further subdivided into global adjustments, or adjustments to the entire image and local adjustments, or adjustments to specific areas. The second chapter describes more advanced techniques involving *combining multiple images* into a single, final composite image. Examples include panoramas, star trail images, and clever methods for achieving a tonal range beyond what the camera sensor can record in a single image but that is much closer to what the human eye perceives.

21

IMAGE MANAGEMENT AND PROCESSING FOUNDATIONS

The camera's ability to sense and record an image mimics, but in no way matches, the actual perceptive qualities of human vision. Fortunately, we are able to digitally alter, or *post-process* the images recorded by the camera to more accurately reflect what we perceive. Often, more than a single image is required to fully capture the essence of what we are able to see, or to correct an artifact in the image. This chapter briefly outlines the essential steps of image management and post-processing of a single image. We will cover basic methods to adjust the image's brightness, contrast, sharpness, and color, any local adjustments we feel are appropriate, and how to rectify simple imperfections. The next chapter describes some of the results possible through processing two or more images. First, though, after describing how to color-calibrate your monitor, we begin with an overview of Adobe Lightroom's image management capabilities and how they can help you keep your collections of images organized and up-to-date.

MONITOR CALIBRATION

One of the very first steps worth undertaking is to color calibrate the monitor you will use to perform your image processing. A properly calibrated monitor will help ensure the color corrections you make to the image will translate properly into its finished form, whether electronic or printed. An incorrectly or uncalibrated monitor, however, can unintentionally lead to disastrous results, since the colors that appear on other monitors or in a print version of your image can be noticeably different.

The color calibration of a monitor is easily done using tools developed specifically for this purpose, Figure 21.1. To perform the calibration, the tool is placed gently against the monitor's surface and the calibration program is initiated. The program causes the monitor to sequentially display very specific colors, the results of which are detected by the tool and analyzed for any deviations. Once complete, the program then adjusts the monitor's settings to correct any deviations that were found. If desired, the calibration can be repeated to confirm compliance.

IMAGE MANAGEMENT

Your choice of image management strategy is a crucial decision that deserves careful thought. You will likely create tens to hundreds of thousands of images that all need to be labeled and organized for easy retrieval. Adobe Lightroom has emerged as one of the photographer's most popular systems for helping you manage your collections of images. It has many built-in capabilities for handling just about every task imaginable. Many excellent books have been written about Lightroom's capabilities; here our focus is on briefly describing the basics of using Lightroom to manage your photos and perform the most common tasks.

Lightroom's basic image management structure is its virtual *catalog* of all your images. Your Lightroom catalog is your single, primary warehouse of information relating to your original images, and any modifications you make to them using the Lightroom program itself. The process begins by copying your images from your camera's memory card to your computer using commands within Lightroom and *importing* them into your catalog in the process. Alternatively, you may copy the images yourself and import them to your Lightroom catalog separately.

An important decision is how to organize and file your photographs. One approach is to simply have a single, enormous folder containing all your images. Alternatively, you may create a separate

21.1 A properly color calibrated monitor is crucial to achieving correctly color balanced images. This is easily done with a monitor calibration tool, as shown here. Any incorrectly set color settings on the monitor are automatically corrected by the calibration tool and software in a process that only takes a few minutes.

21.2 The Adobe Lightroom Library
—a popular way of managing all your images.

folder for each individual photo session, even if they occur on the same day. You will likely settle on a system somewhere in between. Lightroom organizes your imported images within its *library*, Figure 21.2, which is its way of describing the manner in which you choose to organize your photographs; in physically separate folders, virtually distinct *collections* created within Lightroom, or a combination of both.

Once the images have been imported to your Lightroom catalog and appear within its library, you may begin the process of editing or *developing* them. After you are satisfied with the image's appearance, you then use Lightroom to *export* the image into whatever format and image dimensions you desire: Joint Photographic Experts Group (JPEG), TIFF, Photoshop, etc. There are options for relabeling your images, and for synchronizing them with your social media accounts, creating slideshows, printing them, and many other possibilities. Lightroom's ability to concurrently re-label, resize, and reformat batches of images as a single process is a tremendous time-saver. We'll cover all these steps in the discussion below.

IMAGE PROCESSING—LIGHTROOM'S DEVELOP MODULE

Lightroom's powerful and reversible image editing capabilities are remarkable. The following is a very brief overview of the basic steps you are likely to follow; you are encouraged to consult the numerous other, far more comprehensive sources and online videos available on these subjects. The following discussion also assumes you have created and imported your images in the RAW format; many of the steps described below don't work well, or at all, with JPEG images.

Let's go through the most common image processing steps you might like to perform. You begin by opening the image you wish to edit in Lightroom's *Develop module*, Figure 21.3. Remember, if you're unhappy with any of your results, simply click on the *Reset* button on the lower right corner to revert to the original image.

COLOR BALANCING

As we saw in Chapter 10, the color we perceive for a given object depends on both its physical properties and the characteristics of the incident light. We often wish to correct the colors within images made under light sources with a distinct color cast, for example, indoor fluorescent lights (Figure 10.3), so they more closely match those made under a neutral, or white light source. This process is called *color balancing*. Other times, however, we wish to whole-heartedly embrace the specific tints of the light sources, for example, during the warm light of the golden hour.

There are several ways of color balancing images within Lightroom's Develop module. The simplest approach is to use the eyedropper tool, Figure 21.3, to sample a small spot within a neutral gray, white, or black region of the photograph. Such regions should have equal intensities of red, green, and blue hues. Any excess or deficiencies in specific hues will be automatically detected and corrected.

A more comprehensive method for performing color correction is with the complete palette of a color checker tool, Figure 21.4. Here, a reference image is made of the entire palette, as shown in Figure 21.4(b), under the identical ambient light conditions used to create subsequent images. This image is analyzed in Lightroom through a two-step process, and any deviations from white light illumination are corrected, Figure 21.4(c). Any necessary adjustments can then be applied to all the other images created under the same lighting conditions, Figure 21.4(d). This is a very reliable and efficient way to create images that are uniformly correct in their color balance.

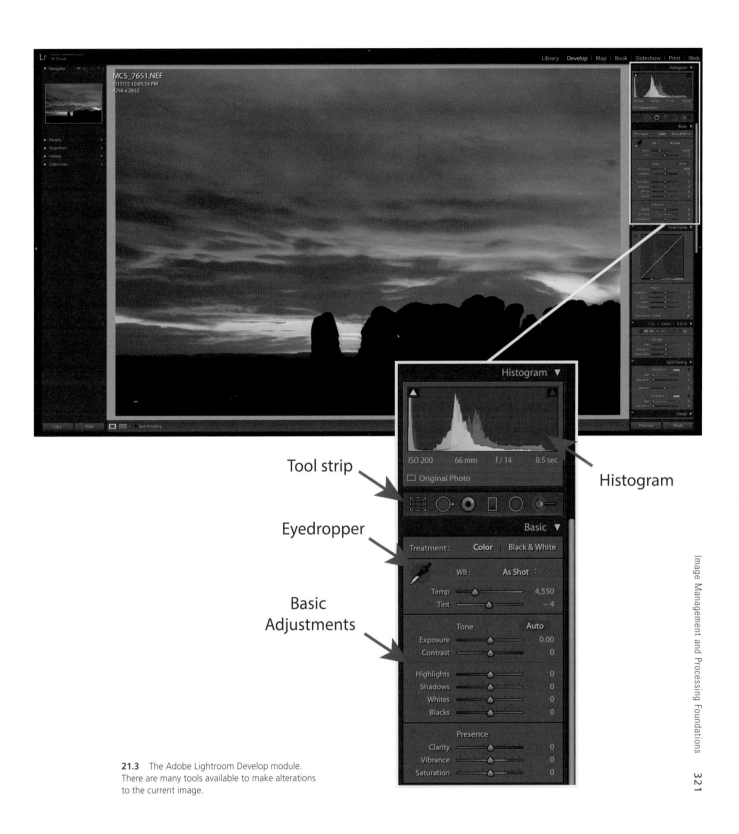

Tool strip

Eyedropper

Basic Adjustments

Histogram

21.3 The Adobe Lightroom Develop module. There are many tools available to make alterations to the current image.

21.4 Color correction using the eyedropper tool in Adobe Lightroom along with a color calibration tool including a neutral gray scale. (a) The as-shot image; (b) the color correction tool shot under the same conditions as (a); (c) the same image as (b) after white balancing and (d), the identical color corrections applied to the original image.

21.5 Four white balance adjustments to the galactic core region of the Milky Way: (a) Auto; (b) Tungsten; (c) manual adjustment; and (d)—as-shot.

The galactic core area of the Milky Way presents a unique color balancing challenge. It generally appears to be a faint white color to the naked eye, yet exhibits distinct colors in photographs made with digital single-lens reflex (DSLRs). Background colors in the night sky from light pollution or simply air glow can further complicate color balancing decisions. The initial color of the galactic core can vary significantly depending on the camera's white balance setting. The photographer thus has wide discretion regarding the choice of how to color balance the galactic core, Figure 21.5. However, the general consensus of the landscape astrophotography community has converged on a faintly yellow color of the galactic core set against a mostly black or dark gray sky, Figure 21.5(c).

LENS CORRECTION

All lenses suffer from a certain degree of inherent geometric distortion, in addition to the chromatic and spherical aberrations described earlier. The short focal length lenses common in landscape astrophotography are especially prone to such effects. In addition, the wide open aperture settings often used to capture the maximum amount of available light can introduce noticeable lens vignetting around the perimeter of nightscape images.

Both effects can be mitigated within Lightroom simply by checking the Lens Profile Correction box within the Develop module once an image is open. Lightroom applies the appropriate corrections after determining the specific lens used to create the image from the image's metadata. If the lens can't be identified via the image metadata, then there are options available for manually performing vignette and geometric adjustments.

BRIGHTNESS/CONTRAST

The brightness and contrast of the image can be adjusted in several ways within the Basic Adjustments panel of Lightroom, Figure 21.3. The overall exposure and contrast can be adjusted directly. The highlights, shadows, whites, and blacks can be fine-tuned separately. The tone curve can be manipulated to emphasize the highlights, shadows, lights, and darks. The image contrast can also be changed through the "Clarity" control in the "Presence" sub-menu.

NOISE REDUCTION

In addition to the noise reduction techniques described earlier, the Luminance and Color controls in the Detail panel can be very effective at reducing image noise, especially for images created at high ISO settings. Caution must be exercised, however; images with excessive noise reduction can appear too soft, and almost mimic a painting in their appearance.

SHARPENING

The image sharpness can be adjusted using the sharpness feature within the Detail panel. Qualitatively similar to a contrast adjustment, sharpening effectively enhances edges within the image. It is a very effective, usually final step that can make a significant difference to your image. As is always the case, however, care must be exercised so as not to overdo image sharpening. Over-sharpened images can appear extremely noisy and bright, with all the stars showing the same brightness.

DEHAZE

A recently added feature in Lightroom is the Dehaze option, found in the Effects panel. This adjustment is gaining popularity within the astrophotography community as a very effective way of enhancing the contrast of the galactic core region of the Milky Way. It is particularly effective when the background sky is relatively bright and doesn't provide much contrast. Judicious application of the Dehaze adjustment can really bring out the abundant details of the Milky Way; as always, care must be taken to not overdo it and produce unwanted noise and other artifacts.

COLOR ENHANCEMENT

In addition to the global color balancing steps described above, Lightroom also offers an enormous level of detailed control over the color of the image. The hue, saturation, and luminance of each of the spectral colors within the image can be fine-tuned individually. The adjustment brush can be used to alter the hue of selected areas. The overall color temperature and tint of the image can also be changed within the Basic Adjustments panel.

SPOT REMOVAL

Spots and other local defects can be easily remedied in Lightroom using the Spot Removal tool in the Tool Panel, Figure 21.3. Lightroom gives you the option of selecting the region used as the spot replacement, as well as the size of the spot's area. Custom areas can be altered by holding down the Shift key while dragging the Spot Replacement tool over the area in need of repair.

LOCAL ADJUSTMENTS—BRUSH TOOL

Local adjustments can be made to images in Lightroom using the Adjustment Brush, Figure 21.3. This is an extremely powerful method for bringing out key regions of the image. The Adjustment Brush allows you to select a sub-region of the image, whose size you control, and independently vary an enormous number of its qualities, including the exposure, white balance, contrast, sharpness, and more. The results can mimic the results obtained through time-honored burning and dodging methods applied during film developing and printing in a traditional darkroom.

IMAGE EXPORTING

Once you are finished editing the image in Lightroom, the final step is to either print it directly from Lightroom, or save a copy for sharing or potentially further editing in Photoshop. This latter task is accomplished by "exporting" the image from Lightroom; here again is where Lightroom is very helpful. You have the option of saving a copy of the image in nearly any format you wish, including JPEG, TIFF, or PSD. You also have the option of resizing and automatically renaming the image during the exporting process. Finally, you have the ability to perform these functions on a batch of files automatically, which can add up to enormous time savings.

ADOBE PHOTOSHOP

Adobe Photoshop gives you the ability to create incredible images and art. Our discussion will focus on only a very select few of Photoshop's techniques and capabilities that are of special relevance to landscape astrophotography. You are strongly encouraged to explore the many

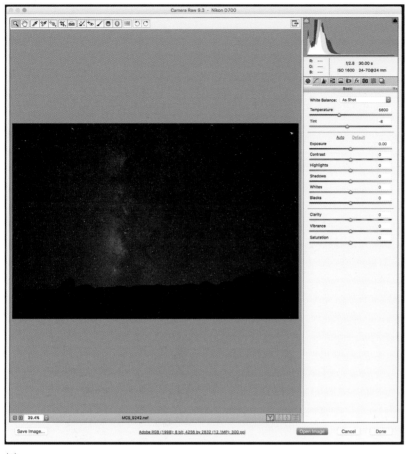

(a)

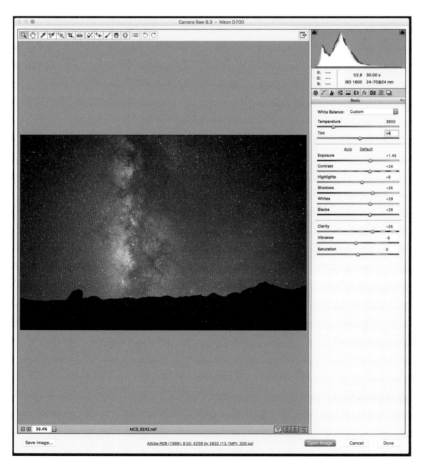

(b)

powerful image-processing capabilities in Photoshop through online tutorials as well the excellent sources provided in the Bibliography section.

Perhaps the best way to illustrate Photoshop's utility for editing a single image is by way of a simple example, Figure 21.6. Let's work with a basic RAW file saved straight from our camera. Opening the RAW file within Photoshop automatically launches the Adobe Camera Raw (ACR) module, Figure 21.6(a). The ACR module is an intermediate step that allows you to make changes to the image similar to those you might otherwise make in Lightroom. We are presented with a very similar panel of adjustments as were described for Lightroom above—color balance, brightness, contrast, exposure, and so forth. After modifying various settings, we arrive at the result shown in Figure 21.6(b). Once we're satisfied, we click on the Open Image tab, which then automatically launches the file within Photoshop, Figure 21.7. Of course, if you open a file in Photoshop that was exported from Lightroom in a PSD format, then the ACR step is skipped, and the file is launched directly within Photoshop.

21.6 The powerful Adobe Camera Raw (ACR) tool showing (a) the as-opened image and (b) after basic adjustments.

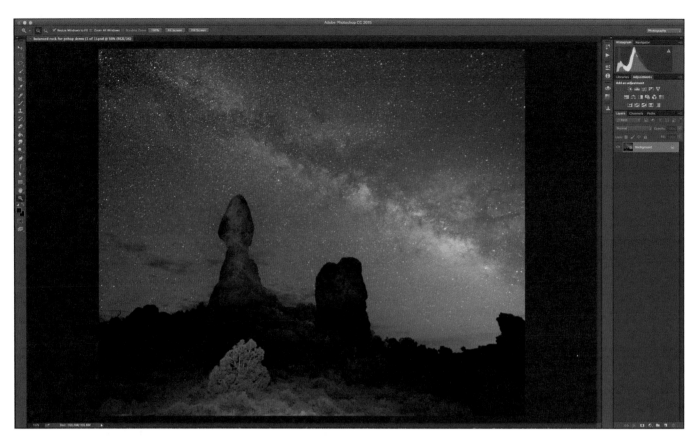

21.7 A basic image opened in Adobe Photoshop. Like Lightroom, there are an enormous number of tools available for making changes and adjustments to the image.

You may be perfectly satisfied with the editing performed within Lightroom and/or ACR. Other times, you may wish to further edit the image from within Photoshop. In fact, there is a great deal of overlap between the three programs; you may find yourself mostly using one or the other. In addition, Photoshop includes an ACR filter option, so you can easily apply all the normal ACR adjustments to any image or layer already open in Photoshop at any time.

Now that we have our image open in Photoshop, we can continue to edit its appearance to match our personal interpretation of the scene. We are presented with several menus, both along the sides and the top of the screen. First, let's recognize that the default is to open our image as what Photoshop calls a *background layer*. A good first step is to make a separate, duplicate layer from within the Layer menu. Any changes we make to this duplicate layer can be deleted simply by deleting the layer, leaving the original image intact.

As you may imagine, there are opportunities to perform many of the same basic image editing processes in Photoshop that are available in Lightroom and ACR. In fact, ACR is one of the filters that can be applied to your duplicate layer. Doing so brings up the same ACR module seen when we originally opened a raw file from within Photoshop. This step can be very helpful when editing JPEG files that normally don't launch the ACR module.

REMOVING AIRPLANE LIGHTS/SATELLITE TRAILS

Let's explore just one example of how to use one of Photoshop's sophisticated tools to remove pesky airplane lights, a common step in landscape images. A typical situation is shown in Figure 21.8(a) where a beautiful nightscape image is marred by the presence of a trail of airplane

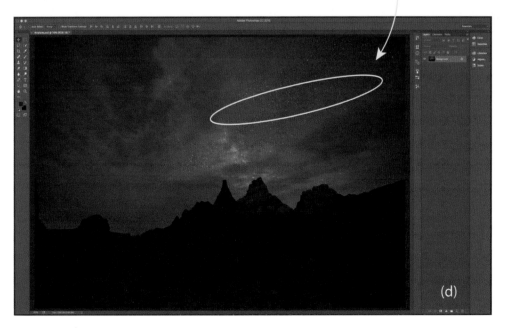

21.8 The process of removing an airplane trail in Adobe Photoshop: (a) Original image with airplane trail; (b) Close-up of region containing the airplane trail; (c) Close-up of the same region after removing the airplane trail; and (d) Final image after removing the airplane trail.

navigation lights. The clone tool, Figure 21.8(b), easily handles the situation. The airplane light trail is removed simply by dragging the tool along the airplane trail after first selecting a reference point to one side. Photoshop's algorithms thus manage to replace the airplane trail areas with very similar content, Figure 21.8(c), without introducing clearly discernible artifacts, Figure 21.8(d).

In addition to Photoshop's extraordinary control over the process of editing your images, its ease of use can be greatly advanced through the use of additional software called *plug-ins* or added features such as *actions* and *scripts*. Plug-ins, actions, and scripts are available online for many common editing steps. They can eliminate the need to learn how to perform these processes step-by-step on your own. Several are described in the following section. Many are freely available, or can be created yourself; others are available for a fee.

PLUG-INS—NIK

The Nik plug-in suite from Google is my go-to set of editing filters, Figure 21.9(b). They make it incredibly easy to accomplish many of my single-image photo editing tasks. The suite includes six separate plug-ins that each serve a special purpose, and when launched, creates and opens a new layer within Photoshop for editing. An example of an image created during civil twilight is shown in Figure 21.9(a, c), before and after editing with the Nik tools. You have options for fine-tuning the color, contrast, noise, and many other image features. All the Nik tools also offer the ability to create extremely detailed adjustments to small regions of the image using a similar feature as the adjustment brush in Lightroom.

STAR SPIKES ASTRONOMY ACTION

Creating diffraction "spikes" around stars can impart an extra "pop" to some images if used judiciously. One very straightforward method for doing so is with the "Astronomy Tools Action Set," which includes several different diffraction spikes options. A before and after example with diffraction spikes added to the stars is shown in Figure 21.10. The set of actions are simply loaded into the Actions panel within Photoshop, and then executed on the currently open image. When operated on a duplicate layer of the current image, they are completely reversible.

As is the case with most post-processing techniques, thought must be given to your purpose in using this filter. While it is possible to apply the filter to only those stars within a given constellation, the result can appear artificial and distracting. Of course, the ultimate choice is entirely yours—this again is the beauty of nightscape photography!

PLUG-INS—FISHEYE-HEMI

Fisheye lenses find widespread use in landscape astrophotography, especially for images containing the aurorae or the Milky Way. Their ability to capture enormous swaths of the night sky is unsurpassed. A major drawback to fisheye lenses, however, is their inevitable distortion, as seen in Figure 21.11(a). The Fisheye-Hemi plug-in is a very good tool for correcting this distortion, or "de-fishing" images created with fisheye lenses. Once installed, it is implemented simply from within Photoshop's Filter menu. Like the other plug-ins, when operated on a duplicate version of the image created in a separate Photoshop layer, if you are unhappy with the results, you can simply delete the layer.

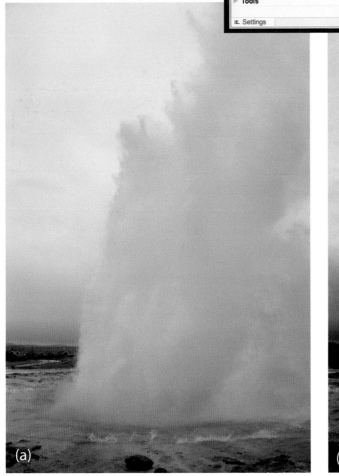

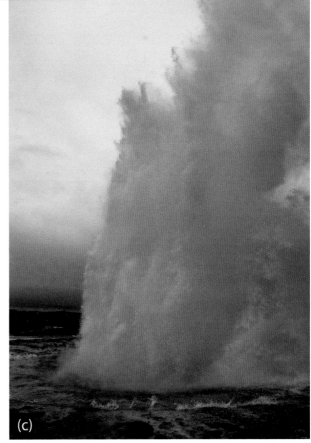

21.9 A before and after comparison of the same image after making adjustments using the Nik plug-ins for Photoshop. This image shows the Strokkur geyser in Iceland during the dim light of twilight.

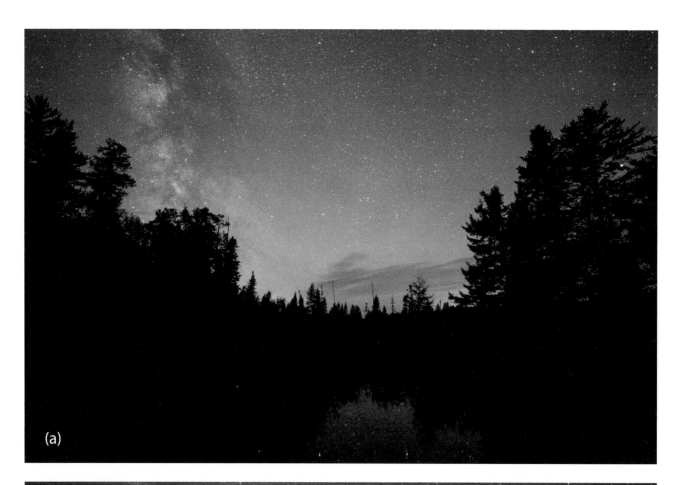

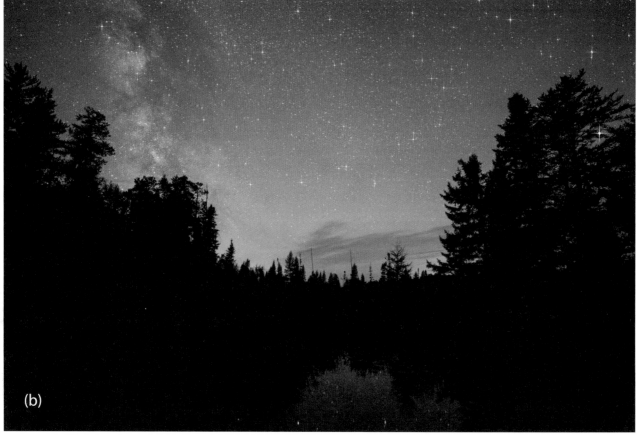

21.10 Diffraction spikes add a certain "pop" to starry skies: (a) before and
(b) after made using the commercially available "Astronomy Tools Action Set."

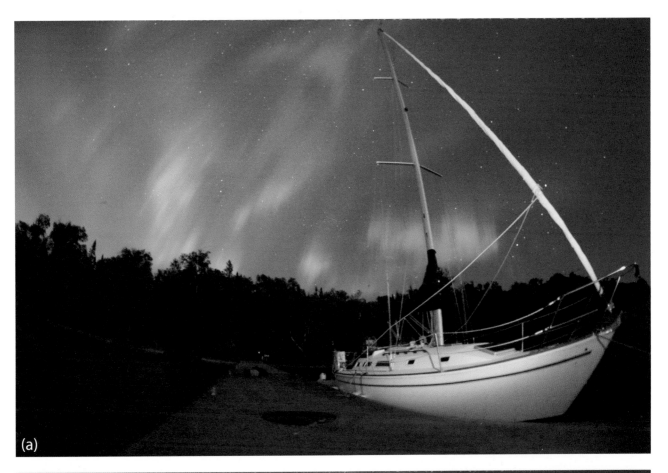

(a)

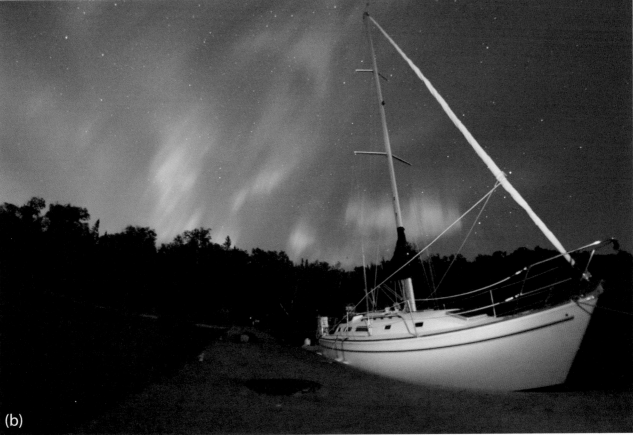

(b)

21.11 A before and after comparison of the same image after making adjustments using the Fisheye-Hemi filter for Photoshop. The artifact of a curved jib of the sailing vessel, "Nordic Song," (a), has been corrected in (b). This image was taken during an extraordinary auroral display during a geomagnetic storm that occurred while docked in the Apostle Islands National Park in Wisconsin.

Fisheye-Hemi is very good at correcting fisheye-lens induced distortion in landscape-oriented images containing a horizon at the image's midplane. However, it can leave behind a noticeably curved horizon if the horizon is located near the top or bottom of a landscape-oriented image. This is the result of its tendency to remove curvature parallel to the length of the image but to leave behind curvature perpendicular to the length.

One clever way around this, as described by the Lonely Speck site, is to extend the canvas of the image roughly 225 percent, give or take, with the original image at its bottom. Doing so converts the overall canvas from landscape-oriented to portrait-oriented, even though the original image is still in a landscape orientation at its base. Running Fisheye-Hemi on this new, portrait-oriented canvas now removes the distorted horizon, since the horizon's curvature is now perpendicular to the length of the canvas.

Finally, you may wish to de-fish your fisheye images in Lightroom or Photoshop directly. You have the option of making both automatic and manual lens-distortion corrections under the lens profile (Lightroom) and lens effects (Photoshop) using the ACR filter described earlier. In general, however, the Fisheye-Hemi plugin correction is superior compared to a rectilinear lens-corrected fisheye image, especially on nightscape images with stars and foreground objects near the edges.

Bibliography

Bair, Royce, *Milky Way Nightscapes*, 2015, RoyceBair.com (ebook)

Dyer, Alan, *How to Photograph Nightscapes and Timelapses*, 2014, Amazing Sky (ebook)

Freeman, Michael, *The Photographer's Eye*, 2007, Focal Press, New York and London

Freeman, Michael, *Perfect Exposure*, 2009, Focal Press, New York and London

Jacobson, Ralph E., Sidney F. Ray, Geoffrey G. Attridge & Norman R. Axford, *The Manual of Photography*, 2000, Ninth Edition, Focal Press, New York and London

Johnson, Charles S., Jr., *Science for the Curious Photographer*, 2010, A.K. Peters, Ltd, Natick, Massachusetts

Horenstein, Henry & Russell Hart, *Photography*, 2004, Prentice Hall, Upper Saddle River, New Jersey

Hunter, Fil, Steven Biver & Paul Fuqua, *Light, Science and Magic*, 2007, Third Edition, Focal Press, New York and London

Keimig, Lance, *Night Photography and Light Painting*, Second Edition, 2016, Focal Press/Taylor & Francis, New York and London

Kelby, Scott, *The Digital Photography Book, Volume 1*, 2007, Peachpit Press, USA

Kelby, Scott, *The Digital Photography Book, Volume 2*, 2007, Peachpit Press, USA

Kingham, David, *Nightscapes*, 2014, Craft & Vision, Vancouver, Canada

London, Barbara, Jim Stone & John Upton, *Photography*, Tenth Edition, 2011, Prentice Hall, Upper Saddle River, New Jersey

Patterson, Freeman, *Photography and the Art of Seeing*, Third Edition, 2004, Key Porter Books Limited, Toronto, Ontario, Canada

Peterson, Bryan, *Understanding Photography Field Guide*, 2004, Amphoto Books, New York, New York

Peterson, Bryan, *Understanding Exposure*, Revised Edition, Amphoto Books, New York, New York

Rowell, Galen, *Galen Rowell's Vision*, 1995, Sierra Club Books, San Francisco, California

Rowell, Galen, *Inner Game of Outdoor Photography*, 2001, W.W. Norton & Company, New York, London

Sussman, Aaron, *The Amateur Photographer's Handbook*, 1973, Eighth Revised Edition, Thomas Y. Crowell Company, New York

Wu, Jennifer & James Martin, *Photography: Night Sky*, 2014, Mountaineers Books, Seattle, Washington

www.google.com/nikcollection/

www.imagetrendsinc.com/products/prodpage_hemi.asp

www.lonelyspeck.com/

www.prodigitalsoftware.com/Astronomy_Tools_For_Full_Version.html

CREATIVE NIGHTSCAPES: MULTIPLE IMAGE PROCESSING

22

The modern ability to combine multiple images into a single, final image in the digital darkroom opens up nearly limitless possibilities in landscape astrophotography. Here, we learn about techniques that range from the nearly routine to those that require hours of work to prepare. In each case, the benefit(s) of combining multiple images will be clearly identified. We will begin with noise reduction and dynamic range expansion, techniques used to enhance the basic quality of images. We will then explore how image shortcomings arising from inherent limitations in aperture, shutter speed, and ISO can be remedied by blending two or more images. Next, we demonstrate how stunning images can be created that combine sunrises and sunsets with the glittering stars of midnight through the blending of several images. We then explore the worlds of star trail and meteor shower images, and specialized techniques to capture and combine images into a final composite. Methods for combining tracked, long-exposures of the night sky with untracked foreground images will be explained. The advantages of light painting and light drawing will be reviewed. We'll explore a few methods to produce large panoramas with jaw-dropping detail. Finally, we'll introduce the basics of time-lapse video creation.

All the examples just described have a similar underlying approach. Most multiple-image composites work with its various components as separate layers within Photoshop, and to a lesser degree, Lightroom. Modifications can be made to the individual layers; if you don't like the way the layer looks, you can simply modify or even delete it without permanently altering the original image. This ability has spawned an entirely new approach to editing images: it is now possible to easily combine hundreds of layers into a single, final composite.

Let's see how to do this by way of a simple example. Here we wish to combine two versions of the same sunset scene into a single, merged result, Figure 22.1. One of the original versions is correctly exposed for the sky and shows a gorgeous mass of clouds beautifully illuminated by the lingering alpenglow, Figure 22.1(left, top). However, the foreground is badly underexposed in this image and barely discernible. The second version of the same image is correctly exposed for the foreground and shows a beautiful set of irrigation canals within a field, Figure 22.1(left, bottom). As you might expect, the sky in this image is badly overexposed. All we need to do is to create a new, blank image in Photoshop and create two layers within it, each containing one of the two versions of the image, and with the correctly exposed sky version on top. We then convert the top layer into a virtual *mask* for the layer below it. By carefully erasing the underexposed foreground regions from the top layer, the correctly exposed foreground in the underlying layer is revealed, Figure 22.1(right). When we are satisfied with the results, we simply merge both layers into one and we're done!

This method of editing and then blending together two or more separate layers is the enabling concept behind each of the following topics. Just as the fruits and vegetables at the grocery store provide the raw ingredients for a limitless range of recipes, so, too, do individual nightscape images serve as the raw ingredients to a limitless number of photographic "recipes," many of which are described in this chapter. Of course, the best part of cooking, and/or photography, is the process in which you create your own recipes... so let's begin!

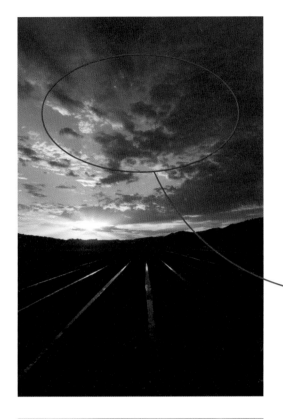

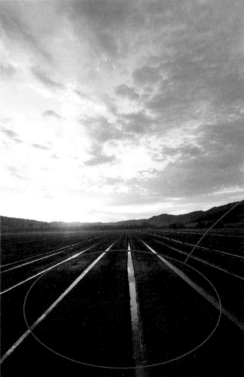

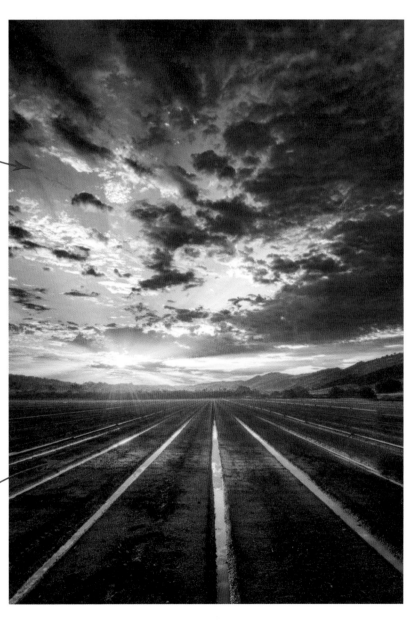

22.1 Two versions of the same sunset scene (left) are merged into a single, composite image (right). The top left image is correctly exposed for the sky, and the bottom left is correctly exposed for the foreground. The optimally exposed portions of each can be extracted and combined into the final result that more closely matched what was seen at the time by the photographer.

NOISE REDUCTION

Perhaps a good place to start, albeit somewhat on the mundane side, is with multi-image noise reduction. Landscape astrophotographs are often made at relatively high ISO settings: 6400, 3200, and often even 12,800. The adverse effects of pixel noise and graininess are well known, yet such ISO settings often provide the best overall exposure, as described in Chapter 12. So what are some multi-image options for reducing the effects of the high-ISO induced noise? The first approach targets the inevitable individual white pixels that occur at high ISO. Such "hot" pixels are entirely an artifact of the sensor operating at this setting. One good way to remove hot pixels and related artifacts is to perform a "dark-frame" subtraction procedure on each image. Many modern digital single-lens reflex (DSLRs) have the ability to perform this task in-camera, and this capability is generally labeled, "Long Exposure Noise Reduction" (LENR) or something equivalent. Even if your camera lacks a LENR capability, it's straightforward enough to do yourself. The basic idea is to create a second identical exposure immediately following the first exposure but with the lens cap on. Any non-black pixels in the second frame must be the result of an artifact within the camera and can be safely subtracted in a Subtract, or Difference, blend operation in Photoshop, Figure 22.2(a).

Another approach to reducing overall noise in landscape astrophotographs relies on the power of averages. Here, the goal is to reduce the color noise of the image, or subtle variation in background color induced by high ISO settings. The way this is accomplished is by taking two or more images made under the same exposure conditions and then averaging them in Photoshop to produce a single image. The averaging process is accomplished by stacking all the images to be averaged as individual layers in a single file, and then assigning an opacity for each layer according to the following relationship,

$$Opacity = 100\% \times \frac{1}{1-L} \qquad \text{(Eq. 22.1)}$$

where L is the number of layers below the layer of interest. For example, in a three-layer stack, the bottom layer will have an opacity of 100 percent, the middle layer 50 percent, and the top layer 33 percent.

Averaging tends to eliminate random color fluctuations in background noise since it is extremely unlikely that more than one image will have the same color noise, as illustrated in Figure 22.2(b). Of course the downside is that care must be taken to deal with the effects resulting from the overall length of the exposure – streaking or stars, or blur of foreground images if using a tracking mount.

HIGH DYNAMIC RANGE (HDR) PROCESSING

Typical camera sensors have the ability to capture a range of scene light values (LV), or a *tonal range* of only around six to seven LV. Compare that to the tonal range of the human eye of around twelve LV and it's easy to see why the rich range of tonal detail perceived by the eye often fails to translate into the photographic image: *the camera simply doesn't have the tonal range to match that of the human eye.* Examples of scenes that suffer from the limited dynamic range of camera sensors include images of the interior of buildings with windows open to the outdoors; and illuminated flowers set against a relatively dark background. In the evening and morning, sunrise and sunset scenes also generally exhibit an enormous range of tonal values, far beyond

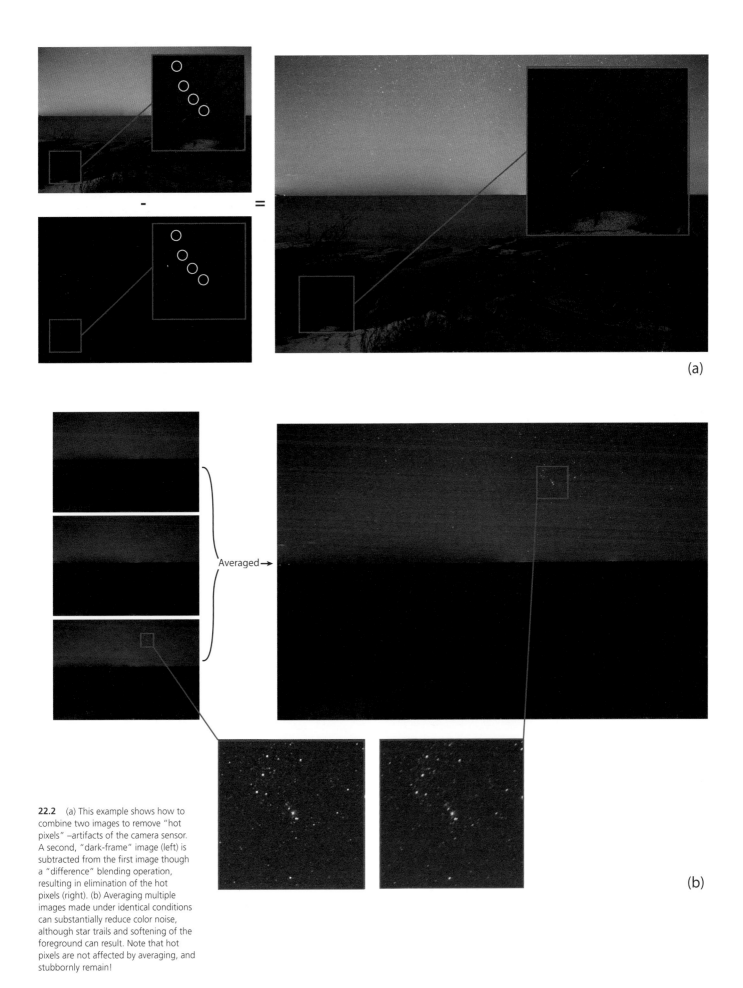

22.2 (a) This example shows how to combine two images to remove "hot pixels" –artifacts of the camera sensor. A second, "dark-frame" image (left) is subtracted from the first image though a "difference" blending operation, resulting in elimination of the hot pixels (right). (b) Averaging multiple images made under identical conditions can substantially reduce color noise, although star trails and softening of the foreground can result. Note that hot pixels are not affected by averaging, and stubbornly remain!

(a)

(b)

the capabilities of a single image with even the best of today's sensors. Consequently, single images made under such extreme tonal range conditions show either severely underexposed or overexposed regions that significantly detract from the overall image quality.

The original way to mitigate the effects of a very large tonal range in the subject is to create intentionally over- and under-exposed images, and blend the correctly exposed regions of both together, by hand, as we saw in Figure 22.1. The primary difficulty with this traditional approach, other than the fact that it can be time-consuming, is that areas of fine detail, such as foliage set against the sky, are very difficult, if not impossible, to properly blend.

In the mid to late 2000s, new High Dynamic Range (HDR) software, most notably Photomatix, began to flourish. Almost overnight, beautiful HDR images started to become widespread, exhibiting tonal ranges much closer to those perceived by the human eye. The basic approach is the same: create two or more images of the same scene but with a different exposure value (EV), process them in any of the available software packages, and then perform adjustments on the final image, Figure 22.3. Consequently, you may well like to develop the habit of *exposure bracketing*, especially around the times of sunset and sunrise where very large ranges in EV are common. Exposure bracketing simply refers to the process wherein a series of images are created in rapid succession, each differing from the next by a fixed difference in EV. The EV variations can be accomplished by systematically changing the shutter speed, aperture, or even the ISO. Sequences of bracketed images are very straightforward to combine using any of today's HDR methods.

FOCUS BLENDING

Wide-open apertures, i.e. low f-stops, are the norm for nightscapes, since the goal is to let in as much light as possible. Coupling open apertures with a focus distance set to infinity, however, brings the risk of an out-of-focus foreground owing to a near focus distance that is beyond the closest foreground subject of interest. Recalling from Chapter 11 how the near focus distance is affected by aperture, you will see that foreground objects that are positioned too close to the camera may not be in focus when the focus distance is set to infinity. Setting the aperture to a higher value to increase the depth of field, and thus bring the foreground objects into focus necessitates increasing the ISO, shutter speed, or both, all of which can degrade image quality.

A relatively simple technique to work around this issue is to blend together two images, both made with the original exposure setting and overall composition from the identical tripod position. The difference between them is that the first one is made with a focus distance set to infinity and in the second one the foreground is clearly in focus. The first image will have a blurred foreground and the second image will have a blurred background. Simply blending the two images together carefully in Photoshop will produce a final image with a remarkable apparent depth of field obtained, as illustrated in Figure 22.4.

22.3 High dynamic range (HDR) photography example. Similar to the example shown in Figure 22.1, (a) overexposed and (b) underexposed images can be processed to produce the (c) correctly exposed image. HDR processing lets the photographer better match the wide range of scene brightness observed in the field to the brightness range in the resultant image. We are thus able to overcome the inferior brightness range capability of even the best modern cameras as compared to the human eye.

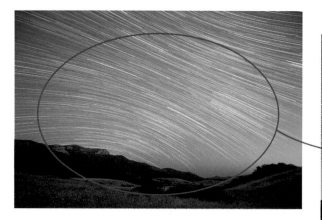

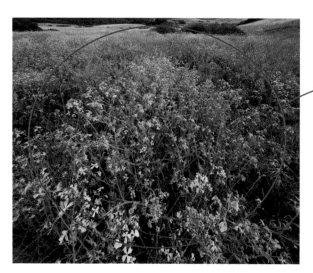

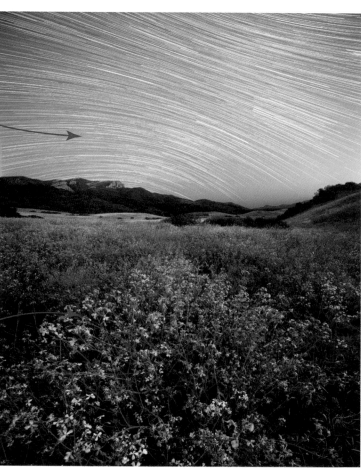

22.4 Focus blending is a valuable method for achieving an extraordinary depth of field. It is accomplished by blending together two images, one focused at infinity (top left) and the other focused on very close foreground subjects (lower left); objects that are closer than the near limit of the camera when focused at infinity. The two images are then layered and blended in Photoshop to produce the final image (right).

ISO BLENDING AND LIGHT PAINTED IMAGES

The high ISO settings used to capture great detail in the night sky have a major drawback. Foreground subjects exhibit all the graininess and noise expected from images made with such a high ISO setting. It is preferable to make the image of the foreground subject with a low ISO setting, thus minimizing image degradation from noise, and maximizing image sharpness. This approach aims to get the best of both worlds.

Here, two images of the same composition are again blended together. Both are taken with identical aperture settings and focus distances, but the first is taken with a high ISO and corresponding shutter speed for the night sky and the second is taken at a much lower ISO and correspondingly longer shutter speed to correctly expose the foreground. When blended together, the high-ISO portions of the sky are retained with the low-ISO portions of the foreground. Since the overall EV of both images are the same, the result is an image with superior night sky quality where some ISO noise is tolerable, coupled with a relatively low-noise foreground.

An example of this method is shown in Figure 22.5, where the two images in Figure 22.5(a and b) were blended to produce the composite image in Figure 22.5(c). The image created with the

22.5 Blending two images together, each taken at a different ISO setting, is a terrific method for extracting the best features of both. Here, the image created with the high ISO setting (a, top left) shows remarkable detail of the Milky Way and the night sky, but an extremely grainy foreground. A corresponding image created with a much lower ISO setting, (b) top right, however, shows a virtually featureless night sky but very good detail of the foreground subject, enhanced by careful light painting. Blending the two images together in Photoshop results in a composite image, (c) bottom, that shows a good level of detail in the sky, coupled with a prominent, high-definition foreground.

high ISO setting in Figure 22.5(a) shows remarkable detail of the Milky Way and the night sky. The image created with the low ISO setting in Figure 22.5(b), however, shows a virtually featureless night sky. Careful light painting reveals the foreground tree in the low ISO image, however, with the crisp detail and sharp definition one would expect in an image made with a low ISO setting. Blending the two together in Photoshop results in a composite image with excellent light sky detail coupled with a high-quality foreground, Figure 22.5(c).

BLENDING TRACKED SKIES WITH UNTRACKED FOREGROUNDS

The use of a tracking equatorial amount, Figure 18.10, allows the creation of night sky images with extraordinarily long shutter speeds and virtually no star trails. Images with exposure times of several minutes in length can be routinely created. Unfortunately, as we have seen, Figure 18.11, foreground objects become undesirably blurred, as the earth now moves underneath the apparently motionless sky.

This problem is easily remedied by blending together a long exposure image of the tracked sky with a second, identically exposed image of the untracked foreground. The night sky will be sharply defined in the first exposure but the foreground will be blurry. In contrast, the night sky will be filled with streaked star trails in the second exposure, but the foreground will be sharply defined. Simply blending the sharply defined regions of both images produces a composite image with extraordinary detail. The exposure of the untracked foreground is best done last when facing east and first when facing west to avoid the potential for underexposing the sky regions in the final, blended image. The order doesn't matter when facing either north or south, as sections of the sky will be inevitably affected in either case.

This technique was used to create an incredibly detailed image of the Milky Way rising over Mt. Boney in the Santa Monica Mountains just outside Los Angeles, California, as shown in Figure 22.6. Both images used to create the composite are also shown, Figure 22.6(a, b); each was made with a shutter speed of 4 minutes and an ISO of only 200. This low ISO setting coupled with a four-minute exposure time resulted in the unprecedented clarity of the Milky Way in this otherwise heavily light-polluted area.

SUNSET/SUNRISE BLENDING WITH NIGHT SKY

Yet another technique for producing powerful nightscape images involves blending two or more images created before, during, and after sunset, as illustrated by the example shown in Figure 22.7. This example shows one of the sheets of ice that forms into piles and stacks along the north shore of Lake Superior each winter. By positioning myself between the blade of ice and the imminent sunrise, I was able to create multiple images that included the Milky Way rising in the pre-dawn astronomical twilight of late February, Figure 22.7(a–c). The composite image, Figure 22.7(d) was created by blending together different regions of individual images created at various stages of twilight using simple layer masks in Photoshop. Admittedly, the result is more a work of art than a simple photograph, and as always, it is up to you where you wish to draw the line between unalloyed documentation and artistic license.

PANORAMAS

Gorgeous panorama images can be obtained by combining, or "stitching," multiple images together into a single composite image with incredible resolution. This is simply accomplished by creating a series of images with 30 to 60 percent overlap between them, Figure 22.8(a). The individual images can then be easily merged within Photoshop, Lightroom, PT Gui, or the Image Composite Editor (ICE) software freely available from Microsoft. Both single row and multi-row panoramas can be created through these techniques.

22.6 The blurry foreground (top right), present in a tracked, long-exposure nightscape, can be mitigated by combing the image with an untracked version with the same exposure settings (top left). The composite image can exhibit extraordinary detail, as shown here for the Milky Way rising over Mt. Boney in the Santa Monica Mountains just outside Los Angeles, California.

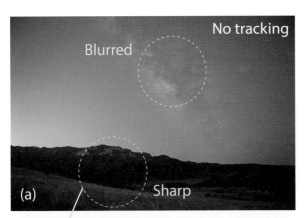

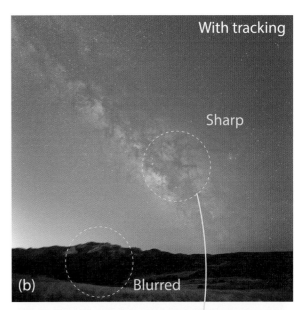

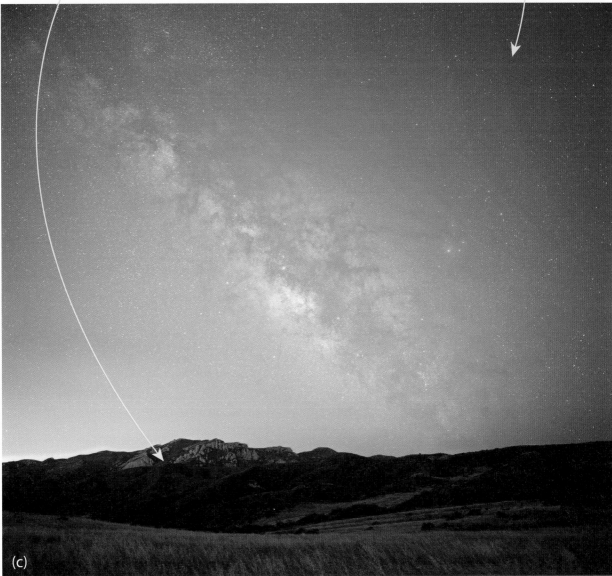

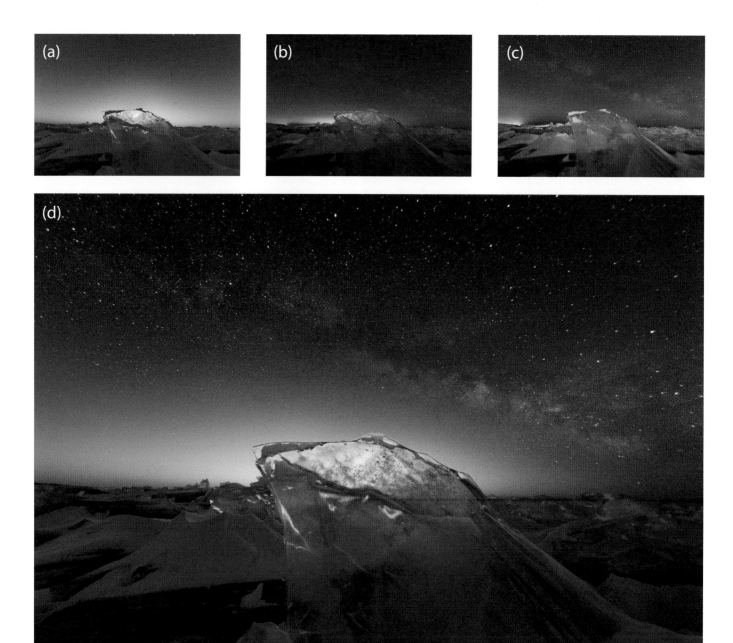

22.7 Beautiful images can be created by combining different versions of the same image but simply made at different times. This example shows a blade of ice that formed along the north shore of Lake Superior during winter. By positioning the camera between the ice blade and the imminent sunrise, I was able to create multiple images that included the Milky Way rising in the pre-dawn astronomical twilight of late February (top). The composite image (bottom) was created by blending together different regions of the top images using simple layer masks in Photoshop.

facing page

22.8 Stunning panorama images can be obtained by combining several images together. This is simply accomplished by creating a series of images with 30 to 60 percent overlap between them, as shown here in (a). These individual images can then be merged within Photoshop, Lightroom, or the Image Composite Editor (ICE) software freely available from Microsoft, as shown in (b), to produce an image with high pixel dimensions. Such images are easily enlarged to create very large prints.

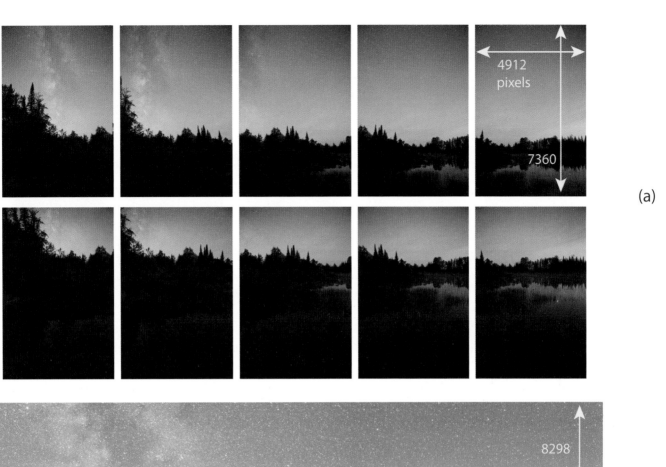

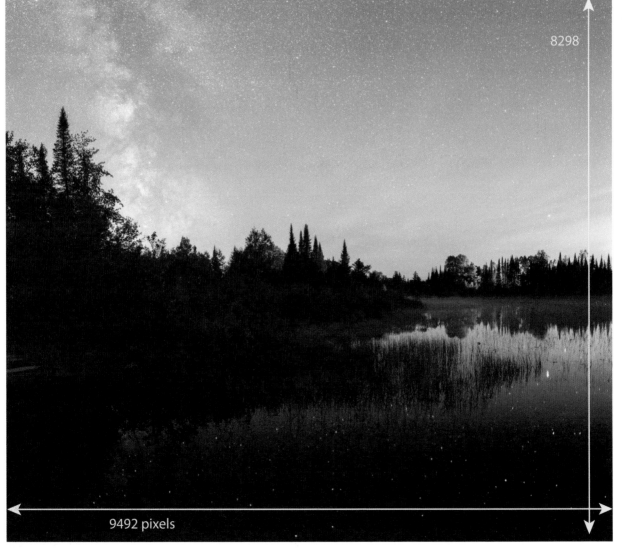

There are a few precautions that should be made when creating images in preparation for the generation of a panoramic composite. First, care must be taken to use a manually focused camera with a manually set white balance and a manual exposure setting. If the focus, white balance, or exposure changes during the creation of the images, then the resultant composites will appear defective. Second, it is important to maintain a level horizon while creating the input images. This step can be assisted immensely with the help of a panoramic head, Figure 18.10. An added benefit of a panoramic head is that it keeps the axis of rotation of the camera through its *nodal point* as the input images are created, thus minimizing the introduction of parallax between successive images. Foreground objects can appear to shift sideways relative to the background in successive images as the result of parallax if the camera is not rotated about its nodal point. Parallax is a common source of alignment error during the merging of images created by hand, or with a simple rotating ballhead. On the other hand, if your image does not contain any nearby foreground subjects, then parallax is less of a concern.

Another issue to bear in mind while you are collecting input images to merge into a panoramic composite image is the need to act quickly. Any perceptible movement within the scene can lead to significant difficulties during the merging of the individual images. For example, clouds, the aurorae, and changes in light in general can all wreak havoc if there are substantial differences between successive images.

Finally, any lens corrections should be performed in Lightroom before merging the individual images. Lens vignetting is an especially important effect that should be eliminated before attempting to merge individual images.

STAR TRAILS
Star trail images are ubiquitous nightscape images that are easy and fun to produce, Figure 22.9. In

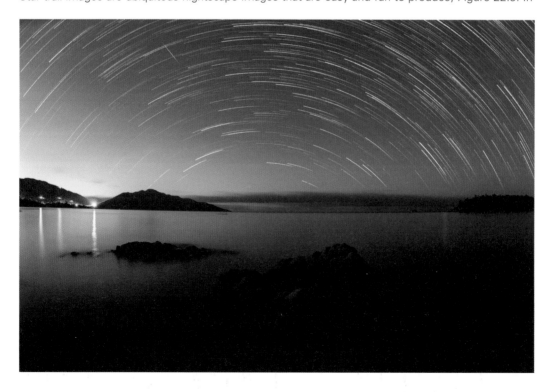

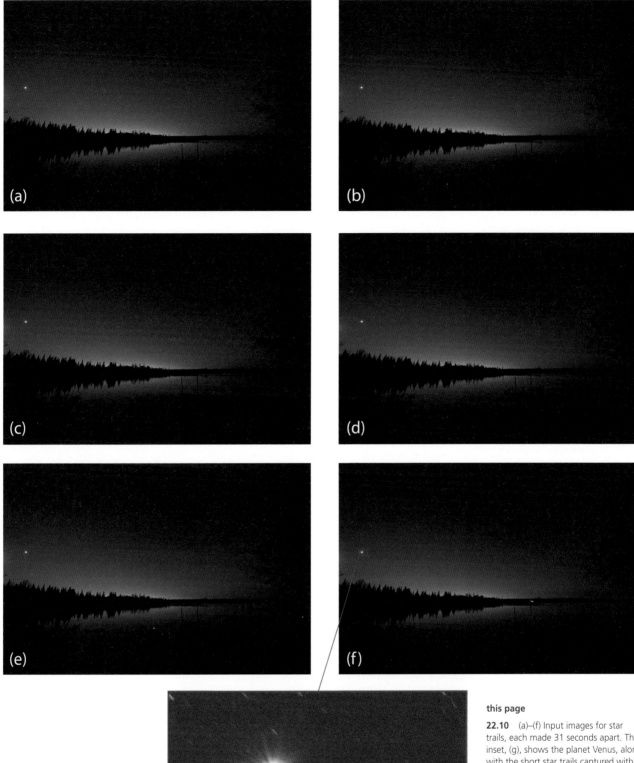

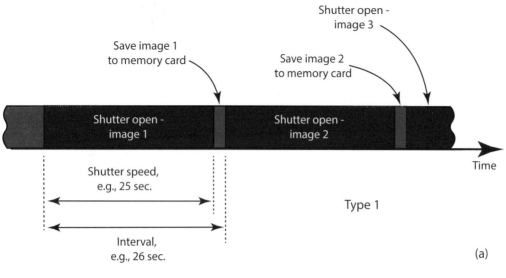

Type 1

(a)

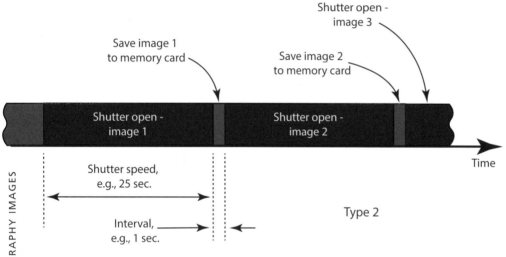

Type 2

(b)

22.11 This schematic illustrates the typical timing sequence used to create a series of star trail images. The main parameters to set are the shutter speed and the intervening time required to store each image. Different manufacturers use different notations to define the interval timing parameters. In (a), the interval includes both the exposure time as well as the time needed to store the image onto the memory card. In (b), the interval simply refers to the duration of the gap between successive images.

fact, you will soon begin to "see" star trail possibilities as you journey along! The basic concept is simple: obtain multiple exposures with relatively short shutter speeds, say 5–30 seconds, Figure 22.10, and then combine them in a way that only the movements of the stars are retained. Star trail image processing can be done using any of several readily available techniques; a few of the more popular approaches are described herein.

Suitable input images can be combined, or "stacked," to create star trails in a few different ways. Their pixel values can be simply added together, resulting in the creating of star trails as the stars move against the dark background between successive images. However, this approach will result in a badly overexposed foreground, since their values will add, too. An alternative approach is to only add together pixel values if they change by becoming brighter between successive images, for example as would be the case when a star moves into a previous dark region of the night sky. This latter approach, implemented through the "Blend – Lighten" procedure in Photoshop, for example, is at the heart of most star trail stacking algorithms.

Let's begin by considering the practicalities of obtaining optimum star trail input images. When using the in-camera timer, or an external intervalometer, there will inevitably be at least a one second interval between successive images. This gap is the result of the amount of time required

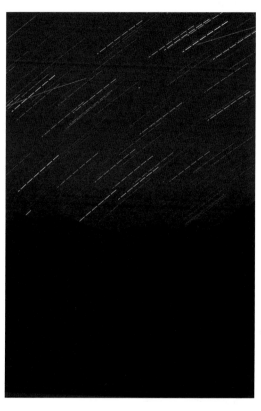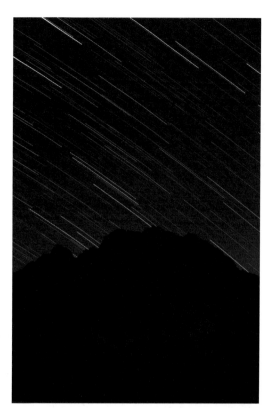

22.12 These two images show the effects of blending star trails with (a) 20 percent vs. (b) 5 percent gaps.

to store each image before creating the next one, Figure 22.11. Thus, if each star trail image is 4 seconds in length, then the resultant composite will suffer from gaps along 20 percent of each star trail. In contrast, if each image is 19 seconds in length, then the gaps will be reduced to only 5 percent of the total length. Examples of star trails with and without gaps are shown in Fig. 22.12.

One way to circumvent this deficiency is to set the exposure mode to "Continuous" and to attach a locked manual shutter release cable. While the cable is attached, the camera will simply record successive images in immediate succession. Each image is held in a temporary memory buffer and stored during the exposure of the subsequent image. Finally, in either method, you may wish to make a final dark-frame image with the lens cap on for subsequent noise reduction.

The next step is to set our ISO, aperture and shutter speed. This process is aided by the case we studied in Chapter 12, e.g. Figure 12.7, where we explored the best of all the possible combinations in aperture, shutter speed, and ISO. The same questions arise in the creation of images for use in star trail stacking. Namely, of the several equivalent exposure settings, particularly those trading ISO levels off against shutter speeds, which combination is the best? Specifically, ignoring the issue of potential gaps, is it better to combine fewer exposures each made with a longer shutter speed and a lower ISO or more exposures at higher ISO made with shorter shutter speeds?

The definitive answer is that the star trail image quality is markedly superior by combining a larger number of shorter duration, high ISO exposures. This outcome is demonstrated in Figure 22.13, where three images are analyzed and compared, each made from an increasing number of nominally equivalent input images, all with identical aperture settings. The first image, Figure 22.13(a), was a single exposure at 240 seconds with an ISO setting of 100. The second

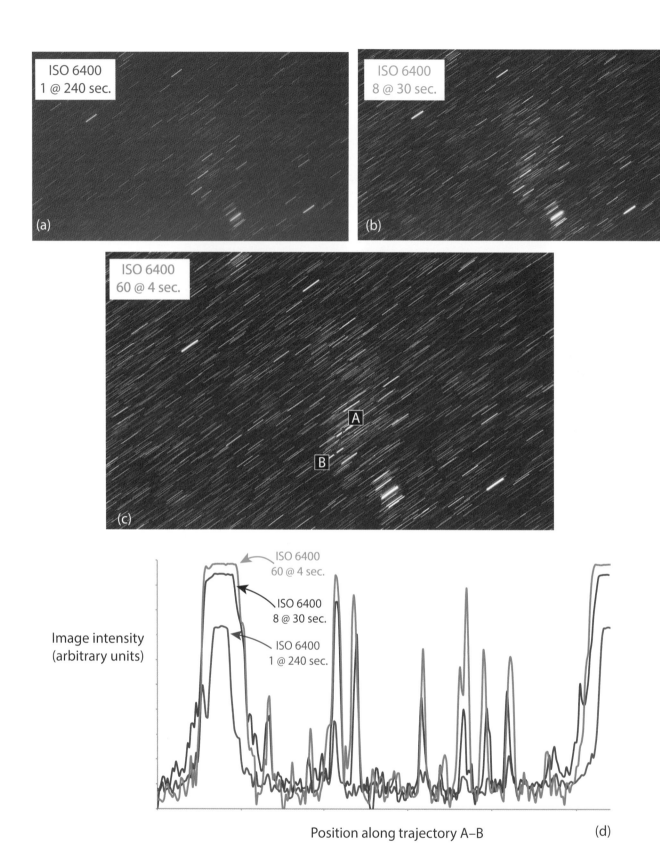

22.13 This exercise demonstrates the benefits of stacking multiple, shorter exposures at high ISO for the creation of star trails. All three images, (a)–(c), were made with the identical EV. The first image, (a), was a single exposure at 240 seconds with an ISO setting of 100. The second image, (b), stacked eight exposures with the same overall EV; each was made at 30 seconds (three EV stops lower than (a)) with an ISO of 800 (three EV stops higher than (a) to compensate). The third image, (c), stacked sixty exposures with the same overall EV as the first and second images; each made at 4 seconds (six EV stops lower than (a)) with an ISO of 6400 (six EV stops higher than (a) to compensate). There are clearly the most star trails visible in the image stacked with the sixty images at 4 seconds apiece even while its background noise level is quite low. (d) Quantitative image analysis accomplished by measuring the image intensity along the line connecting Point A and Point B, (c), in each image. The dimmer star intensity peaks increase by almost *a factor of ten* relative to the sky between the 240-second single image and the sixty stacked 4-second images!

image, Figure 22.13(b), stacked eight exposures with the same overall EV; each was made at 30 seconds (three EV stops lower than the first image) with an ISO of 800 (three EV stops higher than the first image to compensate). The third image, Figure 22.13(c), stacked sixty exposures with the same overall EV as the first and second images; each made at 4 seconds (six EV stops lower than the first image) with an ISO of 6400 (six EV stops higher than the first image to compensate). There are clearly the most star trails visible in the image stacked with the sixty images at 4 seconds apiece even while its background noise level is quite low.

We can further quantify this result through analysis of the resultant images, Figures 22.13 (a)–(c), using the freely available program ImageJ. ImageJ is a public domain image-processing software freely available from the National Institutes of Health (NIH), the same government agencies responsible for the nation's medical research. Originally designed to assist with the analysis of scientific images, it can be used to edit images, create animations, and perform quantitative image analyses.

The quantitative image analysis is accomplished by measuring the image intensity along the line connecting Point A and Point B, Figure 22.13(d), in each image. This is done by: (i) opening each image within ImageJ; (ii) using the line tool to define the analysis path; and (c) executing: Analyze → Plot Profile. ImageJ then measures the image intensity along the selected analysis path and generates the graphs shown in Figure 22.13(d) for each image.

The intensity peaks in the graphs corresponding to the stars can be compared to the relative background intensity level of the sky after first adjusting the background sky level to comparable values. What can be seen is that the dimmer star intensity peaks increase by almost *a factor of ten* relative to the sky between the 240-second single image and the sixty stacked 4-second images! This is an *enormous* difference—akin to more than a three-stop improvement in EV! This example clearly demonstrates the advantages of combining a greater number of exposures with high ISO settings and shorter times than fewer exposures made at longer exposure times. Of course, larger memory cards are needed to hold all the additional images!

Let's now discuss the various methods available to actually perform the star trail stacking. First, it is entirely possible, albeit laborious, for you to individually blend together all of your star trail images within Photoshop. All you need to do is to convert each image to a separate layer within a single image and then perform the "Lighten Blend" operation on each layer sequentially. Fortunately, Photoshop makes it easy for you to automate this process through the creation of a Photoshop *action*, or recorded sequence of automated tasks.

A simpler approach is to use the freely available StarStaX software. StarStaX allows you to easily convert a sequence of individual star trail images into a composite image with several options for the manner in which the star trails are created. They can be combined into solid streaks of light, Figure 22.14(a), or one or both sides of the trails can be preferentially dimmed in what is termed the "comet" mode, Figure 22.14(b). An especially useful feature of StarStax is that the processed, individual images used to create the final composite can be saved as intermediate files and then later converted into a separate time-lapse video sequence with stunning effects, as described below.

22.14 The results of combining multiple input images using StarStaX: (a) basic stacking; no special effect and (b) stacked using the "comet" mode.

Source: http://www.markus-enzweiler.de/software/software.html

Another alternative is the image-stacking Photoshop *script* provided by Waguila Photography. Like the action described earlier, a script is a saved sequence of steps that can be performed automatically. Here, a number of options allow you to tailor the appearance of your star trail images. This method was used to create the image shown in Figure 15.22.

One undesirable side effect of stacking numerous images is the inevitable accumulation of all the hot pixels from each image. Unless these are removed from each image before stacking, the only alternative is to laboriously remove them from the final, stacked image. Airplane and satellite lights are another set of artifacts that should be removed prior to image stacking. Great care must be exercised in doing so, however, to avoid removing nearby stars and thus unintentionally introducing gaps in the resultant star trails.

METEOR SHOWER COMPOSITES

Meteor showers are named after the constellation from which they appear to originate; i.e. where their radiant point is located, as described in Chapter 7. Beautiful images can be made with single meteors, Figure 22.15. Care must be taken to ensure that what appears to be a meteor is, in fact, a meteor. Satellites, airplanes, and Iridium flares can occasionally be mistaken for meteors.

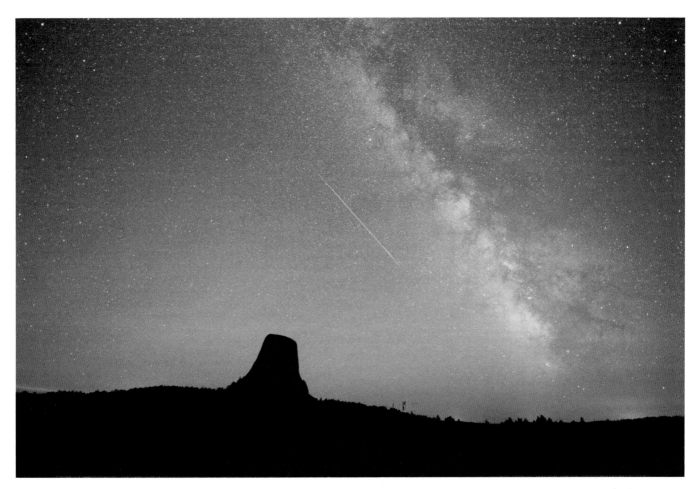

22.15 A lone meteor example streaks across the sky over Devils Tower and next to the Milky Way during the 2015 Perseid meteor shower.

The distinguishing characteristics of a meteor are its containment within a single image, its linear shape, and varied colors from end-to-end. If the object suspected of being a meteor spans two images, or exhibits gaps, then it is not a meteor but another object.

Selecting individual meteors from separate images obtained throughout a single meteor shower, and combining them together, can yield a beautiful composite image. Producing it is relatively straightforward; a significant issue, however is the movement of the stars that occurs during the typically several hours of exposure necessary to capture several meteors. This movement must be corrected for in order to produce an image (a) without star trails and (b) with all the meteors correctly appearing to originate from the radiant. Here's how this is done.

First, be sure your composition contains a celestial pole. If it doesn't, then this alignment technique will not work. The Perseid meteor shower is especially conducive to this approach, since its radiant point is relatively close to Polaris. Next review each image carefully to select those containing a meteor. Separate the meteor-containing images into a distinguishable group.

Pick one of the meteor-containing images to be the image into which all the meteors from the other images will be merged. We will call this the foundation image. You will likely want to select the foundation image to be the one corresponding to the time when the radiant point is the highest in the sky. This will best convey this sense that the meteors are raining down from above.

Open the foundation image and one of the other meteor-containing images in Photoshop, Figure 22.16(a). Copy the second image as a separate layer in the first image. Combine both layers using the "Light Blend" command, Figure 22.16(b). You will see the relative motion of the stars around the celestial pole as miniature star trails. Repeat these steps with the remaining meteor-containing images; when you're done, you will have an image with distant star trails encircling the celestial pole. Create another layer and use it to mark the point of the celestial pole. Keep this layer visible and uncheck the visibility of all but the foundation image layer and one of the remaining layers.

facing page

22.16 Brilliant meteor shower composite images are straightforward, if time-consuming, to make. First, be sure your composition contains a celestial pole. Pick one of the meteor-containing images for the foundation image. Open it and another meteor-containing image in Photoshop, (a). Copy the second image as a separate layer in the first image. Combine both layers using the "Light Blend" command, (b). You will see the relative motion of the stars around the celestial pole as miniature star trails. Repeat these steps with the remaining meteor-containing images; when you're done, you will have an image with distant star trails encircling the celestial pole. Create another layer and use it to mark the point of the celestial pole. Keep this layer visible and uncheck the visibility of all but the foundation image layer and one of the remaining layers. The next step is to rotate the second layer around the celestial pole to bring it back into alignment with the foundation image, (c). This is easily done in Photoshop using the rotate command and moving the center of rotation to the point marking the celestial pole. Once this is done, simply select just the meteor from the second layer using a mask, and discard the rest of the layer. Repeat these steps with the other layers until you're left with a single, composite image containing the correctly aligned meteor from each of the meteor-containing images, (d).

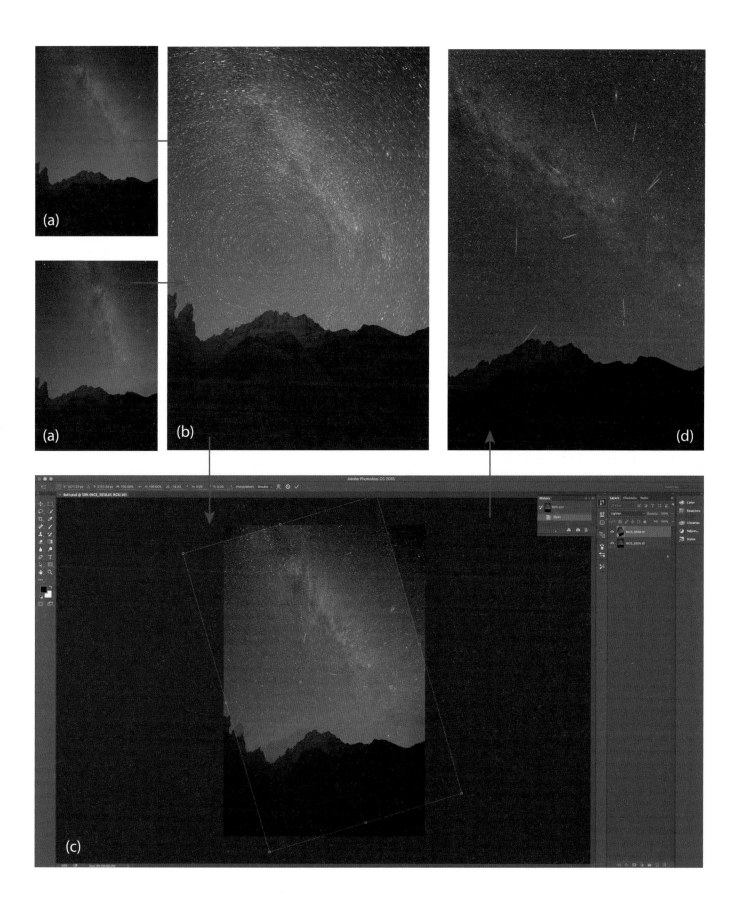

The next step is to rotate the second layer around the celestial pole to bring the sky in this image back into alignment with the sky in the foundation image, Figure 22.16(c). This is easily done in Photoshop using the rotate command and moving the center of rotation to the point marking the celestial pole. Once this is done, simply select just the meteor from the second layer using a mask and discard the rest of the layer. Repeat these steps with the other layers until you're left with a single, composite image containing the correctly aligned meteor from each of the meteor-containing images, Figure 22.16(d).

TIME-LAPSE VIDEO

A burgeoning frontier of landscape astrophotography involves the creation of beautiful time-lapse videos. These are remarkably simple to make using tools that you likely already have, or can download for free. Photoshop has an option to easily create a video from a series of images. All that is required is to open the first image in the sequence, after checking the small box titled, "Image Sequence," in the pop-up dialogue box. After the first image is opened, the "Render Video" command is executed from the "File" menu and the video is automatically created. ImageJ can also be used to create basic videos from a sequence of input files in a similar fashion.

One other program for creating time-lapse videos deserves special mention—LRTimelapse, which was developed specifically with the landscape astrophotographer in mind. It is available in a scaled-down, free trial version that allows you to create a time-lapse video from up to 400 input images, enough to allow you to decide whether you wish to invest in it.

LRTimelapse offers several powerful features that are essential for the best quality time-lapses. One of these is a sophisticated "de-flicker" algorithm. This tool effectively eliminates the minor, but perceptible fluctuations in exposure between successive frames that inevitably result from tiny differences in the actual positions achieved by the individual blades of the aperture diaphragm, even at a constant aperture setting. As the diaphragm opens and closes between each frame in a time-lapse sequence, the diaphragm blades come to rest at minutely different positions, creating subtle differences in the aperture between successive images. The differences in aperture result in barely perceptible differences in exposure between successive images. During the accelerated playback of a time-lapse sequence, however, these differences in exposure manifest themselves as a noticeable flickering. The LRTimelapse de-flicker tool allows the user to smooth out these tiny differences almost completely.

LRTimelapse is also remarkably effective at helping create the so-called "Holy Grail" time-lapse sequences. Its underlying strategy is to identify a handful of images throughout the sequence that it labels as "key frames." Each key frame is selected from a specific point during the holy grail sequence. The first key frame is usually the first image in the sequence, and the final key frame is usually taken near the end of the sequence. The intervening set of key frames are selected to encompass the range of exposures. The user then edits each key frame separately in Adobe Lightroom to achieve the desired appearance. The key frames are then brought back into LRTimelapse and after a few subsequent steps where the exposures of the entire sequence are adjusted according to the exposures of the key frames, the entire sequence is then exported into a video. The entire process is quite straightforward and enables the user to create truly spectacular time-lapse videos of nightscapes.

CONCLUDING REMARKS

This section has focused on the possibilities enabled by combining multiple images into a single, composite result. Images produced through these techniques can be simply astonishing! Now, however, I don't wish in any way to devalue the incredible satisfaction of achieving single-exposure nightscapes that demand expert levels of proficiency in all the subjects described in this book. As you will see in the case studies, for example, such images may take years to create! They can require skilled application of techniques in wilderness environments whose special secrets can be slow to reveal themselves. There is an immense amount of pride in making one of these single-exposure images. They offer evidence of advanced photographic credibility, the joy of witnessing a transient moment of perfection, and the satisfaction of meeting demanding dual photographic and astronomical challenges. Nonetheless, multiple-image nightscapes simply represent yet another avenue of artistic and scientific exploration; both promise a lifetime of worthwhile pursuit.

Bibliography

www.google.com/nikcollection/

http://imagej.nih.gov/ij/

www.lrtimelapse.com

www.markus-enzweiler.de/software/software.html

www.waguilaphotography.com/blog/waguila_startrail_stacker-script

SECTION VII
Detailed
Case Studies

23

FROM CONCEPT TO CURATING—FOUR DETAILED CASE STUDIES

The goal of this chapter is to illustrate all the concepts described in the book through four case studies. Two involve sky-priority images; two involve foreground-priority images. Each case study integrates the foundations of astronomy and photography described in this book along with specific information obtained from our planning tools. A few stumbling blocks are also revealed along the way!

23.1 The constellation Orion poised over the Eastern Sierra in the early morning twilight and peeking through the portal of the Möbius Arch. There are only a few days out of the entire year when this image is possible. The following conditions need to be simultaneously satisfied: (i) Orion is positioned at this precise altitude and azimuth; (ii) at this point within the period of pre-dawn astronomical twilight; and (iii) with the moon below the horizon. A few minutes later, Orion is obscured by the bright sky; a few minutes earlier and it is overwhelmed by the abundance of stars. Furthermore, Orion is not properly positioned through the arch at this same time a month earlier or later. Finally, this image can only be created within a few days of the new moon, otherwise the moonlight sky is too bright. Clearly, thorough planning is needed to ensure success!

Möbius Arch is an iconic landmark of California's Alabama Hills in the Eastern Sierra, Figure 19.7. First popularized by David Muench and Galen Rowell, it features a view of Mt. Whitney, the tallest mountain in the continental United States, through its graceful portal.

One morning in mid-November, I happened to notice the constellation Orion positioned majestically over Mt. Whitney, Figure 1.5. Suddenly, it occurred to me that it might be possible to photograph Orion in this position through Möbius Arch! I ran up the trail just in time to confirm that yes, it

was possible. Unfortunately, the morning sky quickly brightened and Orion slipped into obscurity. I made repeated attempts over the next several years to create this photograph; this case study will take you along the journey.

The key to this image's success lies in several concurrent requirements, starting with the eastern escarpment of California's Sierra Nevada being perfectly oriented to catch the first light of the new day. At sunset, its entire eastern face is in deep shadow and this image doesn't work. Next, as we face to the west, we have the juxtaposition of Orion with the eastern Sierra crest, including Mt. Whitney, in the precise moments when there is sufficient light from the imminently rising sun behind our back to illuminate the mountains. Second, the stage of twilight is such that there aren't an overwhelming number of stars visible; Orion clearly stands out. You will see that these dual requirements limit the window of possible shooting times to literally just a few minutes! Third, the altitude of Orion through the portal of Möbius Arch must be such that it creates a pleasing composition while not blocking any of the key image constituents. As you will see, this latter requirement, coupled with its special timing within twilight, results in its availability for only a few weeks each year! Finally, we have chosen the correct focal length lens, foreground subject distance and depth of field (DOF) to ensure a pleasing framing by an in-focus Möbius Arch.

This image qualifies as a sort of hybrid sky-priority/foreground priority image, Figure 16.1, since it relies on the concurrent presence of Orion, Mt. Whitney, and the Möbius Arch. Nonetheless, since it hinges on the appearance, position, and timing of Orion, we will treat it as a sky-priority image. We therefore start by consulting our virtual planetarium software to determine the dates when Orion is correctly positioned during the transition between astronomical and nautical twilight, Figure 23.2(a). We know that November is a suitable month, based on the date of our initial observations. In October, however, we find that Orion is too high in the sky during pre-dawn astronomical twilight to fit inside the portal; in December, it has already set below the Sierra crest. November it is!

In tandem, we consult our moon phase calendar for the upcoming window of opportunity; in this case, November 2012, Figure 23.2(b). We see that there are only two weekends during which the moon is below the horizon just before dawn—the weekends of November 17 and 25. We also note that Orion lies at an azimuth of approximately 280° on these dates and times, Figure 23.2(a). We confirm that Mt. Whitney lies at an appropriate azimuth from the Möbius Arch for Orion to be in its proper position, Figure 23.3. Right away we see the value of planning; it was only through sheer good luck that I happened to be at this location when the concept originally presented itself, and I was totally unprepared for it. Planning gives us the confidence that we will be ready the next time around!

The next step is to examine the times of astronomical and nautical twilight on November 10, 2012, and at the location of the Möbius Arch. We see that astronomical twilight ends at 5:27 am, Figure 23.3, so we have between approximately 5:30–5:45 am to make our image; the sky is too dark or bright, otherwise. Once we arrive at the Möbius Arch, we estimate that it will take approximately an hour to properly set up our equipment, compose our final composition and achieve a sharp focus. We know that it takes approximately 20 minutes to hike into the Möbius Arch from the trailhead. Therefore, we decide to leave the trailhead at 4 am to give ourselves a buffer for the unexpected.

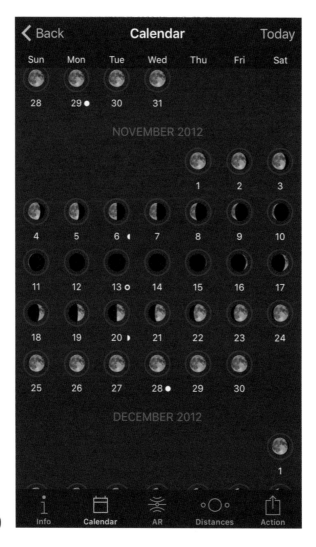

23.2 (a) Virtual planetarium view of Orion in the early morning hours of November and (b) moon calendar for November 2012.

Source: Distant Suns, http://www.photopills.com

Foreground Subject Pin (Gray):
Mt. Whitney

Camera Location Pin (red):
Möbius Arch

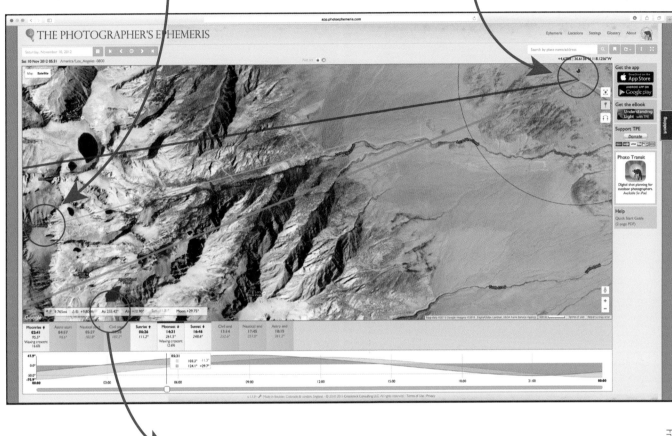

Azimuth
(compass bearing)

23.3 Confirmation in The Photographer's Ephemeris (TPE) of the azimuth of Mt. Whitney from the Möbius Arch. We place the gray subject pin on Mt. Whitney, the red camera location pin on the Möbius Arch, and simply read off the azimuth of approximately 255°.

Source: http://app.photoephemeris.com/

Our next step is to decide what focal length lens to use for the image. While we could simply wait until the morning of the shot and try out several compositions with different focal lengths, we know that we only have a few minutes of optimum shooting time before the sky brightens excessively. We, therefore, conduct a few scouting expeditions during the day to create a series of test images with different focal length lenses, Figure 23.4. We can take as much time during these daytime scouting trips as is necessary to fine-tune and perfect the composition, and then use these images as the basis for our subsequent final selection. We settle on the 24 mm focal length setting of our 14–24 mm zoom lens as our first choice; if anything, a slightly shorter focal length may be necessary.

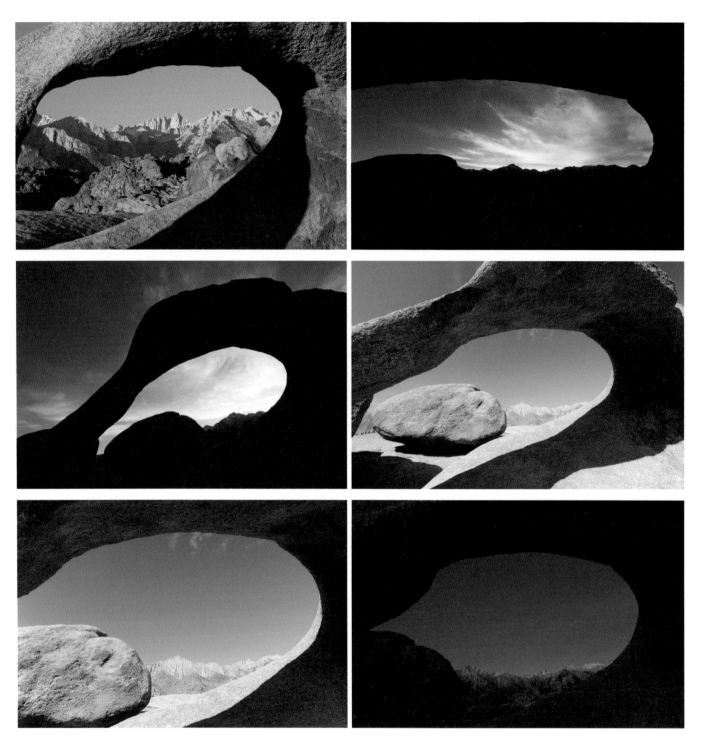

23.4 It is always a good idea to practice during the day making a variety of test images from different vantage points and with different focal length lenses. This is a time-consuming process, and in this case study—we don't have much shooting time available to us!

During our scouting expeditions, we noted that the optimal composition places the camera approximately 25 feet away from the arch. We, therefore, need to choose an aperture setting that will guarantee a DOF between say, at least 20 feet, and infinity. Consulting our DOF planning tools in the field on our mobile device, we see that the minimum aperture that will allow this for a 24 mm lens is f/5.6. We, therefore, decide to set our initial aperture to f/5.6 and create a test image during the day at this aperture. To be on the safe side, we also make a few test images at apertures of f/4.0, f/2.8 as well as f/8 and f/11. Again, here is the value of day scouting; we can

analyze these test images on our laptops before the following morning to make sure our chosen aperture indeed provides an adequate DOF. I did not do this on one of my early attempts, and while I had a beautifully timed and framed image of a sharply in-focus Orion, the edges of the arch were disappointingly out of focus and unacceptably blurred.

You might think that this image would benefit from the focus blending techniques described earlier. Why not simply make an in-focus image of Orion, a second one after refocusing on the arch, and then blend the two images together in post-processing? The only drawback would be if you wanted to make additional images at later stages of astronomical twilight. The length of time required to re-focus on Orion after making the image focused on the arch, compared to the short window of ideal sky brightness, would likely severely limit the number of such attempts.

Now that we have established our aperture, we turn our attention to the shutter speed. We know that the longest exposure time that we may safely choose to avoid noticeable streaking of the stars is given by the Rule of 400/500/600; in this case it is approximately 500/24 ~ 20 seconds.

Our final exposure setting decision is the choice of the appropriate ISO setting. First, we need to know what our camera's exposure value (EV) needs to be in order to match it with the scene light value (LV). Thus, we need to know the approximate LV of our scene. Since we intend to create our images during astronomical twilight, we know from Figure 10.6 that the scene LV will be approximately 0. Turning back to our tables of camera EVs, Figure 12.1, we find that an ISO of 400 will set the camera's EV to -2 for our previously determined aperture of *f*/5.6 and shutter speed of 20 seconds. We're all set!

Bear in mind that these exposure settings are only suggested initial values. We may choose to decrease the exposure time and increase the ISO if we detect the slightest star trails with a 20 second exposure. Alternatively, we may decide to try a smaller aperture, e.g. *f*/8 with a higher ISO if we detect any fuzziness to the foreground. Creative, on-the-fly adjustments are part of the excitement of landscape astrophotography; breaking the rules can also yield stunning results!

Here is a summary of our plans so far. We have decided to leave the trailhead at 4:00 am on Saturday, November 10, 2012. We will have mounted our 14–24 mm lens on the camera. Our initial exposure settings are as follows: ISO is 400, aperture is *f*/5.6 and a shutter speed is 20 seconds. We expect to adjust the exposure settings as the sky brightens. The final step is to set the alarm clock early enough that we arrive at the trailhead by 5 am, hike in, set up and enjoy a beautiful morning creating dozens of spectacular images!

The as-shot image contains all the elements of the pre-visualized image, shown in Figure 23.5(a). Orion is correctly positioned at the ideal moment within pre-dawn astronomical twilight with the added bonus of a few clouds spilling over the ridgeline of the Sierra crest. The image was made with a 21 mm focal length, and an ISO of 1000, aperture of *f*/2.8 with a 15-second shutter speed, corresponding to a scene EV of -4, Figure 12.1, which is slightly darker than our initial estimate of -2.

The final step is to post-process the image to bring out the appearance of Orion as well as add a little mystery to the scene, Figure 23.5(b). This is accomplished first with a minor crop, and then by adjusting the color temperature, hue, contrast, and brightness in Lightroom and Photoshop. The final step is to make slight modifications using the filters within the Nik plug-in collection.

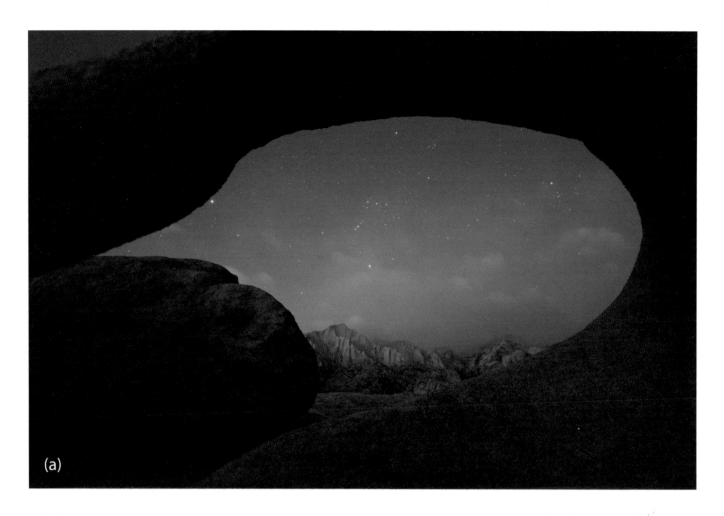

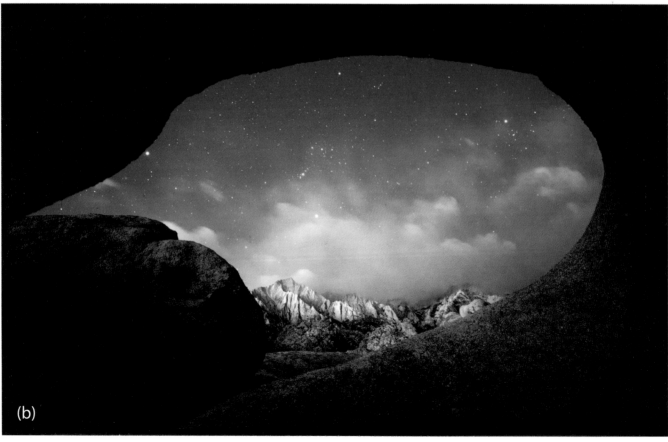

Orion Over Mt. Whitney and Through Möbius Arch

Planning

- Conceive and pre-visualize image concept
- Obtain possible months for when Orion is at this position in the morning from planetarium simulation
- Obtain times of pre-dawn astronomical twilight and confirm azimuth from planning software; select November
- Determine dates of new moon within November
- Decide on preliminary trailhead departure time

Day Scouting

- Confirm travel time to shooting destination from trailhead
- Select focal length, tripod position from images made during day scouting reconnaissance

Fine-Tuning the Plan

- Determine minimum acceptable aperture to ensure adequate DOF from this tripod position
- Determine maximum possible shutter speed to avoid star streaking
- Estimate scene EV from Figure 10.6
- Determine correct ISO to match camera LV to scene EV from Figure 12.1, coupled with candidate aperture and shutter speeds

Day of the Shot

- Create image(s), adjusting ISO, aperture and shutter speed as necessary

Post-processing

- Crop; adjust contrast, color balance, add effects

facing page

23.5 The result: (a) as-shot; (b) post-processed.

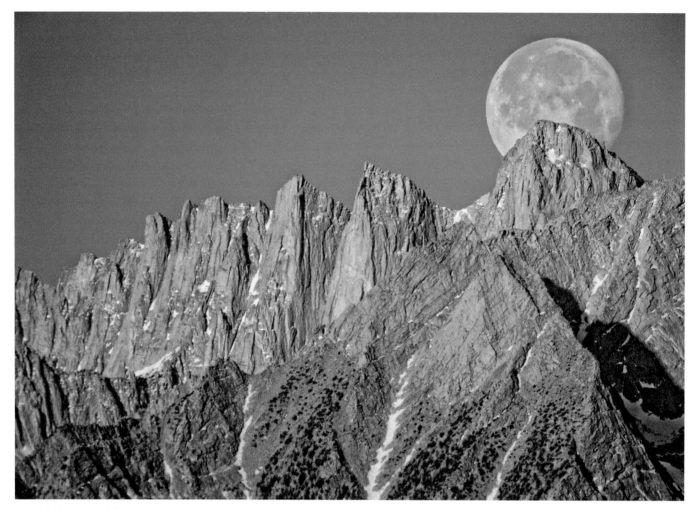

23.6 The largest, nearly full moon of the year, or "supermoon," sets directly behind Mt. Whitney, California; the tallest mountain in the continental U.S., in May, 2012. The key elements of this image are its juxtaposition of a "special" similarly sized moon with the actual peak of the mountain. The diameter of the moon was scaled to the dimensions of the mountain by creating this image from a vantage point over 15 miles away. Knowing the precise shooting location ahead of time was essential; being even just a few hundred feet away would preclude this exact alignment. Coupled with the fact that it only takes a few minutes for the moon to set meant that there was no time to relocate if the shooting location was wrong. Finally, since the supermoon only occurred on one day out of the entire year, this image necessitated careful planning and thorough preparation to ensure success.

The supermoon is a now familiar, much anticipated phenomenon. It regularly occurs whenever the moon is simultaneously full and at its perigee, or its closest point to Earth, during its monthly orbit, Figure 5.12. The supermoon in May 2012, was one such case. I suspected it might be possible to create an image of it setting over Mt. Whitney, thus combining the largest full moon of the year with the tallest mountain in the continental U.S., Figure 23.6. Here's how this image became a reality.

Although there are elements of a foreground-priority shot here, the dominant feature is the setting of the supermoon. This qualifies it as a sky-priority image, Figure 16.1, with a known date of May 5, 2012, Figure 23.7(a). Therefore, the first step was to obtain the setting moon's time, Table 23.1, and approximate azimuth of 260°, with the help of the planning tools shown in Figure 23.7(b).

(a)

23.7 (a) Determining the date of the May 2012 "Supermoon" and (b) the setting moon's time, and appearance for the azimuth of 242° from Distant Suns. The moon appears above the horizon and slightly to the right of the center of this image, consistent with its predicted azimuth of 260° at the moment of moonset.

Source: Distant Suns, http://www.photopills.com

(b)

DAY	DATE (2012)	MOONSET —SEA-LEVEL HORIZON (AM)	ACTUAL MOON INTERSECTION WITH SIERRA CREST FROM SHOOTING LOCATION (AM)	SUNRISE (AM)	CIVIL TWILIGHT (AM)	NAUTICAL TWILIGHT (AM)
Sat	5/5	5:19	----	5:54		
Sun	5/6	6:08	5:30	5:53	5:25–5:53	4:50–5:25
Mon	5/7	7:04	6:16	5:52		

Table 23.1

The next step was to choose a shooting location based on this azimuth. Now in this image, I wanted the moon to clearly stand out as a dominant theme above the mountain. This outcome required the use of a very long focal length lens, otherwise, while the moon would be visible within the composition, its size, and hence "supermoon" qualities would be diminished, e.g. Figure 5.16.

My first choices of potential shooting locations were relatively close to the mountain's base. However, I soon realized that the full scale of the mountain would not fit into the scene from such close proximity locations with the long focal lengths I wished to use. Instead, only its tip, or perhaps its shoulder, would be visible. This was not consistent with my pre-visualized concept; I wanted the entire mountain and its neighbors to fit into the scene along with a substantially sized moon. I quickly realized these dual requirements dictated a shooting location of several miles away, Figure 23.8.

5. Coordinates of required camera position

4. Camera location pin along access road (red)

1. Foreground subject pin (gray): Mt. Whitney

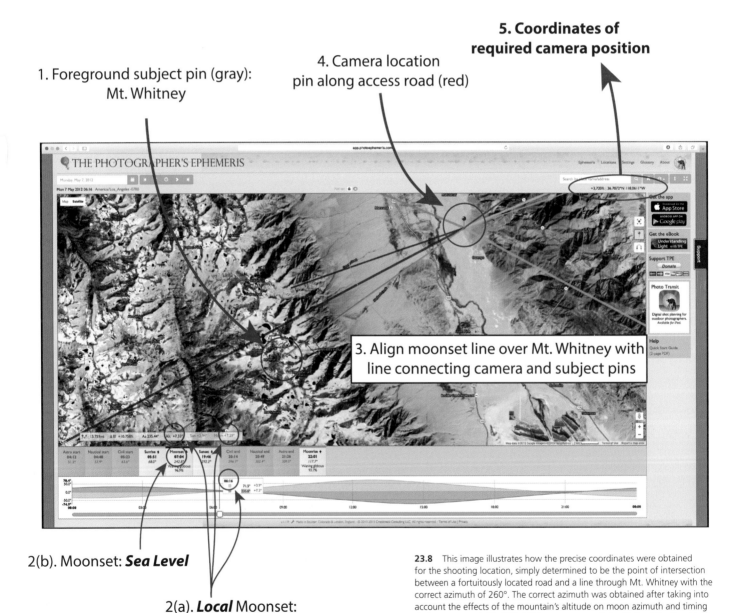

3. Align moonset line over Mt. Whitney with line connecting camera and subject pins

2(b). Moonset: *Sea Level*

2(a). *Local* Moonset: When moon altitude = Mt. Whitney altitude; occurs at ~ 6:16 am, May 7, 2012

23.8 This image illustrates how the precise coordinates were obtained for the shooting location, simply determined to be the point of intersection between a fortuitously located road and a line through Mt. Whitney with the correct azimuth of 260°. The correct azimuth was obtained after taking into account the effects of the mountain's altitude on moon azimuth and timing during moonset behind Mt. Whitney, compounded with the 15-mile subject distance. Local moonset was predicted to occur at 6:16 am on May 7, 2012.

Source: http://app.photoephemeris.com/

Luckily, there was a fortuitously located dirt road, approximately 15 line-of-sight miles away from Mt. Whitney. The road was oriented parallel to the mountain range, thus allowing the pinpoint selection of a shooting location somewhere along its length. The precise shooting location was then simply determined to be the point of intersection between this road and a line through Mt. Whitney with the correct moonset azimuth of 260°, Figure 23.8, using The Photographer's Ephemeris (TPE). The GPS coordinates of this point were noted for field navigation, since there was no cell coverage in this area at the time.

The next step was to estimate candidate exposure settings based on the anticipated LV of the pre-dawn twilight. Noting that moonset occurred only 15 minutes after sunrise on May 6, 2012, Table 23.1, the LV for this time was estimated to be approximately +8, Figure 10.6. Since this is a relatively bright scene, the relatively low ISO of 200 was thus selected as a starting point.

To determine the aperture, I needed to consider the specific details of the lens system I was using. To make this image, the camera was fitted with a 1.7X teleconverter attached to a 4-inch telescope with a 400 mm focal length. This combination resulted in an effective focal length of 680 mm. Noting that the entrance diameter of the telescope was 4 inches ~ 100 mm, the aperture was calculated to be 680 mm/100 mm = f/6.8. This aperture was deemed perfectly suitable, since DOF is not a consideration for such a large subject distance.

For a scene LV of +8, an ISO of 200, and an aperture of, say f/8 (close to f/6.8), consultation of the EV tables in Figure 12.1 indicates a shutter speed of approximately 0.1 seconds for a correct exposure. This should be satisfactory, since the moon should not move perceptibly in this short time interval. Our final exposure settings, therefore, are ISO 200, approximate aperture f/6.8 with a shutter speed of 0.1 seconds.

Having identified its exact GPS coordinates, and preliminary exposure settings, the next step was simply to drive to the shooting location, confirm its location with my hand-held GPS device, set up, and await moonset on the morning of May 6, 2012. There was no need to account for travel time from a trailhead, since the shooting location was right next to the parked car. It was necessary, however, to allow approximately an hour for unpacking, assembling, aligning and focusing the telescope/camera assembly, thus necessitating an arrival time at the shooting destination of 5:00 am.

Two major problems emerged that morning, Figure 23.9(a), both of which originated from my failure to account for the effects of the mountain's altitude on moon azimuth and timing during moonset along the Sierra crest. I had selected the shooting location based on the time when the moon set beneath the *sea level horizon*, not when the moon slipped behind the 14,494 feet tall peak of Mt. Whitney from my shooting location which was 3,720 feet above sea level. Compounded with the 15-mile subject distance, this significant error resulted in the moon intersecting the wrong portion of the Sierra crest, far to the south, or left, of Mt. Whitney. Second, this error resulted in the moon intersecting Mt. Whitney over *40 minutes earlier than expected*— during the final stage of nautical twilight, rather than just a few minutes before sunrise. The result was an unacceptable brightness difference between the moon and the mountain, Figure 23.9(a). Thus, a juxtaposed image of the Sierra crest and the moon both correctly exposed in a single exposure was impossible that morning, owing to the enormous difference in LV between the full moon and the Sierra crest. High dynamic range (HDR) processing of multiple images would have

been a difficult challenge, owing to this extreme difference in LV coupled with the significant flare around a badly overexposed moon in the image correctly exposed for the foreground, Figure 23.9(a).

The lesson learned is to compensate for the effects of local horizons and shooting locations of different altitudes during the planning process. This process is straightforward in both TPE and PhotoPills (PP), for any combination of target and shooting location. Doing so allows you to determine the actual azimuth and time of moonset/rise as well as sunset/rise. As you have seen, these effects can be critical!

A second attempt was made the following morning, May 7, 2012, when the moon was still nearly full (98.3 percent) but intersected the mountain's crest about an hour later, shortly after sunrise, Table 23.1. This difference in time created a far more pleasing similarity between the LV between the moon and the mountain. The setting moon and the peak of Mt. Whitney were also successfully aligned simply by relocating the shooting position to a new location based on properly accounting for the effects of the mountain's altitude on the location of the moon's point of intersection with the Sierra crest.

It was impossible to know with utter certainty the exact point of intersection or "best" composition ahead of time. Consequently, as the near-supermoon approached, intersected and finally set behind Mt. Whitney and the Sierra crest, a series of images with different orientations and compositions were made throughout the event, Figure 23.9(b), constantly monitoring the histogram and focus quality of the images.

POST-PROCESSING

The final step in the creation of this image is the elimination of the haze resulting from the 15-mile distance between the camera and the mountain, Figure 23.10(a), as well as the significant lens vignetting, especially in the upper right corner. Judicious application of contrast adjustments, slight color correction, and minor cropping produces the pleasing final result, Figure 23.10(b)

facing page

23.9 (a) May 6, 2012: the morning after the night of the supermoon. Unfortunately, two problems emerged: (i) The shooting location was incorrect, as I had failed to account for the effects of the mountain's altitude on moonset location and timing; and (ii) the moon intersected the mountain peak within nautical twilight, resulting in a too-great brightness difference between the moon and the mountain for a good image.
(b) May 7, 2012: the following morning, when the moon was still nearly full (98.3 percent) and intersected the mountain after sunrise, creating a far more pleasing similarity in brightness between the moon and the mountain. The effects of the mountain's altitude have also been compensated for, allowing a successful alignment between the setting moon and the very tip of Mt. Whitney. The image at the lower left was made at 6:14 am, May 7, 2012, which agrees very well with the predicted time of 6:16 am.

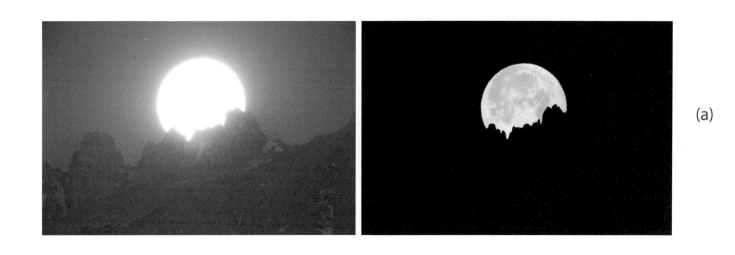

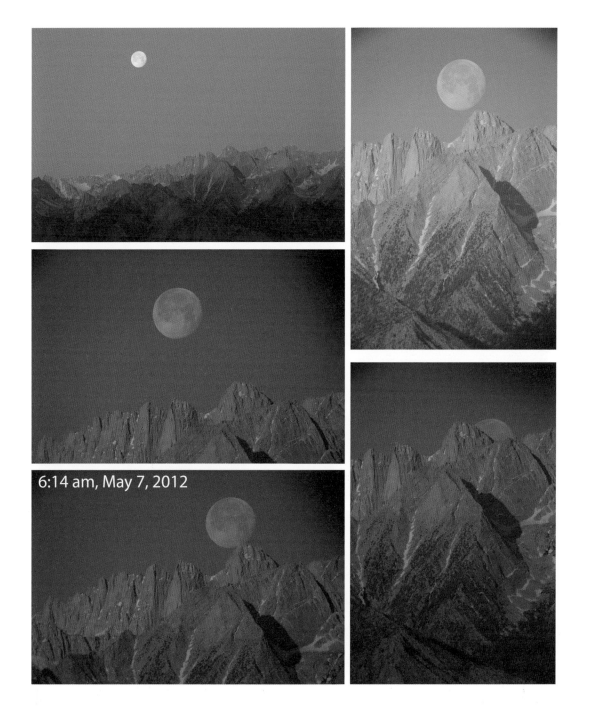

6:14 am, May 7, 2012

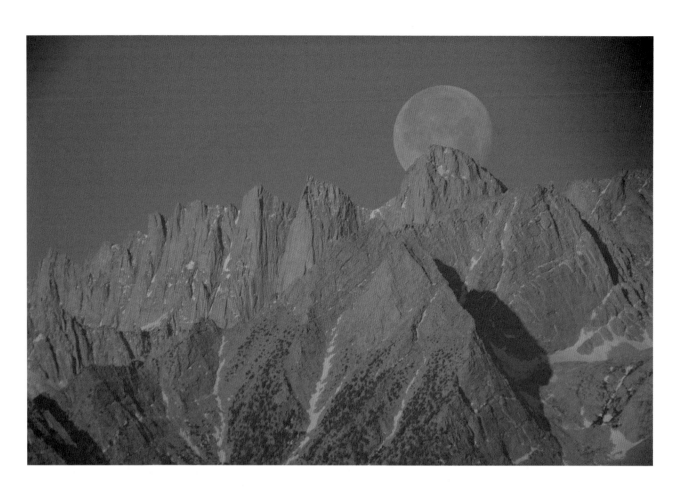

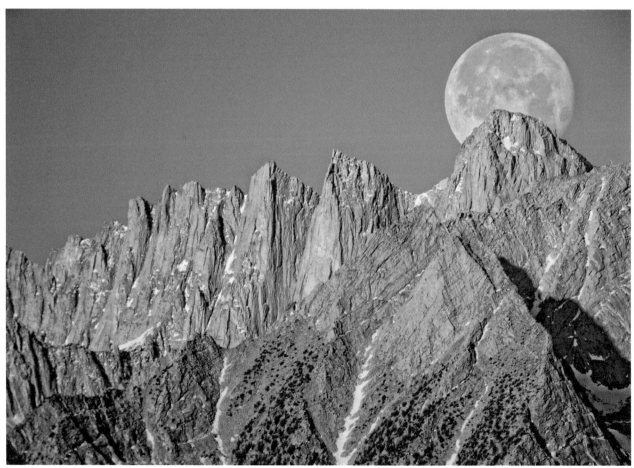

Supermoon Over Mt. Whitney

Planning

- Conceive and pre-visualize image concept
- Determine the date of the supermoon
- Confirm azimuth from planning software and select precise GPS coordinates of suitable shooting location
- Determine moonset time to be close to sunrise from planning software
- Estimate scene EV to be ~8 from Figure 10.6 for typical sunrise
- Choose ISO of 200; minimum available aperture is ~*f*/6, and a shutter speed of ~0.1 seconds.

Fine-Tuning the Plan

- Experience errors in location and timing on May 6
- Compensate moonset time for altitude of Mt. Whitney, adjust exposure settings for sunrise the following day; select new GPS coordinates
- Relocate shooting position; repeat second day

Day of the Shot

- Create multiple images in landscape/portrait orientations throughout moonset event

Post-Processing

- Adjust contrast, color balance, and crop to remove lens vignette

facing page

23.10 The final result: (top) as-shot; (bottom) post-processed.

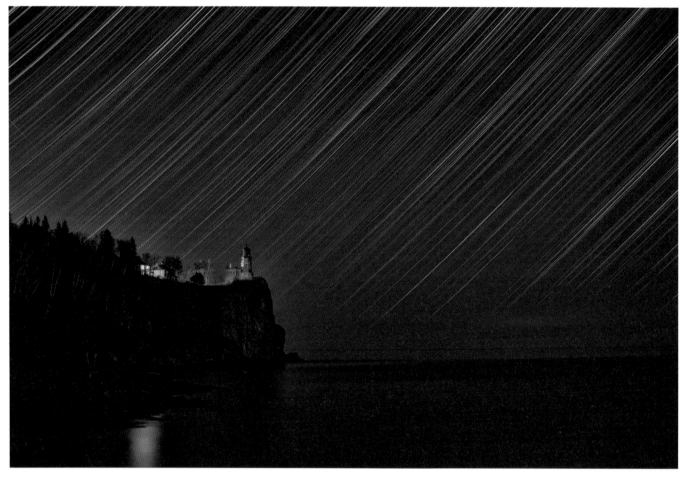

23.11 Star trails over Split Rock Lighthouse—a beloved Minnesotan landmark along the north shore of Lake Superior.

Split Rock Lighthouse is a beloved Minnesotan landmark along the north shore of Lake Superior. Its rugged construction atop the top of a sheer cliff amidst a scenic forest backdrop makes it a highly photogenic subject. Although it is no longer in regular use, it is lit once each year, on November 10, to honor the tragic sinking of the Edmund Fitzgerald in 1975. However, there are few, if any, images made of it with accompanying star trails. I felt that a viewpoint from a location to its west would yield a satisfying composition of star trails arcing upwards at an angle with the vertical equivalent to its latitude, ~47°, over the serene surface of a calm lake. A moonless night would allow the greatest number of stars to be visible. Let's go through the process.

Since we are starting with a specific subject in mind, in this case the Split Rock Lighthouse, this image concept clearly qualifies as a foreground-priority image, Figure 16.1. Familiarity with the area led to the choice of the general shooting area to be somewhere along the rocky shore to the west of the lighthouse. Having pre-visualized the overall concept, the first step was to establish the azimuth, 76°, between the lighthouse and the prospective shooting location, Figure 23.12(a). A check of the anticipated orientation of the star trails at this azimuth at a similar location using the augmented reality capability of PhotoPills, Figure 23.12(b), confirmed that the star trails should have the desired orientation.

23.12 (a) Using The Photographer's Ephemeris (TPE) to determine the azimuth, 76°, between the lighthouse and the prospective shooting location. (b) Confirming the anticipated orientation of the star trails at this azimuth using the augmented reality capability of PhotoPills (but with a different lighthouse).

Source: http://app.photoephemeris.com/; http://www.photopills.com

The next step was to determine the dates of the new moon for the target month, in this case, April 2015, Figure 23.13. We find that the evening night skies will be moonless for the dates of April 12–19, 2015. After April 19, 2015, the waxing crescent moon will increasingly become an issue, as will the waning gibbous moon before approximately April 12, 2015.

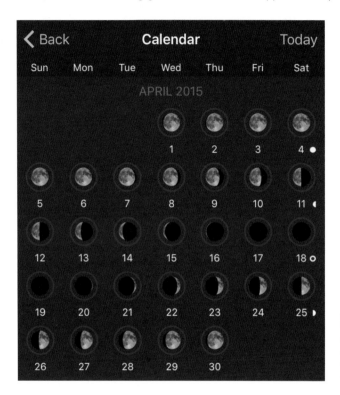

23.13 Moon phase calendar for the month of April 2015, showing that the dates of April 12–19 would have moonless skies in the evening. After April 19, the waxing crescent moon would increasingly become an issue, as would the waning gibbous moon before approximately April 12.

Source: http://www.photopills.com

Having established a suitable set of dates, a suitable starting time for the star trail sequence was needed based on their times of sunset, civil, nautical, and astronomical twilights. I wanted to initiate the star trail image sequence within the final stages of astronomical twilight so that the first few images would retain some of the sunset colors in the sky. Since astronomical twilight on these dates was from approximately 8:20 pm to 9:00 pm, this corresponded to a start time of around 8:30 pm. Giving myself approximately an hour to set up my equipment, finalize my composition and establish a good focus meant arriving at the shooting destination at 7:30 pm. Coupled with a 15-minute walk from the car and 10 minutes needed to unpack the car and load myself up meant arriving at the trailhead between approximately 6:00 and 6:30 pm.

The next phase was to conduct a series of daytime scouting trips to explore a variety of compositions with different focal lengths lenses, Figure 23.14. After reviewing all the potential images, and since I wanted to maintain nearly parallel star trails, I chose a 50 mm focal length, prime lens. The more restricted field of view of this lens accomplished this, compared to the divergent star trails that would result from a wider-angle lens, for example, Figure 15.22. An added benefit of this particular lens is that its minimum aperture was only f/1.4, meaning that the sharpest image would be expected at an aperture of approximately f/2.8, in other words, at two exposure stops above the minimum aperture.

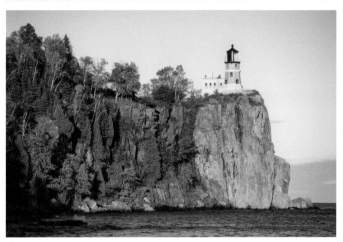

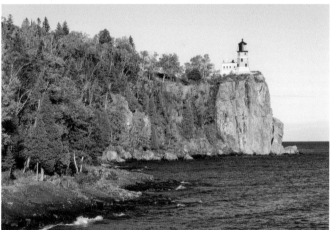

23.14 Daytime reconnaissance to select the optimum composition and lens focal length.

The next step of the planning process involved selecting the camera exposure settings. We have already chosen an aperture of *f*/2.8 since it will produce the sharpest stars across the largest area of the image. A 25-second shutter speed was selected next since we are collecting a series of images to combine into star trails. This was the longest exposure time possible using my in-camera intervalometer. Separately, the scene LV can be expected to be approximately only -5, Figure 10.6, since the scene will ultimately comprise only stars under a dark, moonless night. Coupled with an aperture of *f*/2.8, the result is an ISO of 800 indicated for a correct exposure, found with the help of Figure 12.1. This is good news, since an ISO of only 800 should result in quite noise free images.

An important step is to confirm that the entire image will be in focus for the proposed combination of shooting location and aperture. Here, the distance between the shooting location and the nearest portion of the foreground and the chosen image was determined to be approximately 1,000 feet, measured with the planning tool in TPE in Figure 23.12(a). The DOF tool in PP calculates a minimum, near focus distance of approximately 100 feet for a subject focus distance at infinity with a 50 mm lens set to a $f/2.8$ aperture. This distance is well below the actual minimum subject distance, thus ensuring that our entire scene will be in focus.

The final set of images was collected starting just before 8:00 pm. After trying several combinations of images with different start times, Figure 23.15, the resultant image was obtained, Figure 23.11. This image was processed using the Saucer mode of the Waguila action described in Chapter 22.

Case Study Summary:
Star Trails Over Split Rock Lighthouse

Planning
- Conceive and pre-visualize image concept; select foreground subject to be Split Rock Lighthouse
- Determine candidate shooting location
- Determine azimuth (76°) between the potential shooting location and the lighthouse
- Confirm desired orientation of star trails for this azimuth
- Obtain times of post-sunset astronomical twilight; select image acquisition start time as 8:30 pm
- Decide on preliminary trailhead departure time as 7:30 pm

Day Scouting
- Confirm travel time to shooting destination from trailhead
- Select focal length, tripod position from day scouting reconnaissance

Fine-Tuning the Plan
- Determine candidate shutter speed (25 seconds) and aperture ($f/2.8$)
- Estimate scene EV from Figure 10.6
- Determine correct ISO to match camera LV to scene LV from Figure 12.1, coupled with candidate aperture and shutter speeds
- Determine minimum distance to the closest foreground subject to ensure adequate DOF from this tripod position

Day of the Shot
- Create image(s)

Post-Processing
- Adjust contrast, color balance
- Stack into star trails

facing page

23.15 Examples of images used to create the star trails. The image creation sequence was initiated within the later stage of nautical twilight to retain some color in the sky.

23.16 The river of stars in the Milky Way complements the timeless Chumash 'Ap in the Satwiwa
Native American Indian Culture Center of the Santa Monica Mountains National Recreation Area
just outside Los Angeles, California.

The Chumash 'Ap in the Satwiwa Native American Indian Culture Center of the Santa Monica
Mountains National Recreation Area just outside Los Angeles, California, stands as an iconic
monument to the Chumash and Tongva/Gabrielino cultures. Positioned below Boney Peak, it
seemed like a good subject to couple with the rivers of stars within the Milky Way. Owing to its
proximity to Los Angeles, it also seemed like an excellent opportunity to demonstrate the visibility
of beautiful night sky objects even close to major urban areas. No other such image existed to my
knowledge, so I was excited to give it a try. This case study describes how this image came to be.

Again, since we are starting with a specific foreground subject in mind, this concept qualifies as
a foreground-priority image, Figure 16.1. Consulting our planning tools, we determine a suitable
azimuth for our shooting location to be approximately 220°, Figure 23.17(1), to line up the 'Ap with
Mt. Boney. We also want the Milky Way to rise nearly vertically into the sky next to the 'Ap, as it is
seen to do during the late evenings in the month of August, Figure 23.17(2).

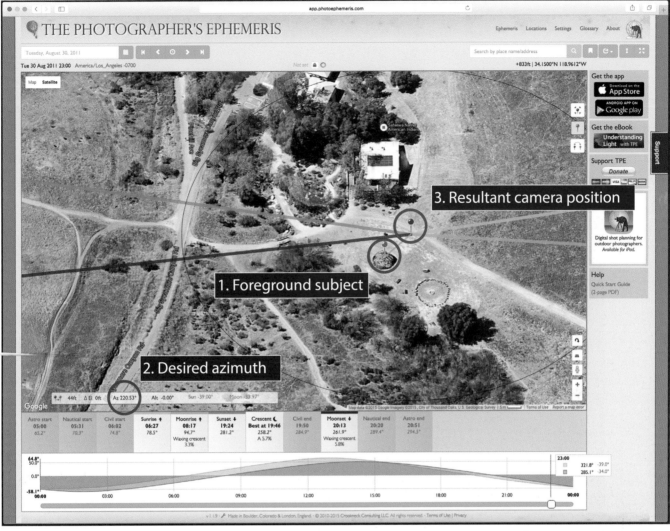

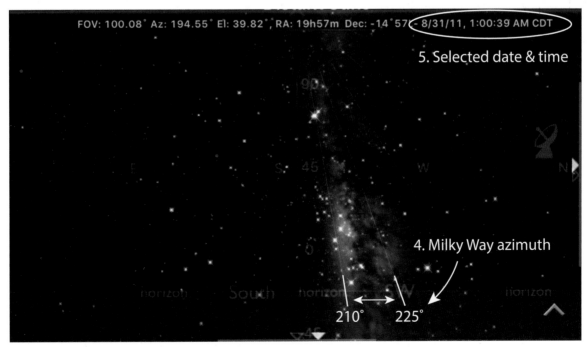

23.17 To determine the date and time of our foreground-priority image, we start with the foreground subject, (1), and desired azimuth to Mt. Boney (2). These form a line which then indicates an area of possible camera position, (3). Consulting our virtual planetarium for our candidate months, we can select approximate dates and time (5) for when the Milky Way intersects the horizon at the correct azimuth of 210°–225° (4).

Source: Distant Suns; http://app.photoephemeris.com/

The next step was to determine the dates of the new moon for the target month, in this case, August, 2011, Figure 23.18. We see that we will experience moon-free skies during the last two weeks of the month. Returning to our planning tools, Figure 23.17(2), we can narrow down a precise date and time combination for when the Milky Way will have a suitable azimuth.

23.18 The moon phase calendar for our candidate month, August 2011, allows us to select the nights when the moon is below the horizon at our desired shooting times.

Source: http://www.photopills.com

The next step was to explore a variety of shooting locations with different focal lengths lenses, Figure 23.19. Since this example was done before I fully appreciated the value of day scouting, I wasted valuable time at night experimenting with different possibilities, Figure 23.19. Nonetheless, despite the relentless movement of the Milky Way during this process, I was able to eventually settle on a suitable choice, Figure 23.20(a).

The camera exposure settings were determined in the field through trial and error. Here again, valuable time was lost; knowledge and planning would have allowed me to spend more time fine-tuning the composition and less time testing endless combinations of ISO, shutter speed, and aperture, all while the Milky Way was slowly moving across the sky!

The final choice of settings were an ISO of 3200, an aperture of $f/2.8$, and a shutter speed of 8 seconds. The relatively short shutter speed was dictated by the unavoidable glow in the sky emanating from the not-too-distant Los Angeles basin. Post-processing allowed me to minimize these effects, Figure 23.20(b).

facing page

23.19 These candidate compositions created at night are presented to illustrate the value of day scouting. I created this image project before I fully appreciated the value of daytime reconnaissance, and I hope you are able to see how daytime scouting can help. By having to make these "practice" images at night, I wasted valuable time when I could have been perfecting my exposure and fine-tuning the composition.

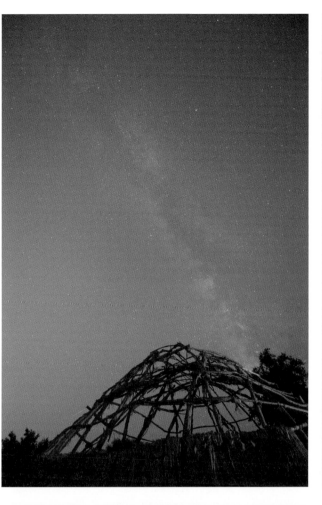
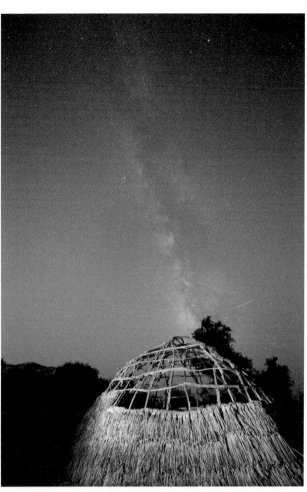
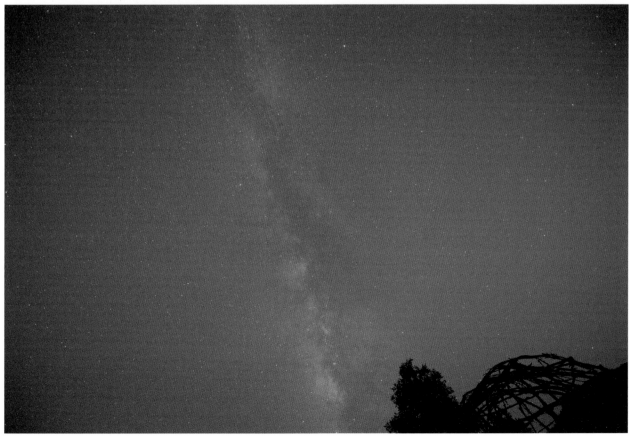

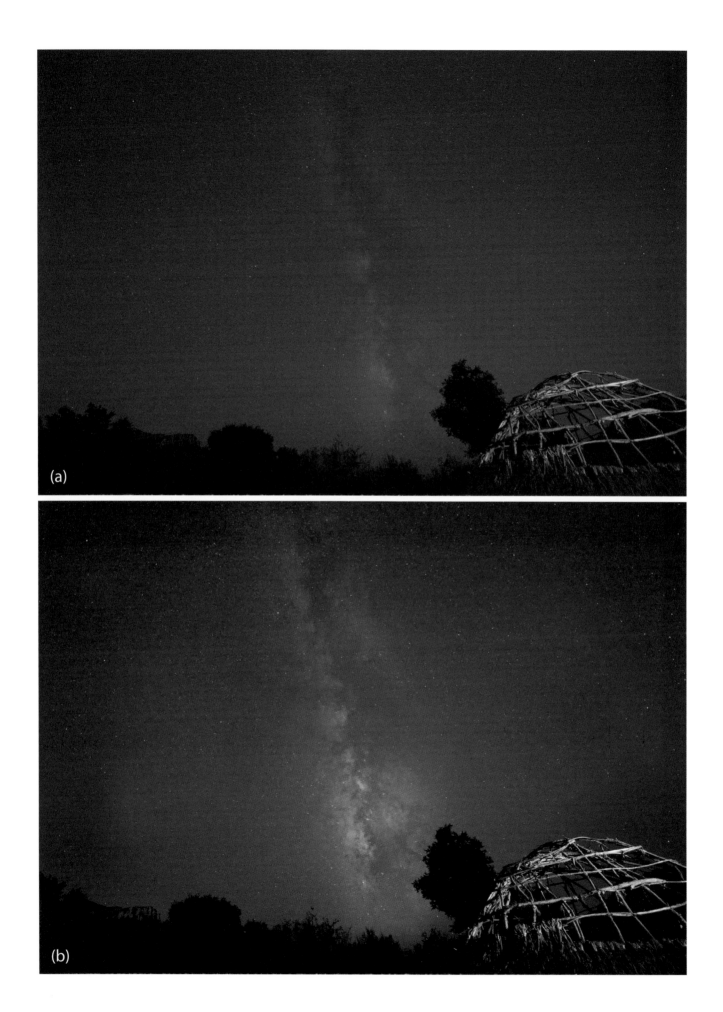

Milky Way Over Chumash 'Ap

Planning

- Conceive and pre-visualize image concept; select foreground subjects to be Chumash 'Ap coupled with Mt. Boney
- Determine candidate shooting location
- Determine azimuth (~220°) between the potential shooting location and the 'Ap
- Determine shooting month, date, and time

Day Scouting

- Not performed; lesson learned!

Fine-Tuning the Plan

- Not performed; lesson learned!

Day of the Shot

- Create image(s)
- Trial compositions and exposure settings done during shoot, losing valuable time

Post-Processing

- Adjust contrast, color balance, dodging to reduce light pollution

facing page

23.20 The final result: (a) as-shot; (b) post-processed.

Bibliography

- https://djlorenz.github.io/astronomy/lp2006/
- www.app.photoephemeris.com/
- www.distantsuns.com/products/
- www.google.com/earth/
- www.photopills.com
- www.stellarium.org
- www.vitotechnology.com/star-walk.html
- www.wunderground.com/

SECTION VIII
Distinguished Guest Gallery

SECTION VIII INTRODUCTION

This section presents a select group of iconic images from the most renowned landscape astrophotographers in the world. It is an honor to include these distinctive images in this book. I greatly respect their generous spirit of collaboration and deeply appreciate their willingness to do so. I hope you enjoy viewing these extraordinary images and find them motivating as well as aesthetically satisfying. Landscape astrophotography has advanced rapidly in recent years owing in no small part to the creativity and ingenuity of these well-known pioneers.

DISTINGUISHED GUEST GALLERY

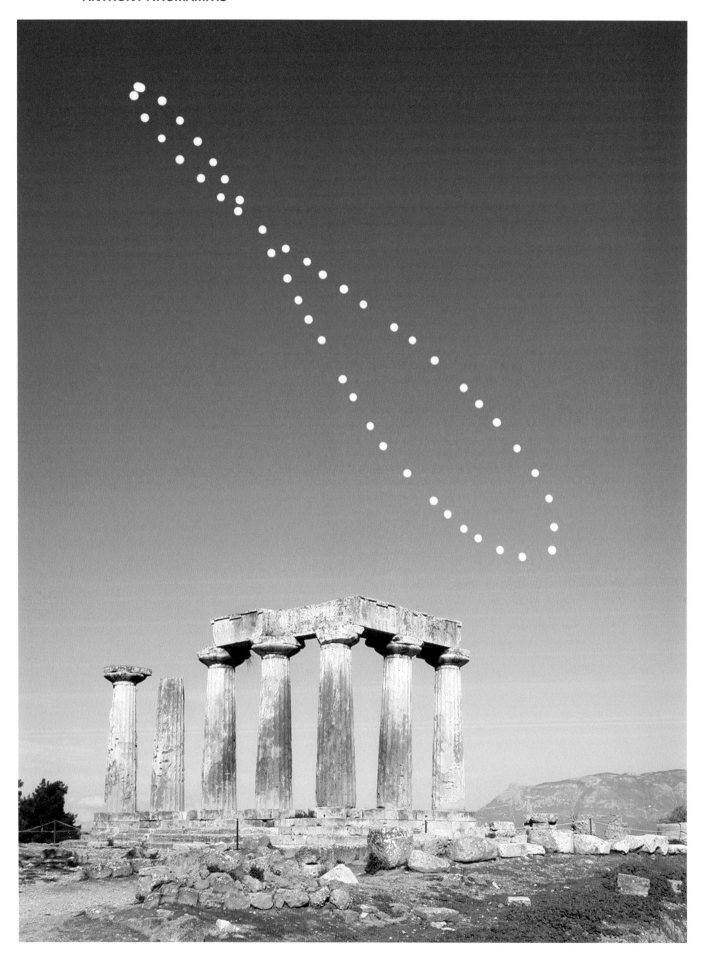

ANTHONY AYIOMAMITIS

ROYCE BAIR

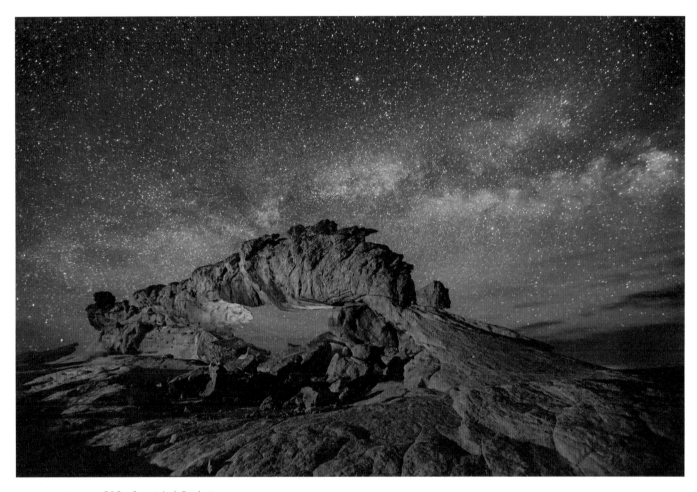

24.2 *Sunset Arch Escalante*
Credit: Royce Bair / www.RoyceBair.com

facing page

24.1 *Apollo Analemma*

Source: Anthony Ayiomamitis / www.perseus.gr / The World At Night

ALEX CHERNEY

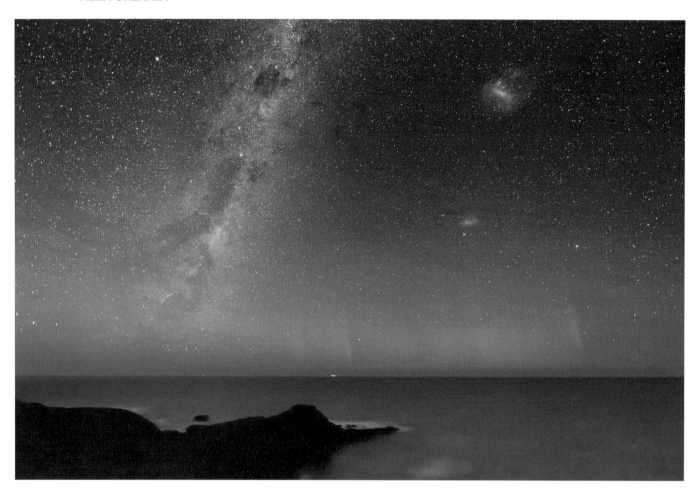

24.3 *Aurora Over Australia*

Source: Alex Cherney / www.terrastro.com / The World At Night

STEVEN CHRISTENSEN

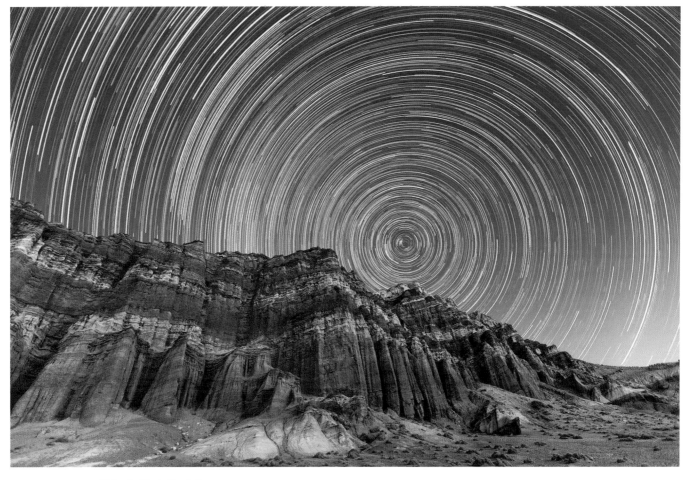

24.4 *Red Rocks Star Trails*

Source: Steven Christenson / www.StarCircleAcademy.com

24.5 *Total Eclipse of the Sun from Lauca National Park*

Source: Alan Dyer / AmazingSky.com

facing page

24.6 *Comet Hale-Bopp and the Great Pyramid of Cheops, Giza, Egypt*

Source: John Goldsmith / www.celestialvisions.com.au

JOHN GOLDSMITH

PHIL HART

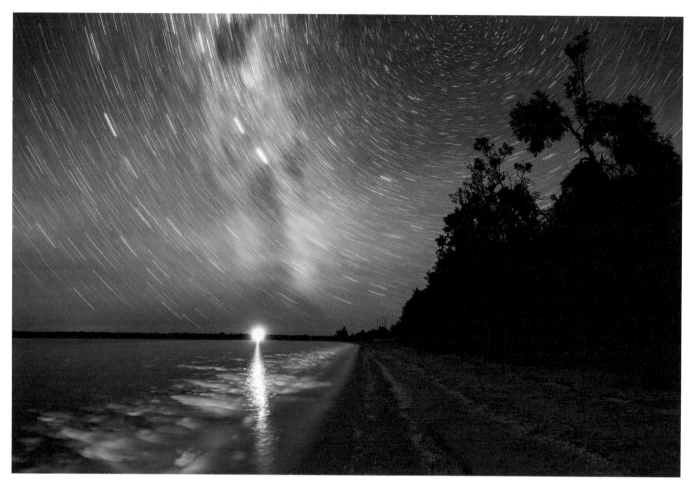

24.7 *Bioluminescence Gippsland Lakes*
Source: Phil Hart / www.philhart.com

facing page

24.8 *Milky Way Tufa*
Source: Lance Keimig / TheNightSkye.com

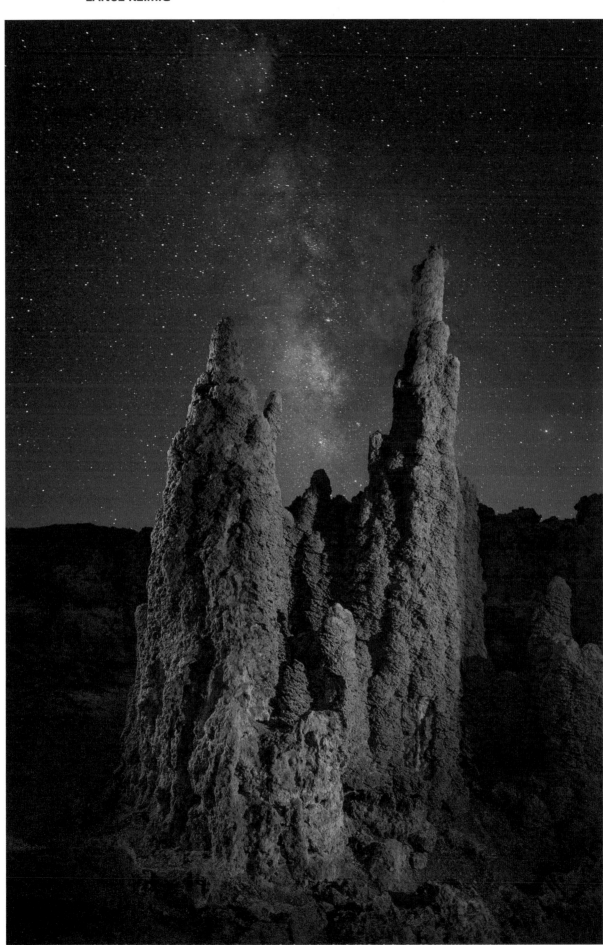

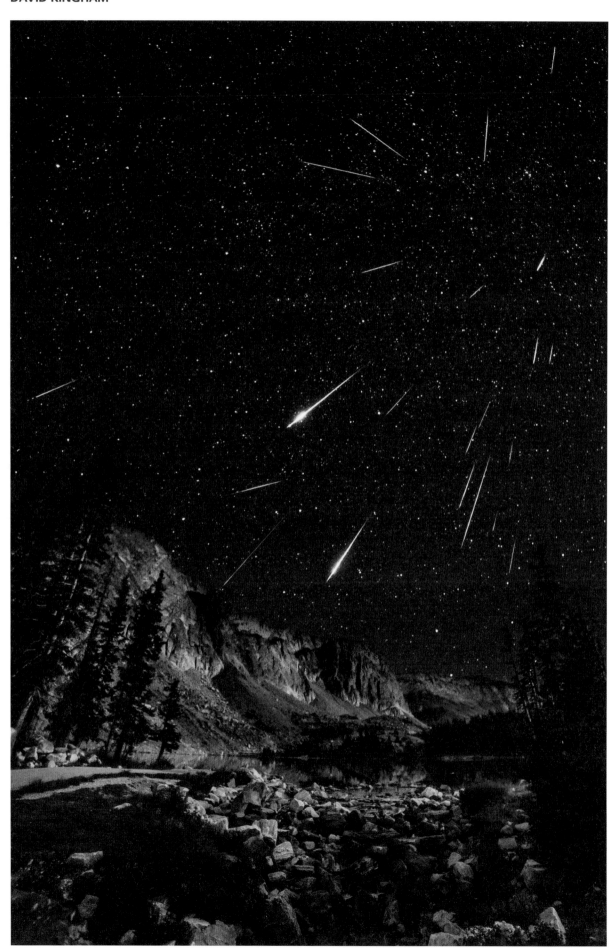

DORA MILLER

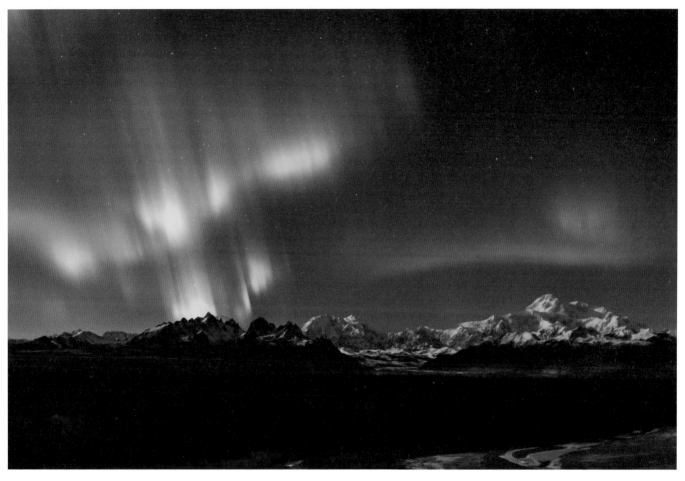

24.10 *Denali & Aurora*

Source: Dora Miller / www.AuroraDora.com

facing page

24.9 *Snowy Range Perseids*

Source: David Kingham / www.davidkingham.com

MARC MUENCH

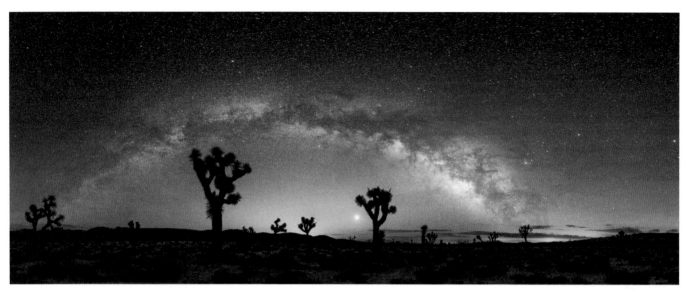

24.11 *Joshua Forest*

Source: © Marc Muench / MuenchWorkshops.com

IAN NORMAN

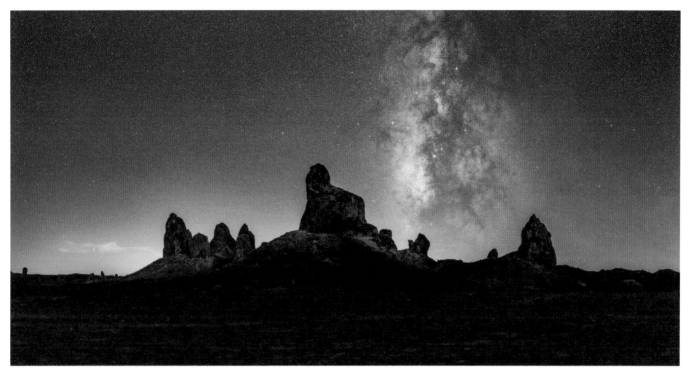

24.12 *Looking South*

Source: Ian Norman / lonelyspeck.com

WALLY PACHOLKA

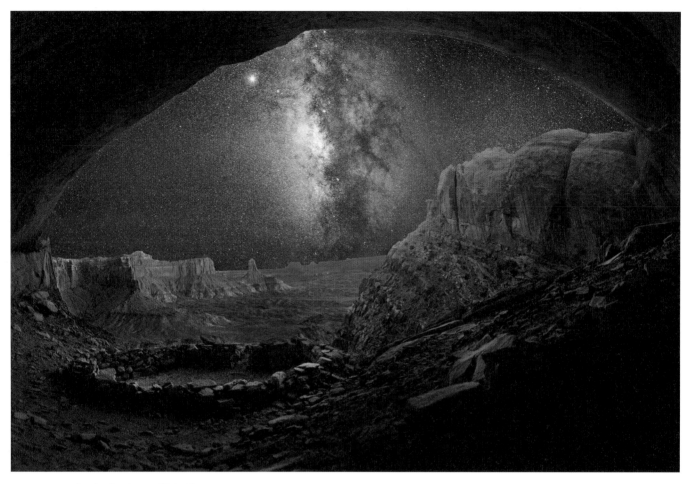

24.13 *True Image of False Kiva*

Source: Wally Pacholka /Astropics.com / The World At Night

BRYAN PETERSON

24.14 *Sydney Harbour*

Source: Bryan Peterson / bryanfpeterson.com

TONY PROWER

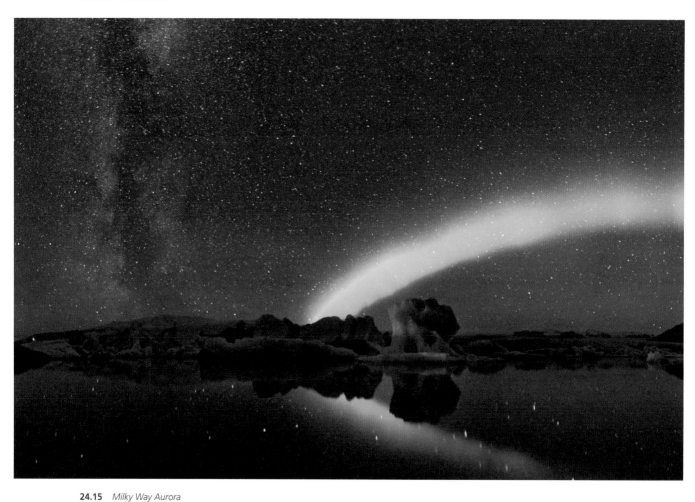

24.15 *Milky Way Aurora*

Source: Tony Prower / TonyPrower.com

BABAK TAFRESHI

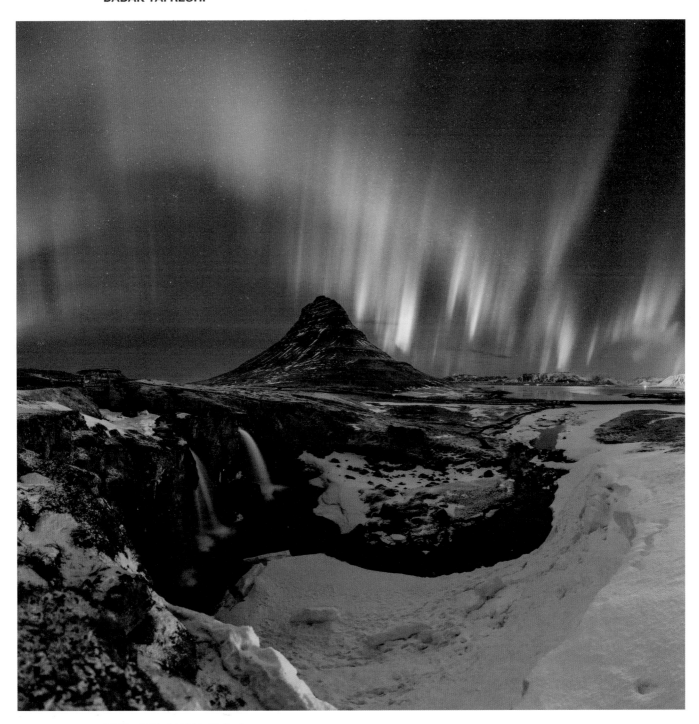

24.16 *A Colorful Night of Iceland*

Source: Babak Tafreshi / The World At Night / twanight.org

YUICHI TAKASAKA

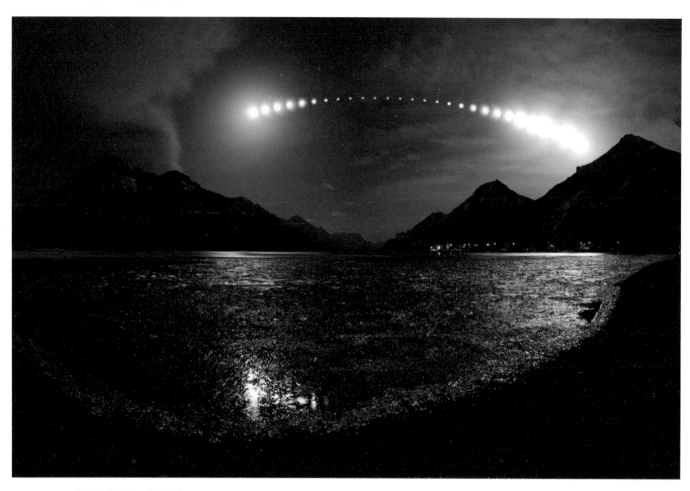

24.17 *Waterton Lake Eclipse*

Source: Yuichi Takasaka / http://blue-moon.ca / The World At Night

BRENDA THARP

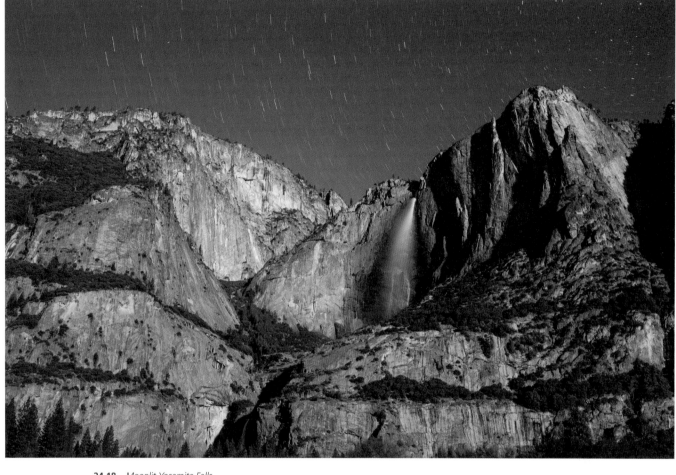

24.18 *Moonlit Yosemite Falls*

Source: Brenda Tharp / www.brendatharp.com

ANDY WILLIAMS

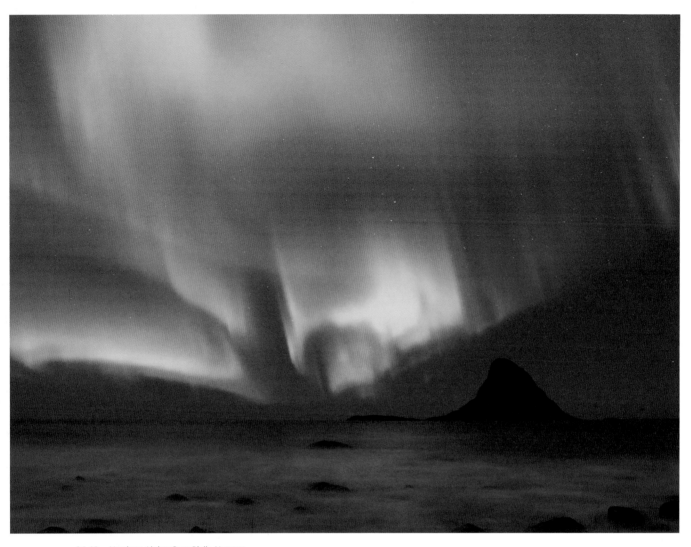

24.19 *Northern Lights Over Bleik, Norway*

Source: Andy Williams / MuenchWorkshops.com

SECTION IX
Conclusions

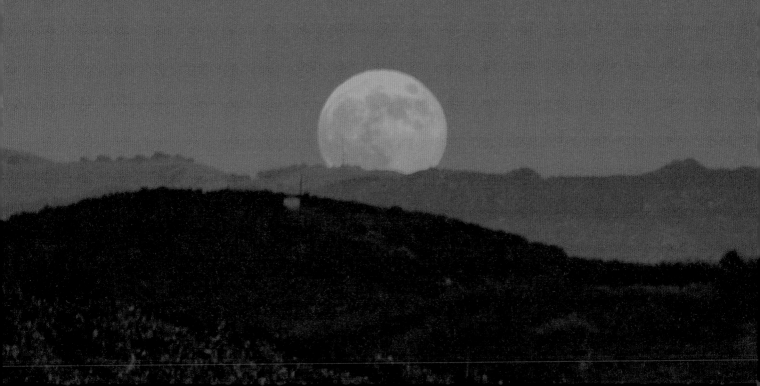

25

WHERE DO WE GO
FROM HERE?

The night sky has been integral to navigation, food cultivation, and religion for thousands of years, yet it still lures our eyes upwards at night with its tantalizing glimpses into the mysteries of the universe. Wouldn't you agree that your own interest in nightscape astrophotography began with your curiosity and appreciation of its beauty?

Landscape astrophotography is in the midst of a genuine revolution. Once the arcane pursuit of a few dedicated individuals, it has gained widespread popularity as it has spread across enormous numbers of curious, motivated people who all share a love of the night skies. Incredible images are constantly being created, each generation more creative and visually dynamic than the one before. Ever more powerful equipment available at lower cost, coupled with the ability to instantly share ones work online, gain inspiration and seamlessly collaborate around the world, is fueling these changes. Landscape astrophotography is truly an international phenomenon and perfectly represents the power of global communication and cooperation.

The future of landscape astrophotography will see increasingly more powerful and lower-cost capabilities in imaging and in-camera processing, especially of high dynamic range (HDR) images. Augmented reality has enormous potential for integrating astronomy and photography within mobile devices. Predictive technologies for atmospheric phenomena such as sunsets and sunrises, the aurorae, and noctilucent clouds will enhance the ability to know when they are likely to occur. Intrepid individuals will continue to explore new regions around the world, discover exciting, dynamic new landscape astrophotography locations and create new image concepts.

Landscape astrophotography has the ability to inspire new generations and old; the night skies have universal appeal. Yet, light pollution poses an ongoing threat to the darkness of the night skies, and vigilant efforts must be made to stop the spread of unnecessary lights. Many organizations, like the International Dark Sky organization, exist to help combat light pollution. The delicate treasures of the night sky must be protected.

The aim of this book has been to help you gain new insights and understanding of astronomy and photography. By understanding the reasons why things are the way they are gives you incredible power over predicting what future events will occur. Interested in lining up the full moon rising over a specific landmark, anywhere in the world? Eager to photograph the brilliant galactic core of the Milky Way arcing over a famous landmark? Now you know how.

I encourage you to seek out and join the community of landscape astrophotographers. You will find many like-minded individuals who share your interest, and in many cases will have your answers. There is no need to reinvent the wheel when a simple question will often be quickly answered. Keep trying different approaches and don't let yourself get discouraged when you run into setbacks. Finally, would you finally like to know the real secret to creating spectacular landscape astrophotography images? It's simple—go outside *tonight* with your camera and start taking pictures of the night sky! Nothing happens when you're underneath a roof! Wishing you clear skies and charged batteries.

APPENDICES

I Equipment Checklist

II Image Summary and World Map

III Annual Night Sky Planner

IV Homemade Planisphere

V Polaris Altitude

VI The Horizon

VII Contributor Websites

SAFETY	PHOTOGRAPHY	ELECTRONICS	PERSONAL
Cellphone	Camera body	Laptop	Folding chair
Cellphone charger	Lenses	Laptop charger	Notebook
Extra battery	Remote release	Memory card reader	Pen/pencil
Basic first aid	Intervalometer	Extension cord	sunblock
Marine flares	Color checker	3-prong adapter	Insect repellent
Water filter	Battery grip		Fruit/energy bar
Water bottle	Loupe	External hard drives	Sunglasses
	Gaffer's tape		Toilet paper
Astronomy		Camera battery charger	Shovel
	Fog filter		
Planisphere	FLW filter	Solar panels	Warm hat
Laser pointer	ND-grad filters	Cables	Shading hat
Field guide	Polarizing filter	Marine battery	Gloves
	10-stop filter	Power conditioner	Windbreaker
	UV filter	Inverter	Bandanna
Field Gear	Filter adapter rings		
		12V power supply / jumpstarter	**Spares**
Compass	Rocket blower		
Swiss army knife	Paintbrush		Car key
GPS	Lens pads & alcohol	**Be sure to check**	Batteries
Flashlight	Lenspen		Memory cards
Handwarmers		Preload location on devices	Lens caps
Maps	Tripod	Preload maps on devices	Extra glasses/case
Notes / plan		Compass magnetic declination	Headlamp
	Camera bag		Flashlight
Lighting			Allen keys for tripod mount, Astrotrac
	Astrotrac		Plastic bags
External flash	Polarie		Camera body & lens caps
Wireless trigger			
	Panorama head		
Light painting/drawing tools			
	Plastic bag for cold camera		
	Camera manual		

Table AI.1

AII.1 World map showing the locations of the images shown in this book.

Source: Google Earth

FIG. #	IMAGE TITLE	CREDIT LINE	SUNSET / TWILIGHT	FULL / CRESCENT MOON	CONSTELLATIONS	STAR TRAILS	MILKY WAY	AURORA	METEORS
1.1			1	1	1	1	1	1	1
1.2									
1.3									
1.4					1				
2.1		www.stellarium.org			1				
2.2		NASA/CXC/SAO							
2.3		NASA/CXC/SAO							
2.4		NASA, ESA, Digitized Sky Survey 2 (Acknowledgement: Davide De Martin)							
2.5					1				
2.6					1				
2.7					1				
2.8						1			
2.9		Jan Koeman / www.koemanphoto.com / The World At Night				1			
2.10									
2.11									
2.12									
2.13									
2.14			1						
3.1			1						
3.2		NASA / NSSDCA	1						
3.3		Steve Hallmark / SteveHallmark.smugmug.com	1						
3.4			1						
3.5			1						
3.6			1						
3.7			1						
3.8			1						
3.9			1						
								1	
4.1		Yuichi Takasaka / http://blue-moon.ca / The World At Night						1	
4.2		NASA/NOAA/SWPC							
4.3								1	
4.4								1	
4.5		NASA/NOAA/SWPC							
4.6		NASA/NOAA/SWPC, www.gi.alaska.edu/auroraforecast							
5.1					1				
5.2					1				
5.3				1					
5.4									
5.5									
5.6									
5.7									
5.8									

Table AII.1

FIG. #	IMAGE TITLE	CREDIT LINE	SUNSET / TWILIGHT	FULL / CRESCENT MOON	CONSTELLATIONS	STAR TRAILS	MILKY WAY	AURORA	METEORS
5.9		Oshin D. Zakarian / DreamView.net / The World At Night; Babak Tafreshi / www.dreamview.net / www.twanight.org / The World At Night		1	1		1		
5.10				1					
5.11				1					
5.12									
5.13		Martin McKenna / www.nightskyhunter.com / The World At Night; Vaibhav Tripathi / The World At Night							
5.14									
5.15									
5.16				1					
6.1									
6.2	Distant Suns								
6.3					1				
6.4				1	1		1		
6.5		Craig Lent / www3.nd.edu/~lent/Astro / The World At Night; György Soponyai / The World At Night							
7.1							1		1
7.2									
7.3		Donald Lubowich / The World At Night							
7.4									
8.1							1		
8.2		NASA/CXC/SAO					1		
8.3	Distant Suns								
8.4									
8.5		www.stellarium.org							
8.6							1		
8.7							1		
8.8							1		
8.9							1		
8.1		Caren Zhao / The World At Night			1				
9.1		P-M Hedén / www.clearskies.se / The World At Night	1						
9.2							1		
9.3									
9.4									
9.5		Mike Crawford / http://ctkmedia.smugmug.com		1					
9.6		Teruyasu Kitayama / The World At Night							
9.7			1						
10.1									
10.2		Tunç Tezel / The World At Night					1		
10.3									
10.4									
10.5									
10.6			1						
10.7									
11.1									

FIG. #	IMAGE TITLE	CREDIT LINE	SUNSET / TWILIGHT	FULL / CRESCENT MOON	CONSTELLATIONS	STAR TRAILS	MILKY WAY	AURORA	METEORS
11.2									
11.3									
11.4									
11.5							1		
11.6									
11.7							1		
11.8									
11.9									
11.10									
11.11			1						
11.12									
11.13									
11.14									
11.15									
11.16								1	
11.17			1						
11.18								1	
11.19							1		
11.20			1						
12.1							1		
12.2									
12.3									
12.4									
12.5									
12.6									
12.7									
12.8								MN	
12.9									
13.1						1	1		
13.2							1		
13.3							1		
13.4							1		
13.5									
14.1									
14.2									
14.3									
15.1	Morning Spindrift Off Mt. Everest		1						
15.2	Curtains of Light							1	
15.3	Winter Twilight		1						
15.4	Liquid Light Show	Alex Cherney / www.terrastro.com / The World At Night			1				
15.5	Capstone Kiva Twilight		1						
15.6	Blood Moon Rises Over Chonqing	Zhou Yannan / www.flickr.com/photos/zhouyannan / The World At Night		1					
15.7	The Northern Big Bear				1				

Table AII.1 continued

FIG. #	IMAGE TITLE	CREDIT LINE	SUNSET / TWILIGHT	FULL / CRESCENT MOON	CONSTELLATIONS	STAR TRAILS	MILKY WAY	AURORA	METEORS
15.8	Double Towers, Double Crescents	Bernd Pröschold / www.sternstunden.net / The World At Night		1					
15.9	Athens Full Moon	Anthony Ayiomamitis / www.perseus.gr / The World At Night		1					
15.10	Nice Ending	Scott Freeman	1						
15.11	Heading North							1	
15.12	Double Lightsaber	Uli Fehr / www.fehrpics.com		1					
15.13	Magellanic Clouds Over Mt.	Steed Jun Yu / NightChina.net / The World At Night					1		
15.14	Kilimanjaro	Alex Conu / alexconu.com						1	1
15.15	Ancient Sky Map	Grant Kaye / http://grantkaye.com					1		
15.16	Eternal Vistas						1		
15.17	Night of Desert People	Babak Tafreshi / www.dreamview.net / www.twanight.org / The World At Night			1				
15.18	Big Sky Aurora							1	
15.19	The Planets Align		1						
15.2o	Fire to Space	Ben Cooper / www.launchphotography.com							
15.21	Solar Eclipse Evolution	Cristina Țintă / www.flickr.com/photos/cristinatinta/ The World At Night		1					
15.22	Starry Nights					1			
15.23	A Hovenweek Sunset		1						
15.24	Ursa Major Over Stromboli	Philippe Mollet / The World At Night	1						
15.25	Southern Cones of Light						1		
16.1									
16.2									
16.3									
16.4		http://vitotechnology.com/star-walk.html							
16.5		https://djlorenz.github.io/astronomy/lp2006/overlay/dark.html							
16.6		wunderground.com							
16.7		http://app.photoephemeris.com/					1		
16.8		Google Earth							
16.9		www.usgs.gov							
16.10							1		
16.11									
16.12						1	1		
16.13			1	1		1	1	1	
17.1		Stellarium							
17.2		http://distantsuns.com; http://vitotechnology.com/star-walk.html							
17.3		www.photopills.com							
17.4		www.photopills.com							
17.5		http://app.photoephemeris.com/							
17.6		hrtapps.com/theodolite							
17.7		ClearDarkSky, WU, NOAA							
17.8		www.heavens-above.com							
18.1									
18.2		Google Maps							

FIG. #	IMAGE TITLE	CREDIT LINE	SUNSET / TWILIGHT	FULL / CRESCENT MOON	CONSTELLATIONS	STAR TRAILS	MILKY WAY	AURORA	METEORS
18.3									
18.4		Kirsten Larson							
18.5			1						
18.6			1						
18.7			1						
18.8							1		
18.9									
18.10							1		
18.11									
19.1									
19.2									
19.3		www.photopills.com							
19.4		www.photopills.com					1		
19.5		www.photopills.com					1		
19.6									
19.7		www.photopills.com					1		
20.1									
20.2									
20.3									
20.4									
20.5							1		
20.6						1	1		
21.1									
21.2									
21.3			1						
21.4									
21.5							1		
21.6							1		
21.7							1		
21.8							1		
21.9			1						
21.10							1		
21.11								1	
22.1			1						
22.2									
22.3			1						
22.4						1			
22.5							1		
22.6							1		
22.7							1		
22.8							1		
22.9						1			
22.10						1			
22.11									
22.12						1			

Table AII.1 continued

FIG. #	IMAGE TITLE	CREDIT LINE	SUNSET / TWILIGHT	FULL / CRESCENT MOON	CONSTELLATIONS	STAR TRAILS	MILKY WAY	AURORA	METEORS
22.13									
22.14		www.markus-enzweiler.de/software/software.html				1			
22.15									1
22.16									1
23.1					1				
23.2		Distant Suns, www.photopills.com							
23.3		http://app.photoephemeris.com/							
23.4									
23.5					1				
23.6				1					
23.7		Distant Suns, www.photopills.com							
23.8		http://app.photoephemeris.com/							
23.9				1					
23.10				1					
23.11						1			
23.12		http://app.photoephemeris.com/; www.photopills.com							
23.13		www.photopills.com							
23.14									
23.15						1			
23.16							1		
23.17		Distant Suns; http://app.photoephemeris.com/							
23.18		www.photopills.com							
23.19							1		
23.20							1		
24.1	Apollo Analemma	Anthony Ayiomamitis / www.perseus.gr / The World At Night							
24.2	Sunset Arch Escalante	Royce Bair / www.RoyceBair.com							
24.3	Aurora Over Australia	Alex Cherney / www.terrastro.com / The World At Night							
24.4	Red Rocks Star Trails	Steven Christenson / www.StarCircleAcademy.com							
24.5	Total Eclipse of the Sun from Lauca National Park	Alan Dyer / AmazingSky.com							
24.6	Comet Hale-Bopp and the Great Pyramid of Cheops, Giza, Egypt	John Goldsmith / www.celestialvisions.com.au							
24.7	Bioluminescence Gippsland Lakes	Phil Hart / www.philhart.com							
24.8	Twin Tufa Towers, Mono Lake, 2014	Lance Keimig / TheNightSkye.com							
24.9	Snowy Range Perseids	David Kingham / www.davidkingham.com							
24.10	Denali & Aurora	Dora Miller / www.AuroraDora.com							
24.11	Joshua Forest	(c) Marc Muench / MuenchWorkshops.com							
24.12	Looking South	Ian Norman / lonelyspeck.com							
24.13	True Image From False Kiva	Wally Pacholka /Astropics.com / The World At Night							
24.14	Sydney, Australia	Bryan Peterson / bryanfpeterson.com							
24.15	Milky Way Aurora	Tony Prower / tonyprower.com							
24.16	A Colorful Night in Iceland	Babak Tafreshi / The World At Night							
24.17	Waterton Lake Eclipse	Yuichi Takasaka / http://blue-moon.ca / The World At Night							
24.18	Moonlit Yosemite Falls	Brenda Tharp / www.brendatharp.com							
24.19	Northern Lights Over Bleik, Norway	Andy Williams / MuenchWorkshops.com							

APPENDIX III ANNUAL NIGHT SKY PLANNER

MONTH	SUGGESTED NIGHT SKY OBJECT OR EVENT
January	Orion
February	Twilight
March	Aurorae
April	Star trails
May	Zodiacal light
June	Milky Way—panorama
July	Milky Way—galactic core
August	Perseids
September	Harvest Moon rise / set
October	Belt of Venus
November	Leonids
December	Geminids

Table AIII.1

You can make your own planisphere by following these simple instructions. First, print out Figures A.IV.1 and A.IV.2. You may wish to glue them onto a stiff piece of paper or thin cardboard. Next, cut along the dashed lines in both figures. You should now have two pieces—a circular piece, the Star Wheel, that has all the stars and months marked along the edge, and a second piece, the Star Holder, with a hole in its middle. Fold the Star Holder figure along the dotted line. You may wish to tape or staple the edges together. Place the Star Wheel within the folded pocket and voila! Your homemade planisphere is complete.

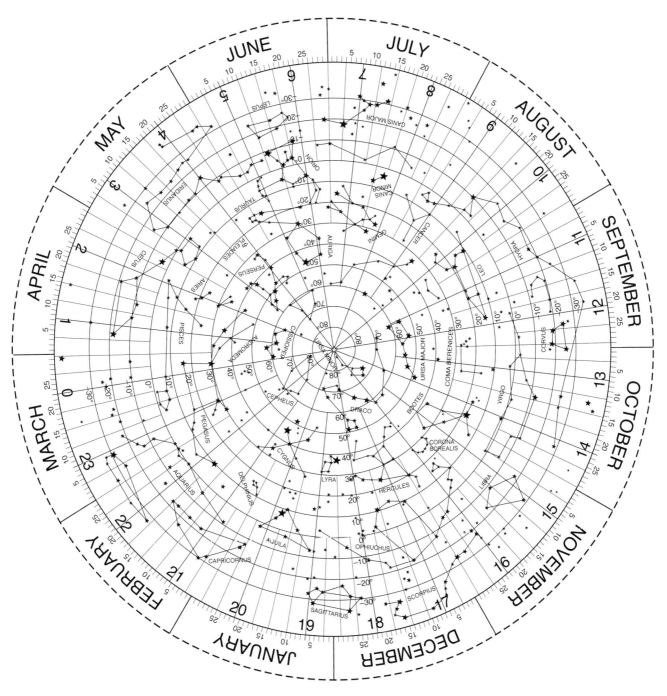

AIV.1 Star Wheel used for a homemade planisphere.

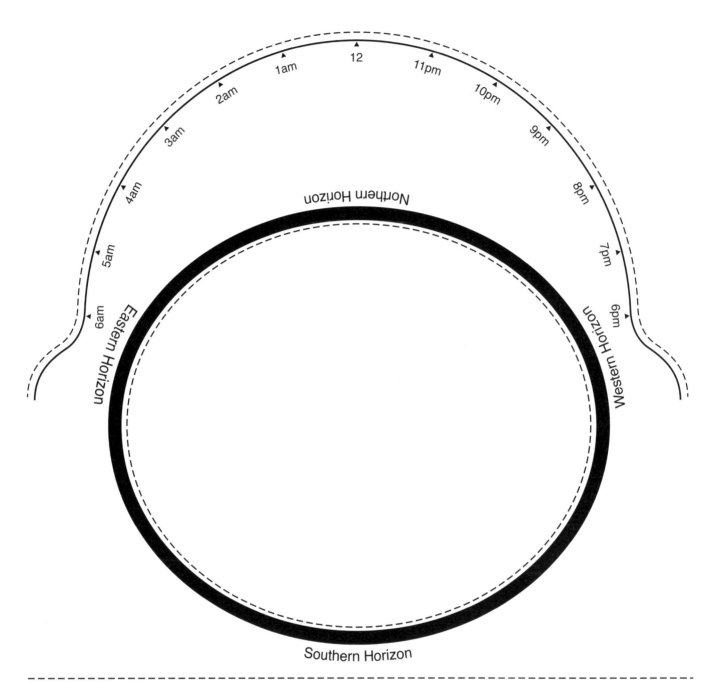

AIV.2 Star Wheel Holder used in a homemade planisphere.

AV.1 Schematic of the geometry used to prove that Polaris (or the south celestial pole) lies above the horizon at an angle, or has an altitude, roughly equal to the observer's latitude. An observer at a latitude of θ° N (green), has an angle of φ° (red) between starlight from Polaris and a line connecting the observer to the center of the earth. Also, because the line connecting the observer to the center of the earth is oriented at a right angle, or 90°, to the observer's local horizon, then the angle between starlight from Polaris and the observer's local horizon must also be θ° (green). Finally, since the altitude of Polaris must be equal to the angle between starlight from Polaris and the observer's local horizon, then we have our proof that the altitude of Polaris is equal to the observer's latitude!

Here, we prove that Polaris (or the south celestial pole) lies above the horizon at an angle, or has an altitude, roughly equal to the observer's latitude. First, note in Figure A.V.1 that since Polaris is so far away, all its light arrives at Earth in the form of parallel rays. For an observer at a latitude of $\theta°$ N (green), then, the angle between starlight from Polaris and a line connecting the observer to the center of the earth is $\varphi°$ (red).

Next, since the sum of the interior angles of a right triangle must add up to 180°, we see that:

$$\theta + \varphi + 90° = 180° \qquad \text{(Eq. App. 1)}$$

or,

$$\theta + \varphi = 90° \qquad \text{(Eq. App. 2)}$$

Also, because the line connecting the observer to the center of the earth is oriented at a right angle, or 90° to the observer's local horizon, then the angle between starlight from Polaris and the observer's local horizon must also be $\theta°$ (green).

Finally, since the altitude of Polaris must be equal to the angle between starlight from Polaris and the observer's local horizon, then we have our proof that the altitude of Polaris is equal to the observer's latitude!

AVI.1 Schematic of the approach used to analyze the distance, *A*, to the horizon. *R* is the radius or the earth and *h* is the height of the observer. Applying Pythagorean's theorem with an approximately 2-m tall observer results in a distance to the horizon of only 3 miles!

The Horizon

What, exactly, is the horizon and how far away is it? The answer is actually easier to determine than you might think, and the results may startle you. If we examine the schematic in Figure A.VI.1, we see that the distance to the horizon perceived by an observer of height *h* is the length of the tangent line, *A*, that connects the eyes of the observer to the closest tangent point on the earth's surface. The radius of the earth is represented by the symbol *R*, and is 6.37×10^6 m. The familiar Pythagorean theorem gives us the simple relationship:

$$(R + h)^2 = A^2 + R^2 \qquad \text{(Eq. App.3)}$$

Rearranging this relationship, inserting the values for the radius of the earth and the height of a typical observer, say 2 m and solving for the quantity, *A*, gives the result that a typical horizon is approximately 5,047 meters, or about 3 miles away.

FIG. NO.	CONTRIBUTOR	TITLE	WEBSITE
24.1	Anthon Ayiomamitis	*Apollo Analemma*	www.perseus.gr
15.9	Anthon Ayiomamitis	*Athens Full Moon*	www.perseus.gr
24.2	Royce Bair	*Sunset Arch Escalante*	www.RoyceBair.com
24.3	Alex Cherney	*Aurora Over Australia*	www.terrastro.com
15.4	Alex Cherney	*Liquid Light Show*	www.terrastro.com
24.4	Steven Christenson	*Red Rocks Star Trails*	StarCircleAcademy.com
15.14	Alex Conu	*And Then It Hit Me*	alexconu.com
15.20	Ben Cooper	*Fire to Space*	www.launchphotography.com
9.5	Mike Crawford	*Ice Halos*	http://ctkmedia.smugmug.com
24.5	Alan Dyer	*Total Eclipse of the Sun from Lauca National Park*	AmazingSKy.com
15.12	Uli Fehr	*Double Lightsaber*	www.fehrpics.com
15.10	Scott Freeman	*Nice Ending*	
24.6	John Goldsmith	*Comet Hale-Bopp and the Great Pyramid of Cheops, Giza, Egypt*	www.celestialvisions.com.au
3.3	Steve Hallmark	*Assiniboine*	SteveHallmark.smugmug.com
24.7	Phil Hart	*Bioluminescence Gippsland Lakes*	www.philhart.com
9.1	P-M Heden	*Veins of Heaven*	www.clearskies.se
15.15	Grant Kaye	*Ancient Sky Map*	http://grantkaye.com
24.8	Lance Keimig	*Twin Tufa Towers, Mono Lake, 2014*	TheNightSkye.com
24.9	David Kingham	*Snowy Range Perseids*	www.davidkingham.com
9.6	Teruyasu Kitayama	*A View From Mt. Fuji*	The World At Night
2.9	Jan Koeman	*Jan Koeman*	www.koemanphoto.com
6.5	Craig Lent	*Solar Analemma Over Trinity School Chapel*	www3.nd.edu/~lent/Astro
7.3	Donald Lubowich	*Comet Hale-Bopp Over New York City Skyline*	Donald Lubowich
5.13	Martin McKenna	*Moonbow*	www.nightskyhunter.com
24.10	Dora Miller	*Denali & Aurora*	www.AuroraDora.com

FIG. NO.	CONTRIBUTOR	TITLE	WEBSITE
15.24	Philippe Mollet	*Stromboli Volcano*	Philippe Mollet
24.11	Marc Muench	*Joshua Forest*	MuenchWorkshops.com
24.12	Ian Norman	*Looking South*	lonelyspeck.com
24.13	Wally Pacholka	*True Image From False Kiva*	Astropics.com
24.14	Bryan Peterson	*Sydney, Australia*	bryanfpeterson.com
15.8	Bernd Pröschold	*Double Crescents, Double Towers*	www.sternstunden.net
24.15	Tony Prower	*Milky Way Aurora*	tonyprower.com
6.5	Gyorgy Soponyai	*Lunar Analemma*	The World At Night
15.17	Babek Tafreshi	*Night of Desert People*	www.dreamview.net / www.twanight.org
24.16	Babek Tafreshi	*A Colorful Night in Iceland*	www.dreamview.net / www.twanight.org
5.9	Babek Tafreshi	*Moonlight in Paris*	www.dreamview.net / www.twanight.org
24.17	Yuichi Takasaka	*Waterton Lake Eclipse*	http://blue-moon.ca
4.1	Yuichi Takasaka	*Aurora Australis Over Tasmania*	http://blue-moon.ca
10.2	Tunc Tezel	*Night Sky in H-alpha*	Tunç Tezel
24.18	Brenda Tharp	*Moonlit Yosemite Falls*	www.brendatharp.com
15.21	Cristina Ţîntă	*Solar Eclipse Evolution*	www.flickr.com/photos/cristinatinta
5.13	Vaibhav Tripathi	*Big Dipper Trailing Over Moonbow*	Vaibhav Tripathi
24.19	Andy Williams	*Northern Lights Over Bleik, Norway*	MuenchWorkshops.com
15.6	Zhou Yannen	*Blood Moon Rises Over Chonqing*	www.flickr.com/photos/zhouyannan
15.13	Steed Yu	*Magellanic Clouds Over Mt. Kilimanjaro*	NightChina.net
5.9	Oshin Zakarian	*Beehive Above Himalaya*	DreamView.net
8.1	Caren Zhao	*Strolls in the Star River*	Caren Zhao

INDEX

18% gray, 176

A

Absolute humidity, 122
Actions, 328
Airglow, 59–61
Airplanes, 310
Alpenglow, 40, 209
Altitude, 241, 242
Altocumulus, 120, 122
Altostratus, 120, 122
Ambient light, 139
Analemma, 86, 91
Ancestral Puebloan, 34
Aperture, 154
Apogee, 79
Asterism, 21
Asteroid, 99
Astronomical twilight, 42, 44
Astrotrac, 280
Augmented reality (AR), night, 287–290
Aurora Australis *see* Aurorae
Aurora Borealis *see* Aurorae
Aurora oval, 56
Aurorae, 50–59, 210
Aurorae predictions, 54–59
Averted vision, 143, 145
Azimuth, 241, 242

B

Belt of Venus, 45, 211
Big Dipper, 21, 22
Bioluminescence, 212
Black hole, 103
Blood Moon, 79
Blue hour, 42, 213
Bolide, 95
Books of knowledge, 286
Bracketing, *see* exposure bracketing
Brightness, 140
Brightness/contrast adjustments, 323
Brush tool, 324
Bz index, 56

C

Catalog, Lightroom, 318
Celestial sphere, 26
Chromatic aberration, 156
Chumash 'Ap, 386–391
Circle of confusion, CoC, 161
Circular polarizing filter, 274
Circumpolar, 32
Cirrocumulus, 120
Cirrostratus, 120
Cirrus, 120, 122
Cityscapes, 214
Civil twilight, 42
Cleaning, lens, 300–302
Cleaning, sensor, 303–305
Clouds, 120–122
Coal Sack, 113
Cold, 306
Color balancing, 319
Coma, 156
Comet, 95, 96
Compass, 270
Cones, 144, 145
Conjunction, *see* planetary conjunction
Constellations, 215
Corona–moon, sun, 129
Coronal mass ejection (CME), 50
Crepuscular rays, 130
Crescent moon, 73, 216
Crop sensor, 149
Cumulonimbus, 120, 122
Cumulus, 120, 122

D

Dark adaptation, 145
Dark nebula, 113
Deep Space Climate Observatory (DSCOVR), 55
Dehaze, 324
Depth-of-Field, DOF, 161
Develop module, Lightroom, 319
Dew, 123
Dew point, 123
Diffraction, 129, 156
Direct light, 139
Dispersion, 125, 132
Distant Suns, 258
Dubhe, 22
Dust clouds, 113

E

Earth's shadow, 45, 79
Earthshine, 68, 89
Eclipse, 78, 220, 229
Ecliptic, 28
Electromagnetic spectrum, 136
Emission nebula, 113
Emu in the Sky, 113
Equatorial mount, 281
Equinox, 34
ETTR, 187
Exporting, Lightroom, 324
Exposure, 176–189
Exposure bracketing, 340
Exposure stop, 141
Exposure value, EV, 176
Eye, 143–145

F

f-stop, 141
Far focus point, 161
Field-of-view, FOV, 152
File compression, 151
File format, 151
Fireball, 95
Firefly analogy, 178
Fisheye-Hemi, 328
FLW filter, 278
Flying seagulls, 180
Focal length, 151
Focus blending, 340
Focus distance, *see* subject focus distance
Focusing, 297–299
Fog filter, 278
Foreground-priority, 240, 247–249
Fovea, 143. 144
Frost, 123
Full moon, 217
Full-frame sesnor, 149

G

Gaffer's tape, 272
Galactic core, 103
Gas giants, 87
Geocentric model, 86
Ghetz, Andrea, 103
Gibbous, 73
Golden hour, 42, 218
Graduated neutral density filter, 277
Great Lakes Aurora Hunters (GLAH), 59

Great Rift, 113
Green flash, 130, 131
Ground fog, 125

H

Hale-Bopp comet, 96
Harvest Moon, 79
Heliocentric model, 86
High-dynamic range, HDR, 340
Histogram, 292
Holy-grail time-lapse, 358
Horizon, 42
Hue, 140
Human factors, 306
Humidity, 122
Hyperfocal distance, 164, 165
Hyperfocal focusing, 164, 165

I

Ice halo, 80, 81
Ice pillar, 125
ImageJ, 353
Importing, Lightroom, 318
Incandescence, 137
Indirect light, 139
Infrared, 136
Intensity, 140
Interference, 129
Interplanetary magnetic field, 56
Intervalometer, 306
Iris, 143, 144
ISO blending, 342

J

JPEG—*see* file format

K

Key frames, 358
Kp index, 56

L

Latitude effects, Milky Way, 112
Lens (eye), 144
Lens correction, 323
Lens selection, 165–172
Libation point, 55
Light, 136–143

Light drawing, 197
Light painting, 192–196, 219
Light pollution, 310
Light pollution filter, 280
Light reflectors, 139
Light refractors, 139
Light scatterers, 139
Light value (LV), 140
Light-year, 103, 117
Lightning, 129, 130
Lightroom, 261
Lightroom, 318–324
Long-exposure noise reduction (LENR), 338
Loupe, focusing, 298
LRTime-lapse, 358
Luminance, 140
Luminescence, 137
Luminosity, 140
Lunar eclipse, see eclipse, 78
Lunation, 91
Lux, 140

M

Macula, 143, 144
Magellanic clouds, 221
Magnetic declination, 271
Mare see Maria
Maria, 67
Merak, 22
Meteor, 95
Meteor shower, 95–99, 222
Meteor shower composite, 355
Meteorite, 95
Milky Way, 102–117, 223, 224
Mobius arch, 364
Monitor calibration, 318
Moon, 64–84
Moon illusion, 82
Moonbow, 80, 81
Mt. Whitney, 364–371, 372–379

N

National Oceanic and Armospheric Agency
 (NOAA), 54
Nautical twilight, 42
Near focus point, 161
Neutral density filter, 276
Night vision, 144, 145
Nimbostratus, 120
Noctilucent, 120, 122

Nodal point, 280
Noise, 149
Noise reduction, 323
North Star, 21
Northern Lights, see Aurorae

O

Open coronal hole, 50
Orbit, 70
Orion-Cygnus arm, 103

P

Panorama, 224, 226, 344
Perigee, 79
Petroglyphs, 34
Phase (Moon), 73
Photopigments, 144
PhotoPills, 259
Photoreceptor cells, 144
Photoshop, 261, 324–332
Pixel, 148
Planet,
Planetarium, 32
Planetary K-index see Kp index
Planetray conjuction, 86, 89, 227
Planisphere, 31
Plug-ins, 328
Pointer stars, 22
Polaris, 21
Polarizing filter, see circular polarizing filter
Post-processing, 318–359
Prime lens, 173
Pupil, 144

Q

Quarter moon, 73

R

Radiant point, 97
Radiative heat transfer, 123
Rainbow, 125
RAW file—see file format
Rayleigh scattering, 38, 48
Red headlamp, 270
Reflection, 125
Reflection nebula, 113
Refraction, 125
Relative humidity, 122

Retina, 143
Rocket launch, 228
Rods, 144, 145
Rule of 400/500/600, 182

S

Satellites, 310
Saturation, 140, 143
Saturation water vapor, 122
Scripts, 328
Seasons, 33
Sensor, 148
Sharpening, 323
Sidereal month, 84
Sky-priority, 240–247
Skyglow, 59–61
Solar eclipse see eclipse, 78
Solar system, 86–92
Solstice, 34
Southern Cross, 22
Spares, 299
Spectrum, spectra, 137
Spherical aberration, 156
Split neutral density filter,
 see Graduated neutral density filter
Split Rock Lighthouse, 380–385
Spot removal, 324
Star trails, 230, 348–355
Star Walk, 258
StarStax, 353
Stellarium, 31, 258
Stratocumulus, 120
Stratus, 120, 122
Subject focus distance, 151, 156
Sundog, 125
Sunrise, 33, 218
Sunset, 33, 218
Sunspot, 50
Supermoon, 79
Supersaturation, 125
Synodic month, 70

T

Terminator line, 66, 67
Terrestrial planets, 87
The Photographers Ephemeris (TPE), 259
The World At Night (TWAN), 267
Theia, 67
Theodolite, 264
Thermosphere, 59
Time-lapse, 231, 358
Tonal range, 338
TWAN *see* The World At Night

U

Ultraviolet, 136
Ultraviolet (UV) filter, 280
Ursa Major, 21
US Space Weather Center, 54

V

Via lactea, 105
Vignette, lens, 156
Volcano, 232

W

Waning, 73
Water vapor, 122
Waxing, 73
Weather front, 120

Z

Zenith, 26, 31
Zodiac, 28
Zodiacal light, 86, 90, 233
Zoom lens, 173